Praise for *Oil and*

"Tremendously entertaining and un~~~~~~~ license, *Oil and Marble* will remind an older generation of the pleasures of Irving Stone's art historical fiction."
—Maxwell Carter, *The New York Times*

"The artistic process can be one of self-doubt, struggle, and sheer physical exertion, and Storey depicts the drama here with truth and insight. A rewarding read for art aficionados and fans of historical fiction."
—*Booklist*

"Vividly evoking the turbulent world and ferociously competitive spirit of Renaissance Florence, Stephanie Storey transports the reader to one of the most creative and exciting moments in the history of that remarkable city."
—William E. Wallace, author of *Michelangelo: The Artist, the Man and His Times*

"With every chip of the chisel and stroke of the brush, Stephanie Storey fashions a mesmerizing tale of the envy, ambition, and artistic genius that drove an epic rivalry. *Oil and Marble* will make readers long for Florence and to see David in the morning light."
—Elizabeth Cobbs, author of *Broken Promises: A Civil War Novel* and *The Hamilton Affair*

"Authentically steeped in the history and culture, Storey captures all the gorgeous, grim, and essential nuances of the creative process. It is a fascinating backstage glimpse of artistry at work."
—Carmit Delman Birnbaum, author of *Burnt Bread and Chutney*

"In the end this book is as much a love story as it is an historical narrative of time and place. Leonardo's love for the muse Lisa and Michelangelo's loving obsession to create something of great beauty from a block of imperfect stone. Stephanie Storey perfectly describes this artistic love as she paints her own masterpiece in the character of Leonardo."
—Thomas Crowe, *Smoky Mountain News*

"*Oil and Marble* is a magnificent story brimming with an all-star cast of world famous artists conducted by the talent of author Stephanie Storey. . . . An intriguing unforgettable classic piece of historical fiction." —Hudson Booksellers, Best of 2016

"Before I got to the bottom of the first page, I was completely engrossed in *Oil and Marble*. I especially liked the way Ms. Storey involved all the great names of the early sixteenth century in the art of politics and the politics of art. This is an eminently readable tale, with the two giants of art giving the story its heart and soul. A fabulous and fun read." —*HistoricalNovelSociety.org*

"The result... is a fascinating, authentic story in a fully realized and beautifully crafted world. Michelangelo and Leonardo both feel like real people and not just like the legends (or ninja turtles) most of us known them as. Storey focuses not solely on their genius, but on their insecurities and failures."
—*Storytime Junction Reviews*

"Storey has produced a shrewd, entertaining book that, while it ought not be confused with history, might inspire a longform cable series." —*Arkansas Democrat-Gazette*

First Paperback Edition 2018

Arcade Publishing books may be purchased in bulk at special discounts for sales promotion, corporate gifts, fund-raising, or educational purposes. Special editions can also be created to specifications. For details, contact the Special Sales Department, Arcade Publishing, 307 West 36th Street, 11th Floor, New York, NY 10018 or arcade@ skyhorsepublishing.com.

Arcade Publishing® is a registered trademark of Skyhorse Publishing, Inc.®, a Delaware corporation.

Visit our website at www.arcadepub.com.
Visit the author's website at OilandMarble.com.

10 9 8

Library of Congress Cataloging-in-Publication Data is available on file.

Cover design by Laura Klynstra

Print ISBN: 978-1-62872-906-1
Ebook ISBN: 978-1-62872-640-4

Printed in the United States of America

Oil and Marble

A Novel of Leonardo and Michelangelo

Stephanie Storey

Arcade Publishing • New York

For my husband, Mike,
who gave me the courage to chase my dreams

✳

1499
Milan

✳

Leonardo
December. Milan

From up close, he could see that the mural was already beginning to flake off the wall. The paint was not smooth, as it should be, but grainy, as though applied over a fine layer of sand. Soon the pigment would break away from the plaster and crumble into specks that would blow away, bit by bit. The earthy tones, made from dirt and clay, would be the first to go. The vermilion, the rusty red color of blood and pomegranate, would most likely stick the longest; it had the most permanent qualities. But the ultramarine worried him most. Ground from precious lapis stones, the brilliant blue was shipped in from a faraway land in the East and was the most expensive hue on the market. By using a hint of ultramarine, a painter could elevate a picture from mediocre to masterpiece, but its use on fresco was rare. Without ultramarine, his work could be dismissed as insignificant or, worse yet, conventional. And it was already starting to crack.

"*Porca vacca,*" he swore under his breath. The deterioration was his own fault. He had pushed his experiments too far. He always pushed things too far. The left side of his face twitched. He took a deep breath, and his expression softened back into serenity. No need to feel ruffled. For now, he reassured himself, this was still a masterpiece, and he was still the master. He turned to entertain his audience with secrets and stories. It was, after all, what

they had come for: to hear the great Leonardo from Vinci explain his latest painting, *The Last Supper*.

"One of you will betray me!" Leonardo boomed, his voice echoing down the vaulted stone dining hall in the church of Santa Maria delle Grazie, where his fresco spanned the north wall.

The crowd of French tourists was delighted by his dramatic outburst. He knew that for many of them, he was a great curiosity. At forty-eight years old, the Master from Vinci was one of the most famous men on the Italian peninsula; his name had spread to France, Spain, England, and the far-flung land of Turkey. He was known for his ingenious designs of war machines and groundbreaking innovations in paint. Tourists traveled from all over the world to see him stand in front of his famous fresco, which was known for its luscious colors, still clinging to the plaster for now—for its thirteen realistic portraits of Jesus and his disciples, and its undulating composition, balanced around a central, stable Christ.

"This is the moment immediately following Christ's accusation," he said, stepping away from the fresco in hopes of diverting the crowd's attention away from the decaying paint. "At this point in the story, no one yet knows it is Judas who will betray Jesus. The revelation that there is an impostor among them is shocking. The disciples jump up, flail their arms, and cry out in alarm. One of them is a traitor. But who?" He scanned the tourists, as though hunting for a snake among them. In truth, he was studying their faces, looking for unique features and expressions that he might scribble into his notebook after they were gone.

"I hear you use your own face for Doubting Thomas," a voluptuous French girl remarked in heavily accented Italian. "But I do not see *ressemblance*." Her lips puckered over the French pronunciation, as though ready to plant a kiss.

Leonardo knew that both women and men appreciated his good looks. Although he often wore spectacles to aid his aging sight, when he looked into a mirror he saw that his golden eyes still sparked with youthful vigor. He was lithe and muscular, with

a full head of wavy dark brown hair just starting to gray. If the masses were going to gawk at him as though he were some sort of mythical creature, he had a responsibility to look good, he reasoned, so he bathed every day and wore fashionable clothing that heralded his success: knee-length tunics, pastel-colored tights, and a gold ring with multicolored gemstones in the shape of a bird, worth more than most artists made in a lifetime.

He slid his eyes to the French girl's bosom, flushed pink and corseted upward in the latest fashion. Sometimes when a tourist caught his eye, he took the boy or girl back to his studio to sketch them, and sometimes they were so excited to meet the maestro that they happily slipped into bed with him, too. "That's because there is no *ressemblance*," he replied, copying her French accent. "If I relied on my own image as a model, I would draw variations of myself over and over again and never generate a unique face. And that would make for boring pictures."

His audience laughed, including the fleshy French girl.

Patrons often told Leonardo that when he spoke, it was difficult to tell if he were serious or joking, so he injected extra gravitas into his voice. "I'm telling the truth."

Except for one detail.

He looked down at the bejeweled bird glinting on the ring finger of his left hand, his dominant hand. God-fearing Italians considered left-handedness an aberration. The right side was the divine side. The left, driven toward sin. Most left-handed children were forced to use their right hands, to keep them on the righteous path. Leonardo's father had produced twelve legitimate children with a legitimate wife and all were right-handed. But for Leonardo, his bastard son, the result of a youthful affair with a lowly house slave from Constantinople, the sinister side had been acceptable.

In *The Last Supper*, two seats to the right of Jesus, a shadowy man in a green tunic reached for a roll of bread with his left hand. Judas was left-handed, too. "Imagine you're part of a large

family." Leonardo stared past the French girl and into his painting. "One of twelve siblings gathered around a holiday dinner table. Your parent is in the middle, trying to keep order and balance. Imagine . . ." The sounds and smells of the room seemed to fall away as he meditated on Judas's left hand. "But as with any family, beneath the surface, there are secrets. In the middle of our boisterous family, one man doesn't belong. He is still among us, but hard to find."

In other depictions of the Last Supper, Judas was easy to spot, often sitting on the opposite side of the table from the others. In Leonardo's version, however, the traitor was in the middle of the group, just one of the disciples, hidden through his very inclusion, only identifiable by the small moneybag he clasped.

"In the moment immediately following Jesus's accusation, everyone is in shock, asking who is the betrayer. Is it him? Or him? Or that one over there? Or, the most frightening question of all, could it be me? When none of us have yet been identified as the betrayer, we all are. We could all be the illegitimate other. We could all be the Judas."

As the spectators leaned in to examine each face, Leonardo groaned inwardly. He had intended to divert their attention from the deteriorating picture, not direct them to scrutinize it more carefully.

Suddenly, the refectory door banged open and an attractive twenty-year-old dandy burst into the chamber. Gian Giacomo Caprotti da Oreno had a panicked look on his smooth-skinned face, and his coiffed hair was mussed. "Il Moro is coming!"

The crowd fell silent and exchanged looks, as though trying to discern if this were a genuine warning or a ruse designed to entertain them. They glanced at Leonardo for a sign. "If you're teasing, Salaì, it's very cruel to these poor people." He called his assistant Salaì, which meant Little Devil, because of his propensity for playing practical jokes during the past—how long had it been now? Ten years already?

"This is no trick, Master. I swear. Il Moro is returning. With an army." Although prone to mischief, the young man wasn't a good actor. He was telling the truth.

Two ladies screamed. The voluptuous French girl pressed her hand against her corseted stomach. Husbands ordered families to flee. If Il Moro was returning to Milan, all of their lives were at risk.

Especially Leonardo da Vinci's.

The Sforza family had ruled Lombardy for fifty years, until two months ago, when the French military invaded the capital and drove the family from town. Duke Ludovico Sforza—called the Moor because of his dark complexion—had escaped unharmed, but it was a humiliating defeat. If Salaì were right about the ousted leader's return, Sforza would mount a vicious assault. Every Frenchman still in Milan would be in danger.

Including Leonardo. For the last eighteen years he had been living and working in Milan, serving the Milanese court, but when the duke fled, Leonardo had not followed like a loyal patriot. Instead, he'd remained in his comfortable rooms in Sforza Castle and offered his services to the French king. If the duke returned to power, Leonardo would probably be arrested for treason. And everyone knew what the Sforzas did to traitors.

"We must go to the king. He'll take us with him to France or Naples or wherever he is headed." Leonardo twirled the bird ring on his left hand.

Salaì's expression darkened. "The king is already gone. He took his court with him. He left us behind."

Leonardo's left eye twitched. He needed time to think, so he pulled out the little notebook that dangled from his belt, sat down on the floor in front of the fresco, and began to sketch the panicked French tourists. With quick strokes, he captured rough impressions: their wide eyes, flared noses, thrashing arms, anything to give the suggestion of fear. The only way to truly understand human emotion was to study its physical effects, and

having the chance to witness this kind of raw reaction was rare. He wished he could capture the sound of rustling fabric, gulped cries, and panting. If he could have drawn the taste of terror, he would have.

"Master, please, not now..." Salaì gently tried to take the notebook from his hands, but Leonardo would not let go. "We are abandoned. We must leave Milan."

"We should think before we do anything hasty." He must sketch that plucky French girl the way he saw her now: head thrown back, mouth open in a wail, chest heaving and flushed. Fear looked a lot like ecstasy, and he scribbled a reminder to study the implications of such an incongruous similarity. As she hustled out of the room, he lamented that he wouldn't have the chance to indulge his desires with her.

The last Frenchman left the hall. The heavy door closed, muffling the cacophony of panic in the streets.

Salaì grabbed Leonardo's elbow. "We don't have time to think."

"There's always time to think, my young apprentice." Leonardo calmly put away his notebook.

Having time to think was why he had tried this now-spoiling experimental fresco technique in the first place. In true fresco, an artist slathered a coat of lime onto the wall and then painted directly into wet plaster, so the picture became a permanent part of the building. However, durability had its price. One had to finish painting an area of fresh plaster before it dried. It required fast, continuous work—but fast and continuous wasn't Leonardo's style. He liked to take his time, to contemplate every detail. He might start a project, stop, and then start again. Moreover, many of his favorite colors, like ultramarine, were made from minerals that counteracted with lime. It was why he'd developed a technique befitting his style, applying an egg-based tempera directly onto a dry wall sealed with primer. Using that method, he could employ his favorite mineral pigments—ultramarine, vermilion, even the sparkling green-blue of azurite. But more importantly,

by avoiding wet plaster, he could take his time, making changes whenever a better idea occurred to him days, weeks, months, even years later. Once, while painting this very fresco, he had thought about a single brushstroke for three days before applying a touch of umber to Jesus's right hand.

Salaì pulled Leonardo to his feet. "I already have your notebooks and loose drawings packed." He patted a heavy satchel slung across his torso. "We'll have to leave everything else behind."

Leonardo looked back at *The Last Supper*. The paint was deteriorating, of that there was no doubt. He would not be able to save the crumbling picture. "That's all right, Salaì," he said, as much to himself as to his assistant. "Those who long to hold onto their belongings forever are misguided. We artists know how to let go of our possessions. Our work, after all, doesn't belong to us, but to the patron. Besides, paintings are never finished, only abandoned."

As they made their way out, cannon fire echoed in the distance. Outside was chaos. Galloping horses carried soldiers out of town. French courtiers and citizens frantically packed up carriages. A stormy winter wind kicked up clouds of dirt, veiling the city in a brown haze. The fashionable northern capital of Milan had descended into anarchy. In the midst of the pandemonium, a solitary French soldier stood peacefully in the piazza and gazed up into the eyes of a massive clay statue, a horse that towered taller than five men standing on each other's shoulders.

That clay horse, a monument to Il Moro's dead father, had been designed by Leonardo as a test model for what would have been the largest bronze equestrian statue in history. Poets composed verses about the glorious beast, and tourists traveled from far and wide to visit the model, planning to return to see the bronze statue once it was finished. But Leonardo had never even completed the mold for the sculpture, and eventually Il Moro had melted down the statue's bronze to make cannonballs for war. When the French invaded Milan, they had used the clay horse for target practice, shooting it with burning arrows and beating it with clubs. The

soldiers took off its ear, part of its nose, and a chunk of its hind-quarters. If it had been a living horse, it would have died within the first few moments. But even though the clay model was full of holes, it was still standing.

"Master, come. We have to go!" Across the street, Salaì was saddling two horses.

Leonardo didn't move. He couldn't take his eyes off the French soldier silently communing with the great horse. Leonardo hoped the monument was giving the young man a sense of peace and purpose during this time of turmoil. The soldier reached into his belt and slowly pulled out a long sword. Leonardo imagined the young warrior placing his weapon at the foot of the statue, as though surrendering before the beauty of his art. Instead, the soldier swung his sword and yelled, "Death to Sforza!" The blade hit the horse's front right leg with a reverberating clang. The leg shattered. The horse held strong for a moment, and then teetered forward and crashed to the ground.

"No!" Leonardo shouted. He had spent four long years design-ing that horse. Many nights he had fantasized about finally cast-ing the statue in gleaming bronze.

At this point in his career he was an uncontested success, but many of his contemporaries were already dead. What would he leave behind once he, too, was gone? He had no children to carry his name into the future. Half of his paintings were unfinished. The other half, including his portraits of Il Moro's mistresses, hung in private rooms and might never be on regular display to the public. He had a slew of unrealized inventions and a stack of notebooks full of useless ramblings. Now his *Last Supper* was crumbling off the wall and the model for his equestrian master-piece was destroyed. Years from now, would anyone remember Leonardo, the painter, inventor, and engineer from the inconse-quential town of Vinci?

"Leonardo!" Salaì called, already astride his horse.

He turned away from his clay horse and crossed the chaotic street. When he'd moved to Milan, he had been thirty years old, just beginning to make a name for himself as an engineer, scientist, inventor, director of spectacular social events and, of course, painter. In Milan, he had grown into an elder master. He'd thought he would die in that great city. He mounted his horse and nodded to Salaì. Side by side, they galloped out of Milan's protective walls and into the surrounding wilderness. No one knew what the future held for the city, or for the war-torn peninsula, as kings and dukes and popes battled over territory. No one knew what the future held for Leonardo. Only one thing was certain: the Master from Vinci needed to find a new home, a new patron, a new life, and a new legacy.

*

1500

*

1500

Michelangelo
January. Rome

A s he waited for the unveiling, Michelangelo Buonarroti felt his world tilt. Then his vision blurred. He darted his eyes around in hopes of getting his bearings, but the marble columns, wood-beamed ceiling, and gold-flaked frescoes swirled around him. The edges of his sight started to go dark. Black spots appeared. He felt like he was falling, so he leaned against the cold stone wall.

He remembered to breathe, and the black dots slowly began to fade.

None of his sculptures had ever been revealed at a grand public event before. No matter where it was happening, this would have been the most important moment of his career. But this wasn't just any location. It was the biggest stage in all of Christendom: St. Peter's Basilica.

How heartbreaking, he thought, that the sprawling three-story basilica had fallen into disrepair over the past twelve hundred years. Along the western side, the wood-gabled ceiling was collapsing and several columns were cracked. An inexperienced mason had erected a crude wall to buttress the structure, but one side continued to crumble. Wind whistled in through gaping cracks, and tiles of marble flooring were missing. But despite the damage, he still felt the soul of the church inside those walls.

The Vatican was packed with pilgrims that morning. It was a

Jubilee year, when the pope offered forgiveness to any sinner who walked through the basilica's doors, so thousands had converged on Rome to pray and confess their sins. That day, in the chapel of Santa Petronilla, they would also witness the unveiling of a new statue by a young, unknown sculptor.

Michelangelo believed he had created something special, but he had to wait and see if it would move the masses. In a few moments, he would be either proclaimed a brilliant success or dismissed as a failure. He shoved his hands deep into the pockets of his tunic. In the bottom of each were small piles of marble dust. He squeezed his hands around the powder and rubbed the granules between his fingers. The ritual kept him calm.

A scruffy twenty-four-year-old, Michelangelo knew he must look like an unrefined brute to the audience. He was short and strong, with muscles developed during years of cutting into marble. He had coarse black hair, rough hands covered in calluses, and a nose that had been flattened during a childhood scuffle with a fellow apprentice who was jealous of his talent. He didn't care what others thought of his appearance; he washed once a month and wore the clothes of a stonemason: a long linen tunic, baggy pants, and heavy boots. But he had been told that his brown eyes flared with such intensity that most who met him didn't notice his dress or smell. They were usually too taken in by his passion.

The archpriest of St. Peter's basilica, his black robes swishing along the marble floor, glided through the mass of pilgrims. His beak-like nose close to Michelangelo's ear, he whispered, "Are you ready, my son?"

Michelangelo tried to speak, but his voice caught. He nodded silently.

As the archpriest murmured a blessing, a cold layer of sweat formed on Michelangelo's forehead and upper lip, and when the archpriest grabbed the rope hanging over the statue, Michelangelo's ears began to ring. He clenched his fists around

the mounds of marble dust until his fingernails dug into his palms. The people would probably hate his statue. They wouldn't understand it. They would mock it, curse it, curse him.

The archpriest yanked the rope.

The thick black curtain dropped to the floor, unveiling a colossal marble statue of the Virgin Mary cradling the crucified Christ. When Michelangelo was six years old, his mother died in childbirth. He was the second oldest of five sons, so she had often been too pregnant to give him much attention, and he'd spent his first two years with a wet nurse, as was customary. Although his own mother had been a distant figure, he was bereft when she died. This sculpture was an expression of that pain: a mother and son alone in their grief, locked in a mass of shadow and light, forever intertwined yet separated. The white stone gleamed with a high polish. Jesus's body lay limply across his mother's lap. His skin rippled with life recently lost. Mary's gown cascaded to the floor in deep folds, while her serene expression revealed resignation to her divine fate.

For the first time, the public was viewing Michelangelo's *Pietà*.

The crowd was silent. He scanned their blank expressions, but he couldn't tell what they were thinking or how they were feeling. His head was pounding, he couldn't breathe, and pressure was building up in his chest.

Two years ago, when the French Cardinal Jean Bilhères de Lagraulas hired him to carve a marble Pietà for his grave site, Michelangelo had already sculpted a few pieces for his own edification and even been paid for a full-sized Bacchus, but he had never received such a high-profile commission. Despite his inexperience, he'd guaranteed in writing that he would carve the most beautiful statue ever produced in Rome. If he were ever going to fulfill his promise of becoming a great sculptor, a statue of mother-and-son grief was his best chance.

For two grueling years, he'd toiled over the gigantic block of marble. He often forgot to eat, drink, or sleep. The first winter he

fell ill, but kept working despite the fever. During that first year, Cardinal Bilhères had often stopped by his studio to check on progress. The Frenchman had praised what he saw emerging from the marble, but then the old cardinal died, never seeing the completed sculpture and never anointing it a success. Michelangelo would have to rely on strangers to decide whether it was a masterpiece or not.

And now, several agonizing moments after the unveiling, the audience was still staring at his creation in silence. Michelangelo pressed his fingernails into his palm.

Finally, one red-haired pilgrim fell to his knees. "*Grazie mio Dio.*"

Then a young mother, grasping two toddlers, dropped to the floor in prayer. Soon the entire congregation broke out in praise. Some wept, some sang, some mumbled heartfelt adoration. Others sat in stunned silence, mesmerized by the sculpture's beauty.

He had created his first masterpiece.

Relief rushed over him. The black dots faded. His vision cleared. When he was a baby, his parents had sent him into the quarries around Settignano to be nursed by a marble quarrier's wife. His first memories were of men digging white slabs out of the earth, the sound of metal hammers clanking against stone, and the taste of marble dust on his tongue. Spending the first two years of his life living among those stonecutters and drinking the milk of a quarrier's wife had given him an unquenchable thirst for marble. He had sacrificed his whole life to sculpt. He had no wife, no betrothed, no children, no hobbies, and now, he was finally going to reap the benefits of his obsession.

"Who sculpted it?" he heard one pilgrim ask another.

Michelangelo sucked in a breath and prepared to feel the delicious tingle that would surely run up his spine at the sound of his own name.

"Our Gobbo, from Milan," the other pilgrim responded.

Michelangelo's throat closed. What had that pilgrim said?

Before he could stop it, that name swept through the crowd like the Arno River rushing through the Tuscan landscape after a heavy rain. "Gobbo, Gobbo, Gobbo," the pilgrims whispered until everyone seemed to be chanting that name. Gobbo, a second-rate hunchbacked stone carver from Milan. Gobbo, whose figures were static and thick, practically deformed. Gobbo, who didn't have the talent to mold the *Pietà*'s pedestal. Michelangelo had toiled his whole life to raise up his family's name through his art, and now those fools were attributing his masterpiece to that lazy, untalented, godless Gobbo.

When Michelangelo was still in the womb, his mother had tumbled off her horse and was dragged behind the beast for several minutes. Doctors predicted the babe inside would not survive, but inexplicably he'd lived. To celebrate the miraculous birth, his parents had bestowed upon him a unique, divinely inspired name: Michelangelo, one who is protected by the archangel Michael.

Surely God did not save him, give him a rare and beautiful name, and instill in him an unwavering desire to carve marble, only to allow all the credit for his masterpiece to go to that undeserving impostor, Gobbo.

Michelangelo was so angry he was dizzy. The church whirled around him, and the ceiling felt like it was caving in. The archpriest, who might point him out to the crowd, was nowhere to be seen. He had to find a way to ensure that no one ever attributed his sculpture to anyone but him. But how?

Then an idea popped into his head, so perfect that it must have been sent from heaven. To set God's plan for his life back on track, he needed to inscribe his name directly into the *Pietà*, so no one could ever mistake who carved it.

There was only one problem. Michelangelo didn't own the *Pietà* anymore. It belonged to the church. He couldn't simply walk up to it and start hacking into the stone. Someone would stop him. Maybe even arrest him. No. To carve his name into the sculpture, he would have to do it late at night, when all the

worshipers were gone, the doors closed and locked, and the priests fast asleep.

And to do that, Michelangelo was going to have to break into the Vatican.

Michelangelo peeked out of his hiding place behind a tomb in a decaying side chapel. He had been lying in wait for hours. Finally, all was quiet. Dark. He told himself to stop obsessing about what might happen if he were caught vandalizing church property. He was protecting his family name. He would risk anything.

"God, please forgive me," he whispered as he crept out from behind the tomb and across the shadowy nave. He had removed his boots to quiet his footfalls, and he clasped his leather satchel tightly against his body to prevent his metal tools from jangling.

In the chapel of Santa Petronilla, a shaft of moonlight cast a soft blue glow across his *Pietà*. It had been weeks since he had been alone with Mary and Jesus. While he'd prepared for the unveiling, priests or pilgrims had always been milling. But now, in the quiet church, he could hear the marble humming. Whenever he carved, the marble spoke to him, a communion between his soul and the soul of stone. The *Pietà* had talked, chanted, and sung to him at all hours of the day and night. Now they were alone again, reunited like old friends. Opening his bag, he dumped his tools onto the floor. They clattered loudly. "*Cavolo*," Michelangelo hissed. He held his breath, bracing for someone to run into the church and catch him, but the only sound was a gust of wind blowing through a crack in the walls. The clanking tools hadn't seemed to wake anyone.

He grabbed a hammer and chisel and climbed onto his *Pietà*. Grainy darkness obscured his vision, but he had labored over this statue for two long years. Even if he were struck blind, he would know every grain.

He ran his hands across the stone and found the familiar marble strap crossing the Madonna's chest. He slid his chisel down and to the left, and then pulled his hammer back to make the first cut.

Once he started, he couldn't stop and leave some half-written word scrawled upon his stone. If he made even a single mark on the perfectly polished statue, he had to finish, or else he would have ruined his own masterpiece for nothing.

Michelangelo swung. The hammer clanged against the chisel. The blade made a heavy, reverberating *thunk* when it hit the rock. The noise echoed through the cavernous church, much more loudly than he had anticipated. Cold fear gripped his chest, but he couldn't stop now.

Clang, thunk, clang, thunk, clang, thunk.

Marble dust swirled and settled into his hair and clothes. Sweat mixed with grime, creating a gray paste that slid into his eyes. It stung.

The serene face of the Virgin Mary stared down at him. He stopped hammering. Silence engulfed him as he waited for the lady to admonish him for cutting into her chest. Most believed marble was nothing but inert rock, but Michelangelo knew life coursed through its veins, just as blood pumped through the hearts of men. He whispered to Mary, but even he wasn't always sure what he said when he spoke the language of the stone.

A swish of movement caught his eye. Was it a rodent scurrying across the nave? A bird stuck in the rafters? A cloud passing over the moon? Then he saw the outline of a torch-bearing figure gliding down the far aisle outside the chapel. The maniacal sound of carving must have woken the priests.

Michelangelo lunged off his perch and ducked into a nearby arched recess, hoping to find cover under the veil of heavy shadows. When he looked back, he saw something that made his stomach sink.

His tools were still lying at the base of the sculpture. The pile would prove to the patrolling priest that there was an intruder. If Michelangelo were caught, he could be excommunicated, drawn and quartered, or hung. The pope would damn him for his sins. His flayed skin would burn in Dante's inferno for eternity.

He didn't have time to grab the tools. The priest, walking up and down the aisles, was quickly advancing. Michelangelo believed men of God could hear fear, and in that quiet church, his panic must sound like thunder. He sucked in a deep breath and held it.

The priest rounded the far end of the apse and started up the transept toward him, waving the torch across each dark corner. Michelangelo counted the approaching footfalls, each bringing him one step closer to capture.

The clergyman reached Santa Petronilla chapel. Michelangelo saw a stern face with sagging, wrinkled skin peering out from under a cleric's hood. The old man looked the severe, unforgiving sort.

The priest scanned the statue. His gaze moved toward the incriminating pile of tools. As Michelangelo pressed back into the arched recess, the top of his head bumped against a small metal shelf positioned just above him. Metal clanked against stone.

The priest swung his torch toward the sound. Light flew across the chapel, heading for Michelangelo. He smashed his eyes closed. The heat of the torchlight crossed his face. He expected to hear a surprised roar, but instead the warmth passed right over him. He squinted one eye open in time to see a rat scurry over the priest's sandaled feet. The padre yelped and shook the torch at the animal. "Rats!"

As the rat skittered back into the dark, the priest glanced around, but seemed content with his search and eager to escape the rodents. He hurried off, vanishing out the back door.

Michelangelo was alone again. He took a heavy, rattling breath.

That rat, he thought, must have been the Holy Spirit sent to scare the clergyman away. God was blessing him and his art once again.

Michelangelo crept out from his hiding place and went back to work. Periodically, a priest checked in on the church, but Michelangelo always slipped back into hiding and evaded capture. Knowing he was under heaven's protection, he took his time carefully fashioning each ornate Roman letter and even spent an

extra hour polishing the Latin words, *Michael Angelus Bonarotus Florent Faciebat.*

Michelangelo Buonarroti of Florence made this.

Michelangelo completed his job and ducked behind a sarcophagus moments before the cardinals filed in for morning mass, a private affair in which the church elite could mingle before the doors opened to the public. A few minutes into the service, he heard a murmur of excitement ripple through the congregation, but he didn't look out for fear of being spotted. Instead he hid silently, waiting for his chance to slip out unnoticed.

After the service, the priests opened the front doors and welcomed throngs of pilgrims into the church. Michelangelo waited until the building was full, and then slid out of his hiding place and mixed in with the multitudes. The layer of marble dust helped him blend in. The travelers were covered with dirt from the road.

As he walked by his *Pietà*, he slowed to listen to the chatter. The pilgrims were all trying out a new, unique name on their tongues. "Michelangelo Buonarroti," they murmured, passing his name from person to person. Michelangelo flushed with pride.

"One of these days, you'll learn to let your art speak for itself."

Michelangelo turned to see Jacopo Galli, the wealthy Roman banker who had recommended him to Cardinal Bilhères for the *Pietà*, walking beside him. Michelangelo was glad his friend was there to witness this triumph.

Jacopo thrust his chin at the *Pietà*. "But in the meantime, I'll admit that when he saw it this morning, he was . . ." He paused as though savoring a drop of honey on his tongue. "Impressed."

"When who saw it?"

"The pope, of course."

Michelangelo stared. Had he heard correctly, or was Jacopo suddenly speaking in tongues? Alexander VI was famous for his power-hungry corruption and fervent sexual appetites, but he

was also the revered head of the Catholic Church, man's closest connection to the heavens. The pope complimenting his work was akin to God sending down heavenly approval.

"His Holiness wanted to see your *Pietà* unencumbered by the general masses," Jacopo said, waving to a cardinal lingering nearby. Jacopo always had something brewing with someone important. "And the archpriest invited me for the viewing, hoping I might be able to extol your hard work and talent . . ."

So that's why there had been a commotion at morning mass, Michelangelo realized. The pope had been in attendance. "What did he say?"

"He praised it for its beauty. Said it moved him to Godly charity. And we all know that's an impressive feat for this Holy Father. He even laughed at your ego in signing it. Said you reminded him of Cesare."

Michelangelo's stomach flipped. Cesare Borgia was the pope's illegitimate son and a notorious rogue. Reared for the church and elevated to the rank of cardinal by the age of eighteen, Cesare had become the first man in history to renounce the cardinal's hat, an unforgivable rebellion in Michelangelo's opinion. Worse still, according to rumors, Cesare had killed his brother, consummated his love with his sister, and murdered her husband out of jealousy. Currently he was leading the pope's army on a bloodthirsty rampage across the peninsula to take control of papal lands that were in revolt. Being compared to the infamous Cesare Borgia wasn't a compliment, unless of course that comparison was uttered by his father, the pope.

"Il Papa said you are all heart and passion," Jacopo continued. "A beguiling arrogance, I believe he called it. He said, let's see, what precisely did he say . . ."

Michelangelo clutched the strap of his leather satchel as he waited for Jacopo to remember the exact words.

"He said, 'I think that Michelangelo Buonarroti will make something of himself one day.' It sounded like, if you keep it up,

His Holiness might even hire you. Wouldn't that be something? Working for a pope . . ."

Michelangelo dropped to knees.

He had come to Rome four years before in hopes of making a name for himself in the ancient capital. The Eternal City excited his imagination. Ancient remains, buried for hundreds of years, were gradually being excavated. Marble columns and triumphant arches were half-exposed, their deteriorating tops rising out of the dirt like tombstones. Every day a new building, statue, or artifact was unearthed. The old Roman Forum was a perfect home for an artist who wanted to study, copy, and imitate the art of the ancients. But despite the great art, Rome disappointed him. The once-powerful capital was now a small, dirty, rural town, teeming with prostitutes, beggars, and thieves. Executed corpses hung on scaffolding, rotting for weeks as a warning to others considering crimes. For a man who was used to the refined beauty of Florence, the coarseness of Rome was shocking. Michelangelo had been ready to flee almost as soon as he arrived, but he couldn't slink back to Florence a failure. He'd bragged to his family that he would become a great master in Rome. He would return home either a success or not at all.

Even though he had dreamed of triumphing in Rome, he had never imagined compliments from the pope. "His Holiness knows my name?"

"Of course," Jacopo said, taking Michelangelo's hand and pulling him to his feet. "Pilgrims will carry word of you and your *Pietà* all across the peninsula and even to the barbarians beyond. Like the French."

"And in Florence?"

"In Florence, they'll throw parades in your honor."

Michelangelo grabbed Jacopo's shoulders and kissed both of his cheeks. "Thank you, *mi amico*. Come. Help me close up my workshop. It's time for me to go back to Florence." Honor, after all, was always worth more at home.

Leonardo
Winter. Mantua

L eonardo lit the last fuse. He and Salaì ducked behind a wooden fence for protection as six metal barrels shot out projectiles. The shells whistled into the air and exploded into gold and silver fireworks. As sparks rained down, the population of Mantua cheered. Though it was a cold night, they had all gathered outside the Palazzo Ducale to welcome the visiting Duke Valentinois, Cesare Borgia, commander of the papal armies, to their city.

"That is an extraordinary contraption," Cesare Borgia said, pointing to the multi-barreled firework launcher. Leonardo had heard the rumors that Cesare's skin was often covered in purple pox, a sign of the French disease, but he saw no such affliction tonight, not even when the fireworks illuminated his face. The duke was inarguably handsome—tall and muscular with eyes of purest ultramarine blue.

"Well, our maestro is quite extraordinary," said Isabella d'Este, nestling her hand intimately into the crook of Leonardo's elbow. She was quite plump these days, even for her. Her husband had been busy on his last extended stay at home, leaving not only Isabella pregnant, but three other local ladies as well.

Leonardo laid his hand over hers. "I gladly accept the compliment from such a beautiful patron."

Upon fleeing Milan, Leonardo and Salaì knew they could not stay in the countryside for long. It was too dangerous. The Italian

peninsula was not a peaceful, unified country, but a collection of battling city-states and kingdoms. The invading French military was marching down the peninsula to lay claim to Naples. In the west, Florence was at perpetual war with Pisa, while in the east, the Republic of Venice was at war with everyone. And Cesare Borgia, commanding his father's papal army, had recently started his rampage across Romagna. In need of a safe haven, Leonardo set his course for the nearby city-state of Mantua, ruled by his longtime friend, the fiery redheaded Marchesa Isabella d'Este, and her husband.

While living in Milan, Leonardo had become friends with Isabella, who often traveled north to visit her younger sister, Beatrice, wife of Il Moro. Whenever Isabella visited court, she insisted on dining next to Leonardo and discussing art, politics, and nature long into the night. When Beatrice died, Leonardo and Isabella exchanged heartfelt letters of grief.

Since the French invasion of Milan, Leonardo had not corresponded with the lady, but he believed she would welcome him to her city. He was right.

So, for over a month, he had been serving as Mantua's chief engineer, and on that night had been charged with impressing Cesare Borgia. Isabella was eager to keep Cesare on Mantua's good side; they didn't need the pope's son as an enemy.

"I came up with the idea for this device while composing a song on the harp," Leonardo explained as Cesare stepped past the protective barrier to inspect the multi-barreled launcher. "I thought, if an instrument can emit multiple notes at once, why can't a launcher discharge multiple projectiles at once?"

"But I've never even seen pyrotechnics launched into the air before . . ." Cesare said.

Salaì flashed Leonardo a triumphant look. Marco Polo had brought fireworks back from the East over two hundred years before, but they were still considered new and experimental. Most pyrotechnic displays were small and safe: eruptions of sparks that

never left the ground. But Leonardo preferred the more danger-
ous method of launching shells high into the air and watching the
colors pour down from the heavens.

"So, now you see the advantage Mantua has gained by employ-
ing our dear Leonardo." Everything Isabella said sounded like a
flirtation.

"I just can't believe you've had him here for over a month, but
don't yet have a painting off of him." Cesare raised one eyebrow.
"I wonder if he thinks himself above the patronage of a simple
marchesa. After all, he is used to serving dukes and duchesses."

"My marchesa is much more generous than any duke or duch-
ess I've ever known," said Leonardo.

"You hear that, Duke Borgia?" Isabella hit the word duke hard.

"Besides, why would I waste my time with paint when I can
light up Mantua's sky?" he asked. Smoke from the fireworks still
hung in the air.

Borgia turned his blue eyes on Leonardo. "Tell me, then. Do
you have other inventions such as these?"

"Of course. I can take you to my studio . . ."

"I apologize, Duke Borgia," Isabella said, her eyes as cold and
impenetrable as volcanic glass. "Your inquiries will have to wait. I
am in need of my maestro's counsel."

"Can you believe that man, trying to poach you out from under
me?" Isabella's anger echoed off the walls as she led him up the
final few steps of the tower in the old Castello di San Giorgio.

"No one could steal me from you, my lady." Leonardo followed
her into her private apartments.

"Mark my words, that man wants your talents for himself."
Isabella opened the doors to her *studiolo*, where she kept her art
collection and often hosted lively discussions about humanism,
literature, and politics. The room was a magpie's nest of treasures,
including marble and bronze statues, contemporary and aging
paintings, stacks of illuminated manuscripts and newly bound

books, gold and silver miniatures piled up on ancient tables, and even a selection of dried animal skins, tusks, and antlers. In addition to art collecting, the marchesa had a reputation as an audacious hunter. "Don't ever let that Borgia monster sink his claws into you, Leonardo. God knows what he would make you do," she said, as she dropped into a high-backed, gold-plated armchair. "Do you know what upsets me most about tonight? That tyrant exposed my secret. My intentions for you can no longer be denied."

He held her stare. "You know I will not deny you anything, my lady." In the confined space of her studio, he could smell her scent of lavender and peaches.

"I had planned to spend a few more months plying your ego, letting you play with my husband's military toys. But now you must know why I want you here so badly."

He took a step closer. "For my talents with a lute?"

She shook her head.

"For my legendary dexterity when tying and untying knots?"

She laughed.

"For my fine seat on a saddle?"

"Paint me, Leonardo." She sat forward in the chair. "I have wanted it since the first time I saw you apply brush to surface."

"Oh, that." He waved his hand dismissively. "Your husband has mentioned only towers and moats and stables." He walked over to a stack of panel pictures leaning against one wall and flipped through them. There he found mediocre copies of masterpieces: Giotto's *St. Francis Receiving the Stigmata*, Masaccio's *Tribute Money* . . .

"Horses, whores, and wars are my husband's passions, but not mine. And since he leaves me in charge more often than he is here himself . . ." She rose and crossed toward him. "Besides, I am carrying the heir to the Gonzaga throne, God willing, so my will is the way." She had a daughter already, but had predicted this one was a son. "Whenever I pawn a jewel to purchase a painting, it is well worth the sacrifice."

"Why do you have this rubbish?" He pulled a cheap copy of his *Last Supper* out of the stack. "My God. By whose hand is this?" He turned to face her. She flushed. "You know more about my fresco than this—this unskilled fool, whoever he is. During your visits to Milan, you watched me develop the design. You sat there while I applied pigment to the wall."

She took the copy from his hands. "You did enthrall me." She'd watched him superimpose geometric shapes over the faces and figures to apply the aesthetics of mathematics. She'd asked him to explain the perspective lines in the ceiling, and the three windows representing the Trinity. He'd even told her about the secret musical score written out in the rolls and plates on the table. "When my sister died, my visits to the north ended. I never saw the final product. This is all I have." She gave a sudden laugh. "You're right, though. These figures are wooden, indeed."

"Let me burn it." He tried to grab the reproduction, but she was too quick. She laughed and fluttered it behind her as she ran across the studio, darting around busts of Roman emperors.

"How do you do it? The figures you create always look so alive, it's as if you pay models to sit and pose inside your picture frames all day." She faced him from behind a table stacked with ancient orange and black pottery. "It's impossible."

"After being struck by steel," he said, moving slowly around the table toward her, "a piece of flint cried, 'Why are you attacking me? I haven't harmed you.' And the steel replied, 'Be patient and see what wonderful things you can do.' So the flint patiently let itself be struck again and again until it finally gave birth to fire. And so it is with me. By steadfast patience, I too learned to achieve marvelous results. Nothing is impossible."

She gazed up at him. "My sister never managed to get a portrait out of you, did she? Why is that?"

"My dear Isabella," he said, reaching out and tracing her jawline with his finger, "you know I am not at liberty to discuss the private lives of my patrons."

"A device like that would put you out of work." Isabella, wrapped in a boar's skin, lay on the floor of her *studiolo*. Leonardo had just slipped out of her embrace to sketch her. He didn't know why he so often ended up in bed with his subjects.

"Perhaps," he said, leaning against a heavy bronze statue of Apollo and pulling a rug, an heirloom shipped in from Turkey, over his bare lap. "But just imagine: a machine that could capture the image of a person in flesh, so true to the real thing that there would be no discernible difference between the person and the picture. Scientists, artists, and engineers would be able to maintain an extraordinary level of objectivity." He opened his notebook and turned to a page half-covered in sketches of horses, several polyhedrons, and a list of the belongings he'd brought with him from Milan. "I wouldn't care if I couldn't make one more *soldi* as a portrait painter if I could use such a device. Just once."

"But if machines, and only machines, were responsible for duplicating images, human connection would disappear altogether. Humanity would be destroyed."

With one line, he captured the curve of her chin. "Getting too close obscures the vision."

"Keeping such a distance is not only ignorant, but dangerous."

If only his family could see him now, the country boy from Vinci debating the moral implications of one of his theoretical inventions with the granddaughter of the king of Naples. When he'd started his career, a painter was nothing but a low-class laborer, but he had forced that perception to change. Now a painter was a man whose opinion not only counted, but was also sought after. Unworthy profession, indeed, he thought. "Attaining proper scientific objectivity is key to all understanding, my lady. It's why I want to fly."

"To what?"

"Fly."

Isabella's eyes widened. "In the air? Like a bird?"

He nodded.

"You're teasing."

Leonardo shook his head. "King Louis understands the value of such an achievement." He held up his left hand and wriggled the massive bejeweled bird ring. "He gave it to me off his own finger. It is encrusted with jewels from the royal collection." If he were willing to sell it, it would bring thousands of ducats. "The king said it was his way of showing his support for my ambitions, and he hoped that once I did learn to fly, I would bring the art to France." The ring was his good-luck charm; as long as Leonardo wore it on his finger, he had no doubt he would one day fly. "Of course, if you and your valiant husband supported my experiments, I would never give the invention to the French, my lady. You have my word. It would be all yours."

"You are not a bird. You are a painter."

"I am much more than just a painter." He quickly captured the way her lower and upper lids cupped her eyeball like an oyster holding a pearl. "Why else would God give me such a yearning to ask questions about everything: body, mind, light, water, numbers, stars? My interests don't distract me from my art, but feed it. Music feeds math feeds science feeds painting. The only way to create something unique is to make connections between seemingly disparate things. If I focus only on art, my art will die."

She picked up a thin gold crown from her collection and placed it on her head. "But I cannot bear to have you fall from the skies and die while working for me. Besides, of all the people I know, you might actually achieve such an impossibility, Maestro Leonardo. And if you do learn to fly, you might decide to fly away from me. So, on the orders of your marchesa, no more flying. Just paint. It's what you were meant to do."

"I will never settle for such a trifle. I want more. I always will. From up there"—he pointed toward the heavens—"I could study the trees, the rivers, the earth, all of humanity. And the best way to truly see and understand something is to study it from a proper distance."

"You and your obsession with objectivity," she said. "If you insist on keeping your distance from everyone and everything, how can you ever hope to feel love?"

"If I ever do find myself in love, signora, I will break myself off from it so I can study it objectively, I assure you."

"And by doing that you will kill the very thing you are trying to study," Isabella said, letting the boar skin drop off her shoulders. "Love cannot exist at arm's length."

After Isabella left to entertain Cesare Borgia again, Leonardo was alone in her *studiolo*. It was a beautiful room, filled with beautiful objects. If he stayed, he could become like one of those collectibles, well polished, adored, and much talked about. He could be fat and lazy, painting picture after picture and enjoying intimate liaisons whenever Isabella's husband was away. It would be an easy life.

The next day, Leonardo and Salaì quietly packed up their things and left Mantua. He thought of going to Venice, where he could design a fantastic city on those canals. Or what about Rome? It was a snake pit of corruption and war, but at least in the Eternal City, art grew out of the ground like weeds. Then he thought of Florence.

Yes, the city was at war with Pisa and wilting under the threat from Cesare Borgia, but it was also one of the wealthiest city-states on the peninsula and home to some of the greatest thinkers in history. Leonardo had spent many years in Florence, apprenticing and beginning his career within her walls. He had not been back in nearly twenty years, and when he'd left, he had sworn he would never return. But Florence was the one city with enough money, creativity, and freedom to launch him off the ledge and into the skies.

✸

1501
Florence

✸

Michelangelo
Spring

From the crest of a grassy hill, Michelangelo could see Florence: a glittering mosaic of white, yellow, and orange buildings, divided by the snaking Arno River, and topped by the soaring terracotta dome of Santa Maria del Fiore Cathedral. The tallest unbuttressed dome in the world, it seemed as though God himself were pulling the cupola up toward heaven. Florentines loved Il Duomo. Those who were gone too long often reported having such a desire to stand under the cupola again that they suffered severe fevers and hallucinations. After an interminable four years away, Michelangelo had such a longing to feel Il Duomo's shadow on his face that his skin flushed and his heart thundered. The disease of the Dome was upon him.

After unveiling his *Pietà*, it had taken him more than a year to make it back to Florence. He had to close up shop in Rome and settle his accounts, and then Jacopo Galli tried to convince him to stay down south. But finally Michelangelo said *arrivederci* to Rome and trekked north, up the pilgrimage route on the ancient Via Cassia. The road was dangerous. He skirted around the French army and nearly got caught in a skirmish between Cesare Borgia's soldiers and a rebelling principality to the west of Perugia. Then a band of renegade mercenaries wearing the Borgia coat of arms attacked him. Never one to retreat from a brawl, Michelangelo fought back, but the bandits gave him a purple eye, sore rib, and

swollen knee. They also stole his moneybag, leaving him with only a few lira hidden in his boots. At least his sculpting arm was unscathed.

After the skirmish, he stopped to recover in Siena, where he received a commission to sculpt an altarpiece for the powerful Cardinal Piccolomini. But the job was an uninspiring slog. The cardinal gave him strict orders for exactly how to carve each statue, allowing him no creative input. So, leaving assistants in charge of the Piccolomini altar, he decided it was finally time to return home. In Florence, he could surely find work worthy of his talents.

He had sent a letter ahead to his family, telling them he was returning. He prayed it had reached them in time to plan a proper festival in his honor. He pictured a parade of adoring Florentines, throwing sunflower petals and playing trumpets, leading him to a feast of bloody meats and red wine. His father might even let him sleep in the large, down feather bed in front of the fire.

As he approached the main gate of Florence's forty-foot-high city walls, he called, "Open up, I am a Florentine."

Two armed guards blocked his entry. The smaller, toothless one grabbed his horse's reins. The bigger one, shouldering a sharpened axe, asked, "What're you called, Florentine?"

"Michelangelo Buonarroti, descendant of the Knights of Canossa." The Buonarroti family, who had paid taxes in Florence for over three hundred years, could trace their lineage all the way back to Matilda of Canossa, one of the eleventh-century founders of the republic.

When the two guards stared blankly, as though his lineage meant nothing, Michelangelo's ire increased. "Sculptor from Medici garden," he said, using the moniker from his youth.

"Medici?" The smaller guard unsheathed his sword.

Michelangelo groaned, immediately regretting using that name. When he was young, being a Medici favorite would open every door in Florence, but the Medici were now no longer beloved rulers, but feared rebels. A connection to the Medici was

enough to get him hung for treason. "No, I didn't mean it, I ..." He tried to pull his horse away, but the guard gripped the reins hard.

"Medici spy," the larger sentry said, grabbing Michelangelo's leg.

"I'm a loyal Florentine." But before he could explain, the guard swung an axe at his right shoulder. Michelangelo dodged out of the way. He couldn't allow some ignorant guard to injure his sculpting arm. As the sentry pulled his axe back to strike again, Michelangelo fumbled through his leather satchel and pulled out his hammer. He cocked the weapon, but before he could strike, he felt a rush of air and a reverberating thud across the side of his head.

So much for a hero's welcome, he thought, and then everything went black.

A punch to the gut jolted Michelangelo awake.

His vision was fuzzy, and his world was upside down; the floor was three feet above his head. He squirmed to get his bearings. Legs bound with thick rope, he seemed to be hanging upside down from the ceiling in a small, windowless cell. His arms were tied behind his back. He smelled like piss and vomit.

A wiry but muscular city guard loomed over him.

"*Ma che cazzo*?" Michelangelo cried. "I am a Florentine!"

"A Medici supporter. A spy," the guard said in a thick Neapolitan accent, then spun Michelangelo. Hard. The room whirled. Michelangelo closed his eyes to keep from throwing up again.

"I'm not a spy," Michelangelo said through gritted teeth.

"You told the guards you were affiliated with the Medici."

"I was a friend of Il Magnifico's, yes."

When Michelangelo was a boy, he had been in awe of "the Magnificent" Lorenzo de' Medici, the unofficial ruler of Florence. One day, when Michelangelo was fifteen, Lorenzo had spotted the young sculptor carving a marble fawn and was so impressed by

his talent that he invited Michelangelo to live in his palace and study in his sculpture garden. Sometimes, when he thought back on those two glorious years that he had lived with the family—sleeping, eating, and studying alongside the Medici children—he feared he had used up all the happiness owed to him; no human deserved more joy than he had already experienced. But in 1492, Lorenzo died and his selfish, boorish son took over. Nicknamed "the Unfortunate," Piero de' Medici had always been jealous of the love his father had showered on the sculptor, so Michelangelo's relationship with the family soured. When Florentines finally revolted against Piero's incompetent rule, all of his contact with the Medici had ended.

When he touted his Medici connections at the gates, Michelangelo had not been thinking about the fact that, for the past six years, Piero had been living in exile, hatching plans to reassert his tyrannical rule over Florence.

The guard grabbed Michelangelo and pulled his face up to meet his. His breath smelled of stale wine and rotting meat. "You have come to help Piero infiltrate our city."

He flung Michelangelo, setting him spinning again.

"I hate Piero de' Medici." To keep his bearings, Michelangelo focused on a spot on the floor. What was it? Mud? Water? Blood? "I would die to protect the Florentine republic and keep her free from that man's foolishness."

"If you're not a spy for Piero, why are you here?"

"I live here."

"I have been in Florence for two years. I know everyone. I don't know you."

"I used to live here. I've been in Rome. Working."

"What kind of work?"

"I am a sculptor," Michelangelo said, and even though he was hanging upside down, he pulled his shoulders back with pride.

"A sculptor!" the guard exclaimed. "That's it! You made art for Piero. He was your loyal patron."

Michelangelo fell silent. It was true—in part—but he would never talk about that.

"If you don't want to tell me, I'll have you tortured as a rebel."

Fear pounded in Michelangelo's head. No one knew he was there, locked in a dungeon, being interrogated for crimes he didn't commit. He swallowed his mounting terror. He could be afraid later. "Torture me all you want. But I am not a traitor."

"According to your arresters, I understand you're rather protective of . . ." The guard cut one of the ropes. Michelangelo's right arm, numb from lack of blood flow, fell limply by his head. He tried to lift it, but couldn't. "If you won't talk, I can make you scream." The guard grabbed Michelangelo's arm and wrenched until it gave a sickly pop.

As a bolt of pain shot through his shoulder, Michelangelo howled, but it wasn't the pain that made him talk, it was the suffocating fear of never being able to grip a sculpting hammer again. "That damned Piero was no loyal patron," Michelangelo blurted. "He only commissioned one thing from me. One, even after all my years of loyalty to his family, after growing up alongside him as a brother."

"So? What was it?" The guard's massive hands gripped Michelangelo's arm as tightly as if holding onto a sail's rope during a thunderstorm. There was no way out.

"A snow man."

The guard released some pressure. "What?"

"A snow man. He ordered me to go out into the street, in front of everyone, and build him a snow man." Even after all these years, the thought of that day made a bubble of humiliation rise in his chest. "Art that melts in the sun. I'd hardly call that a loyal patron."

"A man made of snow?" The officer let go of his arm. Michelangelo slowly rotated on the rope, his arm dangling helplessly.

"It was actually more a man made of ice." If he had to talk about it, he at least wanted the facts to be correct.

"What did it look like?"

"Tall. Thin. I was trying to carve an angel, but the clouds kept parting, so the sun kept melting it and . . ."

The guard laughed, the sound echoing off the stone walls. "A man made of snow. I've never heard of anything so silly. Who would make such a thing? A snowman."

"Like I said, I hate Piero de' Medici." Michelangelo spit. His mouth was so dry nothing came out except a bit of blood from a busted lip. "Can I go now?"

"You have any family who can vouch for your patriotic sentiments?" the guard asked, his wide smile showing off his two front teeth, both broken in half.

"You can't alert my family. I won't tell them I'm in jail." He would lose his arm, his leg, his life. Anything before that.

"Well, I cannot release you until you have someone to vouch for you. Hey," he said as he left the cell, "if you stay through the winter, you can build us a man of snow." As Michelangelo dangled helplessly on the rope, he heard the officer's voice ring throughout the prison. "A snowman! Wait until I tell Uncle Beppe."

White sunlight burned Michelangelo's eyes as he stumbled out of the city's prison. He had been locked in that cell all night, but it was now late afternoon, and he was finally free. "Thank you for vouching for me, my friend. Without you, I might've spent the rest of my life dangling from a rope in the belly of the Bargello."

"I doubt that. The city can't do anything with conviction these days. Except save money. This latest bunch thinks cheapness is next to godliness." Francesco Granacci took a flask out of his pocket and handed it to Michelangelo, who immediately drank down the sweet white wine. Granacci, handsome and from a wealthy family, was seven years older than Michelangelo, but had always insisted that he was much less talented than his friend. When Michelangelo was twelve, Granacci had convinced his teacher, the painter Domenico Ghirlandaio, to accept the young Michelangelo

as an apprentice. "I will always be second to Buonarroti," Granacci liked to say. Regardless of their respective talents, Granacci was now master of a successful painting workshop in Florence, while Michelangelo had returned home broke, looking for work.

"They seemed serious to me." Michelangelo pressed his fingers into the joint of his sore shoulder, but didn't feel any protruding bones or ruptured muscles. It hurt, but it would heal.

As the two walked away from the Bargello, Granacci let loose a deluge about what had changed in town over the last four years. He described the gruesome burning of the heretical Friar Savonarola at the stake, Cesare Borgia's papal army encroaching on Tuscan land, and the ineffectual Florentine government trying desperately to hold onto their republic. Granacci, as usual, walked as he talked, and Michelangelo happily followed. As he listened, he realized he had been lonely in Rome.

They wandered the winding streets. Some shopkeepers recognized the newly arrived sculptor and waved. A few even shouted, "Welcome home, Michelangelo," but his name was always followed by that dreaded "di Lodovico Buonarroti." Here, he was still his father's son. Not one person dashed across the square to breathlessly congratulate him for his glorious Roman *Pietà*. No one even mentioned it.

"So," Granacci finally asked, "did you get any work in Rome?"

Michelangelo stopped walking. If Granacci, his most fervent supporter, didn't know . . . "You didn't hear of my *Pietà*?"

"Your what?"

Michelangelo's breath caught.

"Oh yes, that's right." Recollection crossed Granacci's features. Michelangelo could breathe again.

"I did hear something of it. The statue with the peculiarly young Virgin Mother, eh . . ." Granacci nudged Michelangelo, suggesting something tawdry. "I'm sure it was good, my friend, you were always good." Granacci kept walking without any further comment.

Michelangelo swallowed hard. He now knew there would be no parade. No festival. No celebratory meal. Here, he was still just Michelangelo di Lodovico, the kid sculptor from the now defunct Medici gardens.

"Listen, I know why you're back," Granacci said.

"Why's that?" If no one in town knew him, he wasn't sure of the answer anymore.

"The Duccio Stone commission, of course," Granacci said with a shrug.

Michelangelo stopped walking. "What about the Duccio Stone?"

The Duccio Stone was arguably the most famous block of marble in all of history. Over forty years before, it had been a part of the biggest, most expensive sculptural project since the ancient Roman Empire: twelve colossal marble statues of Old Testament prophets to decorate the high buttresses of Il Duomo. The Office of the Cathedral Works, commonly called the Operai, had started by purchasing a single colossal block of marble from the hills of Carrara. It was nine *braccia* high, three times the height of a man, and the Operai hoped that, once complete, it would be the tallest sculpture carved out of a single block since the ancients.

According to legend, from the moment it was unearthed, there was something extraordinary about that stone. Despite a long, arduous journey out of the mountains and up the Arno River, it arrived in Florence without a scratch, a pristine slab of solid stone that hummed with life. Everyone who saw it said it was the whitest, most beautiful block ever quarried. Upon seeing the stone, the cathedral elders declared that the marble was to be a statue of King David, to symbolize the greatness and faithfulness of Florence. All they had to do was find an artist worthy of carving it.

Donato di Niccolò di Betto Bardi, better known as Donatello, had helped pull sculpture out of the dark ages and into a new era hearkening back to the great classical art of ancient Greece and Rome. Donatello was already the creator of two David statues,

including the city's most beloved version, a bronze sculpture depicting the young shepherd boy standing over Goliath's severed head. It seemed only fitting that this great elder, then in his seventies, receive the commission for this new colossal marble David.

However, Donatello's eyesight was going, and his hands shook from age. So he requested the Operai hire Agostino di Duccio. The official commission went to Duccio, but everyone knew Donatello would work on it behind the scenes. Then, shortly after the contract was signed, Donatello died. Duccio remained on the project, but the protégé didn't have the same sure hand as his master; his first cut into the block was clumsy, the second even worse. One day, desperate to do something dramatic, Duccio cut a yawning hole into the once-pristine block of marble. Throwing down his hammer and chisel, Duccio declared the rock unworkable. On his deathbed, Duccio was rumored to have muttered in delirium that the stone had fought him as though he were not the rock's true master.

After Duccio's failure, other sculptors attempted to salvage the block, but none succeeded. The so-called Duccio Stone was abandoned in the outdoor cathedral workshop, and the program to decorate Il Duomo with giant marble prophets came to an inglorious end.

"What about the Duccio Stone?" Michelangelo repeated.

"The Operai . . . They are looking for an artist . . . an artist to . . . to carve it . . ." Granacci stammered. "I thought for sure you'd heard."

He shook his head. "No, I hadn't." His knees wobbled. The Operai was resurrecting the Duccio Stone? The most famous block of marble in history—a stone touched by Donatello himself? Michelangelo's fingers tingled.

"I'm sorry, I shouldn't have told you," Granacci muttered.

"Of course you should've told me," Michelangelo said, a smile spreading across his face. He grabbed Granacci's shoulders. "That stone was meant for these hands. That commission is mine."

"But, Michel," Granacci said, staring at his toes. "That's what I wanted to tell you. You'll never get it."

"Why not?"

"Because the Operai has already awarded the commission to someone else."

Michelangelo mentally flipped through the artists who were still alive and living in Florence. Sandro Botticelli, painter of *The Birth of Venus* and *La Primavera*—but even though he was a great master, he was a painter, not a sculptor. Pietro Perugino and Davide Ghirlandaio, brother of Michelangelo's own teacher, were also master painters, but hardly able to compete with Michelangelo's natural talents in stonecutting. Andrea della Robbia was famous for his delicate relief sculptures in blue and white terracotta, but he wasn't a master of marble. Giuliano da Sangallo had experience as a sculptor, but his true talents were in architecture and engineering. "There's no one in town better than I am at sculpting marble."

"Yes, there is." Granacci averted his eyes.

Michelangelo stared. It couldn't be Granacci, could it?

"Leonardo," Granacci whispered.

At the sound of that name, the entire city seemed to fall silent. Michelangelo didn't need the clarifier "of the town of Vinci." One name was enough. He had been only seven years old, still living in the countryside, when the legendary Leonardo da Vinci left Tuscany and moved to Milan. Michelangelo had learned how to draw by copying the master from Vinci's Madonnas and poring over sketches of his Sforza horse. He was the artist he was because of Leonardo, and now they were both in the same city, at the same time. The news shook him. "Leonardo lives in Milan."

"Not anymore," Granacci replied. "He's been back for almost a year. And the Duccio Stone already belongs to him."

The stone was no longer Michelangelo's main concern. Surely Leonardo—so worldly, so connected to art and innovation—had heard of his *Pietà*. It wouldn't matter what anyone else thought,

if he had Leonardo's approval. "Do you think I could meet him?" Michelangelo asked, his heart tugging like a boat ferrying him toward his destiny.

"Of course, *mi amico.*" Granacci grinned. "*Andiamo.* I'll take you to him."

Leonardo

Stephanie Storey · 47

"if he had Leonardo's approval." "Do you think I could meet him?"
Michelangelo asked, his heart racing, like a boat ferrying him
toward his destiny.

"Of course," said old man Andiamo, I'll take
you to him."

L eonardo peeked out from behind a curtain at the fashion-
able Florentines packed into his studio, buzzing like open-
ing night at the newest *commedia dell'arte* play. He nodded
to Salaì, perched on a wooden platform hidden in the ceiling, and
then silently counted to three. *Uno. Due. Tre.*

A flash of fire popped, followed by a burst of purple and
green smoke. Some in the crowd screamed and others giggled as
Leonardo slipped out of his hiding place and into the cloud of
sweet-smelling incense. When the smoke cleared, he was posed
as if appearing in the room by magic.

"Sex," he hissed, letting his tongue slide across the "s" like a finger
along a fiddle. The spectators laughed, but Leonardo kept his eyes
on the friars. He had calculated that celibate men would secretly
enjoy a bawdy joke. "The body parts involved in it are so ugly, I can't
imagine why God thought anyone would ever procreate. If it weren't
for darkness, the human species would disappear altogether."

The corners of the friars' lips turned up.

"Music!" Leonardo called, and a band of flutists, lutists, and
drummers struck up a lively tune as his studio assistants—the fri-
ars paid for an entire household—put on an extravagant special
effects spectacle. Candlelight, colored smoke, and water bounc-
ing off drums, reflected in a series of mirrors, creating a pulsat-
ing, kaleidoscopic atmosphere. As he danced through the studio,

Leonardo constantly recalibrated his performance to try to please the friars.

For the past year, he had lived comfortably in this sprawling three-room studio on the top floor of Santissima Annunziata, part of his payment for painting an altarpiece for the church. He liked the rhythms of residing in a friary. The regularly scheduled prayers, meals, and bedtime provided a routine he hadn't experienced since he was a child growing up in rural Vinci, abiding by the cycles of nature. He had become so relaxed that it took him ten months to draw the first lines for the altarpiece. He'd heard the gossip. Many saw this as laziness or lack of focus. He was, after all, notorious for not completing commissions. *The Adoration of the Magi, St. Jerome in the Wilderness*, the Sforza Horse in Milan—all were famously unfinished. But he wasn't procrastinating because he didn't want to work on the friar's painting. No. A masterpiece did not pop immediately to mind. He had to knead the problems like dough: how could the Virgin's face fulfill classical expectations of beauty, yet surprise the viewer with the unexpected; how could each of the figures maintain their separate identities, yet intertwine into a single whole; how could he transform a few scratches of lines on paper into a living, breathing, complex organism? Creating new life took time.

Now that his first year was almost up, Leonardo needed to convince the friars to let him stay. He had barely made any progress on human flight. Relocating now would interrupt his experiments. He had to prove that he was not only working on the altarpiece, but that a painting by him would be worth the wait. So, for the last two weeks, he had been displaying his design to the public, and now he had invited the friars up to witness the spectacle.

As the song came to an end, Leonardo stepped onto a raised platform next to a large panel covered in a piece of black velvet. He raised his hand with a flourish, and Salaì yanked off the cloth.

His cartoon, the life-sized preparatory drawing for the altarpiece, was displayed on a gilded pedestal. Candlelight illuminated

the charcoal and chalk sketch on thin, tinted paper. The picture was of St. Anne, the Virgin Mary, John the Baptist, and baby Jesus, all interconnected in a surging, pyramidal composition. The four figures were vibrant, their faces the ideal of classical beauty. He'd spent months dreaming up that image before putting it down on paper, so when he'd finally started sketching, the lines seemed to appear in a flash. Like his performance that night, it was all part of his show. Let the people think the design had arrived complete and perfect, as if sent by God himself. It would only increase the public's fervor.

A man called from the back of the room, "Let me through. I can't see."

Leonardo's smile fell. He recognized that voice.

The crowd parted like water meeting a warship as Santissima Annunziata's notary made his way to the front. The old man had been an ardent supporter of the uncompromising Dominican friar Savonarola and still adhered to the now dead preacher's austere dress code: plain black clothes with no embellishments. The notary had the same angular face Leonardo remembered, the same pointy nose, and same steely gray eyes still filled with that same look of judgment. Standing on top of the raised platform, Leonardo had the advantage of looking down on the old man, but somehow, even frowning up at him from below, the notary made him feel small.

"I thought I made myself clear," Leonardo said. "If I accepted this job, I would not have to see you."

The friars started to protest, but the notary raised a hand to silence them. He took his time responding. "I came to offer my congratulations." He looked at the cartoon. "It is quite extraordinary. The final painting will be a miraculous treasure for the church." The old notary was so good at acting earnest.

"Why did the music stop?" Salaì called and clapped at the musicians.

As the band started to play again, Leonardo stepped down from the platform and grabbed the notary's elbow, dragging him toward the back door. "I have been back for a year, and you choose tonight to finally speak to me?" Leonardo said in a low voice.

"The friars invited me."

"But instead of stopping by the studio during the day, when we could discuss things privately, you pick a public event. Why? So the whole world can witness your generous show of support?" He shook his head. The old notary wasn't the first person to treat him poorly when he was young and unaccomplished, and then grovel at his boots now that he was successful. His door had been battered down by such shallow flattery since his return to Florence.

"I'm trying to make amends, Leonardo."

"Like a bee: with honey in your mouth and poison in your behind." Leonardo led him out of the studio and into the back hallway, closing the door behind them. "So, you no longer think I'm a ne'er-do-well?"

"I never said that. I said you have too many ideas for your own good, and you would do better to stick to one and finish it, rather than flit from one thing to another. But it is nice to see you have settled down now. I'm pleased"—he placed his hand over his heart—"that this job has been good for you."

He recognized the old man's look of condescension. "You think you convinced the friars to give me this commission, don't you?"

The notary looked to the floor.

"I assure you, it was my reputation, not your words," Leonardo said. "But even if you had secured me some employment, you think that can make up for what you did?"

"I don't know what you're talking about."

"Yes, you do." The thought of that old betrayal was enough to make his left eye twitch. When Leonardo was twenty-four years old, weeks after leaving Verrocchio's studio to open up his own

workshop, an anonymous note was delivered to the Office of the Night accusing him and five other men of sodomy. Although the practice was common in Florence—especially among humanists who celebrated it as the ideal way for man to connect to man—perpetrators, if convicted, could be sentenced to death. Leonardo had long believed it was that damned old notary who had reported him to the authorities, although the old man had never admitted it. "You told me I should burn in the seventh circle of hell."

"I'll admit I'm glad you were caught." He fiddled with the only piece of jewelry he wore: a simple gold wedding band on his thin finger. "If you'd kept at it, you could have found yourselves in real trouble."

"I could have been executed."

"The charges were dropped." He lifted his chin as though he could be proud of the fact.

"The charges were only dismissed because one of the other accused was a relative of Lorenzo de' Medici's mother. If tried alone, I probably would have hung."

The notary shook his head.

Someone tried to open the door from inside the studio. Leonardo grabbed the handle and held it shut. "When I was a struggling artisan, I didn't exist to you. You were a respected notary. I, a low-class laborer."

The notary started to interrupt.

Leonardo went on. "But now that I am revered for my—what words did you just use? Miraculous treasures—now you want the world to see that we are friends? We have never been friends."

The notary's steely eyes connected with his. "No. I suppose we have not."

"Tonight is important to me. I need to be calm. Rational. Focused on my patrons. You're not helping. You need to leave." He stood up straight, refusing to bow. "Please don't come back." He knew the notary had too much pride to beg. Sure enough, the old man walked away without argument.

Leonardo took a few slow breaths. Rolled his shoulders and neck. Then, with a smile, he returned to the party.

Salaì was waiting by the door. "I sent two boys out the front to make sure he leaves and doesn't return. Are you all right?"

"Patience protects us against insults just as clothes against the cold. Now," he said, removing his jacket and handing it to Salaì, "why does it seem so quiet in here? There should be entertainment at all times."

He strode toward his cartoon. He wanted to make sure the friars were enjoying their merchandise. "Once, when I was only a boy in my master's studio, a merchant entered," he said with a jovial tone, loud enough to be heard by the entire crowd. "He was looking for a painting that pleased him, but was agitated by my master's monstrous children, running through the house like delinquents. The merchant asked, 'How can you paint such beautiful pictures, when your children are so ugly?' To which the painter replied, 'I make my pictures by day, but my children at night.'" As the crowd laughed, Leonardo arrived in front of the cartoon. He didn't see any of the friars. Not one.

Salaì scurried up next to him.

"Where are the friars?"

"They left," Salaì whispered back.

Leonardo closed his eyes. The friars were gone. That damned old notary had ruined everything. He took a deep breath and smelled . . . urine? He opened his eyes.

One of the ugliest men he had ever seen was standing in front of him. The stranger was young, with black hair matted down with grime. A disfigured nose. Wearing the soiled clothes of a peasant who hadn't washed in weeks, he was bloodied and bruised as though he had recently lost a tavern brawl. He clasped a ragged leather bag of tools and carried a sketchbook in his front pocket. He was an artist, Leonardo surmised, but judging by his meager dress, not a very successful one. Why were all of these uninvited guests disrupting his party this evening?

"Ladies and gentlemen," Leonardo said, "please welcome a child most certainly made by night."

The crowd laughed, and the young man blushed, hunching his shoulders and crossing his arms in front of his chest; he appeared as uncomfortable with himself as everyone else was. "Maestro Leonardo, it is an honor to meet you." He spoke like a boulder clearing the way during a landslide. "I am a sculptor and at your service."

Well, that explained it; stonecutters were always unkempt. "Sit down and sketch, son. Copying the masters is the best way for a student to learn." Leonardo waved his hand dismissively and returned his attention to the problem at hand. He was going to have to figure out a way to make up the evening to the friars. Perhaps he could invite them in for a private viewing the next day or even attend services that Sunday. He must do something to atone for the notary's rude interruption.

"May I show you some of my work?" The sculptor fumbled for his sketchbook. "It would be a great honor if you could give me your endorsement."

Why was this sculptor still bothering him? Yet another Florentine, desperate for the great Leonardo da Vinci's friendship and approval. What a night. "By all means, young man. Come in, uninvited, to my studio and take me away from my guests. Please, please, allow me to interrupt my night in order to serve the needs of yours. It is apparently the theme of the evening."

The sculptor looked confused. Did he not understand sarcasm?

A well-dressed gentleman stepped forward. Leonardo recognized this stylish fellow as a local artist, Francesco Granacci. "Maestro," Granacci said, offering a deep bow. "This is my friend, Michelangelo Buonarroti."

"Buonarroti?" Leonardo muttered. "I have heard of you."

"Yes, sir?" The sculptor's eyes widened with childlike hope.

"Salaì, what did we hear?"

Salaì leaned in and whispered in his ear.

"Yes, yes, of course," he said. The night was already ruined.

Time to have a little fun at the intruder's expense. "Gather around my friends, to meet a truly legendary artist." He waved the spectators in closer. "My son, why didn't you tell me who you were? I heard of your work all the way up in Milan. The whole court spoke of it. Even Duke Sforza."

The young sculptor flushed. His chin raised a notch. Leonardo recognized the look. It was pride. He was tired of other people's pride.

"This is one of his generation's best and brightest," Leonardo announced. "The famous carver of . . ." He let his voice trail off, letting the anticipation build. "Snow people!"

The guests giggled as the sculptor's expression darkened. Granacci grabbed his arm as if to restrain him.

What was the boy going to do, punch him? Go ahead. Leonardo could use a good fight. "You all remember the snowman young Buonarroti made for Piero de' Medici, right? I, unfortunately, wasn't here to see it. Entertain us, my boy, with glorious tales of your days in ice. Was it cold?"

The sculptor's face drained white as the snow he'd been forced to carve. "So I had one lousy commission. You've had your share."

"Never something quite so laudable as snow art. Congratulations on discovering an art that abandons his maker before his maker can abandon it."

"Perhaps you've heard of my *Pietà*, currently on display in the Vatican." He spit the last word as though flinging a knife toward Leonardo's throat.

"That's Gobbo's. From Milan." Leonardo looked to Salaì, who nodded in agreement.

"No. It isn't. The *Pietà* is mine." He drew himself straighter.

"Poor hunchback, can't even get a decent credit. Ah well." Leonardo turned back to his guests. "Who wants to see a magic trick?"

The sculptor's filthy fingers grabbed his arm.

"Michelangelo, please," Granacci whispered.

"Tell me, tell us all," Michelangelo said, raising his voice. "Have you seen my *Pietà*?"

Leonardo squared his shoulders and turned back around to address the sculptor. "No. The last time I was in Rome I did not have time for visiting inconsequential carvings."

"Then what have you heard about it?" Michelangelo pressed.

"That your Mary is not a thing found in nature. She is gargantuan . . ." He puffed out his cheeks and chest and stomped around like a giant. "Three times the size of Jesus and"—he launched his voice high—"twice as young."

The audience tittered.

"Don't you know," Leonardo went on in a mock-scolding tone, "that mothers are smaller and older than their sons? What are schools teaching students these days?"

He led the crowd in a chorus of laughter.

"A chaste woman preserves her youth and beauty," the sculptor said.

Did Leonardo spot tears in the young man's eyes? Had he taken the teasing too far? As the older and wiser artist, should he help this young buck preserve his dignity? Leonardo leaned in and whispered, "Pipe it, boy, you're losing the crowd." Then he addressed the gallery. "I know. Let's try to turn tin into gold. The wonders of alchemy."

"The body is a reflection of the soul; the more moral a person, the more beautiful," Michelangelo said.

"Thank you for proving I must be more moral than you," quipped Leonardo.

The guests laughed.

"Listen, son," Leonardo said, putting a gentle hand on the sculptor's shoulder. It wasn't his fault that the notary had ruined the evening. "A drop of ocean water had the ambition to rise high into the air. So, with the help of fire, it rose as vapor, but when it flew so high that the air turned cold, it froze and fell from the sky as rain. The parched soil drank up the little drop and imprisoned

it for a long time: punishment for its greedy ambition. You're like that drop of water suffering from too much ambition. I have not seen your *Pietà*. I cannot judge it. But I can assure you, just by the looks of you, that you're not yet a master. So please, sit down and sketch my work. Maybe you'll learn something."

"Bastard." Michelangelo enunciated the word so clearly that no one could doubt what he'd said.

As the crowd murmured, Leonardo took a breath. He had tried to be nice. "Yes, it is true. I'm an illegitimate son. But I am thankful for my illegitimacy." He stared into the sculptor's brown eyes. "If I had been born legitimately to a legitimate married couple, with a legitimate father, I would have had to suffer through a legitimate education in legitimate classrooms, memorizing legitimate information made up by legitimate men. Instead I was forced to learn from nature, from my own eyes and my own thoughts and my own experiences, the best teacher of them all. I am, it is true, an unlettered bastard, for shame, but"—he gestured around the room—"does anyone here think that makes me stupid?"

Silence descended. Guests stared into their glasses of wine.

The night had gotten out of his control. It was time to take it back. He grabbed his lyre and hopped up onto a tabletop. "Painters versus sculptors. A long, spirited rivalry. But I believe I have finally found a winner." He strummed a few chords. "The painter sits before his work, perfectly at ease, moving a light brush dipped in a pretty color. His house is clean, he is well-dressed. But the sculptor"—he pointed toward Michelangelo—"uses brute strength, sweat mixing with marble dust to form a mud, daubed over his face. His back covered in a snowstorm of chips, his house filthy from flecks of stone. If morality is akin to beauty, as this student himself claims, a painter is by definition more moral than a stonecutter."

Michelangelo's flattened nose flared, and he opened his mouth to offer a retort. Instead, he turned and bolted from the studio.

"Music," Leonardo called, and the band began to play once more.

Michelangelo

Michelangelo stormed out of Santissima Annunziata and down the winding streets, trying to burn off his fury. He was exhausted from days of travel and being tortured in the Bargello. Night had fallen. The city was dark except for the soft glow of fires winking through shuttered windows. Most people were already tucked in their homes, sharing a meal. The evening was calm. He was not.

How dare that old man humiliate him when he had done nothing to deserve it? Sure, he had lost his temper and lashed out, but only after that braggart had mocked his work in front of a studio full of strangers. Leonardo hadn't even acknowledged him as a fellow artist; instead, he'd derided him as nothing more than a lowly stonecutter, a forgettable student. What was he supposed to do, kiss Leonardo's feet? The man might be brilliant, but he was also a bully, and the worst part was that Michelangelo had put his faith in that smug blowhard, who wore too many rings and styled his hair in those ridiculous curls. There wasn't even any dirt under his fingernails. What kind of an artist didn't have a bit of dirt under his nails?

Michelangelo cursed out loud, and a pedestrian crossed the street to avoid him. At night, only criminals and prostitutes roamed the city muttering like madmen.

He had been so excited to be in the same room as the maestro. Leonardo's studio was unlike anything he had ever seen: an infinity of books, sketches, musical instruments, paintbrushes, and models for curious inventions. Covering the walls and ceiling were murals of angels morphing into satyrs traipsing through magical landscapes, presumably painted by the artist himself. A silver lyre, a collection of wooden flutes and lutes, and a bagpipe were stacked in one corner. Hanging on one wall was a drawing of a naked man, arms and legs splayed wide, transcribed in a circle and square, that made Michelangelo ponder the ideal dimensions of a man. And cluttering the master's desk were a pair of spectacles, hand-drawn maps, and stacks of loose-leaf pages stuffed into leather notebooks. On a pedestal was a live lizard, fitted with fantastical silk wings, horns, and a beard. A magnifying lens enlarged the strange creature, making it appear to be a giant dragon flicking its purple tongue.

And then there was the cartoon. No wonder crowds were flocking to the studio to see it. It was only a drawing, yet already a masterpiece. Michelangelo had fallen to his knees and pulled out a pad of paper and chalk. Every good student of the arts spent hours copying the masters, and even though he was already a professional in his own right, he still had much to learn.

Then the man himself had walked up. He was wearing a pink shirt, purple doublet, and golden platform shoes. His dark brown hair, streaked with gray, flowed past his shoulders in soft ringlets, framing his white-toothed smile and gleaming golden-colored eyes. He was the most handsome man Michelangelo had ever seen.

But everything had gone wrong so fast. It was as if Michelangelo's very existence had sent Leonardo into a rage.

Michelangelo trudged into his old neighborhood of Santa Croce, the area surrounding the Basilica of the Holy Cross. A few artists and wool dyers kept workshops there, but it was

mainly beggars populating its streets and low-class laborers filling its homes. This was the beating heart of Florence; its hardworking, sharp-tongued residents infused life into the city. He felt much more at ease among these people than amid those stodgy Florentines packed into Leonardo's studio.

He breathed in the smells of wet wool and wood-burning fires, his heart becoming heavy. What if Leonardo was right? What if Michelangelo were nothing more than a sculptor of snow people? Leonardo knew about his *Pietà*, yet had dismissed it as irrelevant. More than that, he'd mocked it. What did Michelangelo have to do to be recognized? Outdo his own *Pietà*? Was that possible? What if the *Pietà* was the best statue he ever carved? What if, at twenty-six years old, he'd already reached the peak of his career? What if he wasn't as talented as he'd always believed? The idea closed around his chest like a collapsing cave.

Turning down a crooked side street, he arrived at a familiar townhouse. At the sight of that dilapidated facade with the peeling green paint, a bubble of relief popped inside his chest. He jostled open the front door and slipped inside.

Inside the dim entryway, he shut the door quietly behind him and stepped over the two floorboards that always squeaked. The house smelled the same: a mixture of fresh bread, body odor, and mildewed curtains. As he moved down the hall, he kept close to the wall, hoping to hide in the shadows. He felt like a teenager again, nervous about telling his father about his day's mistakes, not a twenty-six-year-old man returning from a successful stint in Rome. Approaching the kitchen, he heard the chatter of his family sitting around the table for the evening meal. They were having a spirited debate. He peeked around the corner.

There was his family, looking healthy and well fed, all of their limbs and eyes intact. His oldest brother, serving in the church, was missing, and the youngest was currently fighting in the war against Pisa, but other than that, they were all there. His two

other brothers, father, uncle, aunt, grandmother. When he had been lonely in Rome, he had dreamed of sitting at the table with his family like this, all together. He breathed in the scent of spicy Chianti as a new bottle was uncorked. He wanted to stand there for hours and savor the scene. But the moment didn't last.

"Michel!" Buonarroto Buonarroti exclaimed, spotting him in the shadows. Buonarroto was twenty-three, the shortest and handsomest brother, and Michelangelo's favorite. "*Meno male,* you're home."

The rest of the family turned to see him hovering in the doorway. He wished now that he had stopped to clean up. He knew his family wouldn't judge his tattered clothes or soiled hair; his father was a critic of regular bathing. If he had floated in on a cloud of perfume, dressed in the trendiest southern styles, his family would have spent the rest of the night hooting at the pretentious braggart come back from Rome high on his own prosperity. That would've been something.

Buonarroto pulled up another chair and beckoned him to sit. "You're here just in time. Giovansimone is wrong, and I need you to tell him so."

Michelangelo glanced toward the head of the table. Though they had not seen each other in four years, his father stared down at his food without looking up. Bald, with sagging skin around his toothless mouth, Lodovico was fifty-six, less than a decade older than Leonardo da Vinci, but looked old enough to be the painter's father. Michelangelo wondered if this was what he would look like in thirty years. Lodovico's wrinkles were deep, his brow heavy. He wore the clothes of a former gentleman, faded from too many years of use. The Buonarroti had once been a respected Florentine family, but after several generations of spendthrift patriarchs, including his father, their financial resources and social standing had crumbled. Michelangelo often lamented that he had not been born in earlier years, when the Buonarroti were still a powerful, moneyed clan.

As he edged around the table, his Uncle Francesco gave him a welcoming slap on the back, and his bony Aunt Cassandra kissed his forehead. Michelangelo slid into a chair between Buonarroto and their ninety-year-old grandmother, Mona Allesandra. "*Mangia, mangia*," Allesandra whispered. Her fingers looked like the branches of a gnarled old tree, but her hazel eyes still shone with vigor.

Michelangelo dug into the meager meal of bread, curds, and watered-down wine, and tried to catch up on the family's argument, but they were shouting over each other. He couldn't follow anything.

Finally, Giovansimone hopped up and stood on his chair, commanding the family's attention. Giovansimone was a scrawny, sallow-cheeked, unemployed gadfly who was constantly trying and failing to grow a proper beard, and even though he stood stationary on his chair, he still looked like he was swaggering. "So far, I have me, Papa, and Uncle. But you," he slurred, pointing a lazy finger at Buonarroto, "you have you, Aunt, and Nonnina," he said, referring to their grandmother.

"I also have Mona Margherita," Buonarroto countered.

"Servants don't count. Family only."

Mona Margherita, the family's longtime servant, was eating her meal standing at the sink. She caught Michelangelo's eye and smiled. Nothing ever seemed to faze her.

"The decision lies with you, dear brother." Swaying from too much drink, Giovansimone's dark eyes fell on Michelangelo.

Everyone looked expectantly at him. He swallowed a mouthful of bread and curds. "I don't know what we're arguing about."

"Me or Buonarroto. Which of us is the better son?"

Michelangelo groaned. "*Mio Dio.*"

Buonarroto laughed, and the family exploded into debate again.

"Don't answer that." Giovansimone hopped down from his chair. "You never liked me anyway." He gulped down the rest of

his wine and then raised his empty glass. "It's a tie. And since I'm the youngest and smartest, I hereby claim me the winner."

A chorus of cheers and boos.

"Michelangelo, say something!" Buonarroto implored.

"Wait, wait, everyone," Michelangelo called over the cacophony. "It's three to four. Five, if you count Mona Margherita. You're right, Giovani, I have always liked Buonarroto better."

The brothers laughed until Mona Margherita brought another hunk of bread to the table and noticed Michelangelo's tattered tunic. "What happened to your arm? And your eye, and your . . . Let me get a rag."

"No, no, I'm fine, *onestamente*," he reassured, squeezing her hand. "The Via Cassia is a dangerous road, that's all."

Giovansimone leaned forward on his elbows. "*Davvero*? That's your whole story? *Dai*, you're with family now, don't hold back."

"What're you talking about?" Michelangelo shoved curds into his mouth.

"Oh!" Giovansimone declared dramatically. "You want me to tell them?"

Michelangelo stopped chewing.

"What are you saying, Giovani?" Uncle Francesco asked.

Giovansimone looked around the table with wide, innocent eyes. "I would have thought Michelangelo would want to be the one to tell the family how he was arrested and spent the night in jail."

Michelangelo swallowed his mouthful of mushy curds, as the family erupted. "Arrested?" "What happened?" "Explain yourself!" His father continued to stare down at his plate, his face flushing maroon.

"How did you know?" Michelangelo asked with a heavy tongue.

"I know everything, *caro fratello*." Giovansimone leaned back in his chair, hands crossed behind his head. "I have friends everywhere." Ever since childhood, Giovansimone had enjoyed ratting his brothers out, then sitting back to watch the chaos—or using the mayhem as cover for his own capers.

"I will not have a criminal in my home," Lodovico said and stood up. The first words Michelangelo's father had spoken to him in four years. "You can sleep on the streets." His father and uncle yanked him out of his chair.

"Wait, don't! I can explain."

They dragged him toward the door.

"It was a misunderstanding," Michelangelo sputtered, "about my relationship with Lorenzo."

At the Medici name, his father and uncle exchanged a look. The Medici had kept the Buonarroti family from complete financial ruin. When Michelangelo was a teenager and was invited to live and study in the Medici sculpture garden, Lorenzo gave Lodovico a small government post in exchange for entrusting his son's education to him. Too bad his father never credited him or his art with that position, only the Medici.

"My name is clear." Michelangelo wrenched his elbow free from his father's grasp. "I have not done us any harm."

It took Michelangelo half an hour to calm his family down, but his father finally relented. "*D'accordo*. You can stay."

Relief washed over him. After his day, he could not have borne the added humiliation of being exiled from his own home. As they returned to the table, he elbowed Giovansimone in the head and muttered, "*Che palle.*"

"At least Giovani tries to provide for us," Uncle Francesco said, using a serving spoon to scratch his back. "We haven't seen you in years."

From one argument to the next, Michelangelo thought. Welcome home. "Well, it's nice to see everyone now."

"You missed your mother's funeral," Lodovico said.

"Stepmother," Michelangelo corrected gently. "And I was working."

"You abandoned us," Giovansimone said. "I, unlike you, would never abandon our father."

"I didn't abandon anyone. I went to Rome. To work."

"How much money did you bring home?" asked their father.

Michelangelo's cheeks burned. "None. A few *soldi*." In truth, he had about six lira in his pocket, almost a week's pay.

"So much for working in Rome," said Uncle Francesco.

Michelangelo sighed. He should be grateful to be reunited with his family, but instead he felt only disappointment. He had wanted them to run into the streets, raise him on their shoulders, and shower him with praise. He had dreamed of being welcomed home as a hero.

"Now that you're back, it's time for you to get married. Have children. Marriage would be good for the family." Lodovico's right hand shook as he sopped up curds with bread. Michelangelo had never seen his father's hand tremble before. He had grown old.

"My statues are my children, my tools, my wife."

"You could get a government position."

Would his father's complaints or advice ever change, or would they be having the same arguments when Michelangelo turned forty? "I'm not working in government."

"I have five sons," Lodovico grumbled, "and yet I do everything myself. I wash dishes, repair roof tiles, bake my own bread . . ."

Michelangelo flashed a look at Mona Margherita, already cleaning up the kitchen.

"With your older brother in the church," Lodovico barreled on, "you must take on the mantle of the eldest son and support us all."

"And I will."

"With a proper position."

"With my work."

"As a gentleman."

"As a sculptor."

Lodovico banged his hand on the table. "*Basta!* Do I need to beat that nonsense out of you again?" Even though Michelangelo's talent had attracted the attention of powerful families like the Medici and wealthy cardinals in Rome, his father still thought

sculpting was a disgrace. No son of a landed family, even one in decline, should ever stoop to working with their hands. Every time Michelangelo had said he wanted to be a sculptor when he was growing up, his father and uncle had beaten him. At least he was too old for a lashing now.

"I have always been a sculptor, and I always will be," he said evenly.

"How can you find work here, anyhow?" Buonarroto piped up. "Doesn't that Leonardo da Vinci fellow get every commission in town?"

The mention of that name tasted like spoiled butter.

"Leonardo da Vinci," his uncle said. "Now there's an artist you can respect. At least he's made a name for himself. And he's a painter. Painters are okay."

"Years ago, painters were as inferior as stonecutters," Michelangelo said. "Just another artisan trade. Leonardo is the reason painters have gained respect. Can't you see I want to do the same for sculpture?"

Lodovico reached across the table and clasped Michelangelo's hands, rough and covered in calluses. "My son, with the hands of a common laborer." He sighed. "For my sake and for all of us, I forbid you to cut into another piece of marble. You deserve more than the life of a glorified stonemason."

Without responding, Michelangelo pulled his hands away.

For the rest of the evening, the conversation turned to usual chatter. Giovansimone told a hilarious tale, which might or might not have been true, about fighting off one of Piero de' Medici's mercenaries, and Buonarroto read a love poem by Petrarch. Lodovico complained about his aching gout, while Mona Margherita kept the wine flowing.

Michelangelo joined in the repartee again, taking barbs and dishing them out like always. On his way there, he had fought off outlaws, been robbed, arrested, tortured, and mocked. His

shoulder was busted, his ego bruised, and he had lost all his money. This was no welcome parade, but at least he was home.

That night, Michelangelo slept on the floor of his old bedroom, while Giovansimone and Buonarroto shared the bed and bickered over blankets. A full moon shone through curtained windows, illuminating the doodles he had sketched on the walls as a child. He could still remember drawing that chubby baby Jesus wriggling in the arms of his mother, and how his father had chased him out of the house when he saw it.

Michelangelo closed his eyes. "My Lord, I am your humble servant." As he spoke to his heavenly Father, he empathized with his earthly one. Lodovico only wanted his children to be happy and didn't understand how working in a dusty, dirty sculpture workshop could give anyone joy. To him, sculpting was an ignoble craft that could only bring a respectable family shame. His father was so old and set in his ways, he would probably never change his mind, so Michelangelo prayed for a change of his own. He begged God to give him the ambition to do what his father wanted. He prayed for the drive to procure a government job or become a respectable banker.

God did not answer his prayer. Instead, the desire to carve marble only sang louder. If he followed his art, couldn't he, somehow, raise up the Buonarroti name?

"Michel?" Buonarroto whispered. Giovansimone had finally fallen asleep and was softly snoring. "I met a girl."

Michelangelo smiled. His younger brother had always been a romantic. "*Fantastico*," he whispered back. "Who is she?"

"Maria. The weaver's daughter."

"Pretty?"

"*Bellissima*. Her hands are always dyed red, the color of her wool, the color of my love. And she sings, *mio fratello*, she sings like an angel." Michelangelo couldn't see Buonarroto's face

obscured in darkness, but he could picture the earnest look in his brother's eyes.

"And does she love you?"

"Oh yes. She has already begged her father to let us be betrothed."

"And will you? Marry her?"

"Her father won't consent until I have proper work. I'd like to sell wool, but I need my own shop." Michelangelo understood his dilemma. The family had enough money to survive, but not enough to afford the costs for a wool stand. His brother's dream of opening his own store must seem impossible. "But at least she is young. She won't need to marry for two or three years, so I have time."

He should be more worried, Michelangelo thought. Two or three years would pass quickly. That was the amount of time it had taken him to carve his *Pietà*, and now that felt like a temporary flash. His brother must hurry if he wanted to take a wife in two years. "Don't worry, Buonarroto. I'll get you the money for that shop."

"Would you, Michel? That'd be nice. Because, well, she's all I want."

Michelangelo rolled onto his back. He needed a way to make money as a sculptor. He needed a commission.

Leonardo's leering face flashed in his mind. If Michelangelo stayed in Florence, he would have to compete with the master for jobs. It would be so easy to run out of town and find someplace where he wouldn't have to do battle with a famous artist. He could go back to Siena and focus on the cardinal's altarpiece. Or ask God to lead him to a new city where the money would fall like manna, but instead, he begged for the strength to stay. He wouldn't let that painter chase him away. Leonardo had been educated in Florence, but so had Michelangelo. This was his city, too. This street was his street. This house, his house. That moon, his moon.

The Duccio Stone blazed bright and white in his mind. He had assumed he could not compete with Leonardo for the Duccio Stone, but why? Leonardo was a painter, not a sculptor. His only attempt at colossal sculpture had been the bronze equestrian statue for the Duke of Milan, and everyone knew he had failed to cast it. Why should Michelangelo, an experienced stone carver, step aside so that a mere dauber of paint could get his hands on a legendary stone? He would probably botch it worse than Duccio had. Leonardo might be a great master, but he was getting old; his designs were dated. Michelangelo, on the other hand, was young and eager. He was just getting started. Besides, that old crank was too mean, too condescending, and too pompous to be worthy of that stone. Leonardo did not deserve the commission.

A new prayer emerged on his murmuring lips. He wouldn't leave Florence. He would stay, and he wouldn't accept some staid government position. He'd submit his name for the Duccio Stone, and he would not only compete for the commission, but also win it. Staring out the window, moonlight shimmering in his eyes, Michelangelo whispered up to the heavens, "Amen."

Leonardo

Lying awake, Leonardo felt agitated, like a boat jostling on ocean waves as a storm blew in. He wished he could remove the emotion from his mind, place it on his desk, and dissect it like a corpse. Maybe then he could understand it.

He looked over at the bedside table. According to the wooden clock, the height of German time-telling mechanics, it was nearly two o'clock in the morning. He eased his arm out from under Salaì, slipped out of bed, and, careful not to nudge the door that always squeaked, shuffled into the next room. Moonlight illuminated remnants of the party: empty wine bottles, muddy shoe prints on the floors, someone's scarf accidentally left on a chair. The damned old notary, the disappearing friars, that young sculptor whom he had mocked mercilessly, he wanted to forget them all.

He sat down at his desk, took out a small wooden cigar box, and slid the lid open. Tucked inside was the carcass of a small brown bat. He gently lifted the little body out of his makeshift casket and laid him on a metal tray on his desk. Usually he would light a candle to study by, but he didn't want to wake Salaì. Besides, working in the dark forced him to rely on his other senses. The bat smelled of rot, but also strangely of fresh grass. The bony armature crackled as he carefully opened the wings, but he was surprised at how supple the membrane felt. It twisted and bent without breaking. He compared the weight of the torso to the density of the wing

and thought that if such a bulbous creature could soar into the air, then surely man could too.

He heard a creak coming from the bedroom. Shifting to look behind him, his chair groaned under his weight. Quietly stretching his leg out, Leonardo hooked his foot on the door of a tall, eight-sided wooden box standing next to his desk. He nudged the door open with his foot. Inside the box, each wall was a mirror. He had designed the contraption for Salaì, so he could step in, close the door behind him, and enjoy a three hundred and sixty degree view of himself. Salaì practically lived in the thing whenever he had a new outfit. Leonardo adjusted the mirror on the door until he could see into the bedroom beyond. There, in the shadows, he spotted Salaì reaching into the drawer of the bedside table.

"Giacomo," he called.

Salaì slipped the coins he'd just swiped into his own pocket. "I thought you'd gone out for a walk."

"You ask me to teach you." He kicked the mirror box closed. He'd once been a poor young man, too, with not enough money to buy a new pair of hose. "Come. Sit. Learn."

Salaì crossed the room and looked down at the bat. "I want to be a painter, not an anatomist."

"Those obsessed with art but not science are like captains setting out to sea without a compass. They'll never know where they are going." Leonardo lit a candle and put on a pair of spectacles. "When I was young, many churches allowed physicians and artists to study the dead. I personally cut open hundreds of men. But things have changed." Over the past year, he had gone from mortuary to mortuary, looking for someone to grant him access to corpses, but every father and friar had balked. Two priests had threatened to have him arrested, and one had tried to exorcise a demon from his soul. "These days we must content ourselves with frogs, birds, and bats." He sliced off a corner of one wing, held it near the candle, and used a magnifying glass to try to look at it in the dim light.

Salaì moved away from the desk and grabbed a velvet cape Il Moro had given Leonardo for directing the festivities at his wedding. "Master, if you're going to work all night, don't you think it would be a good idea to work on the altarpiece?"

Ignoring Salaì's plea, he scrawled a few observations into a notebook. At times like these, his ideas came too fast to wait for the ink to dry, so he wrote right to left to ensure that the side of his hand would not smear the ink. "Nature, even if she doesn't yield easily, will eventually give up her secrets to the persistent student."

Salaì put on the cape and studied himself in the mirror box. "Before they left the party, I heard the friars discussing your *Adoration of the Magi.*"

He pushed his scalpel into the wing's membrane. He didn't feel like discussing the friars. Not tonight. "You know how I have encouraged you to study each one of Masaccio's individual brushstrokes to see how they fit together? It's the same thing with anatomy. Every vein, every muscle, every hair of connective tissue matters."

"They were talking about how it's been twenty years, but the *Adoration* still isn't complete. One of them accused you of leaving Florence for Milan so you wouldn't have to finish it. That same fat friar even mentioned how it was also an altarpiece for a monastery. Said maybe you never finish projects for churches." Salaì tied the cape around his neck. "Said maybe you don't believe in God."

"Here's something you'll find interesting." Leonardo took off his spectacles; they were better for small details. He could see people better without them. "Did you know that the bat doesn't follow any natural law in pairing, but female goes with female, male with male, female with male, just as they chance to find themselves together?"

Salaì pulled a chair up next to him and sat down. "I'm not suggesting that you go back and finish the *Adoration*, Master. I'm simply suggesting that you finish this altarpiece. For this church.

If you finish one, people will, well, they'll stop saying you never finish things."

"Animals have souls, just like you and me," Leonardo said, clasping Salaì's hands. They felt soft and smooth, yet strong. The perfect combination of youth and maturity. When Leonardo was that age, no one ever took his hands and told him the truths of the universe. "Animals feel joy. Pain. More so than humans, for they are closer to nature, and therefore are more honest and true. We must study them. Live in harmony with them. Be a vegetarian. It's more in tune with nature and will also help you live longer. Don't you want to have a long life?"

"What I want is to have a roof over my head, and if you don't please the friars . . ." Salaì took his hands away. "Why don't you make some drawings for the Duccio Stone? That would be productive."

Leonardo put his spectacles back on. "I do believe the bat is the best model for human flight. Look here, how the membrane serves as airtight armor, binding the bones. It's an extraordinary design of nature."

"The Duccio Stone is an extraordinary commission."

He waved his hand dismissively. "Soderini has already promised it to me. Here, hold this." Leonardo handed the magnifying glass to Salaì.

"Soderini doesn't have a current seat in the government."

"And the stone isn't the city's to give away. It belongs to the cathedral, but never assume that without a direct link to power you're powerless. Soderini will come through." He adjusted the way Salaì held the magnifying glass. "Angle it this way."

"If it's such a sure thing, why are they holding a meeting to decide the winner?"

"If you cut into a man's leg, he does not necessarily perish. And if you cut into his arm, he can walk away. But slice into his head or heart, and he dies almost instantaneously. Do you think it's the same with a bat?"

"I don't know."

"The answer to flight might not be in the wing." He moved his scalpel to the bat's torso.

Salaì adjusted the magnifying glass on his own this time. "That young sculptor. I bet he finishes things."

The way Salaì's voice lilted made the storm of anxiety blow back in, tossing Leonardo's stomach like a wave. "Why don't you go back to bed? I'll be there later."

Salaì leaned back, taking the magnifying glass with him. Leonardo leaned in closer to the corpse and cut into the chest, through fur, skin, and bone.

"There is something about Michelangelo, Master."

"No more wars, Salaì. I surrender." He pushed the organs around with his scalpel. If he dug deep enough he might locate the bat's flight center. Then, he could transfer that secret into man and take to the skies.

"He seemed passionate."

Leonardo sometimes wondered if Salaì actually found him attractive or if he only thought of him as a replacement father who was willing to buy him fancy clothes and let him filch money from the coffers? Perhaps he would prefer a young, strapping, filthy stonecutter.

"Like he might be something some day."

Leonardo raised his head to order Salaì back to bed, but was confronted by the young man looking at his face through the magnifying glass. Salaì's brown eye was giant and blinking.

"The young man is already forgotten," Leonardo said, pushing his scalpel all the way through the bat until it struck the metal tray below. "And I don't want to hear one more word about him."

Michelangelo
August

G iuseppe Vitelli, the squat-faced, squat-bodied supervisor of the Office of the Cathedral Works, had announced that the Operai would select the next master of the Duccio Stone on Monday, August 16. To most, that date held little suspense. Every Florentine, except Michelangelo, knew the stone already belonged to Leonardo.

Michelangelo spent all day, every day, working on a design for a statue worthy of becoming a part of Florentine history. He reviewed the history of sculpture all the way back to ancient Rome, polished his tools, and sketched hundreds of men in the streets. He made stacks and stacks of original drawings. The lines came to his mind and out his fingers like music. By the end of the summer, his hands seemed permanently stained from gripping so much red chalk.

The harder he worked, the more his father fumed. "Demon!" Lodovico cried, as he tossed dozens of drawings into the fire. "I'll call a priest to have you exorcised." After that, Michelangelo slept with his sketches under his pillow.

Finally, the morning of the meeting arrived. Michelangelo rose early. It was a warm summer day with azure skies. A gentle breeze lilted in through the open window like a lullaby. The weather was a good omen.

With his brothers already downstairs eating breakfast, he was alone in their bedroom. Kneeling on his sleeping pallet, he

carefully selected three of his favorite drawings to present to the judges and slid them, along with a set of freshly polished carving tools, into his leather satchel. Then he reached under a pile of clothes in the closet and pulled out a secret stash of supplies: a jug of water, a washrag, and a fragrant Genoese soap.

His heart was thundering. It had only been one week since his last bath. His father would seethe if he caught him washing again so soon. Michelangelo usually agreed with his father about waiting at least a month to bathe—rubbing with cold water not only made people susceptible to illness, it was sacrilegious to wash off God-given grime. On that day, however, he was willing to break the rules. Leonardo would, no doubt, arrive at the meeting immaculately groomed and smelling of lilacs. Michelangelo did not want the old painter to have the upper hand in anything, so he dunked a rag into the water and washed himself all over, even scrubbing his hair.

After his bath, he dried off and donned a new black tunic. He had used a few of his remaining *soldi* to buy a length of linen, and his grandmother had secretly sewn the garment for him. He would not arrive in hand-me-downs today. He checked his appearance in a cracked, dusty mirror. His nose was too crooked and his forehead too large to be considered handsome, but his new tunic fit perfectly and his dark hair was neatly coiffed. Even his battered leather bag seemed more dignified now. He looked clean and fresh and gentlemanly. He was ready to face Leonardo.

In the distance, church bells chimed. He still had a quarter of an hour to get to the cathedral. Plenty of time. Hoping to slip out of the house without his family noticing his dandified appearance, Michelangelo quietly nudged the door, but it didn't open. He put his shoulder into the thrust. It still didn't move. He rammed against the heavy wooden door. It rattled, but didn't open. "*Ma che cazzo,*" he cursed.

"Get comfortable," his father's voice rang out from the other

side of the door. "We have half the furniture in the house stacked against the door."

Michelangelo's stomach lurched. He couldn't be locked in. Not today. "Open up!"

Silence from the other side. Michelangelo pictured his father, lying among a mountain of furniture, his face set with determination, as immutable as an emperor's profile cast into a gold coin.

"If I don't show up, they will never award me the commission."

"I told you. I won't allow my son to be a lowly mason."

For several minutes, Michelangelo yelled and kicked at the door, but Lodovico didn't budge. Michelangelo sunk to the floor. Tears stung the back of his eyes as he felt the Duccio Stone slip away. Now that insufferable Leonardo da Vinci would be handed the commission without a fight. The stone deserved better.

He stood and scanned the room for an alternative escape route. The only possible answer was the single, tiny window, high on the wall.

He slid the bed under the window and climbed up to get a better look. He could easily remove the wooden shutters, but the opening was much too slender for him to fit through. And even if he could squeeze out, he was two stories above the ground. If he fell wrong, he could break his leg.

"*Babbo*? Please, let me go," he tried one last time.

"No."

Michelangelo snorted, then pulled his hammer and chisel out of his bag, placed the blade along the edge of the window, and began hacking through grout, careless of the noise. It wouldn't take his father long to figure out what he was doing. An unskilled man would have spent an hour breaking through that thick wall. Michelangelo cut through the stone quickly; after two dozen blows, he had removed the entire window frame and two additional stones.

Santa Croce's church bells clanged twice. The meeting was set to begin. He was already late. He stuck his head outside. It was a long drop. If he dangled out the window, maybe he could grab

onto the laundry line to help slow his fall. The muddy road would cushion his landing, but would also sully his clean new clothes.

"He's getting out," Giovansimone called from a downstairs window.

His father cursed and began scooting furniture away from the door. Footsteps pounded throughout the house. The whole family had been alerted to his escape. Mud or no mud, it was time to go.

Michelangelo flung his feet out the window and lowered himself to swing from the sill by his fingers. There was no chance he could catch onto the laundry line fluttering in the wind more than three arm lengths away. He looked down. Now that he was hanging out the window, the drop looked as far as jumping off Il Duomo.

An elderly woman across the street, tossing her garbage out her window, stopped to gawk at him dangling out of his house.

"Michel!" Lodovico called as he finally barreled into the bedroom. The old man gasped when he saw his son hanging out the window. "*Per favore*, let me help you."

As Lodovico reached to grab his son's arm, Michelangelo let go. As he fell, he looked up at his father, whose mouth was open, screaming, "No!" Michelangelo didn't know whether his father was upset that he was falling or that he'd gotten away.

He bent his knees to break his fall, but still he landed hard and rolled down the muddy street. Thankfully, he felt no bones snap.

"Stop him!" Giovansimone burst out of the house.

Michelangelo staggered to his feet and lurched down the street. His family yelled after him, but years of carving marble had made him stronger than his brothers, so he quickly outran them, turning one corner, then another, sprinting toward the cathedral. He didn't have time to stop and clean off the mud, but a quick check in his leather satchel confirmed his drawings were unsoiled. He would have to rely on his designs to outshine his appearance. If he wasn't too late.

Leonardo

I f Leonardo believed in omens, he would have taken the bright blue skies, balmy temperature, and sun shining like a twinkle in God's eye as a sign that the Duccio Stone would bring him legendary success. If he had faith in such things, he would think there was a hint of destiny about the fact that he was reaching the climax of his career at the same spot he had begun it: in the outdoor cathedral workshop where, thirty-five years before, as an apprentice in Verrocchio's studio, he had helped raise the decorative metal ball onto the top of Il Duomo. If he accepted harbingers as truths, he would see the flock of sparrows circling overhead as proof that the contract for the Duccio Stone would help him achieve his goal of human flight.

However, he did not put faith in omens. He never had. He trusted only what he could see with his own eyes and feel with his own skin. And on that day, what he saw and felt told him the exact same thing as the sun and the sky. It was a good day, going precisely as he had planned.

Wearing his finest purple satin tunic, checkered stockings, and green shoes, he was addressing the artists, merchants, guild leaders, clergymen, city council members, and Operai officials gathered to witness his acceptance of the celebrated commission. "And here now, signori, a glimpse of the wonders I'll

conjure with your Duccio Stone. *Ecco.*" He pulled a curtain away to reveal his plans.

Dozens of easels displayed drawings of a winged dragon, fierce and roaring, standing on its hind legs and swiping its front legs at an unseen enemy. Salaì, wearing a costume adorned with sparkling silver scales and an elaborate crimson and orange mask, struck a pose, a real-life representation of what was in Leonardo's mind.

The spectators fizzed with excitement.

"A dragon?" Guiseppe Vitelli asked, exchanging skeptical glances with his colleagues.

"A dragon! How remarkable." Piero Soderini shook hands with Leonardo as though ready to finalize the deal. Soderini was a popular politician known for his populist views, charismatic style, and his pigeon-like features of a balding head, beaked nose, beady eyes, and thin, almost nonexistent lips. As it currently stood, members of the Signoria, including its head, the *Gonfaloniere di Giustizia*, were appointed to three-month terms. Every ninety days, the leadership of Florence changed. In the midst of wars, the invading French army, and threats from Cesare Borgia and Piero de' Medici, there was a push to elect a permanent gonfaloniere to stabilize the Republic. Soderini was a leading contender for the position.

It was through Soderini's considerable influence that Giuseppe Vitelli and his Office of the Works had already unofficially agreed to award the commission to Leonardo. He need only formally present his ideas, and the Duccio Stone would be his. The Operai, with help from the city and the wool guild, had agreed to pay Leonardo a generous salary, install him in a lavish new set of apartments, and cover the costs of his studio expenses, including a team of assistants. He wouldn't even have to physically carve the marble himself; he could develop the designs and direct his assistants to do the dirty work. The project was budgeted to last

at least two years, but everyone expected it to take five. Leonardo hoped to stretch the job to ten and die under their employ. With Florence's financial support, he could spend his remaining years studying mathematics, biology, philosophy, anatomy, optics, geography, and, of course, human flight.

"Not just any dragon," Leonardo said, positioning himself behind Salaì. "But a dragon that moves." Salaì rotated his arms, legs, and head in a jerking, mechanical motion, as though he were a piece of creaking rock. "And breathes fire." Leonardo flicked his wrist and a flame burst out of his sleeve, making it appear as though the blaze were erupting from Salaì's mouth. The audience cheered as Leonardo set off puffs of red and yellow smoke to finish the effect.

"I say it's time to record the official vote," Soderini announced.

"I will call for that, Soderini," Giuseppe Vitelli said, head twitching to one side in a show of annoyance. "This is my meeting."

"Well, then, call for it." Rarely did Soderini drop his charming facade and display any sign of frustration, but the head of the Operai seemed to bring it out in the otherwise smooth politician.

"Time to take the count," Giuseppe Vitelli called.

"Wait!" a voice echoed from a distance.

Heads craned toward the noise.

Who is that? Leonardo wondered.

"Don't start without me! I'm here!" A man hurdled the workshop's fence and stumbled forward. Onlookers scattered out of his way.

The interloper was covered in mud, but Leonardo recognized him immediately. It was that upstart sculptor, Michelangelo Buonarroti. Leonardo hadn't seen him since that night he'd interrupted his party. He'd assumed the young man had fled the city in shame. But here he was, looking like he'd been dragged behind a wagon down a muddy hill. It was one thing to eschew personal hygiene, but quite another to purposely cover yourself in sludge.

Granacci cleared the way, leading his friend to the front of the crowd. Leonardo heard Granacci whisper, "I thought you weren't going to make it."

"I'm here," Michelangelo panted.

"Here for what?" Soderini said, wrinkling his nose in disgust. Not even he could keep his cool in the face of such unexpected filth, Leonardo thought.

"For the stone."

"What stone?" Giuseppe Vitelli demanded.

"The Duccio Stone."

"Are there any other events you plan on interrupting, Buonarroti?" Leonardo asked, catching Salaì's glance. "I'd like to prepare myself next time."

"My dear Michelangelo," Piero Soderini said with a pandering smile that made him appear to be completely sincere and completely phony at the same time, "the city's other prominent craftsmen have already graciously bowed out in deference to Master Leonardo."

Gathered near the front of the crowd, all of Florence's most notable artists were in attendance. Each of them, Leonardo noted, was at least twenty years older than Michelangelo. The flamboyant Andrea della Robbia, maker of famous blue and white ceramics, was sixty-six. The renowned architect Giuliano da Sangallo and master painters Sandro Botticelli and Pietro Perugino were all in their fifth decades. Even Davide Ghirlandaio was nearing the half-century mark. All of these men, including Leonardo, towered over Michelangelo in both age and experience.

"It's true, son," Botticelli spoke up. His voice sounded like an orchestra, rich with the instruments of time and experience. "We have all withdrawn in favor of Leonardo."

"Perhaps you should step down, too," said Soderini.

"But none of these men are masters in marble. I am." Michelangelo said, fumbling with the latch on his muddy leather satchel.

"Leonardo is a master of every art, my boy," Soderini corrected.

Leonardo and Salaì exchanged smiles. He didn't need to defend himself. Let others do it for him.

"Here." Michelangelo pulled several sheets of paper out of his bag. "I have made drawings."

Giuseppe Vitelli started to take the pages, but Leonardo snatched them away first.

He looked down at the top sheet and inhaled sharply. This was not the scribbling of an amateur. This was a picture of a living, breathing man with rippling muscles and ideal proportions dressed in flowing draperies and lion skins. Leonardo flipped to the other two sketches. The compositions were dynamic, depicting twisting, lunging figures. Shadows rendered with a few masterful strokes. Each face had a different expression: fear, faith, and bravado. With nothing but a bit of chalk on paper, Michelangelo had captured life.

Out of the corner of his eye, he looked the sculptor up and down. His face was still smeared with dirt, his clothes muddy and sweaty, but the youth no longer looked so ridiculous.

"It will be a Hercules," Michelangelo said. "A symbol of strength that will declare to the world that Florence is the true inheritor of ancient Roman culture and power."

"Son, we are all pleased to have such a spirited artist in our midst," Piero Soderini said without even glancing at the sketches, "but you can't honestly believe you can compete with Maestro Leonardo. You don't even have your own studio."

"But that means Michelangelo can work for cheap," Granacci piped in.

"How inexpensively?" Giuseppe Vitelli asked, suddenly looking interested.

"Surely"—Leonardo handed the sculptor's drawings back—"you wouldn't trade my experience for the brash, unproven talent of youth for the sake of a few *soldi*."

Michelangelo stood taller. Leonardo immediately regretted using the word talent.

"Granacci is right," Michelangelo said, handing the drawings to Giuseppe Vitelli. "You do not need to pay for my workshop. I don't need one."

"Where are you going to carve the statue? Out here?" Leonardo opened his arms wide.

Michelangelo nodded. "I enjoy the outdoors. And I live with my family, so no need for lodgings either."

Leonardo's shoulders tightened. This unknown sculptor couldn't swoop in and steal his future from him. Could he?

"I make my own tools, so I wouldn't need you to pay for those," Michelangelo continued in earnest. "Or for extra marble, or assistants . . ."

"*Non ci credo,*" Leonardo cried. "The boy couldn't carve that monstrous slab with the help of twenty assistants, much less alone."

"Maestro Leonardo," Giuseppe Vitelli said, looking closely at Michelangelo's sketches, "would you consider lowering your salary request to compete with the young man?"

"Never," Leonardo said, raising his chin. "I prefer death to loss of liberty."

"I can live on a few florins a month," Michelangelo said.

"You'll get what you pay for," Leonardo said.

"I am the only one here who has carved a colossus out of a single block of marble," Michelangelo said. "When I was seventeen, a Hercules, smaller than this one will be, but still about this tall"—he raised his hand over his own head—"and a Bacchus, down in Rome, taller than a full-grown man. And I'm the only artist here capable of creating another marble colossus for you now."

Leonardo felt his eyes widening incredulously. "Did I hear you correctly? A colossus? Meaning you expect to carve a statue out of the Duccio Stone, without adding any extra marble?" The boy's drawings were good, but his brain was apparently askew.

"Of course," Michelangelo said without any hint of irony.

"That is a bold claim, young man," Giuseppe Vitelli said. Leonardo detected an unnerving hint of admiration in the man's voice.

"And how tall do you expect this so-called colossus to stand?" Leonardo inquired, keeping an eye on Giuseppe's face. He was looking for any hint of growing regard.

Michelangelo shrugged. "As tall as the block itself."

A murmur swept through the assembly.

"Why? How tall is it?" Michelangelo asked.

"Nine *braccia*," Leonardo responded.

Michelangelo looked up as though pondering the height. The stone would tower three times as tall as an average man. He nodded slowly. "Yes. Yes, that'll be perfect."

The spectators gasped.

Leonardo frowned. No sculptor had carved a statue that size out of a single block of marble since the ancient Roman Empire, more than a thousand years ago. Few had even attempted such a feat. This sculptor had more audacity than a donkey charging a stable full of lions. "Do you know which of these rocks is the famous Duccio Stone, Buonarroti?"

Michelangelo surveyed the workshop, but shook his head.

"So you've never actually seen the stone?" Leonardo pressed.

"No." Michelangelo scowled.

"Well, then," Leonardo said with a congenial smile. He had seen a dozen of these young, ignorant, arrogant artists come and go without making much of a mark. This one would be no different. "Please allow me the honor of being the one to show it to you."

Michelangelo

Stephanie Storey • 85

"That is a bold claim, young man," Giuseppe Vitoli said. Leonardo detected an unnerving hint of admiration in the man's voice.

"And how tall do you expect this colossus to stand?" Leonardo inquired, keeping his eye on Michelangelo's face. He was looking for any hint of growing regret.

Michelangelo shrugged, "As tall as the block itself."

A murmur swept through the assembly.

"What? How tall is it?" Michelangelo asked.

"Nine braccia," Leonardo responded.

Michelangelo looked up as though pondering the height. The

Following the sweep of Leonardo's arm, Michelangelo surveyed the sea of marble fragments littering the cathedral workshop. He was searching for a stone of mammoth size, pristine whiteness, and unspeakable luminance, but none of this debris looked anything like the Duccio Stone he'd pictured. Leonardo took a step sideways and pointed to the ground. Michelangelo saw only a pile of rubble.

Bending down, Leonardo laid his hand on a long, dirty, gray rock lying in a pool of mud. "This, my young friend, is the Duccio Stone."

As Michelangelo looked down at the hunk of rock, his heart hiccupped. The mangled block was lying on its side, weeds growing all around. The stone seemed too narrow to support a proper figure, with a deep gash hollowing out one side, and a jagged knot protruding awkwardly from the other. The surface was weathered from decades of exposure to the sun and rain. The longer marble was left out in the elements, the more brittle it became, and this rock looked likely to shatter if he so much as tapped it with a chisel. It didn't even look like marble. Fresh marble was white and supple and sang in choral hymns, but this slab was gray and lifeless. He knelt down and touched the stone, hoping to feel life kicking inside. He felt nothing.

Michelangelo looked up at the other artists, who all nodded grimly. He shuddered, realizing they had probably only stepped down because they believed it was impossible to carve anything of value out of that ruined block. They would rather see Leonardo fail than fail themselves.

"So, what are you going to do with it?" Michelangelo asked.

"I'm going to add more stone," Leonardo replied with infuriating logic. "A new block for the head, more for the arms, extra marble for the legs. It's the only possible solution."

Michelangelo took in Leonardo's display of drawings and the strange man, wearing a sparkling body suit and a mask, lurching mechanically. It looked more like a show put on by a court jester than a serious entry into an artistic competition.

"He's going to make a dragon," Soderini said. "That's much more impressive than yet another statue of yet another man."

Michelangelo's head snapped up. "Nothing transcends man. We are God's greatest creation. By honoring man, we honor God."

A flash of concern crossed Giuseppe's brow. "Now wait. Hercules was a Roman demigod, was he not? A pagan hero . . ."

"Yes. Pagan. Not for a church." Soderini pointed emphatically. "Moreover, Leonardo's dragon will move and breathe fire."

Michelangelo crinkled his forehead. Had he heard correctly? "Move and breathe fire? That's impossible."

"Maybe for you. Not for me." Leonardo gestured toward his drawings. "I have already designed the device that could power this dragon for hundreds of years. I'll use a mechanism similar to a clock."

Michelangelo shook his head. "The mechanics don't matter. *Marmo* isn't strong enough for that kind of movement. It's too soft. It'll shatter."

"This rock," Leonardo said, sitting down on the Duccio Stone, "is brittle from fifty years of exposure to the elements. Botched from dozens of failed attempts."

"Exactly," Michelangelo agreed.

"The only answer is to add extra material. What you propose, a single colossus without adding more marble, is a laudable idea, but futile."

"Maybe for you, not for me."

"You have aimed too high, my boy," Leonardo said haughtily.

Michelangelo considered his words. "I think . . . the greater danger for most of us is not in aiming too high and falling short, but in aiming too low and hitting the mark."

"I have declared it hopeless," Leonardo said, standing back up and brushing the dirt off his tunic. "And so have you, by the look on your own face when you first saw the thing."

It was true. He had. And yet, the stone might be disfigured and ugly, but it deserved a chance to prove itself. "There is nothing even the greatest artist can conceive that doesn't already exist inside some block of marble," he said, kneeling down and laying his hand on the rock. "This stone will tell me what already lives inside. All I have to do is carve down to the skin and stop." Michelangelo closed his eyes and pressed the tips of his fingers into the fine grain of the marble. "Have you ever been in love before, Master Leonardo?"

"I know about love." Leonardo's tone was defensive.

"We are like lovers, aren't we, we artists?" Michelangelo dragged his fingers across the rough stone. "Timid at first, skeptical about what we might find beneath the surface, but the more time we spend with the objects of our desire, the more we start to understand them. We find their flaws but also their possibilities. And when we connect, our hearts beat in time, and when we speak, our voices come from one mouth. Through love, we dialogue with our own souls." Michelangelo opened his eyes and stared into the gray stone. "Love defies planning, doesn't it? There is no reason and no answer and no rhyme that can recreate it. But in an instant we feel it, a tingle on top of our heads, down our necks, into our fingertips. And we don't know why or how

it's there, but it is, existing because of us, in spite of us. We don't know what it is. We don't know, and in the very act of not knowing, we feel everything."

"Emotion without intellect is chaos," Leonardo sneered.

"Chaos erupting into beauty. That's art." He stared into Leonardo's golden-colored eyes and silently swore he would hold that gaze even if Dante's Inferno started nipping at his heels.

Leonardo looked away.

Giuseppe Vitelli waved members of the Operai, Signoria, and wool guild forward to discuss. "Has Leonardo ever carved a marble statue on his own before?" he asked.

"As they say," a city councilman commented, "if you want something done on time and under budget, don't ask the Master from Vinci."

"Hold on, hold on," Piero Soderini protested. "Cesare Borgia and his papal army threaten our borders. He's marched on Siena, for God's sake. And Piero de' Medici is always plotting. In the midst of this most serious peril, you want to leave an unknown, inexperienced youth in charge of creating a symbol to inspire all of Florence?"

"I can do it," Michelangelo declared with as much confidence as he could muster. "I know I can."

Leonardo emitted a disdainful snort.

"At least he has heart," someone offered.

"A single colossus would be impressive," another chimed in.

"Leonardo says it's not possible. What if the young man fails?"

Michelangelo held his breath. This was the moment that would decide everything.

"Then it'll be a cheap mistake," Giuseppe Vitelli reasoned. "All in favor of giving the job to Leonardo da Vinci."

Only Soderini raised his hand.

"You don't get a vote here, Soderini," Giuseppe grumbled. "All in favor of Buonarroti?"

All members of the Operai, Signoria, and wool guild raised their hands.

Michelangelo's heart paused for a beat. Was it possible?

"Michelangelo Buonarroti, the Duccio Stone is yours," Giuseppe Vitelli announced. He reached over and shook his hand vigorously. "The Duomo expects you to create a beautiful statue for her facade."

As well-wishers swarmed, Michelangelo's ears filled with the sound of rushing oceans. "*Congratulazioni! Buona fortuna*," supporters cheered, patting him on the back and shaking his hand. Michelangelo barely felt their touch or heard their voices. They sounded far away, as though he were trapped inside a glass bottle closed with a cork. It was all happening too fast. He could hardly catch his breath.

His friend Granacci pulled Michelangelo into a hearty hug. "*Splendente*. You did it." Other artists stepped forward to offer congratulations. Andrea della Robbia, Pietro Perugino, Giuliano da Sangallo, even Davide Ghirlandaio, the brother of Michelangelo's teacher, Domenico Ghirlandaio, God rest his soul. Davide had always been jealous of Michelangelo's talents, but on that day, he applauded Michelangelo as if he had always supported the younger man.

Then Botticelli cupped Michelangelo's cheeks in his wrinkled, bony hands. "May God bless you, my son," the aging master said, staring into Michelangelo's eyes as though trying to transmit some of his power and knowledge into the younger man's soul.

When Botticelli finally ambled away, Michelangelo turned to greet another admirer, but instead came face to face with the Master from Vinci. Leonardo's face was stoic, but his eyes flared. Michelangelo tried to bow respectfully, but couldn't move. Even his breathing stopped.

"Buonarroti," Leonardo said. "Here's a tale for you to ponder. An ass fell asleep on a frozen lake, but its body heat melted the ice, so that ass awoke in a cold, unwanted bath." His eyes flicked from Michelangelo's dirt-stained face to his muddy feet, then back again. "In hindsight, you may find you have already started

melting the ice, for that wretched stone will no doubt be the end of your career and the end of your name. Forever." He turned and strutted out of the workshop, his costumed assistant, lugging all of their materials, following him.

As the spectators continued to congratulate him, a new emotion rolled into Michelangelo's chest and competed with his joy and pride. This new wave was of undeniable terror. Leonardo was right. He was lord of the Duccio Stone, which meant he was overseeing a silent, dead hunk of rubbish, tied around his neck like an anchor.

Michelangelo laid his hand on the stone and patted it like it was a distressed, wounded horse. "I hope you're in this with me," he whispered.

He waited for a response from the marble, but heard nothing.

Leonardo
Autumn

Wandering through the Piazza del Mercato, Leonardo sidestepped an aggressive butcher waving a stuffed pig's head and walked down another aisle of overflowing stalls. Where was he going to find a human skull for sale? The market was not the right place to find such things. He was better off digging up some fellow out of the cemetery. Although the priests would probably refuse to let him dig up bones, too.

If he could get his hands on just one body to dissect, he could probably figure out a way to fit a proper human figure into that botched block of—*Stop thinking about the Duccio Stone*, he commanded himself. *It does not belong to you.*

Now, where was that apothecary, again? He should pick up some clay and cobalt to mix a new set of pigments—the friars were eager as ever for him to start applying color to the altarpiece. He pushed himself past the barking merchants, haggling housewives, and the potpourri of orange incense, fresh leather, and horse manure. Usually Salaì led the way, but he'd left his assistant back at his studio. Taking Salaì to the market was always a risk. The young man had sticky fingers. He would either swipe merchandise or steal money from Leonardo's pocket. Either way, the master had to pay. That was the problem with Salaì. Trouble with him, trouble without him.

Trouble if I'd won that wrecked slab of marble, torture without—Stop!

As he wandered in search of pigments and skulls, he marveled at how much busier the market was now than when he was young. Back then, there were some leather makers, a few silk weavers, a butcher, a cooper, and a hosier. Shopping in the market had been a bucolic experience. But over the last few years, an entrepreneurial spirit had taken hold of Florentines like a fever, and every citizen seemed to have a stall. There was a desperate rush to buy and sell goods. Leonardo had pondered the shift for quite some time and, after much deliberation, had developed a theory to explain it. Less than fifty years before, Johannes Gutenberg had given the world the printing press. Before Gutenberg, manuscripts could only be reproduced by hand. They were rare and expensive. However, since the creation of the printing press, more books were available to more people. Literacy was on the rise. Revolutionary ideas of independence and freedom trickled from the upper classes all the way down to the men, women, and children sleeping on the streets. The masses were still illiterate, but the democratization of information empowered people to take control of their lives, which resulted in, among other things, a rise in independent merchants.

Leonardo applauded autonomy, but the changes also worried him. He mistrusted book learning. If he wanted to discover how light reacted to a curved piece of glass, he didn't read about it, but found a piece of glass and exposed it to light. If he wanted to cook soup, he didn't use a recipe, but experimented with his own ingredients. If he wanted to find out what was hiding in the back of a cave, he crawled inside on his own hands and knees. With the explosion of books, people were more likely to rely on the theories of other men instead of learning from their own experiences. That path led to the regurgitation of old ideas, not newly formed thoughts. With a large library, people would no

longer memorize facts, but look up whatever they wanted to know in a book.

The only way Leonardo had ever made a unique discovery was by contrasting, comparing, or combining two disparate pieces of knowledge already housed in his brain. If he no longer mentally stored information, he would no longer make unexpected connections and create something new. A unique thought sprang from a unique being, possessing unique knowledge. A book, although a handy storage unit, did not have the capability of the human mind to develop fanciful inventions. If the explosion of books continued, the world might be left with a bunch of mindless merchants selling meaningless material goods to each other, no one capable of inventing something new and spectacular. It was ironic. An exceptional invention like the printing press might end human innovation all together.

A goose squawked. Leonardo looked down and realized he had stepped on its tailfeathers. Tied up in front of a bird seller's stall, the squawking goose flapped his wings at Leonardo's feet. He bent down to inspect the goose. The bird's right wing was bent, probably too damaged to fly. It was a shame. In Leonardo's estimation, there was only one thing worse than never having flown: to have tasted flight and not be able to repeat it. He gently patted the bird's neck, then explored the rest of the stall. There was a basket of quail, a few cooing pigeons, a flock of woodpeckers, and a tiny cage packed with seven agitated white doves. Doves were usually docile animals, but these were angry, screaming creatures furiously flapping their wings and biting at the bars, while the red-faced, pudgy bird seller shouted profanities and smacked their cage with a club.

"Ignore the brute, my friends," Leonardo whispered into the cage. "Man has great powers of speech, but what he says is mostly vain and false. Animals, on the other hand, have little voice, but what they have to say is useful and true." He gazed into the doves' round, pink eyes. Whenever he had a chance to study birds in

flight, he took it, and this flock had a special combination of agitation, anger, and energy that seemed ready to explode.

With the merchant busy kicking the squawking goose, Leonardo flipped open the lock on the cage and swung the gate open. The doves did not flee.

He bumped the cage with his elbow. The metal bars rattled. The birds screeched and then sprang from their prison, shooting into the air like cannon fire. As they soared away, Leonardo pulled out his notebook and sketched them.

"Thief!" the fowler roared.

"Do not fret, I will pay you," Leonardo said with a calm smile. He'd done this exact thing in a dozen markets all over Italy. The vendor usually cursed Leonardo for releasing the product into the air, and onlookers often laughed at the strange man for wasting his money, but there was nothing anyone could do as long as he was a paying customer.

Leonardo reached into his moneybag to retrieve a few *soldi*. His fingers scraped the bottom of the bag. He didn't feel a single coin.

"Give me my money," the fowler said.

Leonardo darted his fingers around the bag, but felt nothing. It was empty.

Salaì. Salaì must have swiped his money before he left the studio.

"Damned thief." The bird seller grabbed Leonardo's left arm and unsheathed his sword. "Bird for a hand."

"Wait, I have the money," Leonardo said, struggling to keep his voice calm. He fumbled through his pockets, hoping to find a spare florin, but they, too, were bare. "Let me return to my studio and collect some coins." He tried to pull his arm out of the fowler's grasp, but a blacksmith, a candlemaker, a forester, and a farmer all stepped forward to restrain him. None of them liked a thief. Let one get away, and their stall might be next. The blacksmith grabbed Leonardo's shoulder, and the farmer clutched him

around the neck. Leonardo was strong, but not strong enough to fight off five men. "No, wait. I am Leonardo da Vinci."

"I don't care who you are or where you're from. You can't steal my birds and get away with it." The fowler, with the help of the other merchants, bent Leonardo over and forced his left hand down on the counter of the stall. "I'll be nice and take your left."

"I'm left-handed!"

"That's your problem. If I cut off the sinister limb, maybe you won't steal anymore." The bird seller spat onto the ground and raised his sword with a flourish.

"Stop! I have that man's money." A woman's voice rang out over the din.

Leonardo, who'd shut his eyes, cracked them open.

The merchant's sword froze in midair. "What is the meaning of this?" he bellowed.

Despite the farmer's arm still wrapped around his neck, Leonardo could twist far enough to see a young lady, in her mid-twenties, step out from the crowd.

He had never seen her before. She wore a cream-colored gown made of shimmering silk, with gold embroidery adorning the bodice and sleeves. Metallic ribbons fluttered off her back like wings. She was pretty, but not strikingly so. She had a full bosom, her body curving like any mother's. Her heart-shaped face rounded at the cheeks and pointed softly at the chin. Like most Italian women, she had long, curling brown hair, olive skin, and coffee-colored eyes, but unlike ladies of good breeding, when she spoke, she gazed directly into the eyes of men.

"This should more than compensate for your fowl," she declared, and dropped several gold coins onto the vendor's stall.

"Madonna," the bird merchant said with a condescending smirk, tinged with a touch of familiarity. He was missing most of his teeth; only two yellow nubs protruded from behind thick lips. "I see your husband isn't with you at the moment. But while I appreciate that you're willing to part with his money to help a

wretched soul, a thief is a thief. I can't let him go without taking his hand. I am bound by justice."

"The money is not my husband's nor mine. It is this gentleman's," she said with the haughty tone of royalty, although Leonardo saw no indication that she was anything more than a merchant's wife. "He left it with me for safekeeping. I hadn't the chance to return it to him. It is not his fault he was without coin to pay you, my good man. It is mine." She rolled up her sleeve to expose her bare wrist and laid it on the wooden counter next to Leonardo's. "If you would like to chop off someone's hand, take this one." The mysterious lady held the fowler's glare. Leonardo had never seen a common woman speak to a man in such a manner. Not even Isabella d'Este had that kind of courage, for when she spoke that way, she was protected by walls and armies and royal titles.

The other merchants released Leonardo and stepped awkwardly away. The crowd started to disperse. Taking the hand of a lady was no sport.

The fowler lowered his sword and snatched up the gold coins.

"*Andiamo*," the lady urged, grabbing Leonardo's arm and leading him away from the stall. They zigzagged down one aisle, then another, past tables piled high with rugs and pots and flowers and wine. Finally, they erupted out of the market at the edge of the sun-filled piazza. "Go. Get out of here," she ordered.

"Wait," he called as she started to walk away. "Why did you help me?"

She looked back. "Why did you free the birds?"

"Please, what is your name? I can reimburse you for the money you spent or . . ." Leonardo stared into her luminescent olive complexion. An entire world reflected back in her brown eyes. "An ant picked up a grain of wheat," Leonardo said in a rush of words, hoping to stall her departure, "but the grain said, 'If you'll allow me to do my job, I'll take root and reward you with thousands of grains just like me.' The little ant listened, and the grain kept its

promise. Please, allow me to be your grain. You saved my hand. Let me repay you."

The lady shook her head.

"If not with money, then let me paint you, I'm an artist—"

"I know who you are. Learn to fly, Master from Vinci. That will be enough thanks for me." The lady picked up her skirts and hurried back into the market.

Leonardo stared after her. He had thought his dreams of flying were a secret, known only to him, Salaì, and a few others, like Isabella d'Este and the King of France. Was the woman a spy, working for an enemy, following his every move, looking for some weakness to exploit? Was she a seer, able to read people's minds and hearts? Or was she an angel sent from God to protect him and encourage his dreams?

There was only one thing he knew for certain as she disappeared back into the market. *I must see her again.*

Michelangelo

I n the days after winning the Duccio Stone, Michelangelo
worked alongside cathedral laborers to raise the block of mar-
ble off its side. It took a dozen men three tries to lift the unwieldy
rock and stand it on its narrow base. A large knot, the apparent
result of Duccio trying to hack out a swoosh of drapery, weighted
down the left side, making the block lean, so Michelangelo con-
structed a wooden scaffolding to stabilize the stone and allow him
to climb from bottom to top with ease.

Once the stone was situated, he studied the shape, making
notes about its height, width, depth, and the size of its gashes and
bumps. It looked like a weathered old tree trunk, tall and skinny,
all its branches knocked off during decades of storms, left with
only a few knots and holes where life used to flower. He hoped
some miracle of design would pop to mind, allowing him to fit a
human figure into that mangled, shallow stone, but the more he
analyzed it, the more obstacles he found. If he drew a figure slen-
der enough to fit inside the block, it would be too static to make
a monument worthy of Il Duomo. However, if he constructed a
design dynamic enough to make for a true masterpiece, it would
not fit inside its narrow girth.

He drew thousands of sketches; some of models he paid using
his last few *soldi*, others of strangers in the streets, still more out
of his imagination. Sometimes he drew entire figures, other times

just pieces: an arm, leg, head, torso, foot. Then he burned all of those sketches in a metal cauldron he had borrowed from his father's kitchen. He fed page after page to the flames. He didn't want to leave behind any evidence of strife. He wanted future generations to believe his Hercules had sprung immediately to mind in a singular burst of genius. If only he could experience the burst.

Sketch, burn, sketch, burn. Day after day, week after week he fought with his sketchpad, the chalk, the stone, himself, and all under the scrutiny of the public. All around him, carpenters and stonecutters tended to the cathedral's constant repairs. Every day the men hung new tiles, replaced crumbling marble, and cleaned the exterior, struggling to keep up with the perpetual wear and tear. Michelangelo enjoyed the hum of the workshop, but he regretted not asking the city for a private space. Florentines camped out with loaves of hard rye bread and *fiaschi* of Chianti to watch him toil and to take bets on whether he would finish. The locals called the stone *"Il Gigante,"* not only because of its enormous physical dimensions, but also for its outsized problems.

His family despised the public spectacle as much as he did. Michelangelo had hoped they would be proud of him for being hired to decorate Florence's cathedral, but his father barely spoke to him anymore, even when Michelangelo did make it home in time to join the family for dinner. Buonarroto, who was usually supportive, begged him to give up the commission. Maria, the silk weaver's daughter, the one with the pretty singing voice, would never marry into a family with a lunatic brother, Buonarroto whined. Giovansimone, of course, cursed him for debasing the family name. "If you don't stop this nonsense," he screamed, his face turning a disturbing shade of scarlet, "I swear I'll destroy you and your damned rock before you destroy us all." Michelangelo began to notice Giovansimone following him, spying on him.

Even more irksome than his family's disapproval were the artists who stopped by to offer their unsolicited advice. "Turn the

figure to the right," Botticelli suggested, resting his arms on the wooden fence of the cathedral's workshop.

"No, to the left," countered Pietro Perugino.

"Turn it on its head; it's not going to matter," said Giuliano da Sangallo.

"Just start cutting, already," Davide Ghirlandaio grumbled.

Then Leonardo joined the fray. "I thought you said you were an experienced sculptor." The jeweled ring on his finger glinted. "Miracles were supposed to pour from your fingertips like holy water at a baptism." Even after Leonardo went home for the night, his words made Michelangelo burn with ire.

As the weather turned colder and the autumnal smells of smoke, pine, and rain rolled in, Michelangelo soldiered on, sketching the stone, studying it from all sides, running his hands over every grain. He hardly ate and only trudged home to his father's house late at night for a few hours of sleep. He slept on the kitchen floor, balled up in front of the fire near the door, so he could wake before sunrise, grab a scrap of stale bread, and head back to work before his family woke to harass him. He put all of his energy into the stone, and yet it remained silent.

He had never encountered a mute block of marble before. Every piece of stone he had ever carved had spoken to him. Some whispered, others screamed and kicked, but they all had something to say. He had carved his first sculpture, a shallow relief of a Madonna and Child sitting on the stairs to heaven, when he was only fifteen years old, and even that scrap of marble had murmured softly. The stone that eventually became the *Pietà* had cried out at all hours of the day and night. The Duccio Stone, however, had never spoken to him. And until he could hear the marble, he had no hope of carving it.

When future pilgrims viewed his *Pietà*, they would wonder at that strange name carved across the Madonna's chest. Who was that artist who only created one good statue, they would ask.

History would wipe his name from memory as quickly as it forgets an individual grain of sand.

"Signor Buonarroti?"

Michelangelo startled. His hand jerked, scrawling an errant line across his latest drawing. "I'm working," he said to the young man hovering over him.

"I've a message from the Operai." The boy presented a seal as proof of his official position.

Michelangelo balled up his ruined sketch and tossed it into the fire. "What do they say?"

"I am to summon you inside the cathedral."

Michelangelo's neck itched. Could the Operai fine him for working too slowly? He didn't have any money. He wouldn't be able to pay. Could they have him imprisoned and torture him in the basement of the Bargello? Could they burn him at the stake for treason? "I should go home." He stood and picked up his leather satchel. "Change clothes. Clean up a bit." If he could get away now, he could make a run for it. He could return to Rome, move to Siena, or hide up in the hills until the city forgot about him and that silent stone.

"I am told to bring you immediately."

Michelangelo considered taking off at a sprint. He could surely outrun the youth. But if he fled, the Operai could hold his family accountable for his crimes. He had to face the charges himself. He dropped the rest of his sketches into the cauldron and followed the boy to his fate.

Michelangelo had been attending services inside the Cathedral of Santa Maria del Fiore since he was a child, but he was still struck by its beauty. Outside, the cathedral was famous for its dome, but inside it was dominated by high arches, long lines, and open space flooded with light streaming in through stained-glass windows. This is what heaven will look like, he thought as the door closed behind him.

Standing by the altar at the other end of the nave were Giuseppe Vitelli, leaders from the Signoria, several members of the wool guild, and a handful of other dignitaries. He didn't see a single friendly face among them. As he walked, his heavy boots clumped on the marble floor. He was relieved to finally reach the front of the nave and silence his awkward footfalls.

"Buonarroti." Giuseppe Vitelli stepped up on the stairs in front of the altar as though he were a priest officiating mass. "We have called you here because we, the church, the city, and the wool guild together, have for once managed to agree."

Michelangelo's throat closed. All he could do was nod.

"We have decided . . ." Giuseppe adjusted a crucifix sitting on the altar. "We do not want a Hercules."

Michelangelo opened his mouth to defend his statue, but his usual bravado drained out of him. He stood there dumbly. This was it. They were firing him. They would give the marble to Leonardo to make his fire-breathing dragon monstrosity. Michelangelo had battled with his family for the right to take this job and now he would have to skulk back into their house as a disgrace.

"We cannot approve a pagan symbol to adorn our cathedral. We would like a traditional Biblical figure instead," Giuseppe said.

A Biblical figure? That couldn't be Leonardo's dragon.

"We think it's about time the city had another . . ." Giuseppe paused. The others nodded encouragingly until he finally added, "David."

The word landed hard as a boulder.

Another David? He shoved his hands into his pockets in search of a pile of calming marble dust, but they were empty. They couldn't be suggesting "I'm sorry, you want what?"

"The shepherd boy David, standing triumphant over Goliath," Giuseppe said.

Michelangelo looked from face to face, hoping to catch someone smiling. They had to be teasing. "But Florence is already home

to the two most famous David statues, carved by the two greatest masters in history."

"And now we want another one."

"I can't trump the *David*s by Verrocchio and Donatello, and you know it." Michelangelo's voice had been louder than he'd intended. He lowered it. "Please, gentlemen, I have planned to give you a great heroic man, hearkening back to the sculptures of the ancients. The shepherd boy David was a pudgy, fleshy, prepubescent youth. A child. I spent years in Rome and never once did I see an ancient heroic statue of a boy."

"A Biblical figure will give glory to God," Giuseppe said.

"I too want to give glory to God." Michelangelo crossed himself. "So, let's compromise. How about a different Biblical figure? St. Matthew? St. George? Moses?" Any adult male, he thought.

"No. It must be a David."

"Why?"

Giuseppe averted his gaze.

"Signor Vitelli?" Michelangelo stepped closer. "This wasn't your idea, was it?"

Giuseppe shifted his weight.

"Whose was it?"

"Mine." A stranger stepped forward. In his thirties, he had skin so pale it had a hint of blue about it, and he moved with the slow assurance of someone who never lacked for time.

Giuseppe Vitelli waved an introductory arm. "Chancellor Niccolo Machiavelli."

Michelangelo had heard of the talented diplomat. He had been elected to his government post when he was only twenty-nine years old, and his skill for mediation and manipulation was already legendary. But Michelangelo would not be intimidated. "Shouldn't you be up in France negotiating with King Louis, not down here interfering with my statue?"

"Michelangelo." Giuseppe flushed.

"It's all right, Vitelli. I understand the temperament of such

men." Machiavelli turned his oily black eyes to Michelangelo. "I was discussing the project with Maestro Leonardo . . ."

"Leonardo has nothing to do with my statue. Tell him, Signor Vitelli."

Machiavelli raised a hand. "We were simply discussing how the previous masters of the stone, Duccio and Donatello himself, both intended it to become a David. We think its destiny should not be altered now. Of course, if you don't think you can do it," Machiavelli said, and Michelangelo had an urge to beat him over his head with his hammer, "I'm sure we can find another artist who would be up to the task."

Michelangelo watched several of the men exchange self-satisfied smiles. This was a trap. The Operai wasn't going to fire him. They had offered him the commission in public. They didn't want to cause a scandal. But if he stepped down on his own, they could say he had quit, and he would be the one who looked like a fool. "Fine. If it's a David you want, it's a David you shall have."

Michelangelo mounted the stairs of Palazzo della Signoria two by two and entered the inner courtyard. There, as government workers hurried to and from their offices, he came face to face with a bronze statue of a nude boy wearing a hat and holding a long sword down by his side.

Donatello's *David*.

Michelangelo hadn't seen the statue in years. He advanced slowly, like a stranger approaching a wild stallion that might bolt. Raised up on a high pedestal in the center of the courtyard, the statue was smaller than he remembered, the height of a child and just as slender. He put his hand on the boy's toe and caressed the soft bronze, hoping some of the brilliance would rub off on him.

When it was crafted in the 1450s, Donatello's *David* was the first freestanding nude statue since the Roman Empire, and it had inspired a new kind of art based on classical sculpture. Wearing only leather boots and a wide-brimmed shepherd's hat, the

beautiful boy, with ringlets of soft hair framing his tranquil face, stood triumphantly over the severed head of Goliath. Hand on his hip, *David*'s left elbow bent out, while his left knee bowed inward, giving him the feel of a vine growing organically up from the soil. Like Christ standing triumphant over Satan, Donatello's *David* represented the best, most idealized version of man standing victorious over evil. When Michelangelo was young, this statue had stood in Medici Palace. For hours, he would sit at its feet and draw it. The mixture of realism and grace had crushed his concept of beauty and forced him to rethink all art. Now he was being asked to trump Donatello's masterpiece. Impossible.

Hunched over from the weight of Donatello's genius, Michelangelo left city hall and walked over to the left of the palazzo, into the Loggia dei Lanzi, an arched portico that was home to a dozen Florentine statues. With so many on display, any single sculpture was lost in the crowd, but he knew the one he needed to see.

Andrea del Verrocchio's bronze *David* was not quite as famous or groundbreaking or beloved as Donatello's, but Michelangelo was more afraid to face it.

Like Donatello's, Verrocchio's bronze depicted a boy with curling hair, sword in hand, standing over the severed head of Goliath, but this *David* was clothed, and this face wasn't idealized. No, this was an actual boy, with well-defined features. He had a straight nose, jutting chin, full lips. His eyes were a little sunken, and his cheekbones protruded and caught the light. Anyone who saw him would call him handsome. Everyone in town knew that Verrocchio had used one of his teenaged studio assistants as the model for this statue.

And everyone knew that assistant's name was Leonardo da Vinci.

That boy was beautiful and talented and beloved, while Michelangelo was nothing but an unkempt, unknown sculptor with a badly healed nose. How could Michelangelo ever compete with such beauty? No matter what he did with his hunk of battered

marble, he was sure to fall short. He had no hope of silencing this *David* with his own. This one would always sing louder.

David or Leonardo. Leonardo or *David*. He had an overwhelming urge to climb up onto the statue and punch that straight-nosed boy in the face. But he didn't. Because he knew the metal would break his hand and leave that perfect bronze nose unbroken.

As he walked back to the cathedral workshop, Michelangelo hoped the crowds had gone home for the night. He didn't want to cry in front of anyone else. When he saw three figures not just hanging over the fence, but actually inside the workshop, standing next to the stone, he groaned. It was the painter Pietro Perugino, architect Giuliano da Sangallo and—who was the third? His disappointment turned to rage when he recognized the last man.

"Michel, my boy," Leonardo called, spotting him in the distance. "There you are. We've been waiting for you."

Leonardo

D id you go out for a stroll to clear your head?" Leonardo asked as Michelangelo approached, huffing and puffing like a wounded bull. "A mind is like a flame. It needs air to grow. It's always good to walk away from a problem when you're stumped." He adjusted his spectacles and eyed the stone. "And you are stumped."

Giuliano da Sangallo grunted agreement.

"Don't worry. We're here to help," Pietro Perugino said, standing up as straight as possible. He was the shortest of the three masters and always trying to compensate for it.

Michelangelo threw his leather satchel on the ground in front of the stone. "I appreciate your input, signori," he said, jaw clenched, "but please leave me alone." He dropped to his knees in front of a metal cauldron and stoked the coals into flames. Several bars of iron were already heating on the coals.

"I told you he wouldn't want my help." Leonardo stepped back and leaned against the workshop fence.

"He doesn't even know what we're here to say. Michelangelo, how old are you?" Perugino asked in a cheery tone. "Twenty-four, twenty-five?"

Ignoring the question, Michelangelo took one piece of iron out of the cauldron, placed it on a flat stone, and began beating it with a hammer.

"If Botticelli were here, the young man would listen," Sangallo muttered. "I should go get him."

"Nonsense, we don't need him," Perugino said, and turned back to Michelangelo. "When I was your age, or thereabouts, I was still living and working in Verrocchio's studio. Alongside Leonardo and Botticelli, and your own teacher, Domenico Ghirlandaio . . . When did you leave his workshop? At fifteen? I'd barely even started my studies by then."

"And I stayed in my father's studio until I was much older than you," Sangallo added, crossing his arms.

"None of us left our masters' nests to fly out on our own before we were ready," Leonardo said. Michelangelo was about the same age as Salaì, and he could hardly imagine his unruly assistant living on his own, much less managing his own commissions, negotiating contracts, being responsible for the Duccio Stone. "You're much too young to be doing this alone."

The sculptor pounded his piece of metal harder.

"By staying in a workshop," Sangallo went on, "we all received support from each other. We learned from older apprentices, taught younger ones . . ."

"Learned to cast bronze from expert craftsmen and mixed colors alongside experienced assistants," added Perugino.

"And even learned marble carving from Verrocchio himself." Leonardo sniffed. He hoped his meaning was clear: his training in marble far outstripped the young man's.

Michelangelo flipped the piece of iron over and began hammering the other side.

"The point is," Perugino said, "we all relied on each other. Do you have a family?"

"Of course," Michelangelo barked.

"That's good," Perugino said.

"That's lucky," Sangallo added.

Leonardo did not chime in.

"But your artistic family is as important as your blood one,"

Perugino said. "And right now, you lack support in your art. We take responsibility for that."

"You?" Michelangelo stopped hammering and looked Leonardo up and down like a cook eyeing a suspicious piece of meat from an unknown butcher.

Leonardo nodded. "Part of being a great master is being a great teacher. I have apprentices at my studio, and I see younger artists influenced by my work, but I don't know who will call me their teacher. My assistant Salaì tries to paint, but he has no drive and even less talent."

"The point remains," Perugino said, "you can learn from us. Use our expertise."

"I can teach you how to build sturdier scaffolding, for example," Sangallo offered.

"And I can teach you how to draw." Leonardo crossed over and picked up a few charred sketches scattered around the bottom of the cauldron. "Where did you learn? Not from Ghirlandaio, certainly. Your lines are much more fluid and powerful than his. Although you should stop making muscles so conspicuous, unless the limbs are engaged in a great effort. Look at this one." He sat down next to Michelangelo and showed him one of the sketches of Hercules. "You've drawn a sack of walnuts, not a human figure. You should study anatomy. If you can get your hands on a body."

Michelangelo grabbed the pages and dropped them into the fire.

"Son, the city has given you an enormous commission," Sangallo said.

Perugino added, "No one can do it on their own. We can help."

"How? By talking to Machiavelli about the details of my commission?" Michelangelo returned to hammering out his chisel. The blows came hard and fast.

"Machiavelli?" Sangallo muttered. Perugino shrugged. The two gave Leonardo questioning looks.

He had a vague memory of drinking too much with the diplomat one evening shortly after the Duccio Stone was taken away from him. What had they talked about again? "We might have discussed it briefly . . ."

"They want a David now," Michelangelo said. A vein over his right eye bulged.

"Oh," Perugino said, a false note of cheer in his voice. "That's good."

"Yes. A wonderful idea," Sangallo said, unable to sound optimistic.

"Well," Leonardo shrugged. "At least tell them it's a good idea. Always make the patron think they're smarter than you."

Michelangelo tossed the completed chisel aside and used tongs to pull a new piece of metal out of the fire. "Why did you tell the city to make me carve another David?" He turned his cheek toward Leonardo, but did not look over.

"I didn't tell the city anything. Niccolo and I discussed the history of the stone, nothing more."

"You thought I would be so intimidated by the subject matter that I would beg for your help?" Under Michelangelo's blows, the new chisel flattened quickly.

Leonardo exhaled his frustration, trying to remain patient. Sometimes Salaì wore his patience thin, too. "You're still trying to feel the statue, aren't you, Buonarroti? You must stop feeling so much and start thinking. You should study nature, research the human body, inspect it with your own eyes. Wisdom is the daughter of experience."

"You humiliated me in front of my fellow Florentines. You treated me like a child. But now that I am the master of the stone, you want to be my friend? My teacher? The Donatello to my Duccio?" Michelangelo finished his second chisel and stood up.

Leonardo stood up, too.

Sangallo stepped between the two men. "I know Leonardo lost his temper and said some hurtful things after they awarded you the stone . . ."

"But surely you can understand saying things you don't mean in the heat of the moment," Leonardo said, thinking of that cruel epithet the sculptor had hurled his way the night they met.

"I know why you're here," Michelangelo snorted. The wounded bull was now angry. "You can't have the stone for yourself, so you'll find another way to take the glory. By claiming to be my teacher."

Leonardo opened his mouth to respond.

Perugino interrupted. "Leonardo knows how to solve your problem."

Michelangelo and Leonardo stared each other down.

"You said it was impossible to carve a proper figure out of this botched block of rock." Michelangelo grabbed his sculpting hammer and began circling the stone.

Leonardo shrugged. "I ignored my own credo: nothing is impossible. Your rock is salvageable. I was in the market, about to get my hand cut off—that part is unimportant—and the merchants had me bent over this table . . ." He stretched out his arm and bent over, reenacting that day in the market. "That's when it came to me."

A group of Florentines had gathered to watch the encounter, so Leonardo projected his voice loud enough for everyone to hear. "See that knot?" He gestured to the large bump of marble weighing down the left side of the stone. "It's the key to the entire composition. If you hunch the figure over like so"—Leonardo stood in front of the stone with his back and left shoulder bent into the area of the large knot—"a full-sized figure will fit. Maybe even leaving enough room to add some sort of prop here," he said, gesturing to the top part of the rock. "I know it's awkward, and I have no idea why that stance is part of Hercules's—I'm sorry, David's—story, but time will reveal that answer. Here, I'll draw it for you." He picked up a piece of Michelangelo's sketch paper and chalk and dashed off several magnificent, curving lines, then flipped the drawing around to show it to Michelangelo and the curious spectators.

"See?" Sangallo said. "He's trying to help."

Michelangelo grabbed the drawing and looked at it. He balled

up the paper and tossed it into the fire. "You think you're so clever, but why would I listen to your advice about a sculpture? With the backing of the entire Milanese treasury, you couldn't even cast a horse for Duke Sforza."

Leonardo's left eye twitched. "My bronze was melted down for war."

Holding his stare evenly, Michelangelo's lip curled upward. Leonardo's shoulders dropped with dread. Somehow, this sculptor knew the truth: it wasn't only the lack of bronze that had prevented Leonardo from casting the statue. It was the design. The weight of the horse would have crushed those thin bronze legs. How did this young man know about that secret flaw? Had he been to Milan to study the clay model before it was destroyed? Or could he tell simply from seeing other people's sketches?

"You won't pass on your ignorance this time," Michelangelo said. "You abandoned that statue in shame, leaving Duke Sforza with less money and no art. And the worst part is," he continued, tears shining in his eyes, "those stupid Milanese believed in you. No one should ever believe in you. Anyone who does is a fool."

"I think we should go now," Perugino said, backing away. "The young man needs to be alone. To work."

"A lemon tree," Leonardo said through gritted teeth, "becomes conceited because it already knows how to make lemons. So it separates itself from the other trees. But without the protection of the others, the wind easily uproots it. Do not be an uprooted lemon tree, my young friend. Accept the help of those around you."

"You say that knot is the key to the composition?" Michelangelo gripped his hammer tightly.

"It's that knot that makes the whole thing possible. Without it . . ." Leonardo shook his head.

"You mean this knot"—he climbed the scaffolding so he could reach the unsightly lump of marble—"that has been in front of me this entire time?"

"That's the one I'm talking about."

"This one right here?" He pointed his hammer at the knot.

"Yes."

Michelangelo's face scrunched up as he swung his hammer and smashed it into the center of that knot.

Leonardo recoiled.

"Why. Won't. You. Speak. To. Me?" Michelangelo bellowed as he pummeled that knot over and over again. With every word, he hit the marble harder and harder.

A storm of marble chips whirled around the three master artists. Those who had gathered to watch the standoff screamed and scattered. Even the cathedral workmen, accustomed to outbursts of manly frustration, paused to watch the tantrum.

Michelangelo pounded the marble until the knot broke off and dropped to the ground. It landed with a *thunk*.

"Oh, Michelangelo . . ." Sangallo sighed.

Leonardo observed the piece of marble wobbling on the dirt, then looked back up to the core of the Duccio Stone, still standing, but with a deep gash now hacked out of one side. Ten seconds ago the stone was usable. Now it was not.

Michelangelo jumped down off the scaffolding and paced, huffing like a wolf that had just taken down its prey. Leonardo wondered if he realized how much damage he had done or if his anger had blinded him.

"There," Michelangelo said. "Now this stone doesn't belong to anyone else. Not to Duccio, not to Donatello, and certainly not to you." Michelangelo shot Leonardo a ferocious scowl. "This marble is mine."

As Sangallo and Perugino backed out of the workshop, Leonardo shook his head. "So much for trying to help." It was truly time to stop thinking about the Duccio Stone. The marble was officially dead.

Michelangelo

Once Leonardo was gone, Michelangelo dropped his hammer and turned away from the stone. He couldn't look, for fear of the damage he might find.

He picked up the broken piece of marble and hauled it over to a stack of discarded stone. He dropped it into the pile. Dust flew up. He had loved the stone, begged it, and now he had beaten it. Still, it remained silent.

The cathedral carpenters coughed awkwardly and went back to their work. A few spectators who had ducked behind the fence to avoid the spray of marble chips peeked out at him, while others glanced from behind shuttered windows.

What had he done? He shouldn't have let Leonardo get to him. He'd probably ruined the Duccio Stone, for good this time. Regret squeezed his chest like a fist.

More people started to gather. Witnesses whispered the tale to those who had not been there to see it for themselves.

His jaw tightened with mounting tears. He didn't need to look at the stone or his notes to know that Leonardo had come up with an elegant solution to an ugly problem. Not that it mattered. Michelangelo never could have used the design. If he had, Leonardo would have become the true master of the stone, leaving Michelangelo as nothing but his second-rate assistant.

The crowd of whispering Florentines echoed in his head. How was he supposed to inspect the damage to the stone with that swarm watching his every move? He couldn't work like this anymore. Not in the middle of all of those people with their buzzing judgment and prying eyes and mocking taunts. Art was not meant to be created in public, but to emerge in the quietest, most private moments of the soul. He needed to be alone.

Michelangelo hammered in another nail. Despite the cold temperatures, a crowd of spectators stood outside to gossip about what he was doing. He was supposed to be carving marble, not doing carpentry. But their whispering only made him work harder.

With every strike, he imagined hitting the top of his own head. He missed a nail and smacked his thumb with the hammer. "*Accidente a te*, Michel," he cursed, breath hanging in the chilly air. Using scrap planks from the cathedral workshop woodpile, he was constructing a shed around his stone. Once he was finished, he could close the door and shut out the world. People would not be able to mock him during their siestas anymore, and Leonardo would never be able to harass him again.

"Secrecy is the tool of the devil," Giovansimone shouted from the street. Michelangelo's brother was one of the many Florentines who spent their afternoons watching him work.

"Sorry to deny you any new gossip for the dinner table, *mio fratello*," he called back. What would his brother do when he could no longer spy on him? Giovansimone might actually have to find proper employment to bide his time.

Michelangelo pounded in the last nail and stepped back. As his first work of architecture, it was uninspiring. The corners weren't flush, and it was already leaning to the right; but it had four walls, a roof, and seemed sturdy enough to protect him and his marble from the coming months of wintry rain, wind, and sleet. And from prying eyes.

It was time to go in and inspect the damage. Every possible

catastrophe whirled through his mind. He might have broken off too much stone. There might be a deep hole. A giant crack could have cut across the entire rock. What if there were thousands of tiny fissures running through the marble, and at the slightest touch of a chisel it dissolved into dust? If his temper had destroyed that legendary stone, he would never forgive himself. He would flee Florence in shame and never return.

He put his hand on the shack to steady himself, then stepped over the threshold and closed the door behind him.

Inside, he lit a fire in the metal cauldron; a vertical pipe funneled the smoke. The shed was wide enough to house the scaffolding, his tools, and even an area for him to cook and rest in. Enough sunlight to work by poured in through the space between the planks and through a high window affixed with shutters to block out rain and snow. When the winter weather arrived, the shelter would be too cold to sleep in, but he could always go to his father's house to warm up.

For the first time, Michelangelo was alone with the marble.

"David," he whispered. The name still sounded strange on his tongue. It didn't seem like a David yet. "I built you a home."

The marble did not respond; Michelangelo hadn't expected it to. But now that they were alone, he hoped—no, he had no doubt—that the stone would start speaking soon.

Michelangelo stepped up to the looming block. He didn't see any obvious cracks. Running his hands over the marble, he pushed on every side, hunting for weaknesses. He expected to hear a pop or feel the rock give way and break in half, but it remained stable. There didn't appear to be a fatal rupture. His muscles relaxed a little. That was a relief.

Then he turned to the spot where he had broken off the knot. He inhaled sharply. The damage was worse than he had anticipated. He had taken off a huge chunk, marring almost half the length of the block. With shaking fingers, he touched the jagged surface. He would have to carefully chisel off the bumps,

and in the process would probably remove at least another finger-width of marble. This wound was deep. There had never been enough material for limbs to reach out in gesture, but now, the marble on one side was completely gone. He had knocked off the only part that could have been used for the shepherd boy's left arm.

Panic shot from Michelangelo's belly, up his neck, and over the top of his head. Perhaps he could make up a story in which David had his arm cut off in battle. Italians liked drama, and a story about David having his arm amputated was exciting. As soon as the idea occurred to him, he berated himself for it. He couldn't change the story of David to fit the stone, and he couldn't change the stone to fit the story. He had to change his brain to fit both.

At least a shepherd boy was smaller than a Hercules, he reassured himself. A youngster wouldn't take up so much space with bulging muscles and broad shoulders. Moreover, children were short. He could probably find a spot to lodge Goliath's head under young David's foot. He might be able to add a feathered helmet on top or a sheep at the bottom, just as he had included a mischievous satyr at the base of his Roman Bacchus statue, but he had to find enough room to clothe David. He was uninterested in carving the delicate, flabby flesh of an undeveloped youth. A nude David would also invite a comparison to Donatello's masterpiece, and he knew he would never win such a battle. No, he would add armor or a flowing shepherd's cloak. The thick drapery on his *Pietà* had attracted attention. He needed to recreate that power and beauty again here.

But first, the marble had to wake up and tell his story. Michelangelo would never figure it out on his own. He planted himself at the base of the statue. He would sit there until the stone spoke. In a battle of stubbornness, Michelangelo was sure he could outlast even a rock.

"Help me," Michelangelo murmured. "You have to help me. Speak to me. *Per favore*, I beg of you."

Kneeling at the foot of the wooden altar inside Santo Spirito, a quiet neighborhood church smelling of incense and wine, Michelangelo clasped his hands in prayer. After three days of sitting in front of the silent stone, he had given up begging the marble to speak and turned to a more likely respondent: God.

"My city needs me, my church needs me, the marble needs me. I am to decorate our great Duomo with a symbol to inspire Florence. I must give them something miraculous. Our enemies surround our walls and threaten our people. The French, Cesare Borgia, the Medici. I cannot fail. I will not!" His prayer echoed through the vaulted stone sanctuary.

God did not reply.

What was the meaning of this silence? Had he fallen from heaven's grace? Was the Holy Father disappointed with him? Did God regret choosing him for such an important commission? Would Leonardo have been better?

That was one fear Michelangelo refused to utter out loud, even to God.

It was impossible to feel inspired to carve a boy standing victorious over his enemy, when he felt so defeated. Michelangelo fumbled through his pockets and pulled out a scrap of paper and chalk. "Guide my hand, O Lord. Give me a design, and I will use it." He positioned the chalk over the paper and closed his eyes. "I have lost touch with the stone, but You can still hear it. If You guide my hand, I will listen. I will not question. I will believe."

He opened his eyes. The paper was blank. He was, indeed, alone.

Above the altar hung a wooden crucifix, about three-quarters the size of a real man. Michelangelo scrutinized the craftsmanship of the carving. Jesus's facial features were ordinary. His head was too large for his thin, sinewy body. The way he dangled on the cross was awkward, and he was too lean for a man in his thirties. He had no muscle definition. No power. No passion. Michelangelo sighed. The sculptor of that uninspiring crucifix was an amateur.

"The young man who carved that was very talented," said a voice nearby, as though reading Michelangelo's thoughts.

"He was a rank amateur," Michelangelo snapped in disagreement. "And no better now."

Father Bichiellini stepped closer. In his mid-thirties, the prior of Santo Spirito parish had a shaved head and amber eyes. "I hear that sculptor made quite an impression with his *Pietà* in Rome. Is this not true?"

Michelangelo shrugged. "Luck."

"I doubt you've ever done anything from luck alone, my son."

Michelangelo looked up at the crucifix. He had carved it when he was only seventeen years old, as a gift to the church. Visiting it usually comforted him, but tonight it only made him question his talents.

"I've wanted to come by the workshop to visit you, but you always look so serious," Father Bichiellini said. "You're working too hard."

"There's no such thing as working too hard."

"I saw you build a makeshift studio. Being alone must help."

"Nothing helps."

"Genius is eternal patience, my son."

After a moment of mutual silence, Michelangelo looked the father directly in the eyes. "You know why I'm here."

The prior's face drained of color. He scanned the room, checking to make sure they were alone. "You must not speak of that anymore," he whispered.

"I am lost," Michelangelo implored. "I must find my way again. You can help."

"I can't. Not since . . ." Father Bichiellini shook his head.

Girolamo Savonarola's name hung in the air, though neither had spoken it. Hardly anyone said that name anymore, although his spirit still haunted the city. As the half-millennium had approached, many Florentines feared the end of the world was upon them: French armies invaded, city-states warred, plagues

rampaged, and the corrupt tenure of Pope Alexander VI raged onward. The terrified citizens had turned to Savonarola to save their souls. The friar's sermons against sin and greed whipped them into a mania, and when the Florentines drove Piero de' Medici out of town, Savonarola stepped into the void of power. Under the friar's commands, citizens brought all of their material possessions to Piazza del San Marco and built towering mountains of musical instruments, books, paintings, statues, perfume bottles, fine gowns, dolls, and jewelry. Then Savonarola ordered them to light it all on fire. The city's luxuries burned on the Bonfires of the Vanities. However, the terror woven by Savonarola could not last forever. When he started condemning the pope, the church repudiated him, and soon the people renounced the friar, too. In 1498, after excommunication by the pope, Florentines torched Savonarola on a bonfire of their own. But his teachings and terrors were harder to expunge. A dark underbelly of fear still rose from his ashes.

"Savonarola is dead," Michelangelo stated with conviction, as much to remind himself as the prior.

"I know," Father Bichiellini whispered. "But people aren't as forgiving as they once were. They are afraid. Many would accuse you of tempting Dante's Inferno with the things you suggest."

"The practice has never been smiled upon."

"It is more dangerous now."

"I'm in more need, now. Please. The stone is alive. I know it, even though I can't hear it. I must wake it up. And to do that, I need to study again."

"You made plenty of sketches. Learn from those. Seek out the work of others. There is much to be absorbed from books and teachers. There's no reason for you to go back."

"Wisdom is the daughter of experience," Michelangelo countered. Those words, advice from Leonardo, tasted rotten in his mouth, and yet, in that moment, he had never believed anything more fervently.

"These walls have ears," the Father warned.

"I will be careful. Quiet. I swear it."

"I don't doubt that," said the priest, his face softening. "I do not fear for my neck, but how would I ever forgive myself if you were imprisoned or excommunicated for something I allowed?"

"And how will you forgive yourself if you don't help me free God's vision from that stubborn block of marble?"

Michelangelo followed Father Bichiellini down a dark, dank hallway lit only by the prior's flickering torch. Their footfalls echoed on the stone floor, making it sound as though they were strolling along the bottom of a well. As they approached a heavy wooden door, the priest asked, "Are you positive you want to go through with this?"

Michelangelo's breath caught. How could he be sure? He hadn't walked this path since he was seventeen—and then, he had been too young to grasp the consequences. The last time he left, he swore he would never return. Now he was back, breaking the rules of the church and the laws of man. If anyone found out, he could be ostracized, arrested, or executed. His father would disown him. Was he positive this was the right choice? No. "Yes, I'm sure," he said.

Father Bichiellini grunted consent. He pulled out a heavy metal key and slid it into the lock. The bolt clunked. The prior pushed open the creaking door.

A stench of rot wafted out. Gagging, Michelangelo clasped his hand over his nose and mouth. He had forgotten how bad it smelled.

He peered into the inky black room. He'd been inside many times before, but his heart pounded as though he were staring into the unknown.

With his torch, Father Bichiellini lit a lamp and handed it to Michelangelo. "Make peace with the spirits, my son."

"Leave the door open, Padre," Michelangelo whispered and stepped over the threshold. When he looked back, Father Bichiellini was gone.

He lit two more lamps. Slowly, the room revealed itself. It was a small brick chamber with a single barred window overlooking the street. Four long stone tables stretched out in front of him. Two were empty. Two held shroud-covered heaps.

Hand shaking, Michelangelo touched one of the bodies' stiff legs. He felt the other's arm. It didn't matter where he started; he would probably cut both open before the night was over. He chose the one on the right, if for no other reason than it seemed to smell slightly less wretched.

As he laid out his tools, he felt a chill. The church was silent, yet he sensed ghosts in every shadow. The terror, he recalled, was part of the process. When he was young, the nightmares had lasted for years. They probably would this time, too. "God, help me to do what I need to do. Give me strength. Resolve. Insight. Let me find your purpose." He pulled back the tarp.

Over the next three weeks, Michelangelo returned to Santo Spirito seven times. He dissected toothless beggars, mercenaries killed in battle, and even a rich man covered in a purple rash, probably the result of the French pox brought to the peninsula by King Louis's courtesans. He paid special attention to the two youths he encountered, making copious notes on their round faces, thin legs, undeveloped muscles, and the amount of fat still stored in their bellies. The bodies of children; the bodies of David.

One evening, he descended into the mortuary to find a dismembered corpse on the table. The poor fellow had lost half his head, both arms, and one leg. His body was bloated with river water, his skin half-eaten by fish. He had probably been killed in battle, dropped in the Arno, and pulled out by a local fisherman. The muscles were torn but still connected by flexible ligaments, like roots binding a tree to the soil. Bones

were crushed, but joints still moved. Even though blood no longer flowed, the network of veins converged and dispersed like a system of rivers. Even this body, mutilated by man and nature, could not defy the laws of anatomy. It was still a man, connected and whole, and there was no way to contort even this ragged human form so it would fit comfortably inside that botched block of marble and still leave room for swords and sheep and decapitated heads of giants.

As dawn approached, Michelangelo heard the priests preparing for morning mass. He put down his tools, his shoulders slumping. One of the first scenes he had ever carved was a relief of the Battle of the Centaurs, a jumble of fighting, twisting male nudes. He had to accept the truth: there was no new way to contort the human form that he had not already imagined. Not even the gruesome work of dissections could lead him to an answer that wasn't there.

Michelangelo cleaned up his work area, then slipped out the door, careful not to be seen by the praying priests. He trudged back to his shed and stood, defeated, in front of the silent stone. Michelangelo wasn't going to find the answers he needed by cutting open dead men or staring at a dormant rock. He was going to have to ask the stone. But in order to ask, he first had to wake it up.

He picked up his hammer and chisel and climbed to the top of the scaffolding. He didn't know where he was headed, but at least he could start clearing out excess stone, digging toward the figure he knew was hiding underneath. He placed his chisel onto the marble and struck. Hopefully, the sound of his carving would rattle the shepherd boy out of his slumber.

Leonardo

Sunrise was beginning to bleed over the horizon by the time Leonardo finished scrutinizing every vendor setting up a stall in the market. She was not among them.

Every day for the last month, he had gone to the market to search for the mysterious lady who'd saved his hand from the axe. Whether because of her luminescent complexion, her intense gaze, or her determined plea for him to fly, ever since he'd met her, he had an irrational urge to capture her image in paint. If only he could find her again, he could surely convince her to sit for a portrait. Then, maybe, he could understand his obsession.

"We're never going to find her, Master," Salaì said as they walked away from the market. Morning fog still enveloped the city. "You don't know her name, where she lives, why she was at the *mercato* in the first place. She might not even be a Florentine. Perhaps you imagined her."

The thought had crossed Leonardo's mind. The gold embroidery, the wing-like ribbons, the fearless way she'd protected him. She might be an angel, sent by God to save his precious left hand.

No, Leonardo reminded himself. Her voice had been too alive, her eyes too radiant, her hand too warm on his. She was real, and he knew he would find her in the market. He was sure of it. Judging by her bravado and the fowler's flash of recognition, she was a regular among those stalls. Leonardo would try again at noon. Then

at sunset. Again the next day and the next. He wouldn't give up until he found her.

They crossed to the other side of the river and turned down an alley. There, at the end of the street, a figure was creeping out the side door of a church.

The young sculptor was skulking out of a church at sunrise—and not just any church, but Santo Spirito, a parish with a history of allowing artists to study within her walls. There was only one explanation for such a scene.

Leonardo entered the church and waited in the back of the sanctuary until morning mass was over, and then he accosted the prior. "Father," he began, stepping out of the shadows, "I just witnessed Michelangelo Buonarroti leaving your church."

"Master Leonardo." Father Bichiellini offered a small nod. "I am gratified to see you in a house of God."

"I need your help," Leonardo said, hoping honesty would appeal to the man. "I'm attempting to accomplish something no one has before . . ." He considered revealing his dream of flying, but he didn't need another lecture about how if God intended man to fly, he would have given him wings. "I know what Michelangelo was doing here."

"The young man was saying his prayers," Father Bichiellini replied. "Perhaps you, too, should try kneeling before God."

"Praying?" Leonardo's voice echoed through the church. "He has been here. Dissecting."

As that word wafted through the church, Father Bichiellini's face turned pale. "Excuse me, I must tend to God's work," he said crisply and walked away.

Leonardo followed. "He pays you, doesn't he? I can pay you, too, and more, certainly . . ."

Father Bichiellini cut him off. "I assure you, I cannot be bought. And such a plot would never cross the mind of the pious young Michelangelo. His father taught him how to be a proper Catholic. He is from a good family."

"I apologize. I have not had the privilege of such attentive parentage," Leonardo responded coolly.

"Then you should look to your heavenly Father for guidance," Bichiellini said, opening the front door of the church.

Leonardo only paused for a moment before marching outside. Salaì was waiting for him on the stairs. "Come, Giacomo. Today is our day to catch the wind regardless of the way it's blowing."

"Ready to witness history, Salaì?" Leonardo called over a howling winter wind.

"Yes, sir," Salaì shouted back.

They were standing atop Mount Ceceri, a hill just outside of Florence. The sky was bright and blue, clear of any clouds. It was a perfect afternoon for flying. A gust threatened to lift the flying machine off the ground. That was a good sign. If the device was already trying to take off on its own, it would surely fly once properly launched.

The aerial screw, as Leonardo called the machine, was a large corkscrew wing, made out of cypress wood and linen, coiling around a center pole. According to his theory, as the corkscrew wing whirled around, it would push air downward and create a counteracting force to lift the machine, and its driver, into the air. In the future, he pictured such spiraling crafts dotting the skies. Tourists would ride in them over spectacular landscapes of lakes and waterfalls and volcanoes. In the future, maybe everyone would be able to fly like a bird.

Leonardo secured a bag of rocks in the driver's seat. He wished he could be the one strapping in for the launch, but it was too dangerous. He needed to test it first. He attached a purple-feathered cap to the top of the bag of rocks and scrawled his name across the burlap.

"Imagine, Salaì," he said, gazing out over the distant purpling hills, "if this works, someday soon, I'll be able fly across the ocean

and discover some new world for myself." For the last few years, explorers had been returning home with stories of discovering great new lands on the other side of the oceans.

"Let's try the test run first, Master, before we think of flying over the sea," Salaì said.

Leonardo sighed. Sometimes he worried that he should have taken more time to teach his assistant to dream properly.

They loaded the aerial screw into a large slingshot. Once Leonardo was driving the machine, he would pedal to turn the corkscrew, but for now he had outfitted the contraption with a set of springs, weights, levers, and wheels, much like the mechanics of a clock, to do the pedaling. According to his theories, if the corkscrew kept spinning, the contraption could fly all the way up to heaven. The only problem would be getting it back down.

Salaì and Leonardo pulled back the slingshot.

"*Uno*," Leonardo started to count. He had spent his childhood traipsing across these hills, running through thick grass, hopping over fallen logs, dodging around craggy trees. Now this land would provide the backdrop to his greatest victory.

"*Due*." In the distance, two men cantered on horses, probably headed into Florence for the market day. Instead of returning home with mundane stories from the market, they would go away with an astonishing tale of mechanical flying creatures taking over the skies.

"*Tre!*" Leonardo yelled.

He and Salaì let go.

Bang! The slingshot exploded, flinging the twirling corkscrew into the air.

In the distance, the two horses reared and the riders yelled and pointed up at the sky.

Leonardo had been fantasizing about this moment his entire life. As his flying machine hurtled through the air, the world lit up bright as a painting: the sky was awash in ultramarine, the cypress trees flowered in deep malachite, and the yellowing hills blazed as

if leafed in gold. Streaking across it all was that purple-feathered hat, bobbing jauntily on top of the bag of rocks.

As the machine headed straight for the two men on horseback, a gust of wind rattled the air. The contraption wobbled. Leonardo held his breath, willing it to hold firm.

The flying machine pitched and flipped upside down, plummeting toward the earth, the sack of rocks pulling it down like an anchor. "No!" he screamed and ran down the hill. The wooden armature cracked. The linen ripped. The aerial screw hit the ground with a violent crash, the bag of stones tearing open, rocks tumbling down the hill in a fury. The purple-feathered hat was crushed. If Leonardo had been riding in the contraption, his head would have been flattened, and his guts would have spilled out like those stones.

"No, no, no." He had spent months building that beautiful machine.

Salaì scurried past him to gather up some of the surviving pieces.

Leonardo fell to his knees and dug his fingers into the damp soil, still wet from recent rain. The world looked drab again: the gold leafing blew off the fields, the ultramarine crumbled from the sky.

He took two deep breaths. He would have to rebuild, that was all—design a better, stronger flying machine. The aerial screw had probably been a bad idea, anyway. He should return to his study of birds and bats and dragonflies. He picked himself up off the ground and brushed the soil from his knees. Years from now, this would seem like a minor bump in his long, zigzagging road toward human flight. Perhaps this failure would be the one to finally lead him to success.

Salaì huffed back up the hill. "Borgia men," he called, waving his arms furiously. "Run, Master, run!"

Borgia men? What was Salaì yelling about? Leonardo squinted down the hill. The two horsemen who had witnessed his test flight

were galloping after Salaì. One of the men wielded a sword, the other a club, and their breastplates displayed a red bull over a yellow background, the Borgia coat of arms. Those were Cesare Borgia's soldiers. Dread washed over Leonardo as he realized that, from their perspective, his failed flying experiment must have looked like two Florentine men firing at them from the top of a hill. It could easily be mistaken as an act of war.

Leonardo stumbled backward, then spun around and ran down the opposite side of the mountain, back toward Florence. Gravity propelled him down, down, down, until his left foot caught in a thicket and his knee twisted. He tried to recover his balance, but he was careening downhill too fast. His knee buckled and he crashed on top of a jagged tree stump. The splintered wood cut deep into his thigh, and a searing pain shot through his leg and torso. He cried out in agony as he rolled further and faster down the hill. He spotted a rocky outcropping up ahead. He tried to duck to avoid a collision, but his forehead smacked into the side of a boulder.

He tumbled to a stop at the bottom of the hill. Rolling over, he looked back up the steep hill. The soldiers were nowhere to be seen. Had he really outrun two horses?

"Master. Please. *Andiamo.*" It was Salaì, standing over him. He grabbed Leonardo's arm and tried to help him to his feet. "We must get inside," he said, careful to keep his voice low.

Leonardo tried to stand, but his leg buckled and he toppled over. Salaì grabbed Leonardo under his armpits and dragged him down the hill. As Leonardo's legs bumped over the ground, he saw something move up on the crest of the hill behind them. He squinted at the figures cantering along the ridge. They were the two Borgia horses and riders, towing a wooden, spiral contraption: the remains of his flying machine. Leonardo didn't know whether to feel relieved that he and Salaì had managed to escape, proud that his invention had attracted their attention, or worried that it was now in the hands of the ruthless Cesare Borgia.

Once they were safely inside Florence's walls, Salaì shouted at the guards to close the gates against a Borgia attack. "My master has chased them away for now," he claimed—a flattering lie that made Leonardo smile despite his pain—"but they may return."

On every second Saturday of the month, people streamed into town from all across the countryside to trade at the open market. Leonardo guessed the guards would not close the gates to the incoming shoppers and merchants, but it probably didn't matter. If Cesare Borgia wanted to strike, he would already be at their door.

Salaì led Leonardo away from the open walls, not stopping until they reached the other side of the Arno. He leaned his master against the side of a building and inspected the gash in his left leg. Salaì flinched. "Don't look, Master."

Air stung as it whistled across the exposed meat of his leg. He didn't have to look to know the cut was deep. Salaì ripped a length of fabric off his tunic and wrapped it tightly around the wound.

"I can't make it stop bleeding."

Leonardo grimaced. He hadn't needed to run away from the Borgia horsemen at such an uncontrollable pace. The soldiers had not come after him; all they wanted was his flying machine. His injuries were his own fault. He had forgotten his own philosophy: there was always time to stop and think.

"Master, you need help," Salaì said.

Leonardo felt a shot of worry when he saw that his assistant's face was pale. "Yes, I probably do."

"Stay here." Salaì sounded like a man in charge, instead of a boy in fear. "I'll go get the apothecary." He took off at a sprint.

The apothecary? "Salaì, wait," Leonardo called, but his voice was weak. "Salaì!" he repeated, but the young man ran around a corner and out of sight. "The apothecary won't be there," Leonardo groaned, wiping a layer of sweat off his forehead. It was market day. No merchant would be in his regular shop today.

Blood drained from his leg and pooled on the muddy street. His head throbbed. Nausea sloshed through his stomach and

throat. It could take Salaì an hour to run across town from apothecary shop to apothecary shop, searching for an open one, before realizing where everyone was. And the market was so close.

Tightening his gut against the pain, Leonardo pushed himself off the ground and limped toward the stalls.

Shoppers and sellers packed into the Piazza del Mercato, a dizzying array of colors, smells, and sounds of haggling. As he navigated through the crowd, shoppers shoved and jostled him. Pain tore through his head. Blood dripped down his leg. His hands turned cold, his vision blurred, and he stumbled a few times, bumping against stalls. Where was the apothecary stationed, again? He never could remember.

He limped down another aisle.

Then he saw her.

She had the same flowing brown hair, curving bosom, and olive complexion. The afternoon sun cast half her face in golden light, the other half in gray shadow. Her eyes were downcast, but there was no doubt she was his mysterious savior, who'd protected his hand from the axe and begged him to fly. Standing at a silk merchant's stall, she was surrounded by long drapes of fabric flapping in the breeze: a sea of burnt orange and indigo, a forest of green and shimmering gold, a mountain range of crimson and teal. The lady herself wore a coffee-colored gown that matched the velvety richness of her eyes.

As sweat beaded on his forehead, Leonardo wondered if she truly were an angel sent to save him from harm. The first time, she'd rescued his arm, and this time she'd appeared when he was on the verge of collapse. Leonardo staggered toward her. He was woozy, losing blood fast. The lady, his angel, was so close.

Leonardo tried to speak, but his throat and mouth felt full of sand. He couldn't catch his breath. He doubled over in pain. Using his last bit of energy, he lunged forward and, with muddy fingers, grabbed the lady's skirt.

She yelped and recoiled from the strange man grasping at her gown.

"Help," Leonardo said, his voice low and raspy.

"Get away from my wife," a man growled.

Wife? Did angels have husbands? Leonardo shook his head to clear his vision and muddled brain.

The man came out from behind the stall and grabbed his wife protectively. He was old enough to be the lady's father. His tiny face was squished under a puff of prickly hair, and his small round nose wriggled. He looked very much like the hedgehogs Leonardo had seen burrowing in the fields when he was a boy.

Legs shaking, Leonardo rose up onto his knees. "Please."

A flash of recognition crossed her face. Eyes wide, she leaned in and helped Leonardo drop gently to the ground. Her skin felt soft and warm. Her chest rose and fell with each breath. This was no ethereal angel. She was a flesh and blood woman.

"Lisa!" her husband yelled. "Get away from that man."

Her name. Leonardo finally knew her name. "Lisa," he whispered.

As her husband tried to wrench her from his grasp, Leonardo's vision started to dim. He kept his gaze fixed on the lady's eyes and was transported to the magical landscapes of his youth. Undulating fields of sunflowers and olives stretched out before him. Cypress trees bent in the wind. Dark caves dove beneath the soil. The ground beneath his feet crumbled, and he was swept down a river, speeding toward the ocean in great gulps of pounding waves and tumbling waterfalls.

He had finally found her, his savior. Now he could thank her, repay her, know her. "I would very much like to paint you," he whispered, then exhaled and slipped into blackness.

✳

1502

✳

1502

Michelangelo
Winter. Florence

There was a sharp knock at the door.

Michelangelo jerked his head up. He and David had been alone in the shed for months, but they were about to receive their first visitors. Michelangelo's beard and hair had grown long and unruly. He felt like he looked: a wild sheepdog protecting his flock from a rabid wolf.

"Open up," called Granacci. "*Mi amico*. We are here." The handle rattled, but the door was locked.

The Operai and guild leaders had requested a private inspection of the statue. If these men judged that he had not made enough progress, they had the power to fire him. Michelangelo could not refuse to let them in. The cathedral owned the stone. That was the hardest part about being an artist: he was always beholden to the men with the money.

Rain clattered on the roof. He should not leave important men shivering in a downpour. He should open the door and welcome them inside. But his legs wouldn't move.

Another rap on the wood. Michelangelo knew he looked strong on the outside. Hacking through solid rock was a grueling job, much more akin to manual labor than art, so his muscles were well-defined. Constantly breathing in marble dust made him queasy, so he hardly ate. He had become leaner, his body as hard and chiseled as one of the Roman statues he so admired. But even

though he looked strong, he didn't feel it. He wasn't ready to show off his work. He had made progress removing stone and blocking out the figure, but David had not yet woken and offered his own voice. What if the men could sense David was still asleep? What if they laughed at Michelangelo, mocked him, or dismissed him as an amateur?

"Open up," a man boomed. "This is the archbishop."

Michelangelo could not leave the head of Florence's cathedral standing out in the rain. He lunged forward and released the lock, then cracked open the door. A small group of august men stood in the storm: Granacci, the glaring archbishop, Giuseppe Vitelli, two members of the wool guild, Pietro Perugino, and Sandro Botticelli. Michelangelo's stomach lurched. He hadn't expected fellow artists. The stone wasn't ready for that level of scrutiny. He stepped outside and slammed the door behind him. "You can't come in."

"Michelangelo!" Granacci protested.

A flash of lightning lit the sky. "Let me by," the archbishop said. His gray beard looked like the matted-down hair of a wet donkey.

"The stone isn't ready yet. It needs more work. You should leave and come back another—"

"*Stronzate*," Giuseppe Vitelli grunted and barreled past Michelangelo. The others followed. On his way in, Botticelli offered a supportive smile, and Perugino tipped his hat, dribbling rainwater out of his rim and onto Michelangelo's dusty work boots.

Then a set of purple and pink platform shoes and a turquoise walking cane stepped up to the entrance. Michelangelo let his eyes rise up the checkered hose, violet pants, long sleeved jacket with tails, and pink doublet. Unlike the others, Leonardo seemed perfectly content to stand in the rain. Drops splashed off his rose-colored hat, sparkling like flecks of crystal. A red gash marred his cheek, and a purple bruise colored his eye, but somehow,

Michelangelo thought with exasperation, those wounds only made Leonardo's golden eyes burn brighter.

"Michelangelo." Leonardo offered a sarcastically low bow, and then hobbled into the shed with the help of his cane.

Everyone knew Leonardo's injuries had been sustained during a confrontation with Cesare Borgia's men. The old man recounted the tale with glee anytime someone asked. Florence was inundated with stories of Leonardo's lion-like courage, fighting off two towering Borgia spies with nothing but a bag of rocks. "I defeated giants with a handful of stones," Leonardo bragged. The comparison to David was not lost on Michelangelo. The old man couldn't take his marble, so he stole his glory instead.

Michelangelo followed the men into his shed. As the others examined the statue, Leonardo hung in the back, paying more attention to the state of the shelter than to the marble. He sniffed at a stack of sketches, pushed his toe against a pile of tools, and tapped his cane against one wall, testing its sturdiness. At least Michelangelo had taken a bath and cleaned up before the men arrived. Granacci had insisted. Now that Leonardo was poking around, Michelangelo was glad he had complied. The place looked, and even smelled, respectable. He only wished he had thought to shave off his tangled beard.

He shoved his hands into his pockets to finger marble dust. He tried to look at the statue through the eyes of these men seeing the David for the first time. He had taken down the front part of the scaffolding so the men would have a better view. The emerging figure was like a sketch, barely suggested on the page, beautiful because it left so much to be imagined. Michelangelo didn't even know how the statue would look when it was finished. For some reason, he couldn't get the image of a powerful, muscular Hercules out of his mind. "I'm still finding the figure, but I picture him as a humble child," he said, hoping to describe the image not only to the others, but to himself. "Looking shyly down, awkward

in his triumph. He will be beautiful. Supple. The epitome of human frailty. All the credit for the victory will go to God."

"It barely looks half-done." The archbishop started to take a step up a ladder, but when it creaked, he stepped back to the floor. "What's taking so long?"

Michelangelo flinched. People who didn't sculpt could never understand the amount of work that went into creating a statue. If he did his job correctly, when he was finished, it would look effortless. "It's just a start, I know," Michelangelo said, pushing toward the front of the crowd to stand next to the stone. "But at least it finally looks like marble, and you can see the figure starting to take shape. It will be a full, in-the-round composition . . ."

"The question is, will it be beautiful?" Leonardo asked as he limped up to the stone. "Is there anything here to indicate that beauty will eventually emerge?" Leonardo ran his fingers over the rough marble.

Will it be beautiful? The question was a hot blade slicing through Michelangelo's chest.

"It will," a deep voice answered with confidence. It was Botticelli. The revered painter was circling the stone, his eyes reflecting back the beauty he saw. "At least I think it will. There is something in there."

Michelangelo slid his fingers into a crook in the marble as though holding David's hand. Nothing had ever made him as proud as those words. Botticelli's *La Primavera* and his *Venus* were two of the most exquisite figures ever captured in art. Botticelli knew beauty.

"He has much more work to do," Botticelli warned. "And it could still end as the most spectacular catastrophe the city has ever seen. But it could also become something miraculous. At least we can see the stone is not the problem. The marble is strong, pure, and already glowing." He held Michelangelo's gaze for a long, silent moment. "It is now up to him."

"Well, if Botticelli says it is so, it is so." Giuseppe Vitelli reached into his jacket, pulled out a small leather bag, and handed it to the sculptor.

The sack was unexpectedly heavy. Michelangelo opened the pouch. Inside was a pile of gold coins. "What is this?"

"Four hundred gold florins. You deserve to be paid properly for your work."

As Michelangelo felt the weight of the bag in his hand, Leonardo limped out of the shed, the sound of his dragging foot accentuated by the tap of his cane. The master had not seconded Botticelli's endorsement, but Michelangelo wouldn't worry about that now. With four hundred florins, he could pay for new supplies. Buy his father a new suit. Set his brother Buonarroto up with a shop so he could afford to propose to the wool dyer's daughter. The money meant he was a man who could support himself and his family, no longer a boy chasing some foolish dream.

As the men filed out of the shed, Michelangelo looked up at David, still silent and incomplete, and whispered, "Thank you."

That evening, Michelangelo locked up his shed early for the first time in months and returned to his family's house for dinner. When he sat down at the table, his father remarked, "Ah, the king deigns to join us for a meal."

But nothing could dampen Michelangelo's mood. He had enough gold in his pocket to wipe the sarcasm out of his father's tone forever, but he didn't share his news immediately. Instead, he sat back, drank wine, ate rye bread and mozzarella, and listened to his family bicker.

Finally, Buonarroto, who had been staring at him all night, asked, "What is going on, Michel? You can't stop smiling."

Without a word, Michelangelo took out his leather pouch and dumped all four hundred florins onto the table. They rolled around before toppling into a glittering, golden pile.

Michelangelo was rewarded with the most magnificent silence he had ever heard.

Then the family erupted.

"What is this?" his father said, grabbing a handful of coins.

"A feast for us all!" exclaimed Aunt Cassandra.

"I knew you would get the money for me," said Buonarroto, his shoulders straightening. "I'm gonna get married."

"For my progress on the statue so far," Michelangelo said over the din. He snuck a look at his father. The old man's smile was so wide that the backs of his toothless gums were showing.

"A new bottle of wine, Mona Margherita," his father said. "And don't water this one down."

As the family celebrated, trading opinions about what they should do with their share of the treasure, Michelangelo knew this must have been how David felt standing triumphantly over the severed head of Goliath. This was the feeling of victory. He took a long swig of sweet wine.

Giovansimone picked up a coin and rubbed it between his fingers as though inspecting the quality of a bolt of fabric. Then, loud enough for the whole table to hear, he said, "I didn't know you could make so much money cutting open dead people."

Everyone fell silent. Michelangelo tried to swallow his mouthful of wine, but his throat didn't work. Uncle Francesco dropped the coins as though they had suddenly turned to coals.

"I told you I was following you," Giovansimone said. His eyes looked as dark as the unlit mortuary and made Michelangelo feel just as sick.

"I knew it." Lodovico's right hand trembled so much he had to put down his cup to keep from spilling. "I knew no one would pay this much money for a carving."

Michelangelo finally swallowed his gulp of wine. "People pay for art, Father, and the cathedral paid for mine."

The old man's face was sagging. "Then what is Giovani talking about?"

Michelangelo's heart twisted. He didn't like seeing his father in pain, and he hated to be the one who caused it. Yes, his art was important, but at the expense of his father? For a brief moment, Michelangelo had a pang he had never before felt. In that instant, he wondered if his art was worth it. "It's nothing. I have been studying anatomy."

"Nothing?" Lodovico roared. "Nothing! Are you, are you . . . ?"

Giovansimone began filling his pockets with florins. "Oh, he is most certainly dissecting people. I've seen it."

Uncle Francesco and Aunt Cassandra fell to their knees and began praying. "Hail Mary, full of grace. The Lord is with thee . . ."

"And inside of a church, too," Giovansimone added, his voice dripping with mock disappointment.

Michelangelo considered denying it. Giovansimone could never prove his story. The problem with lying, however, was that Michelangelo did not see anything wrong with dissecting. It was a necessary part of his art, and his art was an expression of God. He would not silence God. "It's true."

"*Santo Padre*," Lodovico muttered.

"But it's not what you think," Michelangelo said. "Studying anatomy is honest work. My teachers at the Medici Palace taught me . . ."

"Those damned Medici." Lodovico turned his head. "I should have known they were corrupting you. They always encouraged you and your Godforsaken art."

"Please," Michelangelo said. "Come with me to see the stone. I'll show you why I must do what I do. I will make you understand."

"I will never understand." Lodovico stood up and pointed toward the door. "Out."

"Father. Please, I can explain . . ."

"Out!" Lodovico walked toward Michelangelo, pushing his son backward simply with the force of his anger.

"I'll stop. I won't go back, I swear." Michelangelo crossed

himself, but Lodovico slapped his hand down as though striking down a demon. "I'll confess. To a priest. I'll beg for forgiveness."

"Will you give up sculpting? For good?"

Michelangelo looked his father directly in the eyes. "You know I can't do that."

"Then you are not my son," his father said, spitting the last word. "You're a devil who chooses a stone over his family."

"Wait, please," Michelangelo begged, panic rising in his chest. "This is my home. I have no place else to go."

"I don't care," Lodovico replied coldly. He opened the front door.

"My clothes, my money, it's all here."

"You have only yourself to blame." Lodovico stepped forward, driving Michelangelo out the front door.

"*Arrivederci*, brother. I'll miss you," Giovansimone called from the table as he dropped the last few coins into his jacket pocket.

"Giovansimone," Michelangelo barked. "Put that money down. That's not yours. That's for the family."

"Don't talk to your brother," Lodovico ordered. "Don't talk to any of us until you return without that filthy art muddying your soul." He backed into the house and shut the door behind him.

"No," Michelangelo whispered. "Please," he called, but one by one the shutters on the windows closed. "Please. Everything I do is for this family," he cried at the locked windows. "I suffer. I toil. And now that I have begun to raise us up a little, now that I bring home a little money, you, you reject me. You, my own brother." His guilt and fear burst into anger. "You, Giovansimone, you spy on me and use my own passions against me, all for your own greed. Body of Christ, if it isn't true! Take the money," he said, backing away from the door. "I will make more. And you know what I will do with it? I'll bring it all back to you, because you're my family and I will never turn my back on you, no matter what you do."

He waited, hoping the door would open, but the house remained silent. Sobs started to build inside his chest, but he

swallowed them. Giovansimone was probably watching from some window. He wouldn't give his brother the satisfaction of seeing him fall apart. He turned and walked away.

He had nowhere to go but the cathedral workshop. He entered the shed and sank to the floor at David's feet. His day of triumph had turned to the bitterest defeat. Michelangelo gazed up at his half-finished statue. He had given up his family for that silent lump of rock. Pulling a blanket over himself, he said to David, "Now would be a good time to start talking."

Leonardo

Sitting cross-legged across the street from the Basilica di San Lorenzo, Leonardo was sketching a floor plan of the church's back dome and rounded chapels when a shadow fell over his drawing. He glanced up to see Salaì blocking the sun.

"The best teacher for designing a building is nature," Leonardo said. "Just look at this plan and tell me it doesn't look like the petals of a flower. The fundamental components are all the same."

"Master?" Leonardo could hear the nervousness in Salaì's tone.

"If you have come to tell me the friars are looking for me, I know. They have been after me like badgers for weeks. Tell them I'm out purchasing pigments. That the color is coming. Soon." He turned the page sideways and drew a cross section of the dome.

"This came for you."

Leonardo looked up to see Salaì holding out a letter emblazoned with the papal army's gold seal. It couldn't be a warrant accusing him of attacking Borgia's men with a bag of flying rocks. Could it?

He took the letter and broke the seal.

A quick scan told him he had nothing to fear. Cesare Borgia did not want to arrest him; he wanted to hire him. His men had found Leonardo's name among the wreckage of his flying machine, and, recalling the maestro's multi-barreled firework launcher in Mantua, the commander now wanted Leonardo's

ingenious mind for himself. Borgia described grand visions of controlling the entire peninsula and beyond, with a territory the size of the former Roman Empire in mind. Il Valentino would pay Leonardo a handsome salary and give him the title of Chief Military Engineer for the Papal Armies if the master would help him achieve his goals.

As Salaì read the letter over his shoulder, a smile simmered on Leonardo's lips. "Oh no, Master," Salaì groaned. "You can't work for Cesare Borgia. It's one thing to turn traitor on Milan and Il Moro, but Florence?"

"This is a wonderful opportunity," Leonardo said, folding up the letter and slipping it into his pocket, "and I would be a fool to pass it up."

The second chancellor to Florence, Niccolo Machiavelli, was the youngest diplomat on the city's payroll, yet trusted with the most delicate negotiations. That past summer, he had traveled to France to meet with the king, and now he was to lead peace talks with Cesare Borgia. The city's future rested on the young man's conciliatory skills. A wily diplomat known for manipulating his unsuspecting opponents, Machiavelli was the man whom Leonardo wanted to see next.

"But, master, I don't trust that man," Salaì said when Leonardo told him about his plans.

"I don't either. That's why I want him on my side."

Inside the Palazzo della Signoria, a guard escorted Leonardo to an upper floor and into the small, cluttered office of the Chancery. Maps, letters, and treaties hung on the walls. Medals, flags, and exotic ceramics, all collected from various foreign nations, littered the desk and shelves. Books were stacked everywhere: on tables, chairs, the floor.

From behind a mountain of papers, Machiavelli watched as Leonardo entered. Then, with a simple flick of his eyes, the diplomat excused the guard, who immediately departed. "I don't

believe I have ever had the honor of hosting you in my office."
Machiavelli stood. He wore plain black clothes resembling a religious cassock, but a ruby ring twinkling on his pinkie exposed his worldly tendencies. "What brings Florence's most unique mind to my doorstep?"

"I'm afraid I have some disturbing news, Signor Machiavelli."
As Machiavelli listened silently, Leonardo told his version of the story: he was out testing his latest flying machine when two Borgia horsemen attacked. Leonardo shot rocks to chase them away, but the soldiers made off with his aerial screw. "They were scouting the area," Leonardo said, "and now they have a prototype of my greatest invention. So unless you want Borgia to be the first to fly, Florence needs to hire me to defend her. I can design miraculous weapons of war, signore. Your army will be outfitted with the most ingenious machines on earth. Imagine if you could fly over enemy territory, dropping fire from the skies."

Machiavelli held Leonardo's stare, but said nothing.

"I have something else you want," Leonardo continued, pulling the letter out of his pocket. "A letter from Borgia."

Still no reaction from the implacable diplomat.

"It contains insights into his military intentions. Information Florence needs."

Machiavelli held out his hand, a silent request.

Leonardo clutched the paper. He was not naive enough to hand over the note so quickly. As long as he was holding it, he held the power. "I'll give you the letter, if you'll help convince the city to hire me as military engineer. Florence needs protecting, signore, and I am the best person to help."

Machiavelli dropped his eyes to the floor and then raised them again to meet Leonardo's. It was almost like a nod. "Now, the letter, please."

Did they have an agreement? Machiavelli tapped his fingers impatiently. Leonardo considered pressing for a verbal

commitment, but did not want the diplomat to think he didn't understand the subtle communications of a high-powered negotiation. He handed over the letter.

With long, bony fingers, Machiavelli opened the paper and scanned it. "You will show this to the city council," he said, handing the letter back. Leonardo did not know whether it was a request or an order.

"And you'll convince them to hire me."

"Your city needs you, Maestro Leonardo." Machiavelli extended his hand to shake. "I'll arrange a meeting with the men needed to approve the hire, and then I'll personally sit down with you to help craft a presentation. Together, we will prevail—for you, for me, and for Florence. Agreed?"

Leonardo's mind whirled with all of the wonderful new inventions he would design. He had calculated correctly. This was going to be a fruitful relationship for both him and Florence. He shook Machiavelli's hand. "Agreed."

Over the next week, the men met to prepare for their presentation to the city council. The more time Leonardo spent with Machiavelli, the more the Master from Vinci trusted the diplomat's agile mind. The young man pondered political machinations the way Leonardo thought about the mysteries of the universe. Negotiation is a dance, Machiavelli explained; always move with the music and follow your partner's lead.

On the day of the presentation, the city council arrived in Machiavelli's office. The current gonfaloniere of justice had only been appointed two weeks before and still looked uncomfortable in his cloak of power. That was a good sign, Leonardo thought. The unsophisticated landowner would be easily manipulated by the brilliant diplomat.

Machiavelli made perfunctory introductions and then rolled out a large map of Florence and the surrounding area, including the territories of Romagna, where Cesare Borgia was attacking.

As Machiavelli described the threats, he lowered his voice so everyone was forced to lean forward to hear him. "Now," he said, closing out his portion of the presentation, "please, tell us your plans, Signor da Vinci."

Odd. Machiavelli usually called him Maestro, and rarely pointed out his roots in the small town of Vinci. The change surprised Leonardo, but he reminded himself to follow his partner's lead. "Of course, Signor Machiavelli. I have developed many plans to fight against Borgia's encroachments."

"Oh, they aren't encroachments anymore. It is his land," the small, pale gonfaloniere said.

"What?" Leonardo asked, startled. He'd not heard this bit of news. He glanced at Machiavelli, expecting to see his partner looking as confused as he was, but the diplomat appeared calm, as always.

"Two weeks ago," Machiavelli said, "the pope gave Cesare a new title. In addition to being the commander of the papal armies and the French duke of Valentinois, he is now also the Duke of Romagna. The official ruler of the land, not its invader."

For Florence, this was terrible news. Borgia had more control. More authority. More money. It certainly helped Leonardo's case. Florence needed protection now more than ever. Nevertheless, he felt a flicker of concern. Machiavelli had clearly known the news, possibly for two entire weeks, and had had plenty of opportunity to share it, but had not. Instead, he had allowed Leonardo to look like an ignorant fool in front of the city council. The moment had played out very dramatically, though, and perhaps if Leonardo had known he would not have been able to act so shocked. Judging by the worried murmurs of the city councilmen, Machiavelli's plan had been a calculated triumph.

"It's true," Leonardo said. "Florence is surrounded and in grave danger. We are vulnerable from every side. Limited lookout towers to the east. A deteriorating guard wall on the north. The south side open to cannon fire from nearby hills." As he spoke,

he pointed out these weaknesses on the map. "And the west side gate is regularly left open to give shelter to mercenaries fighting in Pisa. Anyone could slip in there. Not to mention the Arno, which runs right through the heart of our home and leaves us exposed to myriad attacks." Machiavelli had advised him to lay out the threats in stark detail. Fear was the only way to convince people to take extreme measures. When fearful, people would give up their money, their land, even their freedom, all to protect their security, which, ironically, could never actually be protected.

"And how, sir, can you save Florence?" Machiavelli prompted, just as they had planned.

Using maps and sketches, Leonardo described his ideas for constructing lookout points on neighboring hills, mining local mountains for stockpiles of defensive stone, and even changing the course of the Arno to deprive the Pisans of their fresh water and their route to the sea. This particular idea made the gonfaloniere's eyebrows pop up. He and the other members of the Signoria pressed Leonardo about how such a design might work. Leonardo told them enough to pique their interest, but then said they would have to hire him to learn the rest.

He moved on, showing them drawings of armored vehicles equipped with cannon, portable bridges for crossing enemy moats, a special suit that allowed soldiers to breathe underwater so they could sneak up on an enemy encamped by a river, and of course various flying machines. "Cesare Borgia's men stole my prototype for this contraption, but if they try to use it, they will fail. My design was not complete. But with your backing, I'm certain I can conquer the skies, as well as Borgia's army." He asked the council for unlimited funds and unlimited time to implement his designs. Machiavelli had encouraged him to exaggerate the costs. Cities always haggled with contractors over price, he said. Leonardo should ask for more than he needed, so when they offered less, it would still be enough. "With these plans," Leonardo concluded, "not only can I defend Florence against a

powerful and wealthy enemy, but I can also remake warfare and change the course of history."

The gonfaloniere asked, "What exactly did those soldiers say to you to make you think all of this was necessary?"

Leonardo straightened his shoulders and raised his chin. If he were weak in his answer, the city would be weak in their response. "Those soldiers were scouting our land. There is no doubt." He showed them the letter from Borgia. As the gonfaloniere read it, Leonardo asked, "Why would Il Valentino request the services of a famous Florentine engineer if he didn't hope to use my knowledge of her defenses? Borgia has his eyes on Florence. He is planning an attack. If we do not defend ourselves, we will surrender our Republic forever."

"You were telling the truth, Niccolo," the gonfaloniere said, looking up in alarm.

Machiavelli nodded gravely. "Yes. The last time we met, Borgia told me, 'Florence is either with me or against me. If you refuse me for a friend, you shall have me as your enemy.'" It was an impressive line. Leonardo wondered why Machiavelli had not shared it with him before.

The council members appeared terrified. "We don't have a choice," the gonfaloniere said, a rasp in his voice. "We must pay Borgia off."

Leonardo frowned. Pay Borgia off? That wasn't part of the plan. The plan was to hire him to—

Machiavelli replied before Leonardo could. "War is just when it is necessary; arms are permissible when there is no hope except arms, but today, we still have hope. Protection money is our best answer."

The others nodded in agreement.

"So it's settled?" Machiavelli asked. "You'll send me with thirty thousand florins and assurances we will pay the duke that same sum every year?"

The gonfaloniere extended his hand. "Yes. It's agreed." They shook.

"What about me?" Leonardo asked. "Don't you need me to defend Florence?"

"We don't have money to do both," the gonfaloniere responded. "Niccolo's idea is cheaper than all the things you propose, and less bloody. And changing the course of rivers . . ." He shook his head. "I can't be responsible for that kind of grandiose thinking. And with Borgia off our back, we can focus on the war with Pisa."

As the council turned to a map of Pisa, Machiavelli flashed a guilty but triumphant smile at Leonardo. The Master from Vinci knew that look. He had given it himself many times. It meant he had been beaten. Machiavelli had never intended to help him. He had used him to further his own agenda.

"I can help you with Pisa," Leonardo blurted, the cogs of his mind searching for a way to save the job.

"All of your plans are for warding off an invasion," the gonfaloniere said without looking up from the map. "Pisa is not invading us. We are invading them."

"I can develop other ideas."

"Excuse me a moment," Machiavelli murmured to the others. He took Leonardo's elbow and gently escorted him toward the door. "Thank you, Leonardo. You have been a great service to your country today. You have helped her avoid war. When peace wins, we all win."

Leonardo yanked his elbow away. "Except for me."

"All in good time," Machiavelli said in a soothing tone. "Trust me, my friend."

A few minutes ago, Leonardo had never felt more bonded to another man and his word. But now . . . "I would no more trust a crocodile who wept before he ate me. You promised your help. You're a liar and a hypocrite."

"Leonardo, I assure you," Machiavelli said, "no matter what you think, I'm no hypocrite. For I never once wept for you."

Leonardo left the Palazzo della Signoria to find Salaì waiting for him on the front steps. Leonardo shook his head to forestall any questions. There was no job. There never had been. There never would be. Salaì's shoulders drooped. He seemed to understand everything without being told.

The two walked in silence. Florence hated him, Leonardo thought; it always had. The city government had refused his services. The cathedral had rejected his bid for the Duccio Stone. Even Santo Spirito let Michelangelo dissect while he was turned away. No one believed in him.

Except the lady. That silk merchant's wife who had saved his hand and trembled when he was injured and encouraged him to fly. She understood him, but it didn't matter. He had returned to her husband's stall a few times, hoping to see her again, but she was never there. Leonardo didn't know whether her husband had locked her up in their house for safekeeping or if she truly were an angel sent to protect him when he was in danger. He was the most famous resident of Florence, and yet the only person who supported him was at best a complete stranger and at worst did not exist. He laughed out loud.

"Master? Are you all right?"

"Fly with me." Imagining soaring through the air, Leonardo extended his arms like wings and ran in a winding path. Salaì joined in, flapping his arms and laughing. Leonardo threw his head back and ran as fast as he could into Santissima Annunziata's piazza, feeling the wind tickling his beard and hair.

He only stopped when he recognized a figure waiting by the door. It was that damned old notary. Leonardo stopped running. He felt foolish that the man had seen him pretending to fly. Shame curled around him like smoke.

"Good afternoon," Leonardo said with as much politeness as he could muster, and then tried to step around the notary to enter his studio.

"I'm here to see you," the notary said. He was wearing a fresh tunic. His hair had been carefully combed. "The friars called me here to discuss your contract."

Leonardo stared into those gray eyes. The edges of the old man's eyelids drooped, from either disappointment, sadness, or just age.

"I'm sorry, Leonardo," he said.

"For what?"

"For . . ."—the notary broke eye contact—"being the one to have to tell you."

So this was how his commission with the friars was to end. At the hand of the notary, of course. "Actually, you look rather pleased to be here. Is that a new tunic?"

The notary shook his head. "They have been more than generous, supporting you for two years. I was pleased that they offered you so much Christian grace. But you have yet to place even one drop of paint on the altarpiece. I cannot defend you anymore."

"This church is my studio, my home. I live in these walls."

The notary looked away.

Did the old man want Leonardo to beg? "I have nowhere else to go," he whispered.

"I am sorry. Truly."

"Yes. You say that often." Leonardo brushed past and opened the church door. "No matter, I will plead my case directly to the friars. They are my patrons, they . . ."

"They are not your patrons anymore," the notary interrupted. "From now on, you should address all concerns to me."

He let go of the door. It dropped closed. "You know, I thought of a riddle the other day I think you'll like."

"Leonardo," the notary sighed.

"It's clever, really it is. If only you would listen."

"If you need to discuss your terms of departure . . . you know where to find me."

"There will appear gigantic figures in human shape," Leonardo said, his voice lilting as though telling a good joke. "But the nearer you get to them, the more their immense stature will diminish."

The notary walked away.

"That's it. That's all there is. It's easy," Leonardo called after him. The notary's heels clicked against the stone piazza as he got further and further away. "You have to guess. At least once. I'm not just going to give you the answer."

The notary kept walking until he disappeared around a corner.

Salaì stepped closer. Leonardo knew the young man was probably trying to decide what to say. He wished Salaì wouldn't say anything. "Sir? What's the answer to the riddle?"

Leonardo leaned against the closed church door. "It doesn't matter."

Back in the studio, they found a letter waiting. It was from the silk merchant, Francesco del Giocondo, the husband of the lady in the market. At the time of their first meeting, Giocondo did not know who the Maestro was, but now, he had done his research and discovered Leonardo's great merits. Giocondo was a patron of Santissima Annunziata, so both men shared a spiritual home as well as a love of art, the letter assured. His wife had told him about the master's kind offer to paint her, and he was now writing to offer Leonardo that very commission: to make a portrait of his wife, the dear Madonna Lisa Gherardini del Giocondo. If the letter were correct, then the lady, Leonardo presumed, was indeed real.

But the offer was too late. That night, Leonardo wrote a letter to Duke Valentinois, Commander of the Papal Armies, the newly appointed Duke of Romagna, Cesare Borgia, and accepted the job as his military engineer. Florence might not want him, but someone else did. Leonardo was going to war.

Michelangelo
Spring. Florence

H e's working for who?" Michelangelo roared. "I assumed you knew," Granacci replied. The two were squeezed into the Piazza del Duomo with every other Florentine, waiting for the Easter procession to begin.

"How could I have known?" Michelangelo asked. "I've been locked up by myself for weeks." Easter was the first day he had left his silent stone behind and gone outside to interact with people in over a month. He could hardly believe this first bit of news. "Leonardo may be an insufferable bully, but he's no traitor."

"When Florence refused to hire him, he offered himself to the enemy." Granacci craned around another man's head to get a better view of the cathedral's facade. "I'm speaking the truth, *mi amico*. Leonardo da Vinci is Cesare Borgia's new military engineer."

Easter—its joyous resurrection story, inspiring hymns, and fragrant smells of incense, fresh bread, and roasted meats— usually filled Michelangelo with hope, but this Easter did not feel like a celebration. His family was somewhere in the vast crowd enjoying the festivities without him; they refused to forgive him for dissecting the dead. His marble still had not woken up and spoken to him, and during the quietest moments, Michelangelo feared it never would. Now this news about Leonardo. "Florence welcomed him back with parties and parades," Michelangelo said incredulously, "and this is how he repays her?"

Granacci shrugged. "Serves the city council right for reject-ing him, if you ask me. They should've put him on payroll to keep him loyal."

"Florence shouldn't have to pay for loyalty."

"Why not? They're already paying for protection. They offered Borgia an enormous sum to convince him not to invade. What's the difference?"

"We're bribing Borgia?"

"What choice do we have? We are a people of artists, not warriors. Not that I'm criticizing Florence for supporting art," Granacci added quickly. "But our people stay inside our walls to build beautiful things and hire mercenaries to fight our battles. Our only recourse against a warmonger like Il Valentino is our money."

As the wealthy Strozzi family, dressed in their finest regalia, entered the square to begin the Easter parade, Michelangelo's ears rang with rage. In Rome, he had proudly carved his Florentine heritage into the marble of his *Pietà*. When he had achieved a hint of success, did he stay down south and offer his talents to the Romans? No, he returned home to Florence. His heart, his soul, his mind, his hands, his dialect, his taste buds, they were all Florentine. He could no more betray his city than betray himself.

Leonardo, on the other hand, Florence's most famous resi-dent, had no trouble selling himself to the man who threatened Florence's walls and extorted money from her coffers. Why? Because Borgia paid him well? Gave him a fancy title, prestige, and power? Everyone knew Leonardo had switched loyalties against Milan and Il Moro, but against Florence?

On the front steps of the cathedral, the archbishop opened his Bible and began to read the Easter story out loud. Men with strong voices repeated the scripture to the people behind them, and behind them, other callers repeated the words again. The refrain continued until it reached the back of the piazza and into

the streets beyond. Thanks to the repetition, the entire population of Florence could hear the story of Easter.

As the word of God spread, Michelangelo dropped to his knees. Those around him might think he was praying. Any lingering respect Michelangelo still had for Leonardo was now gone, a candle extinguished between two fingers. "Bring your worst, old man," Michelangelo murmured. As his lips moved, barely a sound came out; yet his voice felt as loud and clear as if he were standing on the cathedral steps, his words being passed from Florentine to Florentine until they reached Leonardo's ears, wherever he was. "Out of that botched block of marble, I'll create something more magnificent than you ever have, more magnificent than you have ever imagined. I will create something so miraculous that the whole world will forget the traitorous name of Leonardo da Vinci. I will prevail with nothing but faith and stone."

When the archbishop called, "Jesus is risen," Michelangelo stood up just in time to see a wooden dove speed down a wire from the top of the Baptistery to the cathedral steps. Every year, a similar wooden dove made the same journey over the heads of the Florentine people, and every year, Michelangelo stood there in awe and meditated on the victory of the resurrection.

This year was no different.

As the dove landed on a wooden wagon and set off an explosion of fireworks, a feeling, pure and bright and clear as the North Star, gleamed in the sculptor's gut. It was as if it had always been there and always would be. In the distance, he heard a faint sound, quiet as a sighing fly. "Excuse me," Michelangelo mumbled, pushing his way through the crowd.

"*Mi amico,*" Granacci called after him. "Where are you going?"

Michelangelo kept swimming forward through the crowd. "*Scusa, per favore.*"

"Come back," Granacci yelled. "It's Easter!"

As the crowd burst into a joyous hymn, Michelangelo broke out of the piazza and sprinted around the cathedral to the workshop in the back. As he rounded the corner, the distant sighing grew louder, a breeze blowing across a giant sea. With shaking hands, Michelangelo unlocked his shed.

When he opened the door, the breeze changed to a wind. He slipped into the shed and locked the door securely behind him. The wind hummed and vibrated, tingling the air like a lightning storm.

Michelangelo faced the stone. He placed his hand on the marble and listened. The wind was not a wind. It was coming from inside the marble. In, out, in, out. He closed his eyes and focused on each breath. Soon, a faint heartbeat emerged. And slowly, the heartbeat grew in strength. Then the breath was no longer a breath, but a whisper. The words were not discernible at first, but a jumble of sounds and letters. As Michelangelo caressed the marble, the letters started to come together. "Light," was the first word Michelangelo understood. "Fear."

"What was that?" Michelangelo coaxed. "Please, say it again. I can't hear you."

Then came the faintest whisper. "The Lord is my light and my salvation; whom shall I fear?"

Michelangelo inhaled sharply. A psalm—a prayer David had said in the fields to his sheep long before his battle with Goliath. The marble was finally speaking.

Another whisper, this one slightly louder. "The Lord is my strength of my life; of whom shall I be afraid?"

"David," Michelangelo exhaled.

"When the wicked came against me to eat up my flesh," David said, his voice growing louder, "my enemies and foes, they stumbled and fell."

Tears knotted behind Michelangelo's eyes.

"Though an army may encamp against me, my heart shall not fear," David called.

"Yes," Michelangelo said, a laugh bubbling out of his throat.

Then he heard the most beautiful sound in the world. David began to sing. "Though war may rise against me, in this I will be confident."

That stone was not dead, but very much alive, and finally, Michelangelo could hear its story.

Other artists had depicted David as a young shepherd boy, innocent and soft, triumphant after defeating Goliath. Now, Michelangelo could hear that his David had a different story to tell. His David was not fresh off a victory. No, his David was standing on the edge of the battlefield, preparing for the fight. There would be no need for a sword or sheep, not even the severed head of Goliath. David would stand alone, facing forward, his right arm falling down by his side, holding the pebble. As for his left arm, where Michelangelo had knocked off the knot, there was still a small lump of marble protruding near the top third of the stone. If he bent the elbow and curled his hand under his chin, the arm would fit. That hand would cradle the sling. David's head would turn to the left, his nose wedging into the corner of the block, glaring off at Goliath, his indestructible foe waiting for him on the horizon. At this point in the story, David didn't know if he would win or die, but knew it was his destiny to fight, and like anyone facing a battle, this David wasn't pure confidence or pure doubt, but an infuriating mix of both. He stood, half-relaxed, half-coiled with anxiety.

Comparisons to Donatello or not, David would also be nude. There wasn't room—or need—for helmets or armor or cloaks. Perhaps that was for the best. Michelangelo had always known that the most effective way to praise God was to praise His most perfect creation: man.

That's when Michelangelo recognized something extraordinary in David's voice. This was not the high-pitched tenor of a boy, but the baritone of an adult male. The courage David needed to face Goliath never would have fit inside the body of a mere

youth. No. The moment David chose to fight his enemy, he ceased to be a soft-bellied, innocent boy wandering the fields, and grew into a powerful, muscular hero and king. This David was a man.

Michelangelo opened his eyes. He could hear David clearly and see his figure longing to break free from the stone. Michelangelo picked up a piece of chalk and drew in the details: broad shoulders with well-defined biceps, the undulating muscles of a powerful chest and stomach, a forehead wrinkled with worry. He drew the head and hands slightly larger in proportion than the rest of the body. They were the most important tools of David's victory: his mind had given him the idea that he could defeat Goliath, and his hands had chosen the pebbles and worked the sling. It had taken Michelangelo months to arrive at this moment, and now he was there, the design fully formed, an amalgamation of his previous thoughts and drawings. If someone had been watching from a distance, they would have seen a singular burst of genius, but this moment was the product of months of thinking, dreaming, and drawing.

Michelangelo's skin tingled and his eyes widened; the same sensation he had whenever he truly started a new statue. This was the moment when his most perfect dreams were possible. This was the moment of pure potential.

As the stone continued to sing, Michelangelo picked up his hammer and chisel. The marble had finally woken. David was calling. Now, it was up to Michelangelo to set him free.

Leonardo
November. Cesena

"**C**rank harder!" Leonardo bellowed over the cacophony of cannon fire, clashing metal swords, and screams. He had been working for Cesare Borgia for nine months, but he still wasn't accustomed to the screams.

"It's no use. We're stuck," a young soldier shouted.

Leonardo and his team were sealed inside a covered, four-wheeled armored war wagon of his own design. Eight soldiers pushed on cranks to turn the wheels, but the contraption was so heavy, the tread only sank deeper into the snow and mud. The vehicle was stuck in the middle of a raging battle and fast becoming an easy target. Leonardo might well die in a box of his own creation. He would have laughed at the irony if he hadn't been choking on the smell of gunpowder and smoke.

The vehicle rattled. Leonardo staggered and toppled onto the floor.

"What was that?" a soldier yelled.

Another bang.

"Do something!"

Leonardo scrambled to his feet and loaded artillery into the last barrel. The round armored vehicle was outfitted with sixteen cannons, all of them pointing in different directions. He had warned Cesare Borgia that without sight holes or an ability to aim, the multi-directional cannon were likely to kill as many

papal soldiers as the enemy, but Borgia didn't care who he had to kill to win. The duke ordered the vehicle built and sent Leonardo into battle without even waiting for a test run.

As Leonardo lit the fuse, he prayed for the artillery to shoot outward as planned and not fire back into the carriage. Ever since going to war, he'd been praying more. "Fire!"

Leonardo and the eight soldiers ducked. All sixteen cannons exploded at once. The wagon shook. The sound thundered like a bell tower toppling over and crashing to the earth. After a moment, the men slowly looked up. None of the cannons had imploded. Inside, they were safe. Outside, the sounds of war had ceased. Leonardo envisioned a circle of carnage surrounding this box of death.

"We got 'em!" The soldiers erupted in celebration and laughter as Leonardo allowed himself to breathe again. He had survived.

A loud bang, and the armored vehicle shook violently again. An axe burst through the thick wooden walls with a horrifying crack. Then another and another. The cannons hadn't killed the opposition. It had only angered them.

"Retreat!" All eight soldiers grabbed their weapons, pushed open the hatch, and fought their way out. With the door open, Leonardo could taste the mist of blood hanging in the air and hear cries of pain. The lid closed heavily. He was alone.

After a few months in battle, he had learned that the worst thing in war was to be alone. Alone, there was no backup, no lookout, and no one to distract him from the doom swirling around his head. Any breath could be his last. He closed his eyes and inhaled deeply. He noticed everything about that breath, how it took him six counts to inhale, seven to exhale; how the smoky warmth traveled through his nose and lungs; and how, under the odors of blood and cannon fire, the air smelled of a mounting storm. He wondered what caused that scent. Was it rainwater collecting inside the clouds? Was it a special, aromatic wind that created a storm? Was there a change in pressure that spun dust and

dirt into the nostrils? Just one more thing he would die without knowing.

The armored wagon shook again. Leonardo opened his eyes. Smoke now filled the carriage, and he could hear the popping of fire. The enemy must have set the vehicle ablaze. If he didn't want to be baked alive, he needed to get out. Covering his mouth and nose with his sleeve, he pushed open the hatch and looked outside.

Sixteen cannon balls sat on the ground around the vehicle, each having landed only a few inches in front of its barrel. Leonardo tried to feel sorry that his invention was a failure, but instead he felt relief. He hated being responsible for killing people, and that blast could have murdered dozens. Perhaps it was best the enemy was burning it.

Leonardo surveyed the battlefield. The city of Cesena was consumed by thick smoke, orange flames, rearing horses, and clashing swords. The papal army looted shops, set houses on fire, and massacred entire families. Blood spewed from decapitated heads and seeped into the white snow. During his half-century of life, Leonardo had seen many men die in the fields—from disease, and during the invasion of Milan—but he had never seen so many men take the lives of others with such relish. War was a most bestial madness.

But he didn't have time to stop and contemplate the meaningless of violence. He slid through the hatch, rolled down the slanted roof of the burning vehicle, and landed in the snow, coming to a stop at the feet of another man. "*Scusa,*" he apologized. No need to forgo politeness simply because he was at war. However, when he looked up, he realized blood was oozing from a wound in the stranger's neck. No need to apologize to a corpse.

Rolling away from the dead man, Leonardo pushed up onto his elbow to assess the situation. In every direction were swordfights, licking flames, and horsemen swinging maces. If he rose to his feet, someone would cut him down. If he waved to a Borgia soldier for help, a Cesenan rebel was likely to reach him first.

Leonardo didn't have a weapon, and even if he swiped one from a corpse, he wouldn't know how to use it. He had never been trained as a fighter.

"Lisa," he whispered. "Angel, save me." Calling for his lady savior was a desperate last resort, but if anyone could rescue him now, she could. She could break free from the market and her husband and find him in the midst of war. He envisioned her traipsing through the battlefield, calling off soldiers, lifting him off the ground, and cradling him in her arms as she carried him to safety. Leonardo willed her to come, but no matter how hard he tried, she did not appear.

What did appear was a Cesenan horseman galloping straight for him and brandishing a long sword. The man's eyes were the color of dark, peaty soil found at the bottom of a cave. Leonardo dropped to his belly, closed his eyes, and lay still. His only option, it seemed, was to play dead. As the Cesenan horse trampled by, the horse's hoof nearly crushed his skull. Leonardo was alone again.

Leonardo had dined with princes and dukes. He had painted some of the most beautiful pictures ever known. He had been to bed with great women and great men. He had lived in Florence and Milan, walked the glittering canals of Venice, picked flowers on the hills of Vinci. He had dreamed up clocks, portable bridges, war boats, and flying machines. So many flying machines. He had always believed he had a long ribbon of life rolling out in front of him, but now, he would probably die, and his legacy would die with him, right there, on that ignoble spot. If he had known he was almost out of time, he would not have come to war. Instead, he would have painted more.

For hours, Leonardo huddled at the base of his smoldering war carriage, his face smashed into the bloody snow, until the sun went down and everything and everyone around him was dead. His body shivered with cold and dread. Every breath brought a new fear that it would be his last. His fingers and toes turned numb. As darkness lowered like a curtain, his pulse slowed until it

barely made a sound. His breathing became shallow. Drowsiness poured over him and thickened around him like hardening wax. He drifted in and out of awareness. Finally, the moon slipped behind a cloud, and Leonardo used the added darkness as cover to slither on his stomach, over corpses, toward the city gates, where he waved down a troop of Borgia men. As the soldiers carried him back toward camp, he finally gave in and passed out.

A pool of blackness thicker than lava began to break apart. Bubbles appeared and burst, letting in holes of light.

Gradually, Leonardo regained consciousness and opened his eyes. It was a bright night full of stars and a glowing moon. A few men murmured and laughed, but the sounds of war were gone. He was back at Borgia's camp, lying on the cold, hard ground and covered with a blanket. A man hunched over the flames of a small campfire and stirred a pot. Was he making dinner? Leonardo groaned and tried to sit up.

"Don't," the man commanded gently. "Lie down. You might faint again." He tucked the blanket around Leonardo's shivering body.

Machiavelli? The diplomat looked even more thin and pale than usual. His bony hands shook from fatigue and cold. He wore a tattered winter coat that was much too large for him. There was a hole and a bloodstain in the back. He had probably taken it off a dead soldier. This was not the brash, brilliant gentleman Leonardo had met in Florence. War, as it did to lesser men, had ruined him. For the last few months, Machiavelli had been in and out of Borgia's camp, trying to convince the duke to sign a long-term peace deal with Florence. So far, Borgia had refused to sign anything and continued to collect protection money from the Florentine treasury. Leonardo and Machiavelli had been circling each other for months up at camp, but had yet to speak.

"You've been very ill," Machiavelli said, then sat back down in front of the fire and served himself a bit of bread and a bowl of thick brown stew. "I thought we'd lost you."

I thought we'd lost me, too, Leonardo thought. He was hungry and considered asking for a bowl of stew, but he did not want to request anything from Machiavelli and be indebted to him in any way. "Why?" Leonardo asked. His voice sounded gravelly and weak.

"You spoke." Machiavelli's smile accentuated his emaciated face and hollow eyes. "That's a good sign. A very good sign."

Machiavelli poured a cup of watered-down wine and helped him sip. The liquid tasted like vinegar, but it soothed him. "Why are you helping me?" Leonardo wheezed.

"You're a great Florentine. It would be a loss for us all if something happened to you."

"I am from Vinci," Leonardo grunted.

"Florentine territory, maestro, and you know it. Would you prefer if I left you to Borgia men? They would let you suffer alone, I assure you."

Leonardo didn't respond. He didn't trust Machiavelli. The diplomat would no doubt try to use his weakened state to manipulate him again.

"Two months ago," Machiavelli said, his breath hanging in the cold air, "I wrote to the city council, asking for gifts to lavish on Borgia and new clothes so I could appear more respectable around camp. I received a response today." He pulled a piece of paper out of his pocket and read it. "'Go scratch your ass,'" he read in an archly dignified voice. "'You can go to the devil for asking so many things.'" He refolded the note and slipped it back into his pocket. "I should turn traitor on Florence myself."

"Don't," Leonardo murmured. "It's not worth it." If only he had chosen to stay in Florence, finish the friar's altarpiece, paint a portrait of the silk merchant's wife, he would not have the particles of war buried into his skin, nor gunpowder permanently embedded in the lining of his nostrils. "Every Florentine must gossip about how I betrayed them."

Machiavelli gazed up into the sky as if giving the statement proper consideration. "No," he said. "They do not. They don't even mention your name. They are obsessed with that sculptor and his stone. Do you know that one time—it seems like a long time ago now—I tried to get the Duccio Stone back for you, even after it was awarded . . . elsewhere?" Machiavelli shrugged. "It was a fruitless ploy."

Leonardo held his hands up toward the fire to warm them. They prickled as the heat returned. Florentines no longer loved him. They had forgotten him. "Michelangelo," he whispered. It sounded halfway between a gasp and a prayer. "The last time you and I saw each other, you did turn traitor of a sort, Signor Machiavelli," he said, brushing the taste of Michelangelo's name off his tongue. "You cheated me out of my post."

"My vow to help you, even though I knew it was a lie, was a necessity of the moment," Machiavelli said without emotion. "And the betrayal a necessity of its own time. Although I do regret that it landed you here." He spread his arms wide.

"You're nursing me back to health. The debt has been paid."

"The debt will never be paid." His face was suddenly serious. "I may advocate that others betray their heroes, but the practice is not for me. I'll always owe you for driving you from Florence. Bread?" He tore off a piece and offered it.

Leonardo was too hungry to refuse. He took the scrap and placed a bite on his tongue.

"But, I will admit, it was a double pleasure to deceive the deceiver," Machiavelli said with the hint of a smile. "You had the gall to pitch a design to divert the Arno River. Do you really believe you could've done it?"

Leonardo nodded, swallowing the bread. "When nature and man work in concert, there are no boundaries." He thought of his armored vehicle, strong and heavy, sinking into nature's thick roads of mud. "It's when they're at odds that things fall apart."

"You're no military man, are you, Master from Vinci? You're

an artist," Machiavelli declared, as though being an artist were an object he could pick up and study.

That was a misconception, Leonardo knew. Artists were not definitive or constant. Being an artist was more like being a moment in time. As soon as art was upon you, it had moved on and changed. But he was too tired to explain the difference. Instead he said, "I'm too old for war."

"Everyone is too old for war," Machiavelli said with a laugh. "Except for the prince, Cesare Borgia, of course. He is perpetually the correct age for battle. His ability to create loyalty in his subjects is miraculous. History will acknowledge him as a great genius."

Would it? After witnessing the destruction Borgia inflicted on every town he invaded, any admiration Leonardo had harbored for the duke fled as fast as life vanished from a beheaded man's eyes. "Borgia is a cruel tyrant, not someone to be revered," Leonardo said.

"Oh, politics have no relation to morals," Machiavelli said dismissively, spooning out a second bowl of stew and handing it to Leonardo.

Though he was a vegetarian, Leonardo didn't ask what was in the concoction. He pushed himself up onto his elbow, dipped his bread into the gruel, and ate. White beans and tomato.

"It is always better to be feared than loved. Il Valentino will be praised in spite of his cruelty. Or because of it," Machiavelli added. The diplomat seemed to roll the thought around in his brain as though folding and refolding a piece of paper, trying to turn that page into a castle. "Part of Borgia's genius is using fear to his advantage. People have heard the rumors of his villainy, so when he steps up to the gates of their castles and declares that he is about to attack, his opponents quake in their courtly shoes. Their fear of him destroys them before he fires the first shot."

"You honestly believe Borgia will be remembered as a genius?" Leonardo asked, lying back down on his pallet and staring up at the night sky. The legacy of a genius seemed such an elusive thing.

"Of course." Machiavelli said it as though achieving such prestige were as easy as purchasing it from the market. "He controls large masses of untamed land far away from his home at a time when maintaining any power is nearly impossible. And once he takes control of an area, he never allows an adversary to sneak in and usurp him. Cesare knows if he isn't the most powerful man on his own land in his own time, his legacy will never survive."

"Because unless he is the master of his own time, he can never be the master of all time," Leonardo rephrased. For years, Leonardo had assumed that he was the greatest artist of his time, but now, the thought stuck in his brain like a blackberry seed. That seed, Leonardo thought, was in the shape of the Duccio Stone.

"Il Valentino knows that Fortune only helps those who help themselves, and he is always willing to fight for his own cause. He cuts down his enemies with cold detachment, thwarting their plans before they can take root."

Had Leonardo allowed an opponent to take root in his own time, in his own town? Did he owe it to himself to return and eradicate the threat? Or was he being paranoid?

"And by defeating all of his opponents, Cesare Borgia declares, to everyone alive today and everyone alive in the future, that he alone reigns supreme."

"And his legacy is secure," Leonardo whispered. When Machiavelli explained it, it all seemed so simple. "Don't you ever worry about praising your enemy in such a way?" His memory floated back to that rough profile, that flattened nose, that tuft of matted, dirty hair.

"You should never be afraid of praising your enemy," Machiavelli exclaimed. For a second, the old fire rose in his eyes. "If you don't praise them, how will you ever understand them? And if you don't understand them, how can you defeat them? Always learn their weaknesses, but more importantly their strengths. Anyone can attack where people are weak, but a true master uses his enemy's strengths against him."

Michelangelo
December. Florence

Michelangelo bounded up the first flight of stairs. He had to duck his head to avoid cracking it against the low ceiling, and the tight spiral staircase made him dizzy, but he didn't slow down. He had never been to the top of Palazzo della Signoria's bell tower before, and he could not imagine why he had been summoned there—by an anonymous letter—or by whom.

He passed an unmarked metal door. That must be the infamous prison cell that held Savonarola before he was burned at the stake. Michelangelo kept moving. He would not allow ghosts to haunt him today. He had a good feeling about this meeting.

Ever since Leonardo had been away at war, Florentines had anointed Michelangelo their new hero. He was no longer the irascible upstart who had rudely usurped their beloved master, but the passionate prodigy toiling away to carve a treasure for their cathedral. The city was awash with rumors about David's burgeoning magnificence. Merchants applauded when Michelangelo walked down their streets, ladies left dinners at his doorstep, and boys begged to be taken on as his apprentice. When he shopped in the market or strolled by the Arno, citizens often stopped him to ask how "our David" was progressing. They spoke as if David were already one of them.

The Buonarroti family, it seemed, were the only Florentines not supporting him. Michelangelo had stopped by the house several times, but his father refused to open the door. The only time he had spoken to a member of his family was when Buonarroto visited the shed to ask if Michelangelo had any more money. Giovansimone, he admitted bashfully, had spent the entire four hundred florins investing in a card game table at the market and had gone bust within two weeks. Michelangelo howled as if a pile of coals had been dropped down his throat. His brother had spent all of his precious earnings on a gambling stall? Surely their father, who had never approved of such games of chance, had exiled Giovansimone for the sin. Buonarroto shook his head. Giovansimone still lived at home and ate every meal at their table. So, Michelangelo pressed, could he, too, join them for dinner now? Buonarroto didn't look him in the eye when he responded that no, he could not. Their father could forgive Giovansimone the peccadillo of losing all their money, but he would not allow Michelangelo back into the fold until he had renounced his art. Michelangelo threw Buonarroto out of his shed. He didn't have any money to give him anyway.

Today's meeting could change all of that. Perhaps this mysterious caller was a patron hoping to hire him for some lucrative new commission. His hope buoyed as he ascended the last step and arrived at the top of the tower.

On all four sides, arches opened onto a panorama of Florence. The city, covered in a rare layer of snow, looked white, pristine, and peaceful, as if it were a delicate relief carved from Carrara marble. Three large bells hung overhead. They were so heavy, they didn't move even with a stout winter wind whipping through the open arches. Braving the cold, a man stood out on the narrow aisle between the archways and the cornice. His back to Michelangelo, he overlooked the city. He was short and slight, with impeccable posture. He did not wear a hat. His only protection from the cold was a layer of thinning hair and a blue cape adorned with gold stars.

Even from the back, Michelangelo recognized Piero Soderini, the politician who had thrown his support behind Leonardo for the Duccio Stone. In September, the city had elected him the first lifelong *Gonfaloniere di Giustizia* in Florentine history. As the new permanent leader of the city's government, he was arguably the most powerful man in all of Florence. Why had he summoned Michelangelo to the tower? This was a sign he had truly arrived.

"Our city's bells were hung here in 1310," Soderini said. He didn't look back nor give any indication that he had heard Michelangelo arrive. Michelangelo held his breath. Did the gonfaloniere know he was there or had he interrupted some private moment? Was the politician talking to him? Or to himself?

"When the bells ring, every able-bodied Florentine is to charge into the Piazza della Signoria to defend the Republic against her enemies," Soderini continued. "They have rung many times during our history. During the siege against Pistoia, to raise troops for battles against San Gimignano, Prato, Volterra, and countless times against Pisa. They sounded during the 1378 Revolt of the Ciompi and before the decisive battle against Milan at Anghiari. They have even called the people to service during famines and plagues. Have you ever heard the bells ring, Michelangelo?"

At the sound of his name, he exhaled. Soderini knew he was there. "No, signore, I have not." Pulling his tunic up around his chin, he walked out to stand next to the politician on the edge of the tower. "But I've always felt safe, knowing this building and her bells were here to protect me. And Florence."

"This tower isn't centered. Why not?" Soderini asked.

It was true. The bell tower was situated to the right and front of the bulky, square building below. Some said it marked the spot of an important ancient tower. Others said it was where the foundation was strongest. Many claimed it was an issue of aesthetics; an asymmetrical design was more beautiful. "Because it's a symbol of Florentine independence," Michelangelo said, feeling his

chin rise with pride. "The Republic does not fall in line with other city-states, and this tower is proof of it."

Soderini nodded. "When Giuliano de' Medici was murdered in the walls of our own cathedral, these mighty bells rang." He paused and closed his eyes as though listening to his memory of those chimes. "Florentines from all over the land rose up to bring the assassins to justice. You were alive then."

"I was three."

"Three?" Soderini opened his eyes and stared at Michelangelo.

"Still living in the country with my nursemaid."

"And when Piero de' Medici was expelled and Savonarola executed?"

"Working in Bologna, then Rome. I wasn't here for either, signore."

"Maybe that is what's wrong . . ." He rubbed the embroidered seam of his velvet cape between his fingers, lost in thought for a moment. "Well," he finally said. "Do you know why we call it *La Vacca*?"

Michelangelo nodded. He had never heard them ring, but he had heard the stories. "They sound like a mooing cow."

"A moaning cow," Soderini corrected, "like a great beast emitting a low, mournful wail. It is one of the most majestic, awe-inspiring sounds you will ever hear. But somewhere, Florence lost her way." He frowned. "When was the last time we rang our bells? When was the last time Florentines barreled into this square, voices and weapons rising to say, 'No, you will not take us so easily, you will not take our Republic, you will not take our freedom?' When was the last time . . . ?" His nose, cheeks, and chin were pink, from either his passion or the winter wind or both. "Do you know why we don't ring our bells anymore?"

Michelangelo shrugged. His father said it was because there was no need; even in this time of turmoil, Florence was safe. She was too powerful, too wealthy, and too beloved to be attacked, even by Cesare Borgia or the Medici. Machiavelli and other diplomats argued Florence could not ring *La Vacca* because her enemies

would take the sound as a challenge and march on Florence just to prove they could. Michelangelo's friend Granacci backed the most common, but most controversial, opinion: if the bells tolled, Florentines wouldn't march out to the square ready to lay down their lives for their nation; they would run back to their homes in fear. The French, the Medici, Borgia, and especially Savonarola had destroyed the people's confidence. The bells were impotent. Better to leave *La Vacca* silent than risk showing the world that her citizens were unwilling to fight. "No, signore, I don't."

The creases in Soderini's face deepened, like roads etched on a map detailing how long he had traveled. "That's too bad." He shook his head and then walked toward the exit.

Michelangelo waited for Soderini to say something, to explain why he had called him to the top of a tower in the middle of winter to give him a brief and pointless history lesson.

"Oh, and son?" Soderini paused on the stairs, but did not look back up. "Do me a favor and don't tell Giuseppe Vitelli we spoke. He gets offended whenever I try to . . ." Soderini paused, as if rolling around a few choice words in his mouth before settling on the right ones, ". . . offer my opinions on cathedral projects." With that, he left the bell tower without another word.

Michelangelo stared down the empty staircase. What was Soderini talking about? He hadn't offered any opinions on anything. The bells had nothing to do with him or his statue. However, as he looked out over the city, Michelangelo had an unsettling feeling that the pressure on his David had just intensified.

✹

1503

✹

1503

Leonardo
Winter. Rome

O*remus."* Pope Alexander VI called across the Sistine Chapel, and Leonardo dutifully bowed his head. The corpulent pope's voice sounded the way he looked, round and majestic. *"Praeceptis salutaribus moniti, et divina institutione formati, audemus dicere . . ."*

The small congregation responded in unison. *"Pater noster, qui es in caelis, sanctificetur nomen tuum."*

As the Lord's Prayer echoed through the chapel, Leonardo watched Cesare Borgia, draped in a black cape and kneeling humbly at the pope's feet. Borgia looked so earnest that he could almost imagine the young duke as his former self, the God-fearing Cardinal of Valencia, dressed in red robes, swishing through the halls of the Vatican. After renouncing his cardinal's hat, Cesare had donned a soldier's uniform instead. From what Leonardo had seen of the young man's insatiable passion for blood on the battlefield, Il Valentino was much better suited to war than religion.

"Amen." The pontiff, wearing a crimson velvet cape and a golden skullcap topping his head like a halo, broke the bread.

This was a special Mass, delivered by the pope to a few cardinals, friends, and family members to celebrate his son's safe return home from Romagna. The congregation stood through the service, except Cesare, who knelt at the pope's feet, publicly

begging for forgiveness for his wartime sins. The prostrate position had the extra benefit of placing even more attention on the victorious duke.

A week earlier, Cesare and his army had marched triumphantly back into Rome. Leonardo had visited the Eternal City once before, a brief trip to study the ruins of Emperor Hadrian's villa at Tivoli, but as a special guest of the duke, he saw the capital from a new perspective. Staying in the lavish private chambers of the pope, overlooking St. Peter's deteriorating basilica, Leonardo sat on his balcony and sketched peasants, farmers, and merchants streaming into the Vatican to ask forgiveness for their sins. He wanted to call down and tell them not to worry; their transgressions were surely nothing in comparison to the sins of those who had been to war.

"*Pax Domini sit semper vobiscum,*" Pope Alexander intoned.

"*Et cum spiritu tuo,*" Leonardo responded with the congregation.

Mumbling inaudibly, the pope dropped a small piece of the Host into the Holy Chalice, and then chanted the *Agnus Dei* three times.

This was the first time Leonardo had been inside the Sistine Chapel. The barrel-vaulted room was three stories tall and nearly three times as long as it was wide—the same dimensions as the Old Temple of Solomon in Jerusalem. The ceiling was painted blue with gold stars emulating the heavens. Leonardo knew no one would ever look up at that ceiling, because who would ever be able to tear their eyes away from the jewels that adorned the walls?

In 1481, Pope Sixtus IV had announced a plan to hire the peninsula's best, most innovative artists to decorate his new chapel. He asked Lorenzo the Magnificent to help choose the painters. Lorenzo had called on Florentine artists Sandro Botticelli, Domenico Ghirlandaio, and Cosimo Rosselli, along with the Perugian painter Pietro Perugino. Leonardo, living and working in Florence, was the

same age as many of the participants, nearly as experienced and, by his own measure, much more talented. He waited for his invitation, but it never came. After a few months of silence, as he agonized about his fellow artists creating masterpieces without him, he'd packed up his belongings and moved to Milan.

Twenty years later, he was finally in the presence of those frescoes, which adorned each side of the chapel. To the right of the altar, on the north wall, were scenes from the life of Christ. To the left, down the south wall, the life of Moses. Each picture trumpeted its own voice, and yet the cycle worked in harmony to create a single artistic vision, like the different ceremonial elements that came together during Holy Communion. Cosimo Rosselli's frescoes were like the pomp and circumstance of any Mass. Embellished with gold leaf, his pictures burst with color and ornate detail. Like the pope's fine robes and golden chalices, Rosselli's pictures kept the eye entertained. Domenico Ghirlandaio, on the other hand, was like the homily, weighty and grounded. He didn't paint thin, airy figures, but actual people. If Rosselli was the light, Ghirlandaio was the heft. Then there was Botticelli. His figures and their swirling clothes moved along the foreground like a well-choreographed song. His beautiful, undulating lines created a soothing flow and energy unmatched by any artist. The Botticellis were the music.

As Leonardo lined up to receive communion, he scanned the northern wall until his eyes came to rest on the most important fresco in the chapel. In this mass of paintings, it was the body and the blood.

Pietro Perugino's masterpiece depicted Christ handing the keys of heaven and earth to a kneeling St. Peter. The two protagonists stood in the center of the foreground surrounded by an elegant flood of contemporary Italians and apostles. Behind them, in the middle ground, two other scenes from Christ's life, the stoning of Jesus and the "render unto Caesar the things that

are Caesar's" speech, played out in an explosion of colorful figures. In the background were two triumphal arches flanking an octagonal domed church, and even further behind stretched a landscape of bluish Tuscan hills rolling into infinity. More than the graceful figures and classical architecture, the painting was hailed for its inventive use of space. Etched on the ground of the piazza were large squares receding backward along bold perspective lines. This was the firm foundation for the middle of the piazza, which was empty, an explosion of openness encouraging the eye to dart from corner to corner, building to building, figure to figure. The piazza seemed to expand beyond the picture frame, the architecture, the surrounding frescoes, and even beyond the Sistine Chapel itself.

As Leonardo's eyes danced across Perugino's picture, he realized that a bit of him had made it into the chapel after all. A few weeks before Perugino had left for Rome to paint this fresco, he'd stopped in Florence to visit Lorenzo de' Medici, and while in town paid a visit to Leonardo's studio. There, Leonardo had shown Perugino a pen-and-ink design for his *Adoration of the Magi* altarpiece. Leonardo's sketch was an energetic eruption of human figures, animals, staircases, columns, perspective lines, and blank space. That same sense of controlled chaos, intended to emulate the experience of human life, was captured in Perugino's Sistine fresco. Leonardo had clearly influenced Perugino, but he couldn't stop thinking that his *Adoration of the Magi* would have been more beautiful. If he had ever completed it, that is.

As Leonardo reached the front of the line and dropped to his knees at the pope's feet, he thought about his rivals, Botticelli, Ghirlandaio, Rosselli, and Perugino, locked in this chapel together, pushing each other to great heights while Leonardo had been alone up in Milan. If he had joined them in Rome, what masterpiece of his might now grace these walls?

Pope Alexander placed a piece of the Host on Leonardo's tongue. *"Corpus Domini nostri Jesu Christi custodiat animam tuam in vitam aeternam."*

As the consecrated Body dissolved, Leonardo compared his own actions to Machiavelli's description of Cesare Borgia. If Machiavelli analyzed Leonardo, the diplomat would say the artist had made a critical error. When his enemies came down to Rome, Leonardo had left them alone in unguarded territory to grow their own empire. From the looks of the chapel, they had prevailed.

After Mass, Leonardo ducked out of the celebratory feast without explanation and traveled through the bowels of the Vatican to a small, private door usually reserved for the pope's personal entrance. He slipped through it and into St. Peter's Basilica.

As he scanned each chapel, he wondered whether he would know it when he saw it. He'd never seen a picture or sketch. He had only heard rumors, and those descriptions had never been precise.

However, when he looked into that tiny, shadowy chapel filled with pilgrims kneeling in prayer, there was no doubt this was what he had come to see.

The statue was heavenly, yet grounded. Quiet yet loud. The undulating lines, soft skin, and pyramidal composition were as beautiful as any he had ever seen, and the rare combination of serene surrender and anguished grief would bring the most stoic viewer to tears. Even he felt a knot rise up his chest. He stepped past the pilgrims, approached the statue, and ran his fingers along the marble. The hood around the Virgin's face was as thin as paper, while the folds in her gown were solid and thick. Christ's skin rippled over his muscles and bones, gentle as a small fish breaking the surface of a calm lake. However, it was the play of light that affected Leonardo most. This marble was luminescent, bulging out to catch a glimmer of sun and then diving into deep crevices,

collecting in pools of shadows darker than the most mysterious cave. The sculptor had captured light and dark. Day and night. The marble was alive with light, a kind of play Leonardo could never hope to accomplish in paint.

This was not luck, produced by a fledgling stonecutter. This statue was carved by the deft hand of an emerging genius. Michelangelo's *Pietà* was a masterpiece.

After leaving St. Peter's, Leonardo went immediately to Cesare Borgia's private chambers and resigned his position as chief military engineer. "Go, Master from Vinci," Borgia dismissed him without looking up, his face hidden behind a black mask. "Go and do not look back."

That same evening, he packed up his things and headed north on the Via Aurelia toward Florence. Leonardo wouldn't make the same mistake twice. He would not allow his competition to work unrivaled; he would face down his opponent, and this time he would win.

Michelangelo
Spring. Florence

Michelangelo struck his chisel again, and the breastbone cracked. Two more blows and the sternum broke in two. He dropped his tools and then wedged his hands into the crevice and pried open the rib cage to reveal the lungs and heart.

Wearing a piece of cloth over his nose and mouth, he looked inside the chest. Over the last few weeks, he had been carving the delicate veins running down David's arms and hands. He had studied veins on live models, but in order to properly understand them, he needed to find their source. He needed to get to the heart.

When he first started dissecting again, he hoped he would only have to endure the practice a few times. It was gruesome work. The putrid stench, always with a hint of a sickeningly sweet aroma, made him retch up his dinner. The smell burrowed into his clothes, hair, and skin; long after he retired to his pallet on the floor of his shed, he woke with cold sweats. Yet he kept returning to the mortuary, searching for more answers. How many tendons were in the abdomen? How many bones in the hands? How exactly did a toenail attach to the soft, supple skin of the toe?

And now, those veins.

Michelangelo reached into the dead man's chest, and his fingers brushed against a thick vessel connected to the heart. He had found the mouth of the river. His own heartbeat quickened. He

grabbed a candle and leaned over the corpse. The mortuary was dark, lit only by a few candles and torches hanging on the walls. Heavy shadows spilled into the room, threatening to obscure his vision, but he refused to be blinded by the night. He pulled the candle closer. This was what he had come for.

A plunk echoed from across the room.

His head jerked up. The sound had come from a corner veiled in shadows. He sensed something there. Someone was in the mortuary with him.

"Hello?" he said.

Silence.

With shaking hands, he lit another candle, but it only shed more light on the oozing insides of the corpse. Beyond where the light reached, anything could be hiding in those pools of blackness. "Is someone there?" he whispered, his pulse thundering. He had always feared that spirits might haunt him for defiling the dead. Perhaps their ghoulish arms were finally reaching up to drag him into hell.

The darkness rustled.

Michelangelo threw his candle in the direction of the sound. It hit the wall, landed on the dank floor, and extinguished. The shadows grew even darker.

He lunged toward the door.

"Going somewhere?" a voice asked.

Michelangelo scanned the darkness for a figure. He saw no one. "What do you want?"

A soft chuckle danced out of the dark. The spirit was mocking him. A foot slid out from the shadows. The limb did not look ethereal, but corporeal. It was followed by a hand. A bejeweled bird ring glistened in the orange glow of the torches.

Even in the dim light, Michelangelo could see he had aged substantially over the past year. His hair was whiter, his face and hands more deeply lined, and the skin around his jaw sagged. "I can't believe that war didn't kill you," Michelangelo said.

"Sorry to disappoint." Leonardo approached the corpse and looked into the open chest.

Michelangelo pulled a cloth over the body. Leonardo couldn't just sneak in and steal the benefits of his research. "How did you get in here?"

"I used to dissect inside these very walls before you—or Father Bichiellini—could grasp a piece of chalk. I know how to get in and out." Leonardo picked up Michelangelo's chisel and studied the point.

"Get out." He snatched his chisel back.

"Over the last two years, you have taught me something, Buonarroti. I have been impressed with your urgency of doing. You don't think. You do, do, do. I always thought knowing was enough, but it is not. Iron rusts from disuse, water loses its purity from stagnation, and inaction saps the vigor of the mind." His eyes slid over every part of Michelangelo's body from foot to head. He took his time. "Take off your mask."

"No." He packed his tools into his leather satchel.

"What are you hiding?"

Michelangelo yanked the piece of cloth off his face. The stench was suddenly a flood, rising up to drown him. His hand flew up to cover his nose and mouth.

"After war, I find that this serene version of death smells almost pleasant," Leonardo said, using his hand to waft more air into his nostrils. "Ah, the sweet smell of science."

Michelangelo grabbed his tools and crossed toward the door.

"I have seen your statue," Leonardo said quietly.

Michelangelo stopped. "What did you do?"

"I studied it. Touched it." He said the last two words as though he had touched another man's wife.

"What did you do to *David*?" Michelangelo pulled his hammer out of his bag and turned to face Leonardo.

"David?" he said, his voice ringing with laughter. "David isn't yet a statue yet, boy. David is a lump of marble waiting to become

a statue. No. I saw your *Pietà*." The look the old man gave him could only be described as a challenge.

Michelangelo cocked his hammer over his shoulder.

Leonardo moved to the other side of the table, using the corpse as a buffer. "I have always been strong and fast, but scrambling for my life on the battlefield has made me more so."

Michelangelo stalked him around the corpse.

"I'm surprised you come into the mortuary by yourself," Leonardo said, circling to the other side of the table. "All alone, with the bodies. If you aren't careful, you might wake the spirits." With one swift movement, Leonardo slid out of the room and pulled the wooden door closed behind him.

Michelangelo lunged after him, but the lock clicked closed. Michelangelo called out and pulled on the door handle, but it was no use. "*Bastardo*." Leonardo had locked him inside the mortuary. He banged on the wood, but quickly stopped. He didn't want to wake the priests.

He turned back to face the corpses. The room was quiet except for a single drop of water dripping into an unseen puddle. One of his torches had already burned out; the others were probably not far behind. Suddenly, the stench overpowered his senses, and he gagged. He felt like the walls were closing in. He heard spirits rustling within them.

He searched the room for an alternate exit even though he knew there was only the one door. When he didn't find one, he seethed. Leonardo was probably standing on the other side of the door, laughing.

Michelangelo turned his attention to the room's only window, a tiny opening high on the wall. He stretched up, but it was too tall. He jumped, but his fingers still didn't touch the bottom of the sill. He looked around for something to climb on top of. The corpses lay on stone slabs attached to the floor with thick bolts, and there was no other furniture. Crawling through the window would not work.

He tried not to think about the mutilated body lying on the table, or the dead man's spirit flying around the room, or what would happen if a priest other than Father Bichiellini woke and found him in the mortuary with the dissected corpse. An intolerant man might call the authorities and have him arrested. They might arrest Father Bichiellini, too.

If he escaped the mortuary without getting caught, Michelangelo swore he would never let Leonardo get the best of him ever again. He wished the war *had* killed that old man. As soon as the thought crossed his mind, cold closed in around his chest and circled his neck. Wishing someone dead apparently angered the ghosts.

He picked up his tools and dropped to his knees next to the wall. He felt around the edge until he found a loose stone that probably wasn't supporting much of the church's weight. It was large. If he removed it, his whole body would fit through the opening. He snatched up his hammer and, picturing Leonardo's face, pounded furiously.

After a few swift blows, the rock was free. Michelangelo pulled out the stone, and mud poured into the mortuary. The hole was right at ground level, but it had rained a lot over the last few weeks, so the earth was soft. He reached his arm through the hole until his hand hit fresh air on the other side. It wasn't far. The mud felt cold and slimy, and it carried the stink of decay, but if he could hold his breath and wriggle out, in less than an arm's length, he would be free.

Closing his eyes, Michelangelo ducked his head into the hole. The thick sludge filled his nostrils and ears and oozed down his neck. He coughed and yanked his head back out. Gasping for air, he wiped the mud off his face and spit out a mouthful.

Dusky gray light was already beginning to filter in through the upper window. Dawn would break soon, waking the priests. Regardless of the mud, it was time to go.

He took a few long breaths; then, holding his nose, he dove

back into the mud, cursing Leonardo the whole way. The mud poured down his tunic, but he forged onward, rotating his shoulders to fit through the opening and pushing off the floor of the mortuary with his knees and feet. His feet scrambled against the slick floor. With his heart thundering and his lungs burning for air, he pushed out from under the wall. His head surfaced. He coughed up mud, and then gulped in fresh air. Still half-buried, he lay down and took several long breaths as the sun rose overhead.

Finally, he wriggled his hips out of the hole and pulled his whole body to the surface. As he did, something hard jabbed into his thigh. He reached down into the mud and pulled out a human arm bone. He had dug his hole right through someone's grave. Yet another spirit he had angered in his quest for greatness.

Leonardo

But then I accidentally kicked that damned broom over and . . ." Leonardo said, laughing so hard he had to sit up to breathe. "He was so frightened I had no choice but to reveal myself."

Salaì pulled Leonardo back into bed. "Don't lie to me. You planned all along to lock him in there."

"Honestly, I was only going to spy on him, find a weakness or a strength to exploit. But when I had the chance . . ." He waved his hand as if flinging a door closed.

Salaì laughed.

"I have learned the value of fear," Leonardo said. "With it on your side, you can destroy your enemies even before the first shot is fired."

Salaì's expression turned serious. "You were gone a long time."

What kind of hardships had Salaì endured while he was away? He had found his assistant still living in a small room in the friar's quarters of Santissima Annunziata, receiving room and board in exchange for helping to maintain the sanctuary's art and polish the silver. It had been over a year since Leonardo had seen him. He appeared thinner and his clothes were tattered, but he still had those same fine features and expectant brown eyes.

"For the last year, I have been a sailor frantic in a storm," Leonardo said, "clambering about the ship, trying to steer the sail,

tossed around like hail before the fury of a hurricane. But then, luckily, I grew a pair of wings and flew away. Now I am back. Safe and alive." He touched Salaì's smooth chin. "I do think it was good, though, to surprise Michelangelo with my return, instead of him hearing about it naturally. Choosing the time and place gave me an advantage. Niccolo would be proud."

"Who's Niccolo?" Salaì asked testily.

"Machiavelli."

Salaì raised an eyebrow.

"He was Florence's envoy to Borgia." Leonardo waved his hand dismissively. "And I'm glad I chose to walk around last night instead of immediately alerting the city to my return." Arriving at the gates of Florence as darkness fell, he'd pulled his hood down over his eyes and wandered the streets—until he saw that candle burning in Santo Spirito's mortuary. "It gave me a chance to re-familiarize myself with my territory before anyone started whispering behind my back about my traitorous turn. Do people talk much?"

Salaì shook his head and looked away, all the proof Leonardo needed that Machiavelli had been telling the truth. Florentines no longer talked about him. They talked about someone else.

"So what do we do next?" Salaì asked. "I'm bored with the friars."

"I need a commission."

"You could always sell your ring," Salaì suggested, twirling the bird ring around Leonardo's finger. "The payment could support us until you find proper employment."

"Never," Leonardo said, rolling out of bed. "Besides, we need more than money." He still had a few papal ducats remaining from his Borgia salary, although they wouldn't last long. "I need to rebuild my reputation, and to do that, I need a patron." Leonardo located a box of his notebooks stacked in a corner and began rummaging through it. "Where are my letters?"

"Come back to bed. We can go through your papers later."

Leonardo heard rustling and a half-suppressed giggle. Salaì had probably just put a lizard in the bed to surprise him. When he was younger, he had always thought that was funny.

Ah ha! "My letters." He flipped through the stack until he found the right one. "The silk merchant's wife."

"Who?"

"The woman in the market. Madonna Lisa Giocondo. You remember her." He pictured her olive skin and tumbling hair. "Her husband wrote to me the day before I left."

"A portrait of a silk merchant's wife? That will hardly bring in enough money to support us for a month. Two at the most."

Leonardo glanced over. Sure enough, a lizard was scurrying up his assistant's arm. Regardless of how many trials Salaì survived, he would always be a boy at heart.

"You doubt my abilities, my apprentice. I can get at least six months out of that striving merchant. Besides, within a few weeks, I'll have charmed Florence once again and offers will rain down in a flood. Then, I'll pick a project to solidify my legacy and show the world who is the true master of Florence." When Leonardo was finished, no one would ever remember that young sculptor's name. "But for now, Mona Lisa will have to do."

"You don't still work for Cesare Borgia, do you?" Francesco del Giocondo asked in a hushed tone. The silk merchant glanced nervously at a noblewoman browsing the selection of chiffon, taffeta, and velvet displayed at his marketplace stall.

Leonardo cocked a disdainful eyebrow. "Of course not. I am back in Florence. For good. Now, if you do not want a picture by my hand"—he made a point of sounding as though he would be relieved if Giocondo recanted his offer—"I would be more than happy to release you and take my services elsewhere . . ."

"Oh, you don't have to do that," Giocondo said in a disinterested tone. "I suppose we could use a new portrait. We have recently moved into a new home on the"—he raised the volume

of his voice—"Via della Stufa." He smiled at the competing silk merchant stationed next to him. "And my wife has just given birth to another son."

"The ideal time for a new portrait," Leonardo said.

Giocondo completed a quick transaction with a servant of the wealthy Strozzi household, then turned back to him. "I would like to offer you a fair price for your skills, Master Leonardo, so I was thinking . . ."

"One hundred florins," Leonardo said.

"A hundred florins?" Giocondo blustered like any good merchant ready to haggle with a demanding customer.

"Oh, I apologize, signore," he said, backing away from the stall, "I thought you were in the market for a masterpiece . . ."

The noblewoman stopped browsing to watch, as the neighboring vendor smirked and leaned in to listen.

Giocondo flushed. "What I meant was . . . was that price, is that just for the—the one, single portrait?"

"I also accept papal ducats, if that's helpful."

"I am being rude," said Giocondo, packing up his receipts and moneybag. "Please, allow me to invite you to my home, where we can share a proper meal and some wine. I can show you my button collection. I bet you thought only fabric came over the Silk Road, but you haven't seen anything until you have seen a button from the East. After all of that, we can discuss this most important commission in private."

"I would rather settle the price first, signore. Here."

By now, dozens of shoppers and vendors had paused to watch the negotiation.

"Well, all right, let's see . . ." His eyes darted back and forth. "For comparison's sake . . . for example, for her previous portrait, I believe I paid ten . . ."

"And for that previous portrait, what was the name of the painter?"

"Well, that hardly matters," the merchant muttered.

"Signor Giocondo, you're clearly a silk aficionado with the finest aesthetic eye in all of Florence"—Leonardo directed the noblewoman's attention to a particularly beautiful brocade—"dare I say it? The best eye on the entire peninsula. Now, surely you can afford a proper portrait of your wife."

"When I was young, before I started my apprenticeship, I used to make my mother walk me through these neighborhoods," Leonardo said, looking out a window and down onto the Via della Stufa. It was the most stylish street in Florence: old homes occupied by new money. "People always stared. We were poor, obviously from the country, and my mother was . . . well, I didn't care what they thought. I dreamed of living on a street like this."

"I still do," Salaì said, standing at the doorway, watching for Lisa's approach.

They were in Giocondo's music room, preparing for the lady's first sitting. The room was large and ostentatious, with crimson velvet covering the walls, a silver embossed ceiling, and a garish mosaic tile floor depicting Euterpe, the Greek muse of music, playing in a band of satyrs. Despite its grand size, the room housed only one musical instrument, an ornate gold-plated harpsichord with the Virgin Mary, surrounded by dozens of flying angels, painted on the lid. Giocondo must have thought it an attractive piece, but the figures in the painting were stiff and improperly proportioned.

A team of assistants, hired for the day, was setting up the room. They arranged bouquets of brushes and jars of paints, tuned musical instruments, and practiced juggling. Leonardo knew such a display would impress Giocondo. Merchants, especially men dealing in indulgent commodities like silk, liked a little pageantry. It made them feel as if their money were helping them to actually become royalty, instead of just pretending to be.

The silk merchant had placed an ugly high-backed chair in front of the room's ostentatious stone fireplace and put a few trinkets on

the seat: a blue and gold tassel, the colors of her father's family coat of arms; a bolt of green silk to represent her husband's profession; and a heavy gold music box. Behind the chair, he'd hung a picture of himself. In portraits, wives often gazed at pictures of their husbands, as though they could think of nothing else.

Leonardo shrugged at the merchant's arrangements. At this stage, it was best not to argue with the patron. Later, he could alter the backdrop to anything he preferred. That was the beauty of paint. Reality was what he made it.

"She's coming," Salaì whispered as footsteps approached from down the hall. The assistants hurried through a last-minute scramble while Leonardo leaned confidently against a window. He knew the backlighting would give him a heavenly glow. As the footsteps came closer, his left eye twitched. Usually, he didn't surrender to such base emotions, but the lady had saved his hand, cared for him when he was injured, and haunted his dreams during war. Of course he was nervous to see her again.

Madonna Lisa del Giocondo entered wearing her hair in a tight bun on the top of her head and a long, gaudy red silk gown. Leonardo assumed her husband had chosen the garment; it reeked of the same bad taste that dominated the room. She looked older, as though the year since he'd seen her had stretched into five. Her face was still unlined, but her eyes were deeper, worldlier; her breasts and hips were fuller from the newest child; and her eyebrows were now plucked bare in the latest Italian fashion. That bald brow gave her face a fluidity and announced to the world that she was no longer an innocent maiden, but a sophisticated lady well versed on the latest styles from Europe's most fashionable courts. Before, her lips had always attracted him; now it was her eyes that drew him in.

"Play!" Leonardo commanded. His musician assistants struck up a lively tune, while five others began a juggling act. "Mona Lisa." He removed his gold-threaded cap and offered a low bow. "Master Leonardo from Vinci, at your service."

His angel marched silently across the room and sat in a hard wooden chair overlooking the balcony. She crossed her arms defiantly.

Giocondo flashed an embarrassed smile and then hurried over to his wife. His voice was hushed, but when she didn't respond, his whispers grew more insistent. Giocondo was about five years younger than Leonardo, but in that moment, he looked like a doddering old man arguing with his stubborn daughter. He finally walked back over to Leonardo. "I fear the lady is not feeling well. This portrait was not a good idea . . ."

Leonardo stared at the back of Lisa's head. Why was she refusing to speak—or even look at—him? Had he, indeed, dreamed his previous encounters with her? Or was she pretending to be upset for fear of showing her true affections for him in front of her husband? Maybe her cold demeanor didn't indicate her indifference, but instead meant her feelings ran even deeper than Leonardo had dared hope. "Signore, perhaps I can calm her, if you would allow me the most improper liberty of spending a moment or two alone with the lady . . ."

"Signore!" It was undeniably improper for a wife to be alone with any man other than her husband, particularly an artist, who spent hours luxuriating in beauty. Anyone drawn to such vanity must, by definition, be dangerous.

"The lady is nervous, that is all," Leonardo said.

Giocondo hesitated, fiddling with one of the gold and pearl buttons adorning his doublet.

"Once, I saw a monkey find a nest full of birds." He put an arm around the merchant and walked with him toward the door. "The monkey was so delighted by the birds that it took one home. The monkey loved the little bird so much that it began to kiss it and hug it, until it squeezed that little bird to death." He let his tone take on a dark timbre. "Do not suffocate your wife, my good man. Ladies, when the men they love are watching on, can become nervous. I see it often. Their faces, right here"—he pointed to

his own cheeks, right around the lips—"get very tight. It will not make for a pretty portrait, signore, I assure you. But if you give me just a few minutes alone with her . . ."

"Of course." Giocondo gave a little nod. "She is simply nervous. Come." He ushered the household staff out of the room, and Leonardo waved his assistants, including Salaì, out with them. Giocondo took one last look into the music room and then swept the double doors closed behind him.

A crystallized silence descended over the salon. Leonardo watched the lady from across the room, waiting for her to speak, but she did not.

He crossed toward her, his wooden platform shoes clacking on the mosaic tile floor, but still, she did not look at him. He stopped behind her and breathed in. She smelled of primrose and apples. "Madonna? We are alone."

He expected her to stand, turn toward him and . . . But she did not move. "What is like a thing hidden beneath the winter snow, but when summer comes stands revealed?" He spoke the words in the rhythm of a love poem. Still, she did not respond.

"A secret that cannot be hidden," he said, answering his own riddle. He moved around to the side of her chair to look at her profile, but she turned her head away. He knelt down beside her. He didn't dare take her hand, so he rested his fingers on the arm of her chair instead. "You must tell me your secret, my lady," he whispered. "Or rather, how you discovered mine. How do you know about my attempts to fly?" That question, as much as anything, haunted him. She was a domestic woman, a wife, a mother. How did she know such dreams even existed? "Tell me, *dimmi, dimmi, dimmi.*"

"Bodies without souls that teach us how to live and die well," she said, her gaze held on the window.

She speaks! And with a riddle of her own. The lady was real, indeed. "The answer is books," he said with a slight incline of his

head. He had heard Cicero's riddle before, but that didn't make her delivery of it any less charming.

"Very good." She looked at him for the first time. Her eyes were not teasing. They were angry. "And if you read the humanists, you know that man is part divine, that he holds an eternal wisdom that will eventually lead him toward good, not evil." She stood. "I thought you had wisdom, man from Vinci, but now I see that you do not." She marched toward the door. "I have sons. Three of them. But you give Cesare Borgia your plans, your ideas, your hands, your time, and you help him bring his wrath down here, in Florence, my home, at the doorstep of my sons and daughters." She paused and looked back at him. He fancied he saw more sadness than repulsion in her stance.

He opened his mouth to defend himself and to assure her that he would protect her and her children, but he couldn't find the words.

"You were my hero. I thought you were perfect," she said.

"I am not."

She put her hand on the doorknob.

"Madonna, please." He stood up and crossed to her. "Your husband has already paid me for my work. How am I supposed to make a picture if you won't let me study you?"

"From memory? It doesn't matter," she added, before he could respond. "Even if you do paint my portrait, no one will see me, even though it is a picture of me. They will see only you and your renowned genius. They will see your brushstrokes. Your colors. People will see a great masterpiece by the great Leonardo da Vinci, but their eyes will pass over me like a ghost. And my husband"—her shoulder half turned—"well, he will imagine the portrait however he wants regardless of reality. I should know. That's how he looks at me." She opened the door.

Her husband stood in the hallway.

Leonardo, not wanting to alarm his patron, bowed to the lady.

"Thank you for your time, Mona Lisa. You have given me more than enough to begin my work."

"You once told me," Leonardo said from the doorway of Machiavelli's office, "that you would always owe me because you drove me out of Florence and into the arms of that monster, Borgia. Was that, at least, true?"

Machiavelli nodded. He was once again dressed in the fine clothes of a gentleman, instead of the stolen, tattered jacket of a dead soldier. "I meant it."

"Then I'm here to collect. It is time for me to defend my homeland."

Michelangelo
August. Florence

Michelangelo understood the risk he was taking when he knocked his chisel into the soft curve of David's bicep. If he hit the chisel a bit too hard or struck a fraction off center, he might break off part of the arm, and he could not simply paint over his mistakes. The thought of adding an extra piece of marble to correct the error never occurred to him. A single colossus was the ideal for every sculptor and, for him, the only way. Once a piece of stone was gone, it was gone for good. Because of this risk, other sculptors ditched their hammers and chisels at this stage of the process and used more precise instruments, like files or rasps, to carve the finer details, carefully shaving off the stone, layer by delicate layer.

For him, the risk of not using a chisel was greater than the risk of using it. Shaving off marble using a file was safe, but the process flattened out every curve. As long as Michelangelo struck true, a chisel allowed him to cut deeper, carve more dramatic angles, and create abrupt changes in lines. David's elbows could fold dramatically. His muscles could cave into dark shadows and then push out toward the light. Michelangelo had used his hammer and chisel right up until the end of his *Pietà* to create dramatic lighting effects and a sense of movement. In that statue, the stunning visual effects came from the undulating layers of the Virgin's gown. Here, they would arise from David's rippling muscles.

Michelangelo rhythmically drove his hammer into the marble until he could swing no more. Arm exhausted from the repetitive motion, he switched to his *arco*. He climbed to the top of the wooden scaffolding and placed a tapered metal rod against David's head. Much like using a stick and bow to start a fire, when he moved the bow back and forth, the rod spun and the drill bored into the marble, creating precise holes that would form the foundation of David's thick curls of hair. As he carved, hour after hour, Michelangelo's body became one with the stone, and he began to sing his own psalm. "David with his sling, and I with my bow, Michelangelo."

"Michel!"

Michelangelo froze. Who said that? Was it David? "Talk to me," the sculptor whispered to the marble. "Tell me what you need."

A thumping sound.

He put his ear to David's chest. "Is that your heartbeat?" The thumping grew until it shook the walls of the shed, but it was too loud to be a heartbeat. It sounded almost like footsteps. Was it Goliath marching toward them to begin the battle? Michelangelo's hands turned cold. It was too soon. David wasn't ready to fight. The footsteps grew louder, as if they would stomp right over the shed and crush them both.

"Open up. Michelangelo!"

He spun toward the door.

"I'm not leaving until you let me in."

Buonarroto.

Hopping down from his scaffolding, Michelangelo tried to shake off his confusion. Had he actually feared his brother's knocks were Goliath's footsteps? Perhaps Granacci was right. Perhaps he was working too hard.

He brushed marble dust out of his scruffy beard and opened the door. White sunlight blinded him. His eyes watered. When was the last time he had gone outside during daylight? He couldn't remember.

"What took you so long? I've been banging on the door for a quarter hour," Buonarroto complained.

"I didn't hear you." Michelangelo rubbed his eyes. "Sometimes I'm working so hard, I don't hear anything."

"Well, it's time to go. The city is calling every Florentine to the piazza immediately."

"I don't hear the bells." He thought back to his conversation with Piero Soderini. If the gonfaloniere wanted the bells to ring, why not ring them?

"Forget the bells. It's an emergency."

Michelangelo looked past Buonarroto. Sure enough, cathedral workers were dropping their tools and scurrying into the streets, where a flood of Florentines were hurrying toward the square in what could only be described as mounting panic.

"*Andiamo*," Michelangelo said, locking the shed behind him. "Let's see what all this commotion is about."

"The pope is dead!" the jowly archbishop cried from the cathedral steps. A gasp surged across the crowd and then crashed into an anguished sob. Voices repeated the news all the way to the back of crowd, an echo rising up from hell. "The pope is dead, the pope is dead, the pope is dead." The crowd waved their arms and wailed in grief.

Michelangelo dropped his head into his hands. He'd lived his entire adulthood under Pope Alexander VI's reign. While living in Rome, Michelangelo had personally witnessed the corruption and violence spread by the Borgia pope. But Alexander was still man's connection to God, and he was gone.

"Where is our family?" Michelangelo whispered.

"Together." Buonarroto shrugged without looking into his brother's eyes.

Michelangelo nodded. He understood without being told. Not even a dead pope could convince his father to forgive him.

"Now that the daylight dies away," a girl's voice rang out,

singing a wailing dirge. Her song rang miraculously over the thousand wails. "By all Thy grace and love, Thee Maker of the world, we pray to watch our bed above."

"Maria," Buonarroto whispered.

"What?" Michelangelo asked. Was his brother pleading with the Virgin Mary to protect him during this time of chaos?

"Let dreams depart and phantoms fly, the offspring of the night." The song continued, clear and melodious, as if coming from the angels guarding the gates of heaven.

"That is my Maria's voice," Buonarroto said. "I would know it anywhere."

Michelangelo craned his neck. Finally, he spotted her. A beautiful girl, mouth open wide, projecting her mournful tune across the piazza. Her hands were raised toward heaven, and sure enough, they were dyed red, as Buonarroto had said. "The color of her silk, the color of my love," his brother had sighed. The singing woman was the girl his little brother wanted to marry.

As a tear dropped off Buonarroto's cheek, Michelangelo slung his arm around his shoulders. With Italy turned upside down, fathers would be even less likely to marry off their daughters to penniless sons of former gentlemen. "What does this mean for Cesare Borgia and his army?" Buonarroto asked, his face pale with fear. "Are we saved?"

Michelangelo didn't have an answer. In his lifetime, there had only been three popes: the great art patron and builder of the Sistine Chapel, Sixtus IV; the zealous persecutor of witchcraft, Innocent VIII; and the corrupt Borgia, Alexander VI. But every time a pope died, another one had to be elected, and Michelangelo had heard the stories of cardinals bribed, blackmailed, and poisoned for their votes. Politicians and common people always talked more of Armageddon and war, as old families jockeyed for control and the dead pope's confederates made one final grasp at the threads of power.

Cesare Borgia might become even more volatile. He had not only lost his power, he had also been stripped of his duty to obey his father. Now, his own conscience would be his only governor.

May God help Florence, Michelangelo prayed, because the future of Italy—of every person in that piazza—was, in that moment, wholly uncertain.

Leonardo
ꓷutumn. ꓭlorence

T
ell me, *dimmi, dimmi, dimmi*," Leonardo murmured, sitting in a shadowy corner of Santissima Annunziata's sanctuary.

He was watching Lisa, kneeling alone in a small side chapel. Fingering a rosary, her face half-bathed in light, half-shrouded in shadow, she was the perfect picture of a faithful Catholic wife. He could not have painted her better.

Leonardo wished he didn't have to spy on her, but since she refused to sit for him, he had no other choice. He needed to see her. For the portrait, of course. Sometimes he hid in the market to watch her visit her husband's stall, or sat across the street from her house to catch a glimpse of her through a window, but his favorite place to watch her was here, in her church, praying in her family's chapel.

A man slipped into a chair next to him. Leonardo looked over to see Machiavelli staring at him with a sly smile. "I was surprised when your assistant told me I could find you here." The diplomat leaned over to whisper in his ear. "Are you angling to get your old altarpiece back?"

"I wouldn't move back into these old walls even if the friars begged. No." His eyes lingered on Lisa's folded hands. "I'm trying to get closer to heaven."

They both settled into silence for several moments. From a distance, he thought, they must look like two devout men engaging in their afternoon prayers.

"I have done what you've asked me to do," Machiavelli finally said in *sotto voce*.

"And you swear this time I'm not a pig being fattened up by a farmer who intends to have me for his dinner?"

Machiavelli looked offended. "You come to me, ask for my help, and yet you still doubt me?"

Leonardo raised a questioning eyebrow.

"I swear on the Holy Bible."

Leonardo was silent.

"On my wife? . . . All right, I swear on the Republic. May it fall to the Medici if I'm lying."

"Then why"—Leonardo leaned forward in his chair—"aren't I talking to the Signoria now? Why this strange meeting in the shadows of a church?"

"Because I wanted you to hear the news from me. Directly. No games. No surprises. I came to find you before the rumors reached you. And I know that in your studio gossip runs rampant like rats in summer."

Leonardo looked down at the ground. He wanted to believe Machiavelli, but the earlier betrayal lingered. He wouldn't be taken for a fool again. This time, he would make the diplomat speak first.

"The pope's death has thrown the Signoria into chaos," Machiavelli said. "It is a natural transfer of power, and yet the people, the government, Soderini, they are panicking. Don't repeat this, but Cesare Borgia still commands the papal army, and he is refusing to allow the conclave to meet until the cardinals promise to elect a Borgia ally. Soderini fears that if the next pope backs Cesare, Florence will fall."

Leonardo nodded. "A lioness, when defending her young

against hunters, keeps her eyes on the ground, so she's not frightened by the spears. Florentines would be best served by not looking at the spears."

"True, but at least their panic has been good for your cause. It wasn't easy to convince them at first. Diverting the Arno sounds ludicrous—and expensive. But once I showed them your plans, they began to see the beauty of the design. Now they're more determined than ever to take back the mouth of the river. They know we're vulnerable as long as the Pisans control our access to the Mediterranean."

"And they're comfortable with it being me?"

"They have their doubts. But I convinced them that with Borgia on the run, you're our best asset. You know his plans better than anyone. In time, they'll learn to trust you as much as I do."

"Thank you, Niccolo," he said, watching Lisa gaze up at a statue of the Virgin Mary. He wondered if she were praying for the protection of her children at that moment. "If the city comes through on this, you have more than made up your debt."

"I may still owe you, maestro. I'm afraid my negotiating skills fell short this time."

Of course, it could never be simple with Machiavelli, he thought.

"While you're under the employ of the city, they want you to, well, provide a small additional service . . ." A bead of sweat collected on the diplomat's pale forehead. "It was the only way, I assure you, to convince them to hire you for the Arno project. I tried to talk them out of it, told them you would refuse, but . . . they want"—he broke eye contact—"a fresco."

Machiavelli went on, speaking quickly. "It is only a small picture depicting Florence's victory at the Battle of Anghiari. You have been to war, studied it, made drawings. You could dash off such a painting in a few short months, I'm positive. And in return for this one, simple picture, you'll have full financial backing to change the course of a river."

Leonardo swallowed a laugh. Did Machiavelli believe he hated painting so much that he had to be convinced to take on a new commission? "And where would this little painting reside?" he asked as though annoyed at being asked for such a trifle. Better to leave Machiavelli thinking he was still in debt to him than the other way around.

"In the Sala del Maggiore Consiglio."

Leonardo turned away to hide his mirth. The Sala del Maggiore Consiglio was the largest gathering hall in the city. Located inside of the Palazzo della Signoria, the chamber had been commissioned by Savonarola to house his all-powerful, five-hundred-member Grand Council. The committee was dismantled when the friar was burned at the stake, but the salon remained. Machiavelli was not asking for a trifle. He was asking for a masterpiece.

Leonardo shrugged. "Well, if I must do the painting in order to get the Arno project . . ."

"So I'll tell Soderini the good news," Machiavelli said, the lilt of a question lingering.

"I suppose I will do what I must," Leonardo said with a tone of resignation. Machiavelli was right. There was a special kind of joy in deceiving the deceiver.

"Excellent. And please accept my apologies that the sermon is over," Machiavelli said as he stood. "I hope I have not ruined your prayers."

What sermon? Leonardo wondered, as Machiavelli walked away. He looked back over at Lisa's chapel.

But the lady was gone.

For once, Machiavelli had been telling the truth.

On September 22, the College of Cardinals elected Francesco Todeschini Piccolomini, a supporter of Cesare Borgia, as Pope Pius III. A week later, Florence hired Leonardo to divert the Arno and paint a fresco inside city hall. They paid Leonardo a generous salary, hired a team of assistants, and provided him with lodgings

on the top floor of Santa Maria Novella's monastery, in rooms usually reserved for popes and kings. As Salaì explored the lavish new studio, he remarked, "Now this is proper employment, Master."

And just as Leonardo suspected, the fresco was no trifle. The mural of the Battle of Anghiari, which was to depict the great victory in 1440 when Florence vanquished Milan and secured her stronghold on the central part of the peninsula, was never intended to be a small painting that could be dashed off in a matter of months. It was a monumental work that would span the entire eastern side of the Sala del Maggiore Consiglio. The chosen wall was enormous, taller than five men standing on top of each other's shoulders and wider than twelve men lying head to foot. It was the largest blank canvas Leonardo had ever been given. That expansive wall, he thought with a smile, was the masterpiece he had been waiting for.

Over the next several weeks, Leonardo's mind fired with possibilities for the fresco. He made hundreds of drawings of soldiers and horses struggling to survive amidst the chaos of war. In between drawing, he obsessed over the Arno. The two projects bounced off of each other like hail crashing in a storm. One design fed the other, until the pebbles of hail were the size of snowballs, and then boulders.

Then, one day, while standing on the banks of the Arno talking to Colombino, the foreman of the river diversion project, Leonardo saw a lady approaching. Her orange and red skirts swished around her like leaves on an autumnal tree. At first he thought she was an apparition, but as she came closer, he realized she was no mirage, but the real Madonna Lisa del Giocondo. He hadn't had a proper encounter with her in six months, not since her first sitting, when she accused him of being a traitor.

"Leave me for a moment, Colombino," Leonardo said. As the foreman returned to work, the lady strode up to Leonardo, stood next to him, and surveyed the riverbed, where a hundred workers sawed wood, hauled boulders, and built scaffolding.

He didn't know when he would have another opportunity to study her up close. So, as if trying to identify the characteristics of a fine wine, Leonardo took dozens of sips of her face to drink in her details: her forehead made longer by her plucked eyebrows, the curve of her almond-shaped eyes, the shadow on her neck cast by her jutting jaw, the hint of cleavage rising from the top of her gown. His fingers itched to pull out his sketchbook and draw, but he didn't dare, for fear of scaring her away.

After a long silence, she spoke. "You work for Florence now." He hadn't heard her voice in months. The sound was as smooth, sweet, and rare as whipping cream.

"I do."

"By changing the course of rivers?"

"Yes."

"How?"

"Allow me to show you." He offered the lady his arm, hoping she would accept it.

She did, tucking her hand into the crook of his elbow, her fingers tapping out a rhythmical tune on his bicep. For the next hour, Leonardo gave her a tour. The site was located in the western part of town, at the edge of the city walls, so Florentine guards could help protect the workers from attacks by Borgia men or Pisan mercenaries. The men were building levees out of large boulders. Once complete, the dam would span the width of the Arno, preventing the river from continuing down its original path. The water would then be forced to flow into a ditch the men were digging that split off from the old riverbed. This alternate canal would lead down to a dry natural creek bed that fed into the Mediterranean south of Pisa, thereby diverting the river around the enemy city. He wasn't personally in charge, he explained; the foreman was overseeing construction, but Leonardo loved stopping by the river to check on progress. Work on his city hall fresco was slow, as always, his ideas taking time to percolate. His designs wouldn't make it onto the wall for

months or years. The Arno project, however, was already ticking ahead. "I have been studying the behavior of water since I was a child," he said, "when I used to swim in the currents of this very river." He bent down and put his hand in the Arno. "The water you touch in a river is the last of what has passed and the first of that which is to come. Just like time."

Lisa dipped low in her skirts and trailed her hand in the river. She seemed much different out in nature than she did locked in her husband's gaudy music room. Inside, she was quiet and stationary, but outside, her hands fluttered, her hair danced in the breeze, her skin glowed in the golden sunlight.

"Here," he said, pulling a pen and ink drawing out of his notebook and handing it to her. "This is a drawing of the countryside I made when I was not yet twenty years old. I was attempting to precisely replicate every geological and biological detail."

Lisa held the drawing carefully, as though it were a crumbling handwritten copy of the Gospel retrieved from the Holy Land.

"But now," he continued, "I see something more than scientific renderings of trees and rocks. When I look at the picture today, I see undulating rivers and mountains interweaving like knots. The lines don't have definite endings or beginnings. Nothing is clear or separate. Everything is connected. If one path is blocked off, the line isn't dead but flows in another direction. No matter the obstacles, nature finds another way."

"It's like language," she said, handing the sketch back. "There are an infinite number of ways to say the same thing. You're never stuck simply because you can't think of the right word. A language can always find another way, whether it's Southern Italian, Tuscan, French, Spanish, Latin . . ."

Leonardo laughed. Not only was the lady literate enough to quote Cicero, but she spoke French and Spanish, too?

"They no longer call you a traitor, but a hero," she said, turning to face him.

"Last year, I was bitten by a tarantula, my lady, but the poison is now gone and my senses returned. I choose Florence as my master, now."

"I am"—she dipped her eyelashes—"flattered."

"I did it so you would feel safer. I don't expect forgiveness."

"My husband will wonder where I have gone . . ." Lisa curtsied. "Do you have enough?"

"Enough what, Madonna?"

She pointed at the notebook hanging off his belt. "You have stopped sketching me. Have you stopped painting me as well?"

"No." His hand twitched over his sketchpad. Did he dare snatch it up and do a quick study of her? "I could always use more."

Turning and walking away, Lisa called back over her shoulder, "Come to the house tomorrow. I'll be waiting."

Michelangelo

ichelangelo grabbed onto a ledge and pulled himself
higher. His metal tools clanged on his belt. His breath
clouded in the cold air. His clumsy work boots pushed
into the side of the cliff. He was scaling a mountain made of pure
marble, so tall that it towered over Florence like a tree soars over
a blade of grass.

He climbed up to the tip of an enormous marble nose, rising
four stories above him. It was part of a giant face carved into the side
of the mountain. The sculpture was so large it could be seen from
the streets of town, across the countryside, and far out into the seas.
The leg was as tall as Il Duomo, the upper lip as high as a man, and
the nostril was a cave large enough to house his whole family.

He dug his chisel into the concave divot just below the fig-
ure's nose. This job was enormous. It would have overwhelmed
any other man. But he carved and carved and carved, digging so
deep that his arm started to disappear into the mountain. The
stone began creeping up his limb, his muscles turning as hard
as rocks, his skin becoming white as marble. He was turning
into the mountain. But the transformation did not scare him.
It exhilarated him. As the white rock spread up his body and
inched closer and closer to his head, he took a deep breath, as
though preparing to dive under water. In a few seconds, he would
become pure marble.

A hand grabbed Michelangelo's shoulder and yanked him off the mountain. Skin ripped from rock. As his body morphed back into flesh, pain shot up his legs and spine. He clung to the mountain, hoping the giant would come to life and save him, but the stone did not stir. His fingers slipped. His toes lost their grip. He tumbled off the mountain with a scream.

"Michelangelo," a voice called from the distance. Was that the voice of the mountain, begging him to stay? It wasn't fair. He still had so much more work to do. But he kept falling, his arms and legs flailing in the open air. He couldn't help the mountain. He couldn't even help himself.

His eyes opened. Granacci looked down on him.

"You're alive," his friend exclaimed.

Michelangelo's heart thumped wildly. His hands and legs shook. Air caught in his windpipe, and he coughed violently.

"*Grazie, mio Dio.* I thought you were . . ." Granacci wrapped a blanket around Michelangelo's shivering body.

Michelangelo rubbed the back of his sweating neck. He had not fallen off a peak. He was in the shed, lying on the cold, hard floor. There was no mountain looming, only David. It had all been a dream.

"It's amazing." Granacci sighed, staring up at the statue in awe.

Michelangelo hadn't allowed anyone inside the shed in months. No one had seen David recently, but there he was, alive as any man. Every detail was perfect, every flexing muscle, every finger and toenail, every bone showing through his delicate skin, every twitching muscle in his determined and anxious face. The only thing left for Michelangelo to do was to polish the surface, still covered in rough cross-hatching marks. It would take him months to work the marble into a high gleam, but when he was finished no one would see any indication of his labors. It would look effortless. Michelangelo tried to pick up his head and tell Granacci about the polish, but he was too exhausted. His eyes closed again.

A deep blackness, dark as a womb, enveloped him.

When he opened his eyes again, Granacci was stirring a pot of steaming soup over the fire in the corner. The aroma of tomato and garlic made Michelangelo's guts churn. His stomach heaved, but nothing came out. "You need to eat." Granacci held a large cup up to Michelangelo's cracked lips.

When had Michelangelo last taken a drink? Eaten a bite of food? Had it been hours or days or weeks? He couldn't remember. He breathed in and detected an earthy, dirty, rainy scent in the air. Was it autumn? What month was it? What year?

Granacci pulled Michelangelo's feet into his lap and untied his boots. The laces, caked in the mud of marble dust, cracked and broke. "You need to take care of yourself, *mi amico.*" Granacci pulled off the first boot.

Michelangelo howled. His toes and heel burned as if Granacci were ripping his limb in two. He grabbed his scorching foot in his hands. His foot was raw and bloody, with patches of missing skin. It burned as though he were standing in a pile of coals.

Granacci groaned. "When was the last time you took these off?"

He winced as Granacci wrapped a sheet around his bloody foot. He didn't have the energy to tell Granacci not to worry. Sometimes, when he didn't remove his boots for weeks, his skin came off with his socks. It was nothing. The skin always grew back.

"This is no time to be sick," Granacci said. "The pope is dead."

"The pope died a long time ago," Michelangelo mumbled. At least he could still remember that. The day in the piazza with his brother. The wailing mourners. The dirge sung by Buonarroto's beloved.

"Not Alexander. The new pope. Only three and half weeks in office, and he's gone." Granacci muttered a quick Hail Mary. Then, "Some say he was poisoned."

Nausea washed over Michelangelo. A new pope, already dead? Maybe poisoned?

"Now Cesare Borgia is on the run with half of the papal army. No one knows what he's going to do next. He's unhinged. Of course,

people fear he will come here," Granacci said, lowering his voice. "You must be well in case we have to flee. Everything is chaos."

Everything is chaos, Michelangelo repeated silently to himself. His hands tingled and burned. His vision waffled between lightness and darkness. "I keep burning in the shadows," he whispered.

Granacci forced soup into Michelangelo's mouth, but the hot liquid only made his throat burn worse, so he opened his lips and let the soup dribble onto the floor. "That's it. I'm getting you help." Granacci hopped up, grabbed Michelangelo's arms, and started to lift him over his shoulders.

"No," Michelangelo groaned and reached back for David. The statue wasn't finished. If Goliath marched up now, he would defeat the shepherd boy. Michelangelo couldn't leave David alone. He was alive as long as David was alive. If David died, he would die, too.

"Stop that. I'm trying to help you."

"Let me down." He tried to kick, but he didn't have enough energy to fight, so instead he grabbed Granacci's fine brown hair and yanked out a fistful.

Michelangelo struggled free and hit the ground with a thud. "I won't leave you," he whispered and crawled back over to David. A cough rattled his chest. Collapsing, Michelangelo curled into a ball. He shivered. Then a line of black appeared at the top of his vision and lowered like a shade until it closed completely.

Leonardo

The maid left the library to fetch more water. The swishing of her skirt grew quieter as she disappeared down the hallway.

Lisa waited a moment, then leaned in. "But what if he doesn't wake up? Would you finish the statue?" she asked, resuming the conversation they had been having half an hour before. Leonardo had been coming to her house to sketch her for weeks, but Lisa still refused to speak openly in front of her husband or their servants. When others were in the room, she lowered her gaze and her hands dropped motionlessly into her lap. As soon as they were gone, however, her eyes danced in the light, her hands fluttered, and her lips moved fast, desperate to keep up with the flood of words tumbling from her brain. To have a real conversation, they had to wait until the household staff, children, and her husband were all out of the room. That happened rarely, and when it did, lasted only a few moments. They had to talk fast.

"I've never been one to waste my time pondering answers to questions that haven't been asked yet, my lady, unless they are my own." The city was abuzz with gossip about Michelangelo's mysterious malady. Was it a fever, a demonic possession, the plague? And if the sculptor didn't recover, what would happen to the city's precious Duccio Stone? Would it be thrown into the rubbish pile, or might the Master from Vinci bring it to completion? No one

had officially asked Leonardo to step in yet, but the rumor was swirling. "Regardless of who finishes it," he said, "I hear Soderini is determined that it not be installed high up on the cathedral's facade, as originally planned, where no one can see it. He wants it down on the ground, which is a shame." With quick strokes, he sketched the soft curve of Lisa's cleavage. Today was the first day she had let her silk scarf slip off her shoulders. "If it did hang up there, the weight of the damned thing might eventually bring it down and it would drop from the sky like a dead bird."

"Don't look so gleeful at the prospect," she said with a teasing smile.

"Why not? I would be happy if there were one less piece of art vying with my city hall fresco. You'll be pleased when you see it, my lady. It will give no glory to the violence of war."

"Good. The desperate brutality of men grasping for power is one of the universe's great idiocies." She dropped her voice and added, "You don't think Pope Julius poisoned Pope Pius, as they say, do you?"

"I've seen many men tumble from grace." He slid his chair a bit closer and leaned in. She leaned in, too. "When I was painting my *Last Supper*, I scoured the streets of Milan, searching for the best model for each figure. For Jesus, I found a beautiful young man on the rise in his life and profession. He had a glowing complexion, beautiful hair, vibrant eyes. For the disciples, I chose a graceful lad for John, a bearded old priest for Thaddeus, and so on. But Judas. Judas eluded me. I couldn't find a wretch damaged enough to stand in for the traitor. Until one day, after two years of searching, a friend told me he had found my Judas: a thief locked away in the local jail. I went to his cell, and sure enough, that criminal was precisely what I needed. His face was lined and angry. His complexion, dark and mottled. His hair, ratted. That man was ravaged. As I sketched him, the thief looked up and said, 'You don't recognize me, do you? You have drawn me before.' I looked more closely and do you know what I saw?"

Lisa shook her head, her eyes wide with anticipation.

"My lady, that was the same man I had used as the model for Jesus, before drink and sin destroyed him."

"The same man," she whispered. Her lips stayed open with wonder.

"Fallen angels are much more human than rising ones, and the pope is, above all else, human," Leonardo said, capturing her parted lips on his sketchpad. "However, if a hunter on horseback kills a basilisk with his spear, the venom contaminates the spear and will kill not only the rider but his horse."

The swish of a skirt approached again.

"What?"

"Such tentacles of evil, if they are true, could infect the entire papacy. You should understand that. You read history."

Lisa's eyes darted down to her lap. "I don't," she said, and blushed. "Read history, or anything else."

Leonardo's brow knotted. "But you quoted Cicero the first day I came to the house."

The maid came back into the room. "I forgot the jug."

Lisa's blank stare returned. Her fluttering hands fell silently into her lap. Her hands were so smooth and unlined. In comparison, Leonardo's own hands were chicken's feet, bony and wrinkled and too thin. Just one more reminder of his age. He was fifty. She was twenty-four. She had an entire lifetime in front of her, and those hands were proof of it.

The maid picked up the jug and then tapped back out of the room.

Lisa did not wait for that swishing skirt to reach the end of the hall. "You don't honestly believe I can read Latin," she said, challenging him.

Yes, Leonardo had believed it. Usually he questioned everything, but he had trusted her. "Why would I ever doubt a lady of your eminent stature?"

"Stature, indeed." Lisa laughed. Her hands accented every word. "Duchesses and queens envy my position."

The swishing skirt approached.

"Perhaps I wanted to believe a merchant's wife could read Latin," he whispered as the skirt swished away again.

"I am a wife and a mother and I cherish those things about myself. I must content myself with pretending."

Leonardo picked up his chair and planted himself next to her. She started, but did not move away. He could feel the heat of her skin and the smell of lavender in her hair. This was the closest he had been to her since their sittings had begun. "Look here." He held his sketchpad between them and flipped through some of his drawings. "Through the years, I have identified ten types of noses, eight kinds of lips, and seventeen eye shapes. I also keep records of chins, cheekbones, foreheads, and patterns of wrinkles. I study how each facial feature changes in response to emotions. In reaction to fear, a nose might crinkle or twitch or flare out wide. In shock, a mouth could sag, form a circle, or purse tightly. Jaws clench and cock to the side. And the eyes either shine with intelligence or they don't." He looked up and held Lisa's gaze. "The mind of the painter must resemble a mirror, which always takes in the precise details of its subject and only reflects back the truth. Whether you can actually read or not is irrelevant. You have a spark of brilliance in your expression that cannot be hidden." He gently laid his hand on top of hers. She inhaled sharply. "You and I, we are the same," Leonardo said. "We are both unlettered."

"You read Latin." She pulled her hand away from his.

He tilted his head to the side. "Not well. And I had to teach myself. A bastard son, even of a wealthy, respectable father, cannot be allowed to have a proper university education. It would upset the order of things," he said, with more bite than intended. As much as he tried to pretend it didn't bother him, his outcast status still felt like a pin pricking the soles of his feet. "When I was in my thirties, I copied Latin words over and over again to learn."

"But you could already read and write Italian. And you had access to books. Paper. Pens. If someone caught you copying, they

would not strike your face, but instead might help you understand. For me, it is impossible."

Impossible. Leonardo hated that word. He wished he could banish it from the world's vocabulary. Calling something impossible guaranteed it would never happen, because no one ever strived to do something impossible. What would be the point? It was impossible, no matter how much work went into it. No. People only kept striving for things that were possible; the irony was that the very act of striving made those things more likely to happen. Thinking something was possible was a self-fulfilling prophecy, just as thinking something was impossible made that so. Most people would think human flight was impossible, but to him, flying was just a goal he had not yet realized. But he didn't want to argue, so instead he said, "Latin is overrated. Learning by observation with your own eye is far superior to reading the thoughts of others. You should always experience the world for yourself and draw your own conclusions. That's the only way to bridge the gap between the scholars and the rest of us."

The maid's skirt swished again.

"That's why you want to fly," she asked rapidly, "so you can experience, what? The life of a bird for yourself?"

The skirt was coming closer.

"In order to study something, I find it is best to keep my distance," Leonardo said, moving his chair back to his assigned location in the room. "If I get too close, I have no hope of rendering a scientific judgment. Getting close creates a dangerous bias. To capture humanity in a medium such as paint, I must observe it from afar."

A flush rose up Lisa's neck, and her hands stopped fluttering. Had he said something to offend her? Before he could ask, the maid entered. She did not leave them alone again for the rest of the day.

Michelangelo
December. Florence

"**T**his is all my fault."

"Father, you must calm down."

"I can't."

"Please, stop crying."

"It won't help him if you kill yourself, too, Papa," Buonarroto moaned.

Kill yourself, too? Had he died? No, his head hurt too badly to be dead. He tried to move, but his arms and legs felt heavy as boulders. He tried to speak, but no sound came out. He took a deep breath. The air smelled of candle wax, mineral medicines, and the heavy sweat of sickness.

"If I had not banished him, he would not be here. I would have watched over him."

Michelangelo focused all of his energy onto his eyelids. They opened a slit. A fuzzy line of orange light glimmered then disappeared.

"Michel!" his father cried. Michelangelo felt his shoulders being shaken.

"Father, be careful. You'll hurt him."

"His eyes opened. I saw them."

"You're imagining things."

"Michelangelo di Lodovico Buonarroti Simoni. Wake up."

He opened his mouth. All that came out was a low, gargled moan.

"Praise God, he's alive." Lodovico started to sob.

A wet sponge, tasting of vinegar, daubed Michelangelo's dry, cracked lips. "Brother? Are you awake?"

He slowly opened his eyes and looked up into the face of his brother. Buonarroto broke into a wide, dimpled smile. "You're right. He's alive."

"My beloved Michel." Lodovico kissed his cheeks over and over again. "Thank God you're all right. I never would have forgiven myself if anything had happened to you."

Michelangelo was lying on a bedroll in a large stone room that he didn't recognize. Nuns tended to other men lying on the floor around him. Three men hurried by, carrying a corpse. "Where am I?"

"*Ospedale di Santa Maria Nuova.*" Santa Maria Nuova was the oldest hospital in Florence. Aunt Cassandra had always treated the family's illnesses with her herbal remedies. Only patients in mortal danger ended up in a hospital. "The apothecary was out of medicines and every priest was already engaged. I didn't want you to die." Lodovico wept softly.

"How long have I been here?" Michelangelo asked. His voice sounded raspy as a mule.

"Three weeks," Buonarroto replied.

Three weeks. It was all a fractured dream. Flashes of stomach pain and shivering fevers. Several times, priests had drained his blood and performed ceremonies to exorcise demons. He had screamed. His father had wept. He'd had nightmares that, in a fit of lunacy, he'd smashed his *David* into a thousand pieces.

"Please, boy, don't cry." Lodovico wiped Michelangelo's cheek. "I know I raised you to regard frugality as a virtue, but you cannot go to extremes. You must take care of yourself, *figlio mio.*" He lifted Michelangelo's head and carefully wrapped it in a warm, dry blanket. "Above all else, you must protect your head. Keep it warm and don't wash it too often. Allow yourself to be rubbed,

but don't wash. It is the only way to stay well. Economy is good, but misery is a vice displeasing to God."

Michelangelo had heard his father give these same instructions hundreds of times. *Keep your head warm. Don't wash too often. Misery is offensive to God.* For the first time, he didn't hear disapproval in those orders. He heard a father's love.

"When you're well enough to leave here, maybe in a day or two," Lodovico said gruffly, "you'll come home with me." He patted his son's hand.

Tears of relief sprang to his eyes. After living in exile for over a year, he was finally going back to his family's home. All it took was nearly working himself to death.

Over the next few days, Buonarroto came and went. He was constantly running back home to check on Giovansimone, who had concocted an irrational plan to protect the family from Borgia and his army if they invaded Florence: he and a band of rogue soldiers had moved into the Buonarroti house and were planning to fight off Borgia's army with nothing but their fists and a few household utensils. While Buonarroto kept the militia away from neighborhood maidens and put out their careless kitchen fires, Lodovico never left Michelangelo's side. He slept next to his son on the floor of the hospital, brought him water and, eventually, food.

"The progress is good," Lodovico said one day, when Michelangelo was finally sitting up far enough to sip from a bowl of steaming soup. "But once you're better, you cannot return to working so hard. Your body cannot take it. No one's can."

Michelangelo swallowed the hot broth. "I have to return to work, Father," he said gently.

"You're killing yourself. For what?"

"For my art."

"Art," Lodovico grumbled. "I saw your statue when we went to that shed to help you . . ." Lodovico took the bowl of soup from Michelangelo. "He's naked."

"Most great classical Roman statues were nudes, Father."

"You're not Roman!" Lodovico barked.

A nun shushed him.

"And you don't live a thousand years ago," he said, lowering his voice but losing none of the reproach. "Don't you remember Savonarola damning us all to hell for images like that? We are a Catholic country."

"God made man. Our bodies are a representation of Him. Why shouldn't I celebrate it?"

"Don't you think church leaders will be embarrassed by a giant naked man? It's supposed to adorn the cathedral, *in nome di Dio*. Can't you add some clothes?"

"Who will be embarrassed?" Michelangelo's ire popped like boiling oil. "The Florentines for whom this statue is a great tribute? Or you?" He laid back down onto his pallet and closed his eyes. He was tired. They could resume the argument later.

But there would be no time to continue such bickering. The next night, Giovansimone and his militia accidentally set another kitchen fire. Since Buonarroto wasn't home to put it out, the whole house went up in a blaze. Neighbors passed buckets of water to stop the fire from spreading to the rest of the city. Such an inferno could burn hotter than all of Savonarola's bonfires combined and devour all the Botticellis, Donatellos, and Giottos housed in Florence's walls. It could destroy the Palazzo della Signoria, the Ponte Vecchio, Il Duomo itself.

When Michelangelo, still wrapped in a blanket from the hospital, finally arrived in front of the smoldering house, a wintry mix of snow and sleet had just begun to fall. There was nothing left but a pile of blackened wood and half of one staircase. It was all gone. Michelangelo looked up to heaven and opened his mouth. The falling sleet, he thought, must be God's frozen tears.

That night, the snow fell for hours, covering the streets and the charred remains of the house with a thick blanket of peaceful white. The neighbors went home. Buonarroto told him the rest

of the family was going to Santa Croce to warm up and rest, but Michelangelo stayed in the street, staring at what used to be his house. The sculptor had always believed his art did no harm, that he was serving God and his countrymen. But his father might be right. His hands were blistered nubs, his eyesight was starting to blur, and he had almost died in the hospital. His family had lost their dignity, their fortune, and now their home. For what? A piece of stone? No wonder God was weeping.

By the time the sun began to rise, the yellow light glinting across the smooth patch of gleaming white snow, Michelangelo had made a decision. His father was right. His art was the devil. It had taken everything from him. It didn't matter that his *David* was still unfinished, nor that the city had already talked of commissioning him to carve twelve more apostles once *David* was done. None of it mattered. It was time to walk away.

Leonardo

Ruminating on the idea of loss and renewal, Leonardo tidied up his desk. Had he actually considered completing the *David* if Michelangelo had remained ill or even died? Now that word had spread that the sculptor said he was no longer an artist, that he would rebuild his family's house and not return to work, Leonardo felt no yearning to pick up a chisel and finish the job. Let the statue fade into the shadows of history. It would only leave more light to shine on his city hall masterpiece.

As he put away brushes, threw out old scrap paper, and shelved books, he wondered why things that housed life were so easily destroyed. Man by death; Michelangelo's home by fire; Lisa by marriage. Leonardo saw the way the life drained out of her whenever her husband or his servants entered the room. In those moments, she was like a burned-down house.

He wanted to rebuild her. But how? Over the past few weeks, he hadn't been able to spend any time alone with her. Her husband and servants were always in the room. The loss of her spirited conversation stung. But, in one way, the constant chaperoning had been a gift because it taught him about her hands.

When they were alone, she spoke with her hands, her gestures accentuating every word, her fingers fluttering like hummingbirds. When her husband, children, servants, or anyone else was in the room, those hands dropped into her lap like stones.

But even when her hands were motionless, he could always sense them yearning to burst alive again. In those moments, her hands had potential.

Leonardo believed in potential like many men believed in God. Whether it was a rain cloud, a new color of paint, or a fresh idea for an invention, he measured things not by how they existed in that moment, but in what they had the potential to become. A perfect, completed state didn't hold much interest for him. He liked it when things could grow and improve. That was why he rarely finished his pictures. When they weren't done, they still had the potential to rise to greatness. Once he called them complete, they no longer had any potential to become. They were what they were.

He picked up the pieces of a half-constructed pair of wings strewn across the floor. Usually messes made him feel calm, but tonight, the clutter made his neck itch.

Lisa wanted to be seen. She wanted her husband to see her, the world to see her. It was hard for him to understand the desire. He was always on display. Tourists clamored to stand near him and shake his hand so they could return home with a story of meeting the great Master from Vinci. He often wished he could be invisible, so he could sit quietly and sketch people without them noticing. She was the opposite. She was desperate to be seen, and he was desperate to give her what she wanted.

He moved into the next room, where he was experimenting with his oils. Resin bubbled in pots over burners, while chemicals smoked in flasks. He wiped up some oil oozing out of a metal press. He loved the acidic smell of oils, their slippery feel, the way his fingerprints were captured in the paint after he blended a section with his thumb. He loved how oils dried as slowly as a pond at the bottom of a cave, leaving him weeks and months to rework lines and shading. He loved how oils could vary in thickness and texture, from a thick wall of pigment to the thinnest glaze. He loved how oil was so translucent; he could apply thin

layers of paint, one on top of another, but leave the earlier layers still visible underneath. The effect made clothing shimmer like real fabric, skin seem to glow from within, and shadows vibrate with hints of buried color. Mainly, he loved how he could rid his paintings of all harsh lines, using brushes and fingertips to blur every boundary. By using oils, he could make light evaporate like smoke into darkness.

For every one of his oil paintings, he developed a special array of tones. The lights would be bright and airy, the darks as rich as velvet. For Lisa's portrait, he was experimenting with mustard seeds, cypress needles, walnuts, gum of juniper trees, ashes from his kitchen fire, his own hair and fingernails, dead ants, ground-up human bone, and fish scales. Some experiments worked, some did not, but his palette of colors was growing.

Lisa wanted to be seen. The thought rolled through his mind like a pebble tumbling down rapids. An idea was about to emerge, but he couldn't quite see it through the muddy water. What was it?

He straightened up a corner full of a small furnace, pots, and glass beakers. He really should throw some of these things out. He didn't need them all. He needed to simplify and—

His mind clicked into place like a peg sliding into a groove. Simplicity was the ultimate sophistication, the path to true complexity. That was it. The painting started to emerge in his mind the way stars appeared in the heavens at dusk.

Leonardo crossed to the other side of the studio in two long steps and rifled through a stack of wood. He had been collecting pieces for several weeks, hoping one might strike him as the proper base for the portrait. Choosing the right board was an important step. Pick the wrong piece and the entire painting could be ruined. The first pieces were too large. He wanted something smaller. A person should not be able to glance at this portrait from down the hall and walk away. It needed to draw the viewer in.

His fingers landed on a piece of poplar wood the size of a small window. Poplar was the most common type of wood for a

panel picture. High quality, strong, durable. Other woods might be more unique, but poplar had potential. This piece was light in color with a slight golden tint. The finish was smooth, without a bump or blemish, but there was a subtle, yet inconsistent grain. It was a little unexpected. He propped the wood on his easel. Moonlight shone through a window and cast a silvery-blue glow across the board. It gleamed. He ran his fingers across the surface. His assistants had sanded it down as smooth as a mirror.

All portraits of women were essentially symbolic representations of the Virgin Mary. Every Italian woman yearned to be compared to the Holy Mother. Leonardo would adhere to this trope, but he would also make this portrait different from any other. This painting would be simple. No distracting objects or costly materials. No reams of silk, jewelry, or tassels. No ostentatious fireplace or horrendous gold-plated harpsichords, and certainly no red silk gown or portrait of her husband looming over her shoulder. She would not hold emblems of her father's family or her husband's success. There would be no physical symbols to identify her. It would be only her in the frame. Her eyes. Her hair. Her lips. The lady, in her simple, mysterious glory.

Before he could begin painting, he had to seal the wood. He mixed a batch of primer, made out of rabbit-skin glue and brown chalk, but instead of leaving the primer a plain dark brown, he split the gesso into two buckets. To one bucket he added a touch of blue paint; to the other a tinge of red. He would use the blue-tinted primer for the top half of the panel, to give a subtle suggestion of cool inaccessibility around Lisa's head. But for the bottom, where her body dominated, Leonardo would switch to the red. He needed a hint of heat.

He swept the blue primer on first and then brushed the red on the bottom. He could already sense her spirit seeping into the wood grain.

As he waited for the primer to dry, he sketched out the portrait that was now clear in his mind. Lisa sat in a chair in front of

a blank background. She wore a gown of dark silk and her curling hair cascaded down around her shoulders. To evoke a sense of movement, Leonardo turned her torso to the right, her head forward, eyes swiveling to the left as though seeing someone enter the room. The portrait was three-quarters in length, stretching all the way down to capture the lady's hands resting on the arm of her chair.

He picked out the smallest brush he owned and yanked out a few bristles to make it even finer. He wanted to use a brush so small that his strokes would be imperceptible. He didn't want anyone to focus on him. People could think about him when they viewed his *Last Supper* or his *Madonna of the Rocks* or the giant fresco waiting to emerge inside city hall, but not when they looked at Lisa. This time, he wanted to disappear into the background. He wanted the world to focus on her.

✳

1504
Florence

✳

Michelangelo

Winter

I n early January, word reached Florence that Piero de' Medici had died in battle fighting for the French. Florentines celebrated. Their longtime enemy, the snake that had coiled around their throat for years, was finally gone. However, the celebration did not last for long. Now that Piero was dead, every Medici son, brother, cousin, and uncle schemed to retake the city in Piero's name. The threat had not died; it had multiplied.

Michelangelo swung his hammer as hard as he could. The nail drove easily into the board. As he breathed in sawdust, he pounded in a second nail just as quickly, then a third and fourth. He grabbed another piece of timber, laid it next to the other board, and began nailing it in, too. At this pace, he alone could finish the kitchen floor in two days. If the whole family worked as fast as he did, they could complete the entire house in a month.

He looked up. On the other side of the room, near where the fireplace used to be, his father and uncle swung their hammers clumsily. They weren't used to doing manual labor; they spent more time chatting and drinking wine than they did working. At their rate, the job wouldn't be finished until summer. Neither Giovansimone nor Buonarroto were there to help. No one had seen Giovani since after the fire, and Buonarroto had taken a job down at Leonardo's Arno diversion project. He'd given up on the

dream of financing his own shop. Maria's father was making her meet with suitors; she would be engaged to a proper gentleman by the end of the year.

Michelangelo pounded in another nail. His fingertips burned with cold. He never felt warm these days. The house was open to the sky; there were no walls or roof. Every night, the family slept in the chilly stone basement of the Basilica of Santa Croce, with other homeless families, until they could finish construction.

He swung hard at a nail, but missed and whacked his thumb instead. He yelped and threw his hammer across the room. Throbbing pain shot through his hand. His eyes watered. At least it was his left thumb, and not his right. With a broken left thumb, he could still polish his marble. He groaned. When would he finally stop thinking about sculpting?

Staggering from too much drink, Uncle Francesco grabbed Michelangelo's hammer and struck a nail. "No wonder you work so fast," he slurred. "This one is better."

Shaking his head, Michelangelo stood up and climbed off the foundation, into the street below. "Where are you going?" Lodovico called, but Michelangelo didn't respond. He needed a break.

As he walked, he cursed Giovansimone for burning down the house and leaving him to clean up the mess. If Giovani were still in town, his father wouldn't cling to Michelangelo so much.

He crossed under the shadow of the soaring Duomo and arrived at his shed. With a grunt of frustration, he kicked open the door. Only then did he remember that he hadn't been inside the shed in months. Not since his family had carried him out in a feverish delirium.

He stepped inside. His eyes adjusted to the dim light.

There was David, exactly where Michelangelo had left him. Standing alone, rough and unpolished.

Somewhere in the back of his mind, Michelangelo had convinced himself that the statue was nothing but a dream. A

delusion manifested by his fever. But this was no mirage. David was alive, and he looked ready for a fight.

With shaking hands, Michelangelo fumbled with the buttons on his coat, took it off, climbed quickly up the scaffolding, and threw the coat over David's face. He climbed back down and rummaged through stacks of pots and scrap wood. Finally, buried under a pile of old scratch paper, he found a stash of tools. He grabbed two hammers and his coat and ducked back out of the shed as fast as he could.

Two days later, Michelangelo was still installing floorboards while his father and uncle sipped watered-down wine.

"*Mi amico!*"

He looked up to see Granacci jogging toward him. Michelangelo felt a rush of joy, but he quickly swallowed it. He didn't have time for old artist friends. "I'm busy," he said and went back to work.

"It's about your David." Granacci crossed the floor with long, purposeful steps.

"The Duccio Stone is no longer my concern." He refused to say the statue's name. It was like speaking the name of the dead.

"If you walk away now," Granacci warned, "the Operai will rescind their request for the twelve apostles for the cathedral. Do you really want to lose such a valuable, long-term commission?"

"Michel, what's going on over there?" Lodovico called.

"Nothing, Papa," he yelled, then turned to Granacci. "Leave me alone. I have real work to do."

Granacci knelt down next to him. "Your David is in danger."

"Go talk to the cathedral. They own the stone. They can decide what to do with it."

"The cathedral isn't in control anymore. Machiavelli forced Giuseppe Vitelli to open up your shed and show Gonfaloniere Soderini and the Signoria your statue."

Michelangelo's head popped up. People had been in to see David? Without him? He couldn't breathe. He started to get dizzy.

"Machiavelli thought they would be offended by the nudity," Granacci went on, "but they were not. Your statue is no longer some decorative element for Il Duomo. It is to be a symbol of the city. They are holding a committee meeting right now to decide where to place the David, whether you polish it or not."

A symbol of the city? It was almost too much. His vision began to dim. He shook his head and forced himself to say, "I don't care."

"You don't care where your giant is displayed?"

"No." He wasn't an artist anymore. He was a good Buonarroti son.

"Some of us, including Soderini himself, have been arguing that it should stand at the entrance to city hall. In place of Judith."

Michelangelo caught his breath. Donatello's bronze *Judith and Holofernes* was one of the most beloved statues in all of Florence, depicting the moment when the widow Judith, sword raised, stood over the unconscious Holofernes, about to decapitate him and save her people from tyranny. It was an exhilarating composition, a symbol of the weak triumphing over the strong. Florentines loved that statue. Never, not even in his most self-aggrandizing fantasies, did Michelangelo dream his work might replace Donatello's. "I don't care where it stands." Then, loud enough for his father to hear, he added, "I am not returning."

"*Grazie mio Dio*," Lodovico called to the skies.

"So you're going to let Leonardo win?" Granacci pressed.

"Leonardo?" Michelangelo's nose flared. He had heard a rumor that the cathedral might ask Leonardo to finish the statue if he didn't return to work, but surely someone would have told him if that had happened. Surely Leonardo had not touched his David. "They haven't given him my statue, have they?"

"No. Not yet. But now that he is changing the course of rivers, everyone listens to him like he is God the Father himself. And they are listening to him right now. He is at the meeting, leading the charge to bury your David."

Michelangelo's gut tightened. "Where does he want to put it?"

"What difference does it make? It doesn't concern you." Lodovico had walked over to join the conversation.

"Buried in the shadows under the loggia," Granacci said gravely.

The back of Michelangelo's neck tingled. The loggia was the covered portico to the left side of city hall. Dozens of sculptures stood there. If David were placed there, he would be lost among the masses; even if people did notice him, they would dismiss him as unimportant.

"Leonardo says it needs to be protected from the elements. He also says visitors might be embarrassed by its . . ." Granacci paused to find the right word. "Forthrightness," he said, waving his hand in front of his crotch.

"Lying old bastard!" Michelangelo shouted.

"Michel. *Calmati*," Lodovico scolded.

"Leonardo is not only burying David, he's burying you," Granacci said.

"My son doesn't care about that," Lodovico responded proudly, patting Michelangelo on the back. "He's a family man now, not a stonecutter."

Was that true? Michelangelo wondered. Even if he never carved another piece of stone, would he ever stop being a sculptor? "Where is the meeting?" Michelangelo rose to his feet.

"Why do you care?" Lodovico demanded.

"Orsanmichele," Granacci answered.

The thought of giving up sculpting vanished like a single snowflake melting in the flames of their burning house. He took off at a sprint.

"Where are you going?" his father called after him.

Michelangelo didn't stop. His family needed him, but so did David.

Leonardo

Many of the city's most prominent men were arguing in the attic of Orsanmichele. The small meeting room smelled of candle wax, stale wine, and the sweat of angry gentlemen.

"The David will be a great symbol of our city," Soderini yelled above the din. "We should celebrate it, not condemn it to the shadows."

"But you're talking about replacing Donatello's *Judith*," Botticelli said, his beard trembling along with his jaw. He was squeezed into an upper balcony with the other artists. "You can't dismiss our great masters with the scribblings of children." Leonardo felt sorry for the aging painter. Was it fair to allow an aspiring sculptor to usurp legendary masters like Donatello and Botticelli? No. It was offensive. Especially when Botticelli was still alive to see it.

"*Judith* was commissioned by the Medici. It is a symbol of Medici power. We should replace it," the architect Giuliano da Sangallo chimed in. Why was Sangallo supporting a bid to make Michelangelo more prominent, Leonardo wondered. The architect was an aging master, too. Leonardo had assumed they would all be on the same side.

"Piero de' Medici is dead," Giuseppe Vitelli reminded them.

"The great snake is no more. Cesare Borgia is on the run. What is this urgency to protect Florence from ghosts?"

A few men called out their agreement.

"They are not ghosts, but skunks, their foul odor lingering long after they are gone, infecting everything around them." It was the first time Niccolo Machiavelli had spoken, and everyone quieted down to listen. "Piero de' Medici may be dead, but his family is more determined than ever to retake the city in his name. And Borgia may be on the run, but even if he is captured, imprisoned, or killed, another will rise in his place. The threats will never stop."

"When the Medici were expelled," Soderini said, "the city moved *Judith and Holofernes* out of their palace and to the front of city hall. Immediately after it was placed there, Savonarola rose to power, we lost Pisa to the French, and the entire city suffered under the threat of Borgia. Does anyone here think Florence has improved under Judith's watch?"

"No!" a few shouted.

"If David stands at the door of the Palazzo della Signoria, he will face in the direction of the city's main gate and stare down any foe that dares enter. David could change our fortunes." Soderini looked to Machiavelli for support.

The diplomat did not respond; instead, he looked up at Leonardo, sitting in the balcony with the other artists. One by one, every man turned to hear what the Master from Vinci had to say.

Leonardo took his time responding. He had been deeply troubled when he'd first heard Soderini's proposal to place David at the doorway of the Palazzo della Signoria. Leonardo's fresco would be housed inside that very building. Visitors would have to walk by Michelangelo's statue in order to visit his masterpiece. The popularity of his fresco would no doubt raise the profile of Michelangelo's David. He could never allow

that to happen. "I do not care what you decide to do with that statue," he finally said, waving his hand dismissively. "It is simply my duty, as an elder Florentine, to direct your attention to things that might offend. Pope Julius is new to office. None of us knows how prudish he is likely to be. He could be as conservative as Savonarola. Like it or not, a colossal nude male statue is controversial."

"Don't listen to that old man," a voice roared. The crowd murmured as the intruder pushed his way to the front of the room.

Merda, Leonardo cursed silently, and then whispered to Pietro Perugino, "The boy looks like a pig accidentally stumbling into stables reserved for the king's horses."

"Why wasn't I invited to this meeting?" Michelangelo asked. His beard was trimmed, his clothes clean. He even looked to have gained some weight. Living at home, not sculpting, seemed to be good for the young man. "I should at least get to offer my opinion about its final placement. It's my statue."

"A statue that you abandoned," Leonardo called over the commotion.

"I was helping to rebuild my family home. Now that the job is underway, I have returned to finish my work."

"That's wonderful news," Soderini said, moving through the crowd to stand next to Michelangelo. "Why don't you tell us where you think the statue should stand, son?"

"I thought we had agreed not to ask the sculptor." Machiavelli's eyes darted up to meet Leonardo's. "Too much bias."

"Yes, because it's ridiculous to consider asking an artist about his art," Sangallo called out from the gallery.

"Well, son?" Soderini pressed. "What do you think? In the shadows of the loggia or at the entrance of the palazzo?"

"Or the cathedral," Giuseppe Vitelli added.

"Not the loggia." Michelangelo glared at Leonardo.

"The artist agrees! The entrance to Palazzo della Signoria it is!" Soderini exclaimed.

The men once again erupted into a screaming debate.

"David should remain covered," Leonardo called out over the other voices, "placed behind the low wall, in such a way that it does not interfere with the ceremonies of state. And it should be decorated with suitable ornaments to cover its . . ." He cleared his throat and spoke louder, ". . . uncircumcised penis and intricately carved pubic hair."

The men fell immediately silent. Soderini gaped. Machiavelli suppressed a chuckle.

"You could speak with a little more decorum," said Soderini.

"Why should I measure my words? The statue we are talking about is nine *braccia* high and nude."

"Have you seen it?" Michelangelo asked, his face flushed.

"No. But I have heard accounts from reliable sources. Are you denying my description?"

All heads craned to Michelangelo. He shook his head no.

Leonardo waited, letting Michelangelo's silent admission spread through the crowd in a murmur. "If we cannot hear the words, what makes us think we can handle the thing itself standing in front of city hall?"

"Savonarola would have burned us all for such a display," Botticelli said, his face turning a shade whiter. Botticelli had been a devoted follower of Savonarola's, even throwing several of his paintings onto the preacher's bonfires. The friar's sermons surely still echoed in his head.

"The loggia it should be," Leonardo declared. "Near the back."

Michelangelo glared up at him like a gull honing in on a glinting fish. "Are you actually going to listen to that man's opinion on matters of the heart?" His voice carried across the room—a trumpet before battle. "How many here have heard him talk about the importance of distance and scientific objectivity?"

Leonardo was surprised by the number of hands that went up.

"Of course you have," Michelangelo went on. "He tells us all, whenever we fall silent for a moment."

A few laughed. Perugino nudged him. Leonardo felt his skin grow hot. He wasn't blushing, was he?

"He sits behind his strange scopes and spectacles and magnifying glasses and studies us like we are some sort of specimen. How many of you have caught him sketching the way your brow wrinkles in anger rather than ask you what is wrong? How many of you have heard him tell a joke at your expense instead of taking you seriously? And how many of you really know him? How many know his passions, his heart, his soul?"

Even Machiavelli averted his gaze then.

"But all of you know mine." Michelangelo's expression softened. "Mine is written across my face, in my eyes, on my marble. Exposed. For everyone to see. So who do you trust to make a decision about a monument designed to inspire your people—him? Or me?"

The vote was not close.

"The entrance of city hall it is," Soderini declared after the last man weighed in. "Now, all you have to do is finish the statue, my boy. We expect it done by springtime, to be revealed at a ceremony this summer." Soderini shook Michelangelo's hand.

As people began filing out, Botticelli leaned over to Leonardo and said, "Good try, my old friend. But I suppose at a certain point, we all must step aside and let the younger men have their glory. I remember when you were nothing but a schoolboy biting at my heels."

Botticelli gave a resigned shrug, and then, using a walking cane for support, descended the stairs. Leonardo was only—what—seven years younger? He hadn't really been the upstart boy to Botticelli's mastery. Had he?

He looked over the balcony and down at Michelangelo, who smiled as the crowd swarmed to congratulate him on his victory.

Leonardo took his time departing Orsanmichele. He didn't feel like discussing the decision with the others. He should have known this building was a bad omen. Orsanmichele. The oratory

of St. Michael. That sculptor's name had been hanging over them the whole time.

After half an hour, Leonardo strode down the stairs and out of the church, his long, rose-colored cape billowing behind him. Outside, everyone was gone except Salaì, waiting patiently on the steps. "Someone ought to destroy that damned statue before the public has to endure it," Leonardo murmured.

"Yes, Master, I believe they should." Salaì was always willing to agree with Leonardo, even when they both knew he was only venting.

"Come, Giacomo. We have work to do." If Michelangelo were going to finish his statue by springtime and reveal it by summer, then Leonardo would complete his work by then, too. The Arno could be diverted faster, his city hall fresco completed in a rush of paint; Lisa's portrait could be drying on the wood within the month. If he worked hard, he might even be able to fly by summertime. Michelangelo's marble David would be nothing in comparison to Leonardo's flurry of masterpieces.

Michelangelo
Spring

That spring, Pope Julius captured Cesare Borgia and exiled him to Spain, and the entire peninsula celebrated. But while Florence basked in the warm sunlight of victory, word spread that Piero de' Medici's two younger brothers were raising a new army and preparing to invade. Machiavelli had been right. The threats would never end as long as Florence was, well, Florence.

The same mix of euphoria and anxiety that flooded the city ripped through Michelangelo's veins. Gripping a piece of pumice stone, he polished the marble David day and night. As if rubbing off a layer of dried skin, the pumice stone slowly began to wipe away rough granules and polish the marble to a high gleam.

One warm spring day, the sun so radiant it brightened even the interior of the shed, Michelangelo finished the heel of David's left foot and laid down his pumice stone. He had spent hours rubbing each ear lobe, elbow, and vein, even obsessively shining between toes. He had purposefully left one small patch on the top of David's head unpolished. In the future, when people saw David, they might think the statue had fallen from heaven, made by God himself. So he left that rough patch to prove the statue did not drop to earth perfectly formed, but was brought to life out of a real piece of stone by the hand of a real human man.

His fingers were blistered and bloodied. His hands felt permanently clenched from gripping pumice and glass paper for months. There was a deep gash along the outside of his left palm. Half his right thumbnail was broken off, the flesh underneath swollen and purple. His hands would probably never look the same, and after working inside that shed for so long, his eyesight had dimmed, too.

He sat down in front of the marble and stretched out his legs. His ears were loud with quiet, and his limbs thumped with emptiness. When he had finished his *Pietà*, a similar feeling had settled around him, but this time the feeling was much stronger. This stillness echoed through his chest like a stampede.

Michelangelo lay back and gazed up at his colossus. David was indeed a magnificent sight. The lines of his body flowed seamlessly from hair to toes, his muscles bulged and rippled like the melody of a song, and his face was the face of a real man burdened with a mix of strength, determination, and fear. After two and a half years, and thousands of hours, the stone finally lived up to Michelangelo's expectations. "It is finished," he said with a smile.

His euphoria only lasted a moment. A problem had been in the back of his mind for over two years. He had hoped that he would somehow solve it while he was carving, but no answer had yet come to mind. The problem—which seemed impossible—could no longer be ignored.

It was the sculptor's job to deliver the statue to its pedestal. Until David was safely installed, his job was not finished. In David's case, that pedestal—thanks to Michelangelo's own plea—would stand in front of the Palazzo della Signoria, over two thousand paces away.

It had taken a dozen men multiple tries to lift that old Duccio Stone off its side and stand it on its end. He had no idea how to move the statue one step, much less two thousand, through narrow, uneven streets. The Greek statue of Naxos, proclaimed the greatest masterpiece of all time, had had its leg broken while

being pulled down a short, soft, grassy hill to its pedestal. After that, the cracked statue was dumped into a quarry because it was no longer a masterpiece; it was garbage. The same fate awaited David unless Michelangelo could somehow make the impossible possible.

Leonardo

Leonardo squinted out over the Arno. The ditch, which would become the new riverbed once the dam was in place, was finally complete; the workers had been removing dirt for months. Now, the men were building the dam, which would force the river away from its original route and into the alternate canal. A small rivulet was already flowing into the new ditch. He loved witnessing the moment when something that had previously only existed in his imagination started to come to life. It was as though his mind had been turned inside out for the whole world to see.

"We're on track to be finished by spring's end." Colombino had a curly black mustache that accentuated his broad smile, and a flabby belly that seemed incongruous with the foreman's firm biceps. A father of five, he often treated Leonardo like he was one of his naive young sons.

"That's good news." Leonardo shaded his eyes and squinted into the sun. With his recent progress on the fresco and on Lisa's portrait, his flood of masterpieces was well on its way. "Is the first levee holding?"

"'Tis, though we had to reinforce it with more stone than you planned."

"More stone? Why?"

"Master?" interrupted a young man.

Leonardo glanced over, taking in brown hair and the frayed clothes of a manual laborer. "Not now." He turned back to Colombino. "Tell me about the stone."

"Signore," the young man pressed.

"Go back to work and leave the maestro be, Buonarroti," Colombino snapped.

"Buonarroti?" Leonardo turned. The young man was quite attractive, with deep dimples, merry brown eyes, and a perfectly straight, aquiline nose. He looked nothing like the frightful stone-cutter. "Are you related to Michelangelo?"

"*Si, signore.* My name is Buonarroto. Michelangelo is my older brother."

"Leave us for a moment, Colombino."

The foreman frowned, but then turned away without responding. "More stone!" he called to the men working in the riverbed.

"You wanted to speak to me?" Leonardo asked the young man.

"Yes, signore. I work here on your project, so every day, I witness your engineering genius."

Leonardo's eyebrows rose. "Does your brother know you work for me?"

"Of course, signore. My brother is my elder, and we are very close." Buonarroti pushed his chest out defensively.

"And does he approve of your work here?"

"He understands the necessity of it." Buonarroto looked down and hunched his shoulders awkwardly. Ah, now he saw the resemblance. "Sir, do you know about my brother's colossus?"

Suddenly, the young man was not so amusing. "Yes," Leonardo said impatiently.

"Well, he must move it from Il Duomo all the way to the Palazzo della Signoria . . ." Buonarroto took a deep breath and then continued. "And he doesn't know how."

Ah, yes. Of course. The largest statue in Florentine history. The challenge was unprecedented. "Go on."

"It must be at city hall in time for the unveiling, and if he doesn't make it, Signor Machiavelli says they won't pay him any more, and if he drops it while trying to move it . . ." Buonarroto shook his head.

If he dropped it, Michelangelo's precious David would be destroyed, just like Leonardo's clay horse under the blows of the French.

"But you, you can change the course of rivers," Buonarroto said, his voice thick with awe. "Surely you could move a stone."

Leonardo could devise a plan to move a statue, no matter how heavy or cumbersome. He had all kinds of ideas for pulley systems and cranes to aid in such projects. "I'm sorry," he said, patting the young man's shoulder. "I am too busy with my own work. But by all means, please tell your brother we spoke and if he wants to come to me with his questions, I'm happy to take a minute out of my day to give him some advice. Make sure and tell him that."

"*Grazie, maestro*," he muttered and, shoulders dropping with disappointment, he trudged back to work.

So Michelangelo's great triumph might not be so certain after all. The David might not make his summer unveiling. If Leonardo could finish one of his masterpieces before then . . . "Colombino!" he called, waving the foreman back over. "You said you had to add more stone?"

"Yes, signore. It will take more time, but in the long run, it will be worth it, I assure you."

Leonardo shook his head. "We must keep to the schedule. In fact, we should speed it up, get it done as quickly as possible. Hire more men if you need to. The sooner we get the original dam built, the sooner we can correct any problems, and the sooner we can turn Pisa into a desert."

"I would prefer to build a dam without problems in the first place, instead of having to fix them later. Signore."

That was the way unthinking men spoke. "Colombino, who is the engineer, you or I?"

"You are, maestro," Colombino said, his mustache twitching.

"And I know how much weight the system will bear. Return to my specifications. They will hold."

Michelangelo

Who said that?" Michelangelo stared up into Buonarroto's innocent expression.

"Leonardo."

Michelangelo's mouth opened and closed, but no words came out.

"From Vinci," Buonarroto clarified.

"I know who Leonardo is. What did you tell him?"

"That you're having trouble moving the statue."

"*Cazzo*," he cursed and stood. He had been lying under the front of David's transport, tightening a rope. The first thing he had done to prepare for the move was to wrap David in a black linen tarp padded with straw. He wanted to protect the marble from any nicks or scratches, and he didn't want anyone else to see the statue until the city was ready to officially unveil it. After securing the tarp, Michelangelo had dismantled his privacy shed and, with the help of forty men and a pulley, loaded David onto a wooden transport.

"He said he was too busy to come here to help," Buonarroto told him, "but he offered to give you advice if you came to him with your plans."

"I bet he did." Michelangelo yanked off his work gloves and rubbed his blistered hands. He couldn't believe his brother had exposed his failures to that condescending bastard.

"It was last week," Buonarroto said, moving out of the way as Michelangelo went to inspect the other side of the transport. "I didn't tell you in case you figured it out on your own, but you seem so nervous, and I'm sure he'd still be willing to help."

"You should get some input from the Master from Vinci," Piero Soderini suggested. The gonfaloniere often stopped by to watch. "I'm sure he could tell us how to make this work."

Moving a delicate statue that was nearly the height of four men standing on top of each other's shoulders was not easy. David would need to remain upright the entire time. Lowering him to his side and raising him to his feet again was too risky. The center of the Duccio Stone had been abnormally shallow. If they lay David on his side, the weight might bow inward and crack his slender waist. But moving him upright created a different set of problems. David was so tall that the men had already taken down the archway over the entrance of the cathedral workshop; he never would have fit under it. Along the road to city hall, Michelangelo feared low-hanging balconies and awnings obstructing his path. David's height wasn't the only issue. The statue's knees were thin, his ankles even thinner. His bent left elbow protruded out to the side. One bump in the road could reverberate through David's bones like a cymbal, cracking him to pieces. David was like the heart of a farmer's daughter in love with a young duke: easy to break and impossible to repair.

Regardless of the risks, Michelangelo would never ask for Leonardo's help. Never. "I have plenty of help already, *molto grazie.*"

Giuliano da Sangallo, the city's most prolific architect, had assisted in designing the transport. The covered statue had been lifted onto a flat wooden bed nailed to the top of five of the sturdiest wagons in town. David was tied firmly to a thick pole rising out of the center of the platform. The marble was tied so tightly that Michelangelo could not move it the width of a blade of grass. On each side of the transport were a series of wooden bars. Two dozen workers, who would each be paid a full florin upon David's safe

delivery to the palazzo, would grip those bars and push the contraption forward. They had already tested the device several times, filling it with boulders and a dozen men. Nothing compared to David's height and weight, of course, but the contraption had held.

"This design will work," Michelangelo declared, although he could hear the lack of confidence in his own tone. "Tomorrow. You will see tomorrow."

Soderini pulled him aside. "I didn't want to tell you this, because I didn't want to put undue pressure on you, but . . ." His voice trailed off.

"But what?"

"Pro-Medici rebels have infiltrated Florence. They claim your statue carries an anti-Medici message. If you can't move it, they will say it is a sign that the Medici should return to power. And you know how partial Florentines are to signs," Soderini finished with a sigh.

Michelangelo's throat tightened. "My David is pro-Florence. The only thing it stands against is tyranny."

"I know that. But the people . . . Please, you must get your statue safely to city hall, even if it means consulting Leonardo, just to be sure."

"I am sure. Gonfaloniere, I promise this will work."

"I hope you're right." Soderini's brow remained furrowed with worry.

Me, too, Michelangelo thought, but he didn't utter that out loud. Instead, he tied another set of ropes around David, hoping to finally make himself feel secure.

That night, Michelangelo didn't sleep. He catalogued every sharp corner and missing cobblestone on the road ahead; calculated every runaway horse David might meet along the way. He was haunted by the sounds of cracking wood, splitting ropes, and popping bolts. During the darkest patch of night, he even imagined an army of Medici men spinning David round and round until the cart broke in two and the statue spiraled into oblivion.

As the sun rose in a brilliant burst of red, Michelangelo reassured himself that the transport was sturdy. The statue was tied down tighter than a chest of a king's gold. And God would surely protect David.

Michelangelo and Buonarroto ate breakfast in silence. His brother would not be there to help with the move. Buonarroto would be at the Arno, helping Leonardo instead. No one else in the family came downstairs to say good morning or good luck. Michelangelo walked to the cathedral alone. As workers began to arrive, he checked and rechecked all of the ropes, but no matter how tightly he tied, he couldn't shake the nagging feeling that the move was doomed.

"What time are we starting?" Piero Soderini asked, pulling his collar up to protect his chin from a howling wind.

"Soon," Michelangelo said. He went over every rope, every piece of wood, every nail and bolt again. He climbed up on the truck bed, grabbed David, and shook as hard as he could. The statue did not budge.

But neither did his feeling of dread.

"You see anything wrong?" he called down to Giuliano da Sangallo.

"Wrong? Nothing's wrong, my boy," the architect said, a smile brightening his wrinkled features. "This is your day of triumph. Time to get on with it."

Granacci circled the transport one last time. "*Bueno*," he confirmed, giving Michelangelo an encouraging nod.

He was just being paranoid. There was nothing wrong with the transport. David would be fine. "To your stations," he yelled.

Two dozen workers went to either side of the transport and positioned themselves behind their wooden bars. "On my count," Michelangelo called, his throat pinching. "*Uno.*"

Please, God, help us.

"*Due.*"

Do whatever you must to protect him, he prayed.

"*Tre!*"

The men grunted and pushed on their bars, edging the wagon forward. The wood groaned and creaked. The bulky contraption seemed large as a mountain.

Something cold struck Michelangelo's head.

He looked up. The red sunrise had given way to clouds, now breaking apart into a storm. Raindrops fell like confetti at a parade. "Wait!" he cried.

The men stopped pushing. The transport moaned and settled. They were still in the cathedral workshop; David hadn't even moved forward a single *braccia*.

"Why did we stop?" Soderini asked. He had been walking in front of the transport as though leading an Easter procession.

Rain fell in large drops.

Sangallo shook his head. "We can't move in the mud. Under this weight, these wheels would dig in faster than a family of rabbits."

"The moment the rain stops, we'll try again," Michelangelo said. They could leave the statue where it was, still on cathedral land, safe under its protective tarp, resting on its transport, until they were ready to try again.

As everyone else hustled for cover, Michelangelo turned his face to the sky and drank in the rain. He should have been frustrated at the delay, but instead, he felt enormous relief. As long as it was raining, he had time to figure out what was bothering him and design a safer transport. As long as it was raining, David didn't have to move. As long as it was raining, David was safe.

Please God, he prayed, *don't ever let the rain stop.*

Leonardo

Rain clattered on the rooftop and echoed through the Sala del Maggiore Consiglio. It had been raining nonstop for nearly two days.

Leonardo paced. His *Battle of Anghiari* fresco would eventually span the massive eastern wall, but he wasn't ready to begin painting yet. He still had more work to do, and the rain was an annoying reminder that he would have to be more careful with this new fresco. Rain left moisture in the air. Moisture grew into mold. And mold led to rot.

Rumors had finally started trickling down from Milan that Leonardo's *Last Supper* was crumbling off the wall. The Milanese were panicking, trying to find a way to repair the damage. Leonardo knew his reputation would never survive a second crumbling masterpiece. No. This fresco would need to adhere perfectly to the wall for centuries.

He would have to use a more durable fresco technique, which probably meant he would need to work fast. No altering facial expressions or adding a brush stroke here or there, whenever inspiration struck. This time, his design would have to be perfect before he began.

Therefore, Leonardo took his time developing his composition. He spent many hours pacing his studio or taking long walks or standing in the empty Sala del Maggiore Consiglio, staring at the

wall. An outsider would probably see this as wasted, absentminded daydreaming, but to him it was the most important part of the process, his mind firing with ideas, lines, shadows, colors, and shapes. In between the days and nights of thinking, he also had bursts of furious drawing, when he got lost in the rhythmical movement of his chalk across paper and his memories of war.

Piero Soderini, Niccolo Machiavelli, and the rest of the Signoria wanted Leonardo's representation of the Florentine victory at the Battle of Anghiari to be a marvelous celebration of war. They'd suggested images of formidable generals wearing grand armor, soldiers riding courageously into battle, and St. Peter alighting from heaven to bless the entire army.

But Leonardo had been to war. What he remembered was pure chaos and brutality: flashing metallic swords, hot crimson blood, smoky gray gunpowder, the chestnut gleam of a horse's kicking hide, the indigo of dusk setting over blue-faced, dying men. His fresco would be a swirling, twirling mass of horses and swords and shields and soldiers, a circular design leading the eye round and round, snaring the viewer in a whirl of madness, like soldiers trapped in the never-ending cycle of war.

"Master!" Salaì burst through the door of the salon.

"I'm glad you're here. Come and stand here, like this," Leonardo said, posing in front of the wall as though being trampled by a horse. "I want to see it from across the room."

"We don't have time. We have to go." As Salaì came forward, he left a trail of water on the floor behind him. "It's a flood."

"Where? The square?" Rain often collected in deep puddles in the piazza.

"The Arno." Salaì stood in front of Leonardo and looked up at him. The assistant seemed shorter than usual. Leonardo looked down and realized the young man was not wearing any shoes. "The levees have broken."

Leonardo examined the young man's appearance. He seemed to have thrown on mismatched clothes, without enough time to

button his shirt properly. His hair was dripping wet; his chest was heaving; his nose, ears and eyes were bright red. "That can't be true." Leonardo turned back to the wall. Should he add another horse to the background to amplify the mayhem?

"Master. Men are dying!"

Leonardo shook his head. Every few years, the Arno flooded. The river swelled and crested over its banks. It rose a few feet, sloshed up against windows, and ruined a few rugs. But no one ever died. "I don't have time for lizards in the bed today, Salaì."

"This is no joke. Your designs have failed. The construction site is destroyed. The workers . . . men are dead."

Leonardo heard the words, but they did not make sense. "Why would you say such things, Giacomo? Are you angry with me?"

"When the people see this carnage," Salaì said, picking up Leonardo's chalk and sketch paper scattered across the floor, "they'll come after you. We must go." His hands shook as he shoved Leonardo's things into his leather satchel.

His concern touched Leonardo, but there was no reason for it. Even so, just in case a bit of water did wash in from the piazza, Leonardo removed his sketchbook from his belt and took the leather satchel and stashed them into a wall niche high above the floor.

"Come, Salaì," he said calmly. "Let's go down to the Arno, so I can prove that you're wrong."

Outside, the rain came down in silver sheets. The downpour sounded like a mountain of collapsing gravel. Thunder crashed in the sky. Within seconds, Leonardo was drenched. His foot dropped into a deep, cold puddle, and as he walked in the direction of the river, the piazza became a lake. Water swirled around his shins.

The air smelled of silt and mossy sludge. But he knew that once

he reached the river, he would see the levees were holding strong. He had checked on progress at the construction site two days ago, just before the storm rolled in. The men had finished building the dam. The Arno had been flowing gently into its new canal. The old riverbed was down to a trickle. His plan had successfully closed off the route to Pisa. The workers were still reinforcing a few leaking levees and building a viewing platform for interested tourists, but the city was on the verge of planning a celebration. Everything had been fine.

The storm. It had been raining for two solid days.

Leonardo's eye twitched, and he walked faster, to the west, in the direction of the dam. "Hurry up, Salaì," he called. In the distance, over the din of rainfall, he heard a cacophony of screams. What was going on? Was Cesare Borgia attacking? Was a fire rampaging the city?

"Master, please." Salaì ran up from behind and grabbed Leonardo's elbow. "Don't go down there. You don't want to see it."

Leonardo yanked his arm away and splashed through the rising water, now up around his knees. With every step it became harder to move against the tide. Salaì fell behind. "Master. Stop!" he shouted, but Leonardo kept going.

Up ahead, a shadow fumbled toward him. As it got closer, Leonardo saw that it was a woman clutching a child. Her skirts billowed in the water around her. She stumbled and fell. The child screamed. Leonardo sloshed toward her, picking up his knees as high as he could. He grabbed her flailing arm and helped her to her feet. "Did someone attack you?" he asked.

"*Dio mi aiuti,*" the lady cried to the heavens and then pushed Leonardo away. Clasping her baby, she continued down the watery street.

What kind of evil had invaded the city?

"You're going the wrong way," a man shouted, but Leonardo kept pushing toward the river. Other people passed, wading in the

opposite direction. Some of their eyes shone with terror, others fumbled away in a daze, a few wailed uncontrollably. Leonardo wished he had brought his sketchbook so he could draw their fearful faces, but if he had, the notebook would already be ruined.

A large piece of wood bobbed toward him. As the black mass got closer, Leonardo realized it wasn't an inanimate object, but a man cradling a dead girl. The stranger had a large gash in his head. Blood trickled down his face. As the man floated by, Leonardo tried to make eye contact, but the man's gaze was blank and distant.

A wave washed Leonardo off his feet and pushed him backward. He found his footing, but another wave knocked over him again, so he put his head down and swam. At the end of the street, the water was so high, rushing so hard, that he had to grab onto the metal railing of a balcony to pull himself forward. He kicked around a corner and looked up the street toward the construction site.

The rain was falling hard, the sky was dark, and the water was so high and so black that he was disoriented for a moment. He couldn't see anything. But then a bolt of lightning illuminated the sky, and in that flash, Leonardo saw the horrible truth.

The construction site was gone. Boards from the building platforms cracked and tumbled down rapids, along with churning boulders and whipping ropes. Workers, down at the river to help reinforce the dam, had been caught up in the raging tides. Men grasped at the riverbanks and the remaining levees, trying to keep their heads above water. As Leonardo watched, one man, struggling to swim, was hit in the head by a splintered plank. His eyes closed. He sank.

Half of the dam had collapsed, and the mighty Arno River was snaking across the city, desperately trying to find its way back into its original riverbed. Part of the levees stood strong, but he didn't know if the obstruction was making the flood better or worse. If the whole thing failed, the river could find its way home.

There was no outsider terrorizing Florence. There was no fire or invading warlord. It was Leonardo's own designs that had caused this devastation.

Salaì was right. The levees had broken. The city was flooding.

Leonardo opened his mouth to scream, but a wave crashed down, filling his mouth, nose, and lungs with water. He let go of his grip and allowed the raging monster to carry him away.

Michelangelo

there was no outsider to nothing Florence. There was no
fire or invading warlord. It was Leonardo's own designs that had
caused this devastation.

"T he levees have collapsed," a man shouted.

Panicked chatter swept through those eating breakfast at Santa Croce basilica. Michelangelo and his family had been sleeping there since the storm began; the new roof on their new house was already leaking. But at least Santa Croce was a dry, quiet place where he could scribble down ideas for a safer transport for David. And his father wouldn't curse at him as long as they were living inside a church.

"The levees?" Lodovico repeated, a bit of curd dribbling from his mouth. The last few months had aged his father so that he was now slow to comprehend anything.

But Michelangelo understood the implications immediately. "Buonarroto." He knocked over his chair as he bolted toward the door. His brother was working on those levees. If they had broken, he might be in danger.

Outside it was raining hard and the puddles were deep, but there was no sign of a catastrophic flood. Of course, he was a long way from the construction site. He took off at a sprint.

He reached the Arno far upstream of the levees, but already the river had swelled over the banks and was sloshing into the streets. Ignoring the cries of men telling him to turn back, he continued to push downstream. As he worked his way to the west, the water rose and swirled around his legs and hips. He was relieved

he hadn't moved David yet. The cathedral was further inland than city hall. His statue was safer under the shadow of Il Duomo.

Past the Ponte Vecchio, he rounded a bend and, in the distance, finally saw the chaos: a mass of churning, whirling water and rocks and wood and injured men. The Arno was a barbaric beast, rising and falling in merciless waves, drowning men like a broken barrel of wine would drown an ant.

How would he find his brother in that mess?

"Do you see him?" Lodovico rushed up behind him.

"Stay here. You'll hurt yourself." Michelangelo kissed his father's cheek, and then, half-swimming, half-marching, headed toward the ruptured levees. He hoped both he and his brother would be back by his father's side soon. "Buonarroto," he yelled. "Buonarroto!" Not his brother, please God, anyone but his baby brother. He paused to check the face of a dead man bobbing in the water. It was not Buonarroto.

Thank you, God.

Michelangelo kept going.

"Grab the rope," a man called down, flicking a line to him, but Michelangelo waved it off. He didn't want to be saved.

"Buonarroto," he called again. He stayed near the edge of the river so he wouldn't be swept into the tide, too. Holding onto the sides of buildings, he guided himself closer to the former construction site. In front of him, the river was a snake, hissing and wriggling and whipping around the city. "Buonarroto!"

"Over there," a man with a bloodied cheek yelled. He pointed to the north side of the river, where one section of the stone levees was still holding. There, standing on top of the half-collapsed dam, Buonarroto was helping to haul fellow workers to safety.

Michelangelo let out a laugh of breath. The river rushed against his back, but he didn't care. His brother was safe. "Buonarroto," Michelangelo called and waved.

But Buonarroto never saw him. One of the large rocks under his feet twitched. Michelangelo saw it move, but none of the

other men did. They were too focused on pulling their cow-orkers to shore. "Buonarroto," Michelangelo shouted with more urgency, but his voice was lost in the din. "Move! You must move."

The boulder creaked, then settled.

Relief unclenched the vise around his heart.

Then, in one blast, the dam of boulders collapsed. Buonarroto and the other men dropped into the river.

"No!" Michelangelo screamed.

Water and stone ground downstream like the jaws of a beast eating everything in its path. The teeth closed in around Buonarroto and dragged him into its belly.

Michelangelo dove into the roiling river and swam toward the collapsed dam, finally spotting Buonarroto's tuft of brown hair, surrounded by a cloud of red blood. He kicked forward and reached out, but Buonarroto spun away from him. Swimming deeper, his lungs tightened from holding his breath. A splintered plank struck his temple. It stung. Another red cloud. Now he too was bleeding.

Buonarroto sank fast. His eyes were closed. His body was limp. His orange tunic billowed around him like a sail catching the wind.

Michelangelo would not let his brother go so easily.

Lungs burning, he kicked forward. His fingers grazed his brother's arm. He stretched and strained until his fingers latched onto his brother's collar. He pulled up, little by little, until he grasped Buonarroto's arm.

Grazie, mio Dio.

Michelangelo strained upward, searching for the surface, but he suddenly realized he didn't know which way was air and which way was drowning. The water was dark and murky, churning in every direction. He fought the urge to inhale, but he couldn't stop from coughing out air. Large bubbles erupted from his nose and mouth.

Every single bubble rose in the same direction.

That was the way up.

Michelangelo pulled Buonarroto in the direction of the bubbles until his head broke the surface. He gasped in a breath of air and pulled Buonarroto's head out of the water, too.

All around them was chaos. Rapids, rain, tumbling timber, screams of agony.

A wave pushed Michelangelo under again. He held tight to Buonarroto as they spun. He erupted out of the water again and caught his breath. "Buonarroto," he cried, but his brother's eyes remained closed. Michelangelo wrapped his arm around Buonarroto's shoulders and, using every bit of strength developed over years of pounding into marble, dragged his baby brother to shore.

He laid Buonarroto on the dirt and knelt next to him. Buonarroto wasn't breathing. His skin was pale. His lips were blue. "Buonarroto." Michelangelo pounded on his brother's chest. "No, please," Michelangelo sobbed and, like the Virgin at the base of the cross, cradled Buonarroto across his lap.

Leonardo

T he flood waters deposited Leonardo in the Piazza della Santa Maria Novella. He sat on the muddy ground, his beard dripping with river sludge, legs splayed in front of him, as a stream of injured workers stumbled away from the destruction. Salaì found him in the square. "Master . . ." was all he could whisper.

Floods and wars. Wars and floods. It was all the same. A jumble of death and pain and unnecessary chaos. "The first time I ever thought of changing the course of a river, I was fourteen years old," Leonardo said. His voice sounded disconnected from his body, as though he were calling to himself from the back of a cave.

Salaì silently watched him.

"One day, my mother walked me to my father's house on the Via della Stufa. She kissed me on both cheeks and reminded me to always wash. Knowing how I hated to bathe, she told me with a wink that swimming felt a lot like flying. Then she walked away. I still remember her black hair flowing in the breeze as she disappeared around the corner.

"That night," he went on, "as I prepared to sit down for my first meal with my father and stepmother, my father instead took me by the hand and walked me out of that stylish house in that stylish neighborhood and down to another part of town where the

artisans lived. Those streets were darker. The cobblestones of the city streets were gone; I was back on dirt." He pressed his fingers into the mud. Salaì did the same.

"My father knocked on an orange door. A man answered. He had a pudgy face and a stern scowl and a small, pursed mouth. I watched my father exchange money and papers with him; then, without a word, my father left. The man identified himself as the goldsmith, Andrea del Verrocchio." He could still smell the paints and chickens and smelted bronze and sweat of fellow studio apprentices. "My obsession with drawing had landed me my first job. That night, while the other assistants slept in piles on the floor, I crept out and ran to the Ponte Vecchio. Standing on the edge of the bridge, I stared into the moonlight reflecting off the rippling Arno. And then I jumped."

Salaì placed his hand over his.

"I landed in the river with a splash. The water was cold and teeming with mud and algae. I dove under, kicking to go deeper. As I swam, I tried to glide as though flying, my hair and tunic billowing. I wondered how long I could remain submerged before I needed to surface for air. I imagined staying in the river all the way to the Mediterranean. I could spend my life swimming from river to river, and never have to walk on land among men again." He had never been content with following the paths set by others. Even Mother Nature. "That was the first time I ever thought of changing the course of a river."

Leonardo was now a man sitting in the remains of that childhood fantasy. He searched his brain, trying to think of some ingenious plan that could repair everything and save everyone, but he could think of none. Nature was pouring the Arno back into its original riverbed, and it was impossible to stop.

Nothing was impossible, Leonardo reminded himself. He had diverted the river once. He could do it again. He stood and started back toward the river.

"Wait! Master, stop," Salaì called.

He swam his way to the diversion site, near what used to be the edge of the river. He grabbed onto a balcony and pulled himself up. From there, he could get a better view. He needed time to study the situation and think. Splintered boards, sandbags, and boulders tossed along the rapids like pebbles. His mind slotted idea after idea into place, but no solution came out.

He climbed down from the balcony and worked all night. He saved many men. Saw many others die. One of the corpses Leonardo dragged to shore was the mustached Colombino, who had warned him about the dangers of pushing too far and too fast, who had a wife and five children waiting for him at home. He saw Michelangelo desperately pounding on the chest of his brother, that young man who had approached him at the river just a week before. "Buonarroto. Buonarroto!" Michelangelo pleaded with God as Leonardo had never heard someone plead with God before, so when Buonarroto finally spit up river water and spurted back to life, and brother embraced brother, and their hobbling old father found his two sons and sobbed, Leonardo allowed himself a moment of relief.

He also had a brief exchange with that old gray-eyed notary. As the old man fished yet another corpse out of the river, he whirled on Leonardo and screamed, "You and your damned visions of grandeur."

That night was like watching a play. He did what he could to pull a few men to safety, but everything seemed to happen at a distance, as though it were being performed on a stage. He'd felt that way in war, too, watching men cart their dead brethren off the battlefield.

Finally, the rain slowed to a sprinkle, and the river found its way back into its bed. Leonardo had no idea how many men were dead, but the count was high. As the other men dragged themselves home to rest and recover, Leonardo sank into a pool of water and stared out over the scene.

He hadn't meant for this to happen. He had only been trying to give the city an upper hand against Pisa. Protect Lisa and her family. But his arrogant attempts to change the course of a river had failed, and now, he would forever be known as the delusional man who had destroyed Florence with a dream of outthinking God.

Michelangelo

I n a town of fifty thousand, the eighty fatalities from the flood touched everyone. People lost family, friends, and neighbors. Buonarroto lost coworkers, and four members of the family's congregation at Santa Croce died, including one man who had slept on a pallet next to them when they were rebuilding their burned-out house.

If the Medici were in charge, some said, this never would have happened. People were hungry and cold, unable to live in their flooded homes. Florentines were accustomed to floods; minor ones happened almost every year, but this deluge had carried mud and debris far into the city. Water marks rose as tall as men, and mold had already begun to sprout. Rugs, furniture, clothing were ruined. The people had lost so much. That kind of bereavement was a boulder that would take years to uncover and discard.

Late nights, Michelangelo and Buonarroto had taken to keeping each other company after nightmares. They sat in front of a crackling fire in their father's rebuilt kitchen and passed a carafe of watered-down wine. "Tell me again what happened when the rains came," Michelangelo said. Before the flood, Buonarroto had said the levees were as fortified as the city walls. Only moments before the dam broke, the men had been adding more rocks and sandbags to further strengthen them. There must have been a

weakness, but no one knew where. Leonardo had not been seen since the flood, so no one could ask him what he thought had gone wrong.

"The water pushed and pushed, and the levees didn't budge. Not one hair. But then . . ." Buonarroto's voice drifted off as he stared into the fire. "Suddenly, it all gave way. Faster than . . ." He took a long slug of wine. "Faster than Father's temper flares when you mention marble," he said, forcing a laugh.

Michelangelo made Buonarroto tell the whole story twice more, starting with his first days on the job and going all the way through those dark moments on the broken levees. But eventually, the young man's eyelids drooped and stayed closed so long that Michelangelo knew it was time to return his brother to bed.

But a grain of sand was still rolling around in Michelangelo's mind.

The levee had been secure. Perfectly stable. Immovable. Until it wasn't.

Strength and stability were something to aspire to, weren't they? Michelangelo was strong. Although not always the most stable, he admitted, thinking of that night when he was hallucinating as his family carried him to the hospital. But that was only because the pressure had risen too high. The pressure to perform, pressure to finish, pressure to be a master. The pressure had built and built, without any release, until he cracked. Michelangelo had been immovable. Until he wasn't.

And with that, a connection sparked across his mind like a bolt of lightning connects heaven to the earth. Fumbling out of bed, he pulled work boots over bare feet and slipped a wool coat over his nightshirt, and then snuck out of the house and sprinted the whole way to the cathedral.

In the pre-dawn light, David, still hidden under his protective tarp, towered on his transport in the same place they had left him when the rains began. A vandal had snuck into the workshop and

scrawled the Medici coat of arms on David's tarp. Soderini hoped the ground would be dry enough to try again in a week, so they could silence the growing pro-Medici faction.

Michelangelo circled the transport, studying the taut ropes, the massive central pole, the thick truck bed. It was stable. Strong. Immovable. Until one day, it wouldn't be.

Marble was like that, too. It was a hearty rock that could stand for the ages, and yet, with one wrong knock of a hammer or one faulty bump in the road, it could shatter. Same with life. When Michelangelo tried to stay strong, clenching his jaw and bracing against shock, setbacks rattled his mind and his gut; but if he relaxed, he moved like an undulating wave, rising and falling across the sea. It was like his body, Michelangelo thought, jumping up and down. If he landed straight-legged, his bones shook, but if he bent his knees, he came down gentle as a feather.

Michelangelo had been approaching the move all wrong. Now he saw the way, and he had Leonardo's failure at the Arno to thank for the revelation. They shouldn't be trying to stabilize David; they should be trying to destabilize him.

It was time to give David knees.

Leonardo

S peak to me!" Leonardo cried, and sat up straight. His heart was pounding, his linen shirt soaked with sweat. Where was he? His eyes slowly adjusted to the darkness. He was lying in his own bed in his own cluttered studio.

He had been having that nightmare again. Ever since the flood, he'd had the same dream every night. In it, Michelangelo was always raging at the base of Il Duomo, screaming at the dome, demanding that it say something to him, but then, Michelangelo morphed into Lisa, and Leonardo began pleading with her to speak to him. But she wouldn't. Or couldn't. She was trying to tell him something. Something important. *Dimmi, dimmi, dimmi,* Leonardo begged, but the Arno burst over its banks, and a wall of water washed her away.

He swung his feet out of bed and dropped them onto the cold stone floor. His old, bony knees creaked and popped. His feet tingled. He couldn't catch his breath. He had a dreadful feeling he was dying.

Machiavelli assured Leonardo the flood wasn't his fault. It was bad luck, the worst storm Florence had seen in a century. Besides, history wouldn't remember the Arno diversion catastrophe as Leonardo da Vinci's project. Yes, he had designed it, but he wasn't out there directing the men, giving day-to-day orders, making sure the site was safe. He was hardly even involved, he said.

Gonfaloniere Piero Soderini took another tack. He said it must be God's will that things should end this way, and they should all see it as part of a greater scheme whose purpose was still unknown. The families of the dead didn't seem to blame Leonardo either. They stopped Salaì in the streets to relay messages of support. They thanked the master for trying to secure Florence's borders and keep the republic free. Leonardo da Vinci was not the enemy. The real enemies were the French, the Medici, the Pisans.

Leonardo wanted to believe Salaì more than he actually did. Feet on the cold floor, his heartbeat still thumping madly after the nightmare, he caught a glimpse of his face in a looking glass. His graying hair was long and greasy. He had a scruffy beard. He hadn't shaved in weeks. He hadn't bathed either. He no longer cared about his appearance.

Wrapping a quilt around his shivering body, he got up, shuffled across the room, and settled on a stool in front of Lisa's portrait. He spent all of his waking hours working on that picture now. He didn't touch the Battle of Anghiari design or fiddle with the final details of his latest set of flying wings anymore. The only thing that gave him comfort was painting her.

He had not seen her since before the flood. He picked up a leather strap with a magnifying glass attached and strapped it around his head. He had rigged up the contraption to get a closer look at the picture while keeping his hands free to paint. He dipped a thin brush into green pigment and then delicately added a speck to a distant rocky outcropping.

After the flood, Leonardo had transformed the blank background behind Lisa into a vast landscape tilted strangely on its axis. While Lisa was depicted straight on, as though sitting directly in front of the viewer, the background was shown from above, as though from the eyes of a bird. Even though viewers would not know why, the differing points of view would make people feel off-kilter, just as he felt when he looked at Lisa. She and nature were both wild, untamed, ungraspable. So he melded

the lady to the landscape, blending the vegetation in with her hair, rolling the hills to mimic her curves, winding the river around to twist into her scarf. The landscape wasn't a real place or time, but an amalgamation of his memories, a countryside that would never burn or flood, because it only existed in his mind. The background was just like Lisa: beautiful, bewitching, and mysterious.

He had already rendered her facial features precisely: the shape of her eyes, the turn of her cheek, the silky curve of her lips. Usually, such a realistic representation of a subject would have satisfied him, but this time, he yearned to go further. He didn't want to only capture the lady's physical features or the glint in her eye or even her energy in a gesture or movement. No, he wanted to know the lady, as fully as anyone, and communicate her whole person to the world. He wanted to capture her soul.

But Lisa was inscrutable, especially when her husband was watching. How was he supposed to recreate her spirit in paint, when he hadn't even felt it with his own senses?

"Master?" Salaì's voice was soft as a leaf on a breeze. He'd probably been standing there for some time, waiting for Leonardo to take a break. "You received a letter." The young man dropped the note onto his lap, then slipped silently back out of the studio.

A letter? What time was it? He looked out the window. The sun was up. It looked to be midmorning. He had been painting for hours.

Leonardo set down his brush. He picked up the letter and turned it over to find his name scrawled across the front. He recognized the handwriting immediately. The letter was from that damned notary. It was probably a summons holding him legally accountable for all the flood damages and deaths. Leonardo dropped the unopened letter onto the floor and turned back to the painting. He daubed a touch of black onto his brush, leaned in closer, and carefully added a shadow under one of the arched supports of a tiny bridge. When he was a child, he had walked across

a bridge just like it once. It had been a bright, sun-drenched day in the Tuscan countryside. The air smelled of honeysuckle and fresh basil. He had been about five years old. He was running and laughing. He was with his father.

He shook his head and forced the memory out of his mind. The bridge wasn't real, he told himself. He had imagined it. And maybe, just maybe, the flood was only a dream, too.

Eighty men dead. He pulled his shaking hand away from the picture. No need to destroy the portrait, too.

Bending down, he picked up the notary's letter. Then, he got up from his stool, lumbered across the room with his quilt dragging behind, and sank down at his desk. He flipped the letter over and over again, and then placed the unopened note on his desk. He took out a fresh sheet of paper, a duck-feather quill, and well of ink.

Madonna Lisa del Giocondo, he began. He did not know what her response would be, but unless he asked he would never know. He finished and signed the letter, *Distinti saluti, Leonardo da Vinci*, then entrusted its delivery to Salaì, with clear instructions that no one should know of its existence except the lady herself.

Michelangelo
May 1504. Florence

"A re we ready to release him?" Giuliano da Sangallo called. Forty men were using ropes and pulleys to lower the statue, still covered by a tarp, onto a new transport: a simple, flat wooden platform lying across fourteen massive greased log rollers. Bolted to the top of the platform was a strong wooden framework from which David would be suspended using a series of ropes. Standing upright, the statue would ride along in a rope swing.

Michelangelo checked the wooden framework and ropes one last time, and then said, "Okay. Let go."

The men released the statue. As David sank into the rope swing, the wooden framework groaned and bowed under the statue's enormous weight. There was a creak. Then a pop. Michelangelo wanted to close his eyes; he couldn't handle watching the device break and drop his marble to the hard ground below. But he couldn't look away, either. He couldn't even blink.

The wood settled into silence.

David, standing in his hammock, swayed gently in the wind.

"It worked!" Granacci called with a tinge of surprise. Sangallo laughed.

Michelangelo exhaled. *You're ready to march into battle*, he said silently to the stone.

As workers shook hands and slapped each other on the back, Michelangelo called, "*Andiamo*," and the men let out a happy roar. The move could now begin.

As the men pushed the platform forward, two workers removed the rear roller and carried it to the front. The group pushed the platform forward again, releasing another log out the back. At this pace, what was an easy ten-minute stroll from cathedral to city hall would take the men days. But as David crawled forward, Michelangelo could see that the contraption was working. As the transport wobbled over the uneven dirt of the cathedral workshop, David swayed gently in his swing, impervious to the jostling.

A crowd hung over the workshop fence to watch the move. Shopkeepers, maids, farmers, wives, children, all chanted and sang. This was the happiest Michelangelo had seen his fellow Florentines since the flood.

But just as David was about to roll off cathedral land and into the streets beyond, the euphoria ended.

"*Traditore!*" a voice yelled from the back of the crowd, and a bottle hurtled over the workshop fence. It landed at David's feet and shattered. As spectators screamed and ducked, the voice rang out, "*Viva i Medici!*"

Frightened murmurs rumbled through the crowd. *Medici, Medici, Medici.*

Michelangelo had been a Medici family favorite when he was young, and now Medici supporters were attacking him and his art. The world was upside down. He leapt onto David's platform and scanned the crowd, searching for the vandal. "You want to fight?" Michelangelo called. "Step up and fight me face to face."

No one stepped forward. As Granacci and Sangallo picked up the broken glass, a nervous pall fell over the crowd.

"Perhaps we should call it a day," Sangallo said, clearly shaken. Behind him, some of the workmen nodded.

"Why?" Michelangelo asked. David hadn't even left cathedral grounds, and the men were already ready to quit? "The move just started. Why would we stop?"

"Michel, we've made a lot of progress today. The statue is secure in his swing. The transport is clearly a success, but . . ." Granacci climbed up onto the transport and cupped his hand around Michelangelo's neck. He had done the same thing since they were young, whenever they faced difficult times. "David was attacked. Let's stop. Just for tonight."

"Because one cowardly savage threw one lousy bottle?" Michelangelo's pulse thumped in his temple.

"*Figlio mio,*" Soderini said gently. "They may be right. As long as David is on cathedral land, people will be less likely to attack him and risk the wrath of God, but once he has crossed out of the workshop, off holy land, and into the streets beyond . . ."

"This bottle," Michelangelo said, taking a shard of broken glass from Granacci, "proves that David is not safe here, either."

"But at least here, we can lock the gate all night," Giuseppe Vitelli offered. They had taken down the archway to allow David to pass safely out of the workshop, but had left the gate in place to protect the workshop tools.

Soderini and Granacci nodded.

"All right. Say he is safe here tonight. So what?" He couldn't believe they were ready to give up and walk away. Were they really so afraid? "What about tomorrow? And the next day, and the next? And what about when David stands on his pedestal in front of city hall? What about then? You think God will turn His back on David simply because the statue no longer stands on church soil? You think my fellow Florentines will not protect him?" As he spoke, men passed his words to those behind them. The speech trickled through the crowd like a sermon. He hoped the vandals were still in the crowd, listening. "If Florence cannot keep him safe there," he said, pointing to the other side of the workshop's fence,

"then Florence cannot keep him safe at all, and he is doomed to be destroyed. And if he is already doomed, then I might as well smash him myself." He pulled his heavy metal hammer out of his satchel. "I'd rather take his life than let someone else."

"Get a hold of yourself, boy," Giuseppe Vitelli said.

"Michel. Stop." Granacci's tone said he knew his friend was bluffing.

"Today is the day David's journey begins." Michelangelo tossed his hammer into the dirt. "Let him face his battles. Let him rise to the occasion. We move. Now. *Andiamo*."

The men worked for another four hours, rolling the statue out of the cathedral workshop and maneuvering it around its first turn. But as the sun began to set, Michelangelo called work to an end. As much as he wished they could keep moving until the journey was complete, he knew that would be foolish. Everyone was tired, and tired men make mistakes. Even a tiny mistake could lead to David's destruction.

But as the others trekked home, Michelangelo couldn't bring himself to leave.

"*Andiamo, mi amico*," Granacci said with a tired smile.

"What if Soderini is right? What if David isn't safe out here?" The shadowy streets suddenly seemed more menacing than a bad neighborhood in Rome, the ones where not even the prostitutes and pickpockets ventured. "I should stay," Michelangelo said. "It's a nice spring night, no sign of rain."

"David will be fine. And you need your rest."

"I'm too anxious to sleep, anyway."

Granacci put both hands on his shoulders. "You and your health are necessary for the success of this move. Go home. Eat. Get some sleep."

"I can't leave him alone."

Granacci sighed. "*D'accordo*. I'll stay."

"What?"

"You need your rest. I'll stay."

"But you're exhausted, too."

"You're more important, *caro amico*." Granacci stepped up onto the wooden platform and settled at the foot of the rope swing. Michelangelo started to protest, but Granacci cut him off. "Don't bother arguing." Granacci took off his jacket and rolled it up to use it as a pillow. "When we were children, do you think I stole your drawings, gave them to Ghirlandaio, and forced him to take you on as an apprentice, all because I didn't believe in you? This is your moment to prove that I was right. Go home. Sleep. If not for you, then for David."

Michelangelo didn't want to leave David behind. But Granacci would be there to protect him. "Keep an eye on him."

"I'll guard him with my life."

Leonardo

T he door closed softly behind her. She raised her head and lowered the hood of her midnight blue cape. He was standing in the center of Florence's Baptistery, an octagonal building with no interior walls or columns; it was open space. Leonardo and Lisa were alone with no place to hide.

He hadn't known how she would respond to his letter requesting a private meeting in the Baptistery. He had been elated when she wrote back to agree, then nervous when she sent a follow-up note that morning saying it must be that night. Her husband would be watching Michelangelo's giant begin its move, and then be out carousing with other merchants. Machiavelli borrowed a key to the Baptistery and gave it to Leonardo, who used it to sneak in after the priests had locked up for the night. Before Lisa arrived, he'd lit a few candles to supplement the moonlight shining through the oculus in the ceiling.

Now that they were finally face to face, he started to thank her for meeting him, but she spoke first.

"I only came to offer you my sincerest apologies about the"— her eyes drooped with sadness—"accident. I feel your involvement in the project was at least in part due to your regard for me, so some of the blame must fall at my feet. I will spend eternity saying Hail Marys as retribution for the lives lost." She curtsied stiffly and then turned to leave.

"You mustn't blame yourself. I took the job out of pride."

She paused, hand on the door.

"I'm the one who has offended God because I believed myself capable of more than I am. Please. Do not leave." He dropped his voice as though they could still be overheard. "You could have told me that at your house."

"I ordered my servants never to leave us alone again, so I knew we would not have another private moment, even if you did return to sketch me again. I thought I would never have the chance to . . . but then I got your letter . . . I shouldn't have come." She cracked the door open.

"Am I ridiculous?" His voice echoed through the round, empty, marble room. "From an outsider's perspective?"

She turned her head slightly back toward him.

"Please. I have no one else to ask. No one else who might be honest with me."

She paused a moment. "Where is your mother? You should ask such questions of her."

"Dead."

Lisa let the door fall closed again. She looked back at him. Concern clouded her features.

"And even if she were alive," he went on, "she would not have told me the truth. When I was young, she was married to a horrible, drunken man. Not my father. She lied all the time to keep us both safe. At fourteen, I was sent away to apprentice. In those years, we hardly spoke, honest or not." He looked up into the domed ceiling, adorned with a magnificent golden mosaic. "For the last two years of her life, she came to live with me, up in the Milanese court, but she didn't tell me the truth then. She was too deferential because she needed my support. My money. My fame." He returned his gaze to Lisa. "No one else will tell me. Will you? Do I appear utterly ridiculous to the outside world?"

She cocked her head and studied him.

He felt self-conscious under her gaze. His mass of curling gray

hair felt like a wig he wanted to scratch off. He was overdressed: heeled leather boots, stockings, and a short maroon tunic were too much for a clandestine meeting. He was too tall. His legs were too skinny. He shifted his weight awkwardly.

"No. Not to me," she finally said.

He itched his beard. "Do I make you feel like you are"— Michelangelo's voice rang in his ears—"some sort of specimen that I inspect through scopes and lenses and spectacles?"

Again, she paused, as if giving his question proper consideration. "Not exactly, but early on, I did feel a bit like you saw me as an ancient Roman artifact: rare, beautiful, and something to be unearthed and studied."

He remembered sitting in Isabella d'Este's *studiolo*, golden trinkets cascading around him as though he were just another collectible. He hated feeling that way. "Early on? But not later?" He took a step closer. "Later, I was more open?"

Her hands fluttered in front of her chest. "I am a wife and a mother and I cherish those things about myself. I must go. My driver thinks I'm only here to pay tribute to my baby girl." She crossed herself and murmured a quick prayer. "He will wonder what is taking so long."

"I have done something to offend you." He wanted to reach out and take her arm, but he didn't dare. "Please tell me. I do not know. Truly."

She took a deep breath. The sound floated up into the dome like a prayer. "You told me that in order to properly paint someone, you needed to maintain scientific objectivity. You needed to keep your distance."

He frowned. It seemed he really did tell that to everyone.

"But you were already so forward with me. You talked to me, touched me, flirted with me. At first I dismissed it as part of your way as a portrait painter, but when you said . . . well, then I had to assume you did not really want to paint my portrait. You were

too close for that, by your own admission. No, you were trying to tempt me into some godless sin."

He opened his mouth to protest, but found no words.

She pulled the hood of her cape over her head again, dropping her eyes into shadow. "My husband *is* ridiculous. But I am a wife and a mother and I cherish those things about myself."

"Signora Giocondo, I apologize. I was wrong." *About so many things,* he added silently. "I wish understanding human beings was as simple as counting the number of trees in a forest or observing how a bird glides through the air. I wish people were as clear and predictable as science. If they were, I could, indeed, keep my distance."

She peered out from under her hood.

"Do you know how many pictures I have not finished because I knew they would never live up to my own expectations? If I were capable of imperfection, I might have delivered more paintings and have more satisfied patrons. I might have been more content, too."

"So you did not invite me here to . . . ?"

"No. I have done enough of that. I asked you here because I thought you could help me begin again. You said you had a daughter baptized here?"

She shook her head. "She didn't live that long. But three sons, yes." She smiled, soft and knowing, the way only a mother can.

"When I was twenty-four, my father finally had his first legitimate son. It had taken him two wives and countless attempts. The boy was baptized here." He ran his fingers along the smooth marble of the ancient baptismal font in the middle of the room. "I ducked in late, watched from the back of the crowd. When I was born," his tone shifted, as though telling a wonderful story with a happy ending, "my grandfather recorded my birth and invited ten godparents to attend to me. Now, that is an auspicious beginning."

They shared a smile as she joined him by the font.

"I lived this strange life, half-accepted by my grandfather and uncle, half rejected for being the son of a house slave. Half loved by my mother, entirely hated by her husband. Half man, half bastard. My father looked pained every time he saw me. And then a new life began for me in this very room because when the legitimate son was baptized, I was no longer half-accepted by anyone. Do you know why this building is an octagon?"

She raised her chin with confidence, and her hood slipped back off her face. "After six days of work and a seventh day of rest, the symbolic eighth day is reserved for new beginnings. Many baptisteries have eight sides, not just ours." She always knew more than expected.

"For centuries," he said, "Florentines have come here in search of new beginnings. I'm no different."

"You said you went to apprentice at age fourteen?"

He nodded.

"So, you and I were both sent off to work at the same age. I was fourteen when I was betrothed. Francesco was thirty-four, widowed twice, with a son in tow. He likes silk and fine velvet brocades and buttons. I've never known a man to be so enthusiastic about buttons." She opened her cape and showed him the ornate silver buttons running down the front of her dress. "But my family had the old, aristocratic name, while Francesco had the money. The ingredients for a happy marriage." She pulled her cape closed again. "I, too, would love a renewal, to fly away to Naples or Milan or Paris. I would love to see the world and have the world see me, but we both know it is not possible. We have lived our lives. And no flood, no matter how deep, can ever wash them away."

They heard boys, screaming and laughing, in the distance. Whatever was going on, those boys were up to no good. No one was ever up to any good at night.

"I really must go," she said.

"Before you do, would you care to see a picture of my mother?"

She smiled, even with her eyes. "Very much."

He took out his notebook and flipped to the back, where he always carried the same sketches. There was Maria, a brunette ten-year-old girl, his first crush. And Carlotta, Verrocchio's voluptuous maid who took him to bed when he was only fourteen—the first person to do so. Then, the beautiful seventeen-year-old boy Jacopo Saltarelli, for whom Leonardo had been willing to risk jail and exile. He flipped past a sketch of the sleepy-eyed Ginevra de' Benci and drawings of Il Moro's mistresses, Cecilia Gallerani and Lucrezia Crivelli. Leonardo had wrapped all of those women in his arms before immortalizing them in paint. Then came the flowing-haired Juan, a poetic courtier in the Sforza court; Edouard, a pretty French lad who barely spoke Italian but captured Leonardo with his fine eyes; and several drawings of the Marchesa of Mantua, Isabella d'Este. Interspersed throughout were dozens of drawings of Salaì.

Finally, Leonardo pulled out one page. It was a lightly sketched image of a long-nosed, almond-eyed beauty with pursed lips and smooth skin. Hair tied back in a bun, she had a sad look of longing on her face. He handed the drawing to Lisa. He had never shown it to anyone before. "Her name was Caterina. She was brought in from Constantinople as a house slave when she, too, was fourteen years old."

Lisa leaned in to get a better look. She touched the picture, her fingers sliding across Caterina's face.

"I have no wife," he said. "No children. No father. No mother. I have half-brothers who do not acknowledge me. Sisters who do not know me. All I have are my paintings. Which are never finished. Only abandoned." Lisa handed the sketch back to him. He filed it away and closed his notebook. "The older I get, the more I realize how young I still am, but everyone else sees me as this old, wise man, an untouchable, unknowable genius, like some sort of divinity."

"I don't see divinity. For God wouldn't need to build a set of wings in order to fly." She moved toward the door.

"You must tell me. How do you know about that?"

She shrugged. "My family attends church at Santissima Annunziata. We, of course, went up to your studio one evening to see the design for the altarpiece."

Leonardo shuffled through his memories, hoping to recall her face among the crowds of visitors, but he did not find her there.

"Hanging all over your studio were drawings of wings and bats and birds," she said. "It was there for anyone to see."

"But no one else ever noticed."

"I did." She bowed her head. "I am a wife and a mother. And I cherish those things about myself." This time, Leonardo heard those words for what they were: a prayer and a promise to herself and to God. She opened the door.

"Will you meet me again?" he whispered, suddenly afraid that his voice might carry out of the security of the Baptistery.

She paused only a moment before nodding. He caught a glimmer of a smile under her hood. Then, her midnight blue cape flapping in the moonlight, she disappeared out the door.

Michelangelo

Granacci stood in the darkness of the Buonarroti doorway. "It's David," he said, his voice shaking. "He's been attacked."

As Michelangelo got dressed, he tried to calm his father, who had been certain the banging at the door was an official coming to tell the family that they had found Giovansimone's dead body. Once his father was breathing normally again, Michelangelo followed Granacci into the streets. As they ran, Granacci recounted the story. He'd fallen asleep and woken to rocks crashing against the platform. He'd called for help and Giuseppe Vitelli, who lived in a room overlooking the workshop, came running with a torch. Giuseppe's booming voice and ability to throw a rock of his own chased the vandals away.

"Is he hurt?" Michelangelo asked as he mounted the transport and circled the rope swing.

"No. But they might come back." Giuseppe swiped his torch at the shadows.

"I'm afraid we won't know for sure about damage until we remove the tarp after the move," said Piero Soderini.

"What are you doing here?" Michelangelo asked the gonfaloniere.

"Giuseppe sent an assistant to alert the city guards of the attack. When I heard the news, I of course crawled out of bed and

dashed here immediately. You must know you have the full backing of the city against this attack."

"I can't believe you fell asleep," Michelangelo growled at Granacci. "You were supposed to be standing guard." He reached into the rope swing and tried to feel through the protective covering for any breaks. He touched David's arms, hands, and legs. He didn't feel any cracks, but Soderini was right. It was impossible to tell through the tarp. "Who would do such a thing?"

"Medici supporters," Soderini said grimly. "I told you, they don't want David to make it to the piazza."

Michelangelo picked up a rock lying at David's feet. Heavy and jagged, it had the potential to do real damage. "I won't let anyone destroy you," he whispered to the marble. "I'm not leaving," he said loudly, so the others could hear. "If anyone comes back, they'll have to contend with me. And I," he said, pacing the platform like a dog protecting his master's home, "will not fall asleep."

Granacci laid his jacket on the platform. "In case you get cold." He walked away, head down.

Giuseppe left a tinderbox, candle, and small carafe of wine. "Shout if they come back," he said, and marched back to his house.

Soderini stood next to the platform as though planning to stay there all night.

"Go," Michelangelo ordered.

"*Buona fortuna, figlio mio*," Soderini said and quietly shuffled away.

Michelangelo paced for a few moments. Then he yelled into the night, "If you want to hurt him, you will have to do it over my dead body!" His cry echoed down the streets. He hoped it was loud enough to ring across the countryside. "You hear me? You'll have to kill me first."

The echo from his voice quieted. The city dropped into stillness. A sliver of a moon cast blue light across the city. Michelangelo squinted down one street, then another, and another. Shadows obscured corners and crevices. He settled down at David's feet.

"It's just you and me again," he said, although he didn't expect it to stay that way for long. David's enemies would not be chased away by a torch and a few screams. They would be back, and when they were, Michelangelo would be waiting.

He sat up and rubbed his eyes. He shook off the fog that had settled in his head. Where was he? And what had woken him? A rock landed next to him. His eyes adjusted to the darkness. Yes, he was standing guard in front of David. He must have fallen asleep. *Accidenti*, he cursed himself. Another rock hit Michelangelo's shoulder. Laughter echoed down one street, then another. Where were the voices coming from? *Thwack!* That one struck the wooden framework near David's head. This was no dream. They were being attacked.

Michelangelo stumbled groggily to his feet. "*Che cavolo*," he yelled, his heart rolling like a drum at an execution. "Come out and face me, *voi vigliacchi!*"

Another rock hit. More echoing laughter swirled around him. He stood in front of David and tried to bat away the missiles— the tarp would not protect the marble from a direct hit—but they were coming too fast. One rock hit Michelangelo's thigh. Another his shoulder. He ducked before one struck his face.

The next rock struck David's arm. Michelangelo thought he heard something crack. His muscles tensed with rage. Did the attackers expect to take David down with rocks? No. Rocks would never take David down, because David could always take down his enemies with stones of his own.

Michelangelo picked up the rocks and hurled them, one after another, into the darkness. He couldn't see his attackers in the darkness, but he kept flinging stones hard and fast. Months and years and decades of frustration and anger poured out of him. All of the hours carving and sanding and drawing, his father's beatings, Giovansimone's betrayals, Leonardo's sneering face. "Get out of here!" he screamed. "Get out, get out, Satan, get out!" With

every word, he hurtled another rock into the murky blackness, each thrown harder than the last. He and David had fought too hard to survive, and damned if some Medici rebels would ruin it all now. "Out, out, out!" He kept throwing stones, bombarding his invisible attackers, until they stopped throwing rocks of their own and fled.

The streets fell silent again.

Panting, Michelangelo gathered up the remaining rocks and stacked them in a pile under the rope swing. If the enemy returned, he would be ready. There was no way to check David's wounds for blood and declare the statue alive or dead, but for now, he had won.

Leonardo

When he returned to his studio, he was surprised to find it empty. Salaì must be out for the evening. He sat down in front of Lisa's portrait and stared at her expression, but still could not feel her there. Over the next two hours, he added three more tiny brushstrokes to the dark silk of her gown.

Finally, Salaì came home, his shoes dirty with fresh mud. "You won't believe what I have done." His eyes shone with passion. His face was flushed. His chest glimmered with sweat.

"You look as though you have been lingering down on the Via del Bell'uomo," Leonardo said, setting down his brush. If Salaì—Giacomo—wanted to indulge his desires with men his own age, Leonardo should not only allow it, but encourage it. He couldn't always expect such a young, virile man to tend to the needs of his aging boss, and he didn't want Salaì to become like his mother, spouting lies in order to keep a roof over his head. "I hope you know, Giacomo, that I will continue to support you, even when you surrender to your passions elsewhere."

The young man laughed. "Master . . ." He took off his jacket and dropped it to the floor. "It's nothing like that. I made your wish come true tonight."

Leonardo watched Salaì approach, his shirt sliding off of his shoulder. "And what wish is that, my mischievous inamorato?"

"I have destroyed the statue before the public has had to endure it."

The smile fell from Leonardo's face. "What?"

"I am a giant slayer," Salaì said with a lopsided curl of his lips.

Leonardo stood up. "What did you do?"

"I recruited friends to help. Earlier in the day, an actual Medici supporter threw a bottle, so everyone will blame them. No one will ever suspect me."

"But what did you do?" he demanded, louder this time.

"We threw rocks. The first time"— Salaì's eyes were still bright with excitement—"we were chased away quickly, but when we came back for the second round, we were ready. We threw hundreds of rocks at that marble, Master. They rained down in a flood." Almost immediately, his face fell. "*Mi dispiace*, I didn't mean to call it a flood . . ." He dropped to his knees. "But it was a lot of rocks. The David is surely dead, and it is all because of you."

As Salaì stared up at him with large brown eyes, Leonardo was reminded of his mother's funeral in the sanctuary of Santa Maria delle Grazie. At the time, he was painting his *Last Supper* just down the hall. A silver cross sat atop a plain wooden coffin, resting on a simple bier. In honor of his place at court, Il Moro stopped in for a prayer, and other Milanese friends—architect Donato Bramante, mathematician Fra Luca Pacioli, and psychic chemist Zoroastro— stayed and said nice things about Caterina. After the service, Leonardo returned to his studio, recorded the expenses in his notebook, and when he was done, found fifteen-year old Salaì, kneeling in front of him, eyes wide and brown, staring up at him. It was that moment when Leonardo first leaned down and kissed the lad.

Now, nearly nine years later, Salaì looked up with those same eyes.

"I didn't want you to harm that statue," Leonardo said, dropping heavily into his chair.

The joy fell out of Salaì's face. "Yes, you did. You told me so. After the committee meeting, when the city decided to raise it in front of city hall."

"I did? No. I didn't."

"You said—" Salaì paused to reconstruct Leonardo's exact words. "You said you wanted it destroyed before anyone else had to endure it."

Leonardo felt his brow wrinkle. "If I did say that, I didn't mean it. I was angry."

"You did. You did mean it. I heard it in your voice." Salaì suddenly sounded hoarse. "So I did it. I did it for you."

Leonardo grasped onto the sides of his chair. The room spun as if he had just been twirled in a hundred circles. "What has provided my livelihood, paid for our food, our studios, your clothes? What dropped a lifeboat down to me when everyone else was trying to kick me back into the surf? Art is my tormentor and my heart. My passion and my slave driver. I could no more destroy a piece of art than I could kill you, Giacomo. Destroying the David. Why? Why would you ever do such a terrible thing?"

Salaì tilted his head and looked up at him. "For love, Leonardo. Why else?"

Michelangelo

After that first night, Soderini appointed a troop of soldiers to stand guard over the statue, and the vandals didn't return. Michelangelo wouldn't know whether they had inflicted a fatal wound until he removed the tarp, but he couldn't waste his time obsessing about that; he had too much work to do. Despite the fleet of guards, he hardly slept, keeping constant vigil over David, moving log by log over the uneven, winding streets. Along the trek, they faced down squawking chickens, protruding balconies, garbage tossed from windows, braying mules, and even a runaway horse, but David survived them all and finally, on the fifth day, rolled into the Piazza della Signoria.

After five days of crawling down narrow, dim streets, it was a relief to finally enter the wide, open square. Dozens of Florentines waited near David's pedestal to witness the moment, and when the colossus, still hidden under its tarp, rolled into the square, the people cheered as if welcoming a hero home from war. Walking behind the transport, Michelangelo felt excitement sizzle up his spine like a lit fuse. This piazza was the heart of the Florentine Republic, where government officials went about the work of liberty and citizens held annual festivals to celebrate their independence. It was fitting that his David would stand guard.

It took those forty men another week to roll the transport to the front of the palazzo, lower David from his rope swing, and then use a system of pulleys to hoist him up and set him gently on his marble pedestal. It took another three days to construct a wooden scaffolding and erect another privacy shed, so they could remove the tarp and inspect the marble for injury without anyone seeing the statue. Only if David had safely completed the move without any damage would the city prepare it for the official unveiling. Michelangelo prayed that whatever damage they found, he could fix.

Finally, the day of the inspection arrived. On the steps of the palazzo, Michelangelo prepared to step into the shelter and cut off the protective tarp. Granacci, Soderini, Giuseppe Vitelli, Botticelli, Perugino, and Giuliano da Sangallo all waited with him. It was a small group. No one wanted word of a broken arm or split knee to spread through the city before they could decide how to repair it. Nausea churned in Michelangelo's stomach. Black spots flickered in his vision. He shoved his hand into his pocket and kneaded a pile of marble dust to calm himself. This was no time to faint.

Piero Soderini nudged Michelangelo toward the door. "*Buona fortuna.*" Granacci handed him a lit torch.

Ears ringing, Michelangelo took the flame, stepped into the wooden shelter, and closed the door behind him.

Once he had removed the tarp, once he had examined every inch, once he had come to terms with what he saw, Michelangelo stepped out of the shed.

At first, he couldn't speak. When Soderini saw his face, he groaned. "Oh no. It's bad. Can you fix it?"

He found his tongue. "God."

"Oh no. It's completely ruined, isn't it?" Sangallo said. "It is my fault. Instead of the ropes, we should have—"

"God saved him," Michelangelo said.

"What?" Granacci asked.

"God. God must have carried David here in the palm of his hand." Michelangelo said, his voice growing louder. "God must have stood between him and those stones, because I swear there is no other explanation for what I have seen. That marble doesn't have a scratch on it."

Soderini grabbed the torch and lunged into the shed. Giuseppe Vitelli followed.

"Really?" Granacci said. "I thought for certain . . ."

"It's true," Soderini called from inside the shed. "Not one blemish."

Michelangelo's throat tickled. From deep in his gut, a chuckle erupted. One, then another and another. Soon, he was laughing like he hadn't laughed since he was a child. Granacci, Sangallo, Perugino, and Botticelli all joined in. The men laughed until tears sprang from Michelangelo's eyes and fell down his cheeks.

One by one, each of the men ducked in and out of the shed.

"It's extraordinary," Giuseppe Vitelli declared. "I can see my reflection in the stone."

"Look at that furrowed brow and those piercing eyes," Perugino exclaimed. "He's fearsome."

"I swear his veins are pumping real blood," Botticelli said.

Soderini examined the statue the longest, and then said, "His nose, in proportion to the rest of his face, is a little . . ." He waved his hand as he searched for the word. "Thick. Is it not?"

"What?" Botticelli gave a look that seemed to say that men with power and money always fancied themselves just as ingenious as men who devoted their lives to the arts. Michelangelo blamed himself and the other artists; they made the work look too easy.

"I think you should adjust it a little," Soderini suggested.

Granacci grimaced.

David had survived a harrowing move and Medici rebels, but now he would be destroyed by the bad opinions of a politician? Michelangelo sucked in a breath to tell Soderini to go to hell, but he chewed up that impulse and swallowed. Gonfaloniere Soderini was his patron. He had the power to lock David away for all eternity. If Michelangelo wanted his statue approved for public display, he had to please the man, no matter how ignorant. "Why sir, I think you're right." Michelangelo did his best to mimic that infuriatingly charming lilt Leonardo always had in his tone.

"Michel," Granacci said. "The nose is fine."

"Let's see what we can do about that." Michelangelo pulled his hammer and chisel out of his satchel and approached the statue.

"Wait, Michelangelo, don't," Botticelli said, and turned to Soderini. "I'm sorry to offend, sir, but I do not believe the young man should change anything. The statue is perfect as is . . ."

"Nonsense, Maestro Botticelli," Michelangelo said, climbing the scaffolding to reach David's head. "Gonfaloniere Soderini has one of the finest aesthetic eyes in the country. If he says the nose is wrong, the nose must be wrong."

"Michel," Granacci whispered, "no."

"Please. Allow me to work," Michelangelo said and placed his chisel against the tip of David's nose. He tapped his hammer against it.

As marble dust drifted to the ground like snow, Botticelli buried his head in his hands. Granacci groaned.

Soderini smiled triumphantly. "Your decisiveness is inspiring, young man."

Michelangelo blew a bit of marble dust off the nose and wiped it clean with a rag. He descended the scaffolding and slung his arm around Soderini's shoulders. "*Molto grazie*, Gonfaloniere Soderini, you were right."

"So glad I could help," Soderini responded with a self-satisfied grin, and then stepped closer to get a better look at the results of his suggestion.

As the artists all huddled around Michelangelo, Granacci whispered, "What did you do?"

"Nothing." He opened his hand to reveal a pile of marble dust he had pulled from his pocket. As he'd pretended to chisel the nose, he had let the dust fall from his hand. It was easy to convince Soderini he was altering the statue, when in fact the only thing that changed was Soderini's perception. "Always let the patron think they are smarter than you."

"I'm telling you, that one little cut made all the difference," Soderini crowed. "David's face is now ideal."

"You do have an impeccable eye," Botticelli exclaimed, walking over to Soderini. "I hope you will order a painting from me soon, so I, too, can benefit from your brilliant artistic vision."

Soderini pulled a leather sack out of his pocket. "Here." He dropped the pouch into Michelangelo's hand. "You deserve it."

"What is this?" He untied the sack and looked in. He had never seen that much gold.

"Consider it a bonus. For a job well done."

That was enough money to set his brother up in any kind of shop he wanted so he could win Maria's hand before another suitor took his place, buy his father a fine suit, purchase new furniture for the rebuilt house, and still have plenty left over.

As the other men began discussing plans for a festival to commemorate the unveiling, Michelangelo ducked out of the shed and looked out over the empty piazza.

His family would be overjoyed with the money, no doubt, but a sack of florins was not important, nor was the approval of a handful of supporters and friends. To hear his fellow Florentines cheer his statue, that would be his moment to celebrate, not before. Because if the people didn't embrace David, all of this—the money, the joy, the relief over the successful move—would mean nothing.

Leonardo
Summer

As they strolled across the Piazza della Signoria, Lisa tucked her hand in the crook of Leonardo's elbow. The heat of her skin, separated from his by only her thin lace gloves and his silk tunic, was thrilling. Her smell, a mixture of primrose and citrus, made him feel intoxicated, although he hadn't had a sip of wine all morning.

"But you have seen it," she said, stepping over a pile of horse manure. The piazza was crowded with horse-drawn carriages, government workers, and pedestrians.

Leonardo shook his head. "When I viewed it, he had barely begun roughing out the figure. It was nothing. Machiavelli described it to me—he saw it just before the polish—but he's a politician, not an artist, so his description was obtuse. I don't know what it looks like now. I will see the finished product with everyone else."

They were walking near the entrance of the palazzo, in front of Michelangelo's statue, which was still hidden behind a protective shelter. Giving the lady a preview of the sculpture was the latest of Leonardo's excuses to see her without her husband. They hadn't yet been able to schedule another private meeting, like the one in the Baptistery, but had managed to arrange a few public outings like this one.

"But if it is finished and standing here, why wait until September to unveil it?"

"Soderini wants to make a statement about Florence's independence, wealth, and power. He is making a production out of the thing, planning a parade and welcoming dignitaries from all over the peninsula. Even the pope is invited."

"Do you think he'll come?"

Leonardo shrugged. "If Soderini has any hope of Il Papa venturing up to Florence, he must give the man time to prepare. Besides, there's nothing like making people wait to build up their anticipation."

"Is that why you refuse to show me my portrait? Are you trying to build my anticipation?" Her long gown rustled against his leg.

"I would never tease you so, my lady. I'm simply not finished yet, and the subject of a portrait should never see the picture until it is complete."

"If you aren't finished, why don't you draw me anymore?" she asked, as they strolled through the covered loggia, among a forest of marble statues looming like great old oaks.

"No need. I have drawn your features a thousand times and already captured them beautifully."

"So what do you still lack?"

"I now need to capture your soul."

She paused in front of an ancient Roman statue of a seated woman whose head and arm had both been broken off and lost to time. "But you cannot see someone's soul. So how can you represent it in a picture?"

Ah, the question that leads to everything. He started to respond.

"Signor Leonardo," a voice interrupted.

Lisa removed her hand from his arm and stepped back a pace.

The intruder was a young man dressed in a conservative dark brown jacket and wide-brimmed hat. He had a jaw as strong as Leonardo's and steely gray eyes. Leonardo recognized him

immediately, but could not recall his name. He had blocked it from memory. Arturo? Antony? Antonio. Of course, Antonio, how could he forget? The young man bowed politely, but Leonardo did not return the gesture. "I have been searching for you. I have news," the young man said.

Leonardo's eyebrow rose slightly, but other than that, he gave no response.

"It's about my father," Antonio continued.

"You know I don't care about that damned notary. *Andiamo*, Madonna Giocondo, I have more art to show you." He took the lady's elbow and marched her back down the loggia.

"Who is that?" she whispered.

But before he could respond, Antonio called after them, "At the seventh hour this morning, my father entered the great sea."

Leonardo stopped walking, but did not turn to face the young man. Instead, he took in a deep breath. The loggia smelled of old urine and mold. Why had he brought a lady on a walk through such filth?

"I thought you should know," Antonio stated simply. Leonardo listened as the young man walked away, his footsteps marching into the distance until they faded altogether.

"Who was that? Who has died?" Lisa asked.

"No one." He gazed off into the distance.

"It is not no one. You're clearly upset. Please, you must sit down. You're pale."

She took him by the arm, but Leonardo brushed off her hand. He did not want to be touched by anyone.

He looked down at the bejeweled bird ring adorning his left hand, the one given to him by the King of France in support of his experiments in human flight. If that damned notary had heard about his plans to fly, he would have denounced Leonardo as a threat to humanity. "Beg your husband for my forgiveness, for sending you home without an escort." He gave a curt nod, and then strode out of the piazza.

Was it possible? Was that gray-eyed old devil truly dead? Leonardo approached the four-story beige town home. Above its purple door, black wool hung in the windows, announcing the family's grief. He had never been invited inside that house, and he would not ask to enter on that day either. He was content to settle on a stoop across the Via dei Rustici and watch from afar.

Hours passed. The sun crossed from east to west and dipped toward the horizon.

As the sun lowered in the afternoon sky, mourners began gathering in the streets. The bereaved all wore brown. The men ripped their tunics while the women wailed to the heavens and pulled out their hair in handfuls. Why did human beings succumb to such overwhelming grief when death was an inevitable part of life? The greatest honors and ceremonies were always paid to men when it was too late. No amount of screaming would bring one back from the dead.

That damned old notary wouldn't want Leonardo's tears anyway.

At dusk, the grievers began lighting torches, hundreds of them, as though attempting to light the way for a man who had lost the power of sight forever. The purple door opened and a procession of mourners left the house. They wept and shrieked and tore their clothes even more violently than those in the streets had. Leonardo watched as five sons carried their father's body on a board raised above their heads. Lying flat on his back, the deceased was dressed in a bright green tunic and covered in a blanket of white lilies. Leonardo scrutinized that aquiline nose, the pointed chin, the wide forehead, the long neck. No doubt, that was the notary. And no doubt, he was dead.

"There will appear gigantic figures in human shape," Leonardo said in the cadence of a prayer. It was the same riddle he had told the old man before setting off for war. "But the nearer you get to them, the more their immense stature will diminish." Leonardo never had the chance to tell him the answer. "The shadows cast by

a man at night with a lamp," he whispered as the sons carried the body around a corner.

The procession was gone.

Leonardo leaned heavily against the side of the building. There was no reason for him to follow the mourners. He had not been invited to the funeral. He stood on the stoop and listened as the wailing grew quieter and quieter until it faded completely.

A word flitted through Leonardo's head. It was a word he didn't like to use, one he'd always wished would simply cease to exist, and it had been decades since he had applied that word to the old notary. But now he could think of nothing else to say. He opened his mouth and whispered to the wind, "*Arrivederci*, Father."

The sound of the wind hummed in Leonardo's ears as he walked back to Santa Maria Novella in a daze. He ascended the stairs and strolled into his studio without acknowledging the two people waiting for him: Salaì and Lisa.

How did Lisa know where his studio was? Had she waited there all day for him?

"Sir. Are you all right?" Salaì grabbed Leonardo's elbow and guided him toward a chair.

Leonardo shrugged off his hand and kept walking past the front room, into the private chambers beyond.

Lisa followed. "Why didn't you tell me it was your fath—"

Salaì cut her off with a cry. "Don't!"

Leonardo grabbed a lit candle and sat down at his desk.

"Are you all right? Is the lady telling the truth? Is Ser Piero truly—" With a shaking hand, Salaì poured a glass of wine and set it down next to Leonardo. "Please. Speak to me."

Leonardo pulled out a sheet of fresh paper and a quill. He had been ignoring his finances for too long. He needed to catch up. Over the last few days, he had given three *soldi* to Salaì for a box of sweet fritters. Spent one florin on a new studio chicken. Ten *soldi* to Salaì for wine. Another fifty on paint

supplies. Five ducats on Salaì's newest wardrobe. He spent a lot of money on Salaì.

"Leonardo . . ." Lisa sighed.

He dipped his quill and, next to that list of mundane accounting, wrote, *On Wednesday at the seventh hour Ser Piero da Vinci died, on the ninth day of July 1504.*

He caught a glimpse of himself in a mirror hanging over the desk. For the first time, he noticed that he didn't resemble his father nearly as much as his mother. He wondered, whenever Ser Piero had looked at his eldest son, had he seen the woman he once loved—but could never marry—staring back at him?

A memory tickled Leonardo's brain. He set down his pen and searched through a stack of loose papers. It wasn't there. He flipped through another stack. Still nothing. He rifled through his desk, looking through compartments, drawers, and clutter. Where was it?

"Can we help you find something?" Lisa asked, gently taking a stack of pages from his hand.

"Leave us be." Salaì grabbed the papers from her. "He doesn't need you."

Crumpled in a back corner of a nook, Leonardo finally found what he was looking for. He carefully removed the letter and smoothed it out. There was his full name, written in that familiar hand. "Leonardo di Ser Piero da Vinci." It was the letter Ser Piero had sent after the flood. Leonardo had never opened it. He turned it over. On the back, he had absentmindedly sketched a design for a flying machine.

He unsealed the letter. Scanning it, he saw this was no summons or castigation for his crimes. The letter did not mention the flood or any of Leonardo's failures. It was a short note, describing Ser Piero's physical ailments and monetary concerns. It closed with a suggestion that Leonardo stop by the house for dinner.

He dropped the letter to the desk. "Observe the flame of a candle and consider its beauty."

"Sir?" Salaì whispered.

"Blink your eye and look at it again. What you see now was not there before." Leonardo waved his fingers through the flames of the candle on his desk. "And what was there before is not there now. Who is it who rekindles this flame which is always dying?" He and Ser Piero would never make amends. It was impossible to go back.

Impossible. Leonardo hated that word.

He pushed his chair back from his desk, the legs screeching across the wooden floor. He crossed the room in three long steps and pulled back a tarp. Underneath was a pair of giant bat wings made out of cypress wood and linen.

"Master? What are you doing?"

Leonardo folded up the wings into a long tube and heaved it onto his shoulder.

Salaì stepped in front of the door. "I won't let you."

"Get out of my way."

Salaì folded his arms across his chest and widened his stance. "No."

Leonardo swung the long wooden wings around toward Salaì's head. As the tube spun, it crashed against shelves, knocking off books and beakers. Salaì ducked. Leonardo dodged one way, then the other, and ran out the door.

"Master, wait," Salaì called. "Those wings aren't finished."

Bat wings dragging in the dirt behind him, Leonardo stumbled to the top of a hill overlooking Florence. A full moon lit up the wilderness. The hill was covered in long, soft grass. Trees blew in the wind, bending like the backs of old men. In the distance, the Arno curved gently, and Florence glittered with candlelight.

"Master," Salaì called from a distance. Leonardo looked behind. Salaì and Lisa were chasing him.

He had to work quickly. He dropped the wings near the edge of the cliff and unfolded them, carefully stretching each wing out

to the side. When he designed the wings, he had expected Salaì to help strap them on. His fingers shook as he secured one leather strap to his right arm, and then fumbled to attach the left.

"Master, stop!" Salaì was getting closer.

The wings weren't tied as tightly as Leonardo would have liked, but it would have to do. He was out of time. As he clambered to his feet, the wind whistled and caught in the wings. The fabric expanded. Arms bending backward, Leonardo pressed forward. At the edge of the cliff, he planted his feet and steadied himself. He stood under the full moon, wings billowing out wide, and gazed out over Florence.

When he was a boy, he awoke one morning in his crib in front of a farmhouse he'd never seen before. Across the yard, he saw his father screaming and his mother sobbing. There was a strange man with them. He was tall and brutish, with a red face. "You can't make me marry that man," his mother cried, pushing herself away from the stranger. "I want to marry you," she begged, grasping onto his father's tunic.

"I cannot marry you," his father had said. "I have a duty to take a wife worthy of my station." As his mother called, "You don't love her," Leonardo's father walked away. Then the beastly stranger struck Leonardo's mother across the face.

Leonardo remembered looking up into the blue sky and seeing a large bird of prey circle the yard. He liked the bird. It was strong and powerful, and it floated up in the sky on expansive feathered wings, far away from the mud and the dirt and the screaming. Then the bird's wide yellow eyes spotted him, and the animal dove toward his crib. He was so fascinated by the bird careening toward him that he didn't scream, not even when the bird opened its hard, gray beak as if to bite him. The animal stopped midair, bent its body around, and smacked Leonardo's mouth with its large, feathered tail. He could taste the earth and grime caked onto the feathers. The bird stopped and hovered over him. In that

moment, Leonardo knew that one day he would fly high into the sky with the birds and never come back down.

Finally, at fifty-two years old, Leonardo was fulfilling his destiny.

He backed away from the cliff to get a running start.

"Leonardo, no! You'll hurt yourself." Lisa and Salaì rounded the top of the hill and ran toward him.

The time for thinking was over.

Leonardo sprinted to the edge of the cliff and jumped. His feet left the ground. His wings caught the wind, lifting him like a leaf toward heaven. As the earth passed smoothly under him, he pressed his chest out, arched his back, splayed his fingers, and pointed his toes to mimic that soaring bird from his youthful memory. Years ago, he had finally identified the bird that had smacked his mouth with its tail: it had been a kite, a great bird of prey, the same form the Egyptian goddess Isis took when resurrecting the dead. Tonight, he was that kite.

He was flying. His lifelong ambition, his waking dream. He wanted to twirl and spin joyously, diving, then climb back up into the clouds like a real bird, but he did not dare try. It was enough to glide along with the wind. From up there, he could soar through the air, move rivers, speak to the dead, make the impossible possible.

His right arm shuddered.

What was that? Leonardo looked over, but a cloud had passed over the moon. It was too dark to see anything.

A tie on his left arm had come loose. He dropped a few feet, and his stomach lurched, but the wings caught wind again.

A crack resounded as the wood frame split.

Leonardo looked down. Falling now would be like leaping from a bell tower.

The wings tore from their frames. Air screeched by his ears, up his nose, into his mouth. He was no longer flying. He was falling.

"Leonardo!" he heard Lisa scream.

Tattered fabric flapped helplessly around him. Wood splintered. Wind thundered. He flapped his arms, kicked his legs, anything to slow down, but the earth came closer and closer. He had been born too early, at the wrong time, in the wrong place, to the wrong people. One day, someone would learn to fly, but it would not be him.

As he plummeted, Leonardo saw Salaì and Lisa sprinting toward him, but he knew they would never catch him. His deepest regret was that they had witnessed his final failure.

Lisa was right. Some things were impossible.

"*Mio Dio*," Leonardo shouted. As he struck the ground, everything went black.

Leonardo didn't remember Salaì and Lisa running to his side or carrying him back to the studio. Salaì told him they tried to salvage the pieces of his wings, but there was nothing left to save. Leonardo vaguely recalled emerging from the darkness, lying in his bed, and screaming with pain, but it was a fleeting memory and probably best left unrecovered. Salaì, not Lisa, nursed him back to health. That he remembered. Leonardo's left eye was swollen, his shoulder throbbed, and his right ribs ached constantly, except when he moved or breathed, at which time a sharp pain shot up his whole right side.

Gradually, he healed enough to sit up and eat and ask Salaì to trim his scruffy beard and hair. After a couple of weeks, his bruised body stopped aching long enough for him to crawl out of bed and sit in front of his easel to work on Lisa's portrait.

He was sitting there, brush in hand, when he heard someone push open the door to his studio and creep inside. He turned to see Lisa standing in the doorway, wearing a forest green silk gown, a breeze of jasmine wafting in with her.

Salaì hurried over and turned the easel around.

"It's all right." Leonardo groaned as he tried to rise from his chair to greet the lady. "If she wants to see the portrait, she can." Grimacing, he pressed a hand against his aching side.

Salaì and Lisa rushed to his aid, each taking one arm. "Is it finished?" she asked, as they helped him into a more comfortable chair.

"No."

"Then I'll wait."

Salaì arranged a pillow behind Leonardo's back, then backed out of the studio. "I will leave you." He was even gracious enough to close the door behind him.

Silently, Lisa walked around the studio. She ran her fingers along a metal scalpel, gazed at a wooden model of a giant underwater war ship powered by twenty oars, and stepped into and out of the eight-sided mirror box. "I'm sorry about your father," she finally said, as she leafed through a notebook filled with drawings of his last, nearly fatal, set of wings. Leonardo wondered what she thought of those designs now that she had seen them fail.

"There is nothing to be sorry for. I hardly knew him."

"That man we met in the loggia, who told you the news," Lisa said, gently closing the notebook. "Your brother?"

"Ser Piero's first legitimate son."

She sighed, and he knew she was thinking of their night at the Baptistery. "I am sorry."

"There is nothing to be sorry for. I hardly knew him," he repeated.

"Men will fall from great heights without harming themselves. They will come upon unknown destinations in the sky, then flee in terror from the flames that pour down . . ."

Leonardo was confused. What was she talking about? Why was his brain so muddled and cluttered these days?

"They will hear animals speaking in human language," she went on. "Their bodies will glide in an instant to various parts of

the world without moving. In the midst of darkness, they will see the most wonderful splendors. What is it?"

"What?"

"The thing I described. What is it?"

"You came here to ask me a riddle?"

She nodded.

"Well. Let me think," he said, settling gently back in his chair, careful not to jar his aching ribs. "Men see wonderful splendors and hear animals speak?"

"Yes."

"And fly, without harming themselves . . ."

"That's right."

There could only be one answer. "Dreaming."

"You should try it sometime instead of jumping off mountains," she said wryly.

He chuckled and pain shot up his side.

She helped him adjust his pillow, and her expression turned serious. "You could have died." She laid her hand on his. The feel of her fingers against his bare skin radiated across his body like a song echoing through a cathedral.

"I did not fly."

"I saw that."

"And I never will."

Lisa knelt in front of him. "I know."

Forgetting his pain, he leaned toward her. "Thank you. For saving me."

"Thank you. For seeing me." She sighed. "I cannot visit you again. I am a wife and a mother and I cherish those things about myself."

"I know." He wanted to beg her to run away with him. He would take her to the Far East or to Rome or to France. "Some things are impossible."

Their eyes locked. Falling into the well of her pupils was like dropping into a bottomless cave. Suddenly, she put her hands on

his cheeks, pulled him toward her, and pressed her lips onto his. Leonardo could think of nothing, could only taste her minty lips, hear her soft moan, smell the jasmine in her hair. In that moment, he was everything and nothing. He was of the world and beyond it. He was no longer his own; he was hers, and she was his.

Lisa pulled away first. His lips parted from hers reluctantly. He opened his eyes in time to see her stand and square her shoulders like a ship righting itself after a storm. *"Arrivederci,"* she whispered and headed toward the door.

Perhaps it was best that he was injured. He couldn't chase after her.

At the door, she stopped. Resting her hand on the knob, she turned back one last time. The sadness faded and the hint of a smile began to flicker across her lips; her eyes started to crinkle with happiness. He could see the memory of their brief passion in her expression. It was their secret. She would carry it with her forever, and in those moments when she remembered, she would be his again. She would always be his. He waited for the slight upturn of her lips to spread fully across her face, but that half-grin never broke into more. Instead, with the hint of a teasing smile still lingering on her lips, Lisa turned and walked out the door.

Michelangelo

Michelangelo rubbed David's right hand with a cloth, rhythmically working from the palm all the way down to the tip of each finger. He spit on the rag and gave the knuckles one last wipe, and then stepped back to survey his work. Though the statue was hidden inside a dim shed, the marble gleamed. Imagine what David would look like under the bright light of the sun. "I'll be back tomorrow," he said. He planned to return every day until the unveiling, scheduled for less than a week away. He wanted the marble to be immaculate.

Slipping out of the shed, he nodded to the guard, who was posted to protect the statue from vandals and keep curious citizens from stealing a peek. Florence was abuzz with rumors about the statue. Some were even attributing magical powers to the marble. Michelangelo tried to appear calm, but his nerves were growing in concert with the soaring expectations. The greater the expectations, the less likely his statue could meet them.

Merely thinking about the unveiling made his neck sweat. All around him was a bustling construction site as workers rushed to finish the temporary stage, and men carried in more than twenty-five chairs to hold all of the dignitaries scheduled to attend.

"Michel!" Granacci called, waving frantically as he hurried across the piazza. "Michel!"

Michelangelo groaned. He couldn't handle another crisis. Not now.

"You might as well hear it from me." Granacci climbed up onto the makeshift stage. His face looked grim.

Michelangelo leaned against David's shed for support. He feared Granacci had come to tell him his family was boycotting the unveiling. Michelangelo had yet to tell them about the payment he'd received for completing the statue. He'd planned to show them the sack of gold at the official ceremony, the ultimate cap to the celebrations. He'd invited them to the event, but they hadn't told him whether they were attending or not. He'd asked them at dinner the night before and again at breakfast, but got no response. If his family did not show up, his triumph would be dampened.

"It's Leonardo," Granacci said.

Michelangelo frowned. Ever since the flood, Leonardo had practically disappeared. He had been spotted around town only once or twice. "What can that old man do to me now?"

Granacci took a deep breath. "He's revealed a new picture."

"What?"

"People are already lined up around the block to see it."

"And on the eve of my victory, *naturalmente.*"

"They say it's a miracle to behold."

"Let me guess. The city hall fresco." Michelangelo released a vanquished sigh. Leonardo's *Battle of Anghiari* was already famous, even though the maestro had yet to touch brush to wall. It was supposed to be a symbol of Florentine strength and independence, housed in the Palazzo della Signoria, the same building David had been charged with guarding. If Leonardo had managed to finish the picture, no one in Florence would attend David's unveiling, unless they happened to witness it while waiting in line to see Leonardo's newest masterpiece.

"No, not the fresco," Granacci said. "It's a portrait."

"Of who?" Who had Leonardo painted to make Granacci turn so pale? The King of France? The pope? God himself?

"A housewife," Granacci said in a tone of dread.

Michelangelo laughed. "You had me frightened, *mi amico*," he said, slapping Granacci on the back. "Calm down. It's only a little painting. How magnificent can it possibly be?"

Leonardo

Looking down at the sun-drenched entrance of Santa Maria Novella, Leonardo watched a stream of fashionable Florentines trickle inside. A woman wearing a long cape and hood strode toward the entrance. When she reached up to lower her hood, his heart beat faster, and he leaned out the window to get a better look. She lowered her hood and revealed a shock of red hair. She was not Lisa.

Leonardo had sent the lady a private, handwritten note two days before, personally inviting her to attend. Why wasn't she there yet?

The maestro's studio was filled with visitors sipping wine, munching on sugary elderberry fritters, and singing the praises of his latest masterpiece. Displayed in a high-ceilinged receiving room on an easel made of dark rosewood, the portrait of Mona Lisa sat near a window so the sun could bathe it in a soft, glowing light. The picture mesmerized the visitors. "It's so beautiful and lifelike," one man praised, "it will make every other artist tremble and lose heart."

Leonardo knew why they were so transfixed: it was the look on Lisa's face, the same one she had given him on the way out the door the last time he had seen her. It had taken him over a month to depict that slight upturn to her eyes, to adjust her pupils so she looked directly out at the viewer instead of off to one side, to add that subtle suggestion of a smile to her mouth. To an inexperienced painter, those small changes would have

seemed inconsequential, but in those few strokes of paint, life had taken hold.

Another woman strode through the courtyard, but she was not his lady either. She was too large of hips, too wide of shoulders, had too strident a march.

That morning, Leonardo had sent Salaì to every house, stall, and workshop to tell every Florentine that his portrait of Mona Lisa del Giocondo would be displayed in his studio for one day, and one day only, before it was sealed up in Giocondo's private collection forever. A throng of Florentines had packed into Leonardo's studio. It was all going according to plan. When Lisa finally arrived, even if she were on the arm of her husband, she would walk into a crowd of people gazing at her. She, not anyone else, would be the center of attention. She would hear the audience murmuring about her beauty, her fine glowing skin, and that mysterious look on her face. For one day, she would know what it felt like to have people truly see her.

Today was his gift to her.

But in order for her receive the gift, she had to attend. He had specifically instructed her to arrive during the daytime, so she could enjoy her painting in the best possible light. As the sun set and darkness rolled in, he began to doubt she would appear at all. But, stoking an ember of hope, he brought out an army of candles to light up the portrait and posted Salaì by the door with instructions to alert him if she tried to slip in unnoticed.

Eventually, nighttime blanked the sky and his desk clock chimed midnight. With a few guests still lingering in front of the picture, Salaì approached him with a shake of his head. Leonardo sighed with the disappointment of a gift ungiven.

He was not going to see her that night. He might not ever see her again.

"Salaì," he said, staring down into the now empty courtyard, "I think the portrait is finished."

"Yes, Master, I believe it is."

Michelangelo

S itting on a shadowy stoop across from Santa Maria Novella, Michelangelo and Granacci watched guests leave Leonardo's studio. "She is so alive," a stylish wife exclaimed, "it must be a miracle."

"God has touched his hand," her husband added as they strolled away.

Granacci had wanted to go inside and view the portrait with the rest of the public, but Michelangelo didn't want to give Leonardo the satisfaction of spotting him among the other admirers. They had camped out across the street for hours, waiting for the party to end.

Finally, the last guest filed out and each candle in the studio was blown out, one by one, until every window was dark.

After the studio had been quiet for almost an hour, Michelangelo whispered, "It's time." He turned to Granacci, but his friend was lying on the stoop, snoring softly. Michelangelo considered waking him, but instead rose silently and approached the church. He preferred to face the painting alone.

When he was an apprentice, Michelangelo had worked in this church alongside Granacci with their teacher, Domenico Ghirlandaio, decorating the Tornabuoni chapel with stories from the lives of Mary and St. John the Baptist. It was here, on these very walls, that he had honed his drawing skills and learned how

to prepare and paint a fresco. He had become a professional artist in this church. He remembered every staircase and room as well as he recalled his father's old house before the fire.

He crept through the sanctuary and up the stairs. From the street, he had taken note of which windows were lit up by candles during the party. The room filled with the most guests had been at the end of the hall.

He moved down the shadowy hallway. The first door was wide open. Two figures snored in bed. A shaft of moonlight struck one of their faces. That was Leonardo da Vinci, sleeping soundly. Michelangelo held his breath as he passed that room. He didn't want Leonardo to catch him skulking around the studio. At best, it would give the old painter an excuse to taunt him. At worst, Leonardo could have him arrested.

Exhaling at last, he reached the room at the end of the hall. It was a proper, high-ceilinged salon decorated with upholstered chairs, a thick red carpet, and a pianoforte. This was a room in which to receive guests. He entered and quietly closed the door behind him. The curtains were drawn, so he opened one, letting in a bit of moonlight.

There in a corner was an easel, covered by a curtain. Unlit candles were arranged all around it. Did he even want to see it? Maybe it was better not to know. Michelangelo took hold of one corner of the thick velvet curtain and, his heart clattering like a cymbal, pulled the fabric off.

Underneath was a small panel picture.

The sliver of moonlight shining in through the window gave little illumination, but the portrait seemed to be an average picture of an average woman painted from the waist up. Michelangelo let out a half-sigh, half-chuckle. Why were people raving? Was it only because the great Leonardo da Vinci had painted it, so therefore viewers were expected—no, required—to swoon?

Feeling emboldened, he took one of the candles and located a small tinderbox sitting on the windowsill. Lighting a candle was

a risk. It might attract attention. But he wanted to see the portrait to confirm his growing suspicion that the only miracle in the room was Leonardo's overblown reputation.

He lit the candle. Once he had a steady flame, he turned back to the picture. He expected to feel joy rise up and erupt on his face in a triumphant smile. Instead, his throat closed.

Michelangelo had never seen a portrait so alive. It was as though the lady herself were sitting in the room. Her skin glowed from within, her eyes sparked with life, and her chest seemed to rise and fall with breath. Leonardo hadn't captured the likeness of a woman; he had captured the lady herself.

Michelangelo held the candle close to the picture; still, he couldn't discern a single brushstroke, though he knew there had to be thousands of them. He hadn't known paint could be applied so delicately. Every edge blurred and blended in with the next. Just as in real life, there were no lines between light and dark, only varying degrees of shadow.

And this lady. She did not look demurely away in a suggestion of modesty and humility. She looked directly, challengingly, right into his soul. Whenever he tried to look away, her gaze seemed to follow, drawing him back in. Why? When he looked closely at her face, there was nothing exceptional about it, no hint of a smile, but the moment he averted his gaze, she began to smile and beckon him back.

Real people, Michelangelo knew, didn't hold posed expressions for long periods of time, as most portraits portrayed them. Their expressions were always changing. But he had never seen that effect captured in paint. This lady's expression seemed to be perpetually in the process of either becoming or fading. But unlike a real woman, who would eventually either smile or frown, her smile would never fully form. It was always appearing, but would never appear. It was simultaneously full of hope and disappointment.

A rock grew in Michelangelo's chest and sank into his belly. His seventeen-foot giant would be slain by one look from this

woman. Michelangelo was decades of practice and study away from this level of mastery, and even with a hundred patrons, a hundred jobs, a hundred years, he still might never achieve such genius. What was the point of competing when he could never win?

Michelangelo backed away. He considered dropping his candle and letting the whole studio, including that picture, go up in flames.

Instead, he blew out the candle and ran away. He didn't stop to gather Granacci, but sprinted as fast as he could toward the city walls. He would leave Florence and never come back. Let them unveil David without him. He didn't need to be there. He couldn't be. Because, no matter what he did now, he knew he could never beat the Master from Vinci.

Leonardo
September 8

Sitting on a wooden stool in his studio, hands folded in his lap, Leonardo gazed silently at the portrait. His eyes scanned the panel from top to bottom, corner to corner, burning every detail into his memory. This was the last time he would lay eyes on Lisa. He didn't want to forget her. He smiled and waited for her to smile back, but she did not, and she never would.

Leonardo carefully wrapped the painting in a piece of linen, tying it up with burlap string, to protect it during its journey across town. "Please allow me to reschedule, sir." Salaì said, standing in the doorway. "I've planned the delivery too early." The young assistant always treated his master so tenderly. When Leonardo grew old and decrepit, he knew it was Salaì who would care for him.

"That won't be necessary, *amore mio*." He could put off the delivery forever. "Art, after all, is never finished. Only abandoned. But it is finally time to abandon this one." He thought back to that day, four and a half years before, when he'd discovered his *Last Supper*'s peeling paint. At the time, he thought he could abandon the fresco without regret, but now he knew that letting go of a piece of art was as heartbreaking as burying the dead.

"Are you sure you don't want me to drop it off? It's a simple delivery."

"No. It is part of what the patron pays for. A private meeting with the maestro to crow over the beauty of his new possession."

He checked his appearance in the mirror. Beard trimmed. Stockings neat and clean. Bird ring recently shined. And yes, his green taffeta jacket was sure to impress any silk merchant.

Leonardo and Salaì departed the studio solemnly. Outside, Leonardo was surprised to see men, women, grandparents, and children laughing and dragging one another toward the center of town. It was an overcast Sunday afternoon. Morning mass was long over. Sunday was usually for rest, reflection, and prayer. This bustling atmosphere felt like a holiday. "What's going on?"

"The unveiling of Michelangelo's David." Salaì gave a rueful shrug. "I hoped that choosing today for the delivery might distract you."

He nodded. "Sometimes your trickery is very clever, Giacomo."

Portrait tucked under his arm, Leonardo fought his way against the tide of revelers. As he and Salaì walked farther away from the Piazza della Signoria, the crowd thinned. The laughter dimmed in the distance. Leonardo strolled more and more slowly, but eventually, they turned up the Via della Stufa. Strange—the street no longer looked as bright and glimmering as it had in his youth or when he first started coming there to sketch Lisa. The road was narrow. Grimy. Fresh coats of paint did not erase hundreds of years of dirt and mold.

He arrived at Giocondo's front door. It was time to return the lady to her husband. Giocondo owned her image, just as he owned her. Her husband had the right to hang her in his family parlor forever, where visitors would glance at her, but never really look at her. They would see her only as the mistress of the house, wife of the husband, subject of that picture by the Master from Vinci. That's who she was. Lisa had long ago learned to accept her place in the world. He needed to learn to live with it, too. He took a deep breath and knocked.

Michelangelo

Mouth dry and stomach rumbling, Michelangelo checked his satchel again. There was a pile of gold florins, but no wine, no bread, no dried fish. He had eaten his last morsel of food at supper the night before and swigged his last bit of wine that morning. He sucked on a metal coin, hoping to satiate his hunger, and lamented how useless money was when there was no place to spend it. If he wanted to eat or drink, he would have to go to the market. But he couldn't. Not yet. Not today.

He'd been in hiding for nearly a week. After fleeing Leonardo's studio, he hadn't left town, but had instead gone to his favorite spot: the abandoned guard tower near the bridge of San Niccolo, on the far east side of town. The three-story tower had been built in the 1300s, but as long as Michelangelo had been alive, there had never been anyone stationed inside. He had been using it as a hiding place ever since he was a teenager.

He had some chalk and paper in his bag, so he'd spent most of his time on the roof, sketching and writing a few lines of awkward poetry. "After being happy many years, one short hour may make a man lament and mourn," he wrote. Using his chisel, he'd etched a calendar into the wall to carefully record each passing day. According to his calculations, it was finally the second Sunday of September.

Michelangelo stood up. From the roof, he could see Palazzo della Signoria towering over the city. Under that famous bell tower, his David would finally be unveiled to the public that afternoon. Michelangelo would watch from this spot. Perhaps he would hear a distant whoop of joy or a cry of anger. From there, he would watch the proceedings without the proceedings watching him.

As he squinted across the city, his gaze landed, as it always did, on the gleaming orange dome of the cathedral. When he'd first arrived back in Florence over three years before, he had looked on Il Duomo with relief and love, but today he felt only anxiety. Florence was home to so much glorious history, so much beautiful art, so much greatness. What if he fell short?

When Michelangelo first started work on the Duccio Stone, he had harbored secret childish dreams that his clash with Leonardo from Vinci would be counted among the great rivalries of the city's long history. Florence was legendary for such battles.

In 1401, to commemorate the new century, the city had held a competition to pick an artist to design a set of bronze doors for the Baptistery. Many of the city's best artists had competed for the honor, but the final contest came down to two goldsmiths: Filippo Brunelleschi and Lorenzo Ghiberti. Brunelleschi was older and more experienced, already a member of the goldsmith guild, while Ghiberti was trained primarily as a painter. Each man was eager to make a name for himself, and each believed he was the best artist for the job.

As a tie breaker, the city ordered the men to design a sample bronze panel depicting the sacrifice of Isaac, the Old Testament story about God ordering Abraham to sacrifice his son to prove his devotion to the Almighty. Brunelleschi and Ghiberti toiled day and night to outdo each other, pouring their souls into their work.

In the great tradition of ancient art, Brunelleschi depicted realistic human figures suffering raw agony. Harsh lines and shapes underscored the mental and spiritual anguish of a father sacrificing his own son. Every bone and muscle was visible in Isaac's

scrawny body. The panel was so physically and psychologically realistic, the Romans themselves would have embraced it as one of their own. The city's judges could not imagine anyone creating a better representation of classical design.

Then Ghiberti presented his work. The younger, less experienced artist used as many dynamic and original poses as Brunelleschi. He included as many, if not more, naturalistic details of human anatomy and landscape. But Ghiberti added something more. His panel was pure grace, building to a climax right at Isaac's face, staring up at the heavens, begging God for mercy. Every element worked in harmony to make the viewer feel an overwhelming mix of sadness, fear, and hope.

Brunelleschi's panel hearkened back to the ancients. Ghiberti's surpassed them. He won the contest. It took Lorenzo Ghiberti over two decades to complete all twenty-eight panels for those bronze doors. When they were finished, everyone agreed the best man had won. A hundred years after they were made, Michelangelo believed the doors were so beautiful that they were worthy of being the Gates of Paradise.

Brunelleschi, however, was devastated by the loss. He abandoned sculpture and moved to Rome, where he began to study architecture. Twenty years later, he returned to Florence to enter another competition. Once again, his competitor was Lorenzo Ghiberti, but this time, Brunelleschi was the victor. In this second contest, Brunelleschi won the right to remodel the city's cathedral, and he went on to build the now famous, fever-inducing, orange-tiled Duomo.

When Michelangelo had been carving David, he had thought he was bringing an unstoppable giant to life. Then he'd seen Leonardo's portrait. With every passing day, her gaze haunted him even more. But with that same time and distance, David was already slipping from his memory. Doubt was creeping in. What if David were not so wonderful? What if he had been deluding himself? Ghiberti and Brunelleschi had both created masterpieces,

but if only one side of a rivalry reached true greatness, was there ever a rivalry to begin with? A rivalry that came to nothing on one side wasn't a rivalry at all. Was it?

A hundred years ago, the better man won, and the Baptistery doors were born. This time around, the better man lost. Leonardo should have had the Duccio Stone.

"*Buongiorno, mi amico*," Granacci called, climbing onto the roof of the guard tower.

"What are you doing here?" Michelangelo asked, putting down his sketchpad. He'd been drawing his own hand over and over again for hours.

"I came to get you. Your David is about to be unveiled."

"I know that. How did you know I was up here?"

Granacci sat down next to him and pulled a flask out of his jacket pocket. "Despite what everyone else said, I knew you'd never leave Florence. You would want to see the unveiling, I told myself, but probably wouldn't want anyone to see you see it . . ."

Granacci took a drink, and then handed the flask to Michelangelo, who took a swallow. The wine was cooler and sweeter than he'd expected.

"And then I thought, ah-ha. He would go up high, of course," Granacci said triumphantly.

Michelangelo drained the flask.

"I searched every apartment around the piazza, even climbed up the Duomo . . ." He pulled a piece of bread and some cheese out of his pocket and handed it over.

Michelangelo shoved a handful of bread into his mouth. He bit off a hunk of cheese, too. It was fresh, soft, and salty.

"But it was from the top of Giotto's bell tower," Granacci went on, "that I finally saw a little head bobbing along on this roof. And then I remembered you used to hide up here whenever Ghirlandaio screamed at you—usually for drawing better figures than him." He slapped Michelangelo's current sketch as proof.

"So, two days ago, I came over, camped out up in those mountains for a couple of hours and, *boffo*, here you are."

Michelangelo swallowed the mouthful of bread. "For two whole days you could've been bringing me wine and cheese?"

"If I'd come to get you, you would have run away again. And then I'd have to go find you again, and . . ." Granacci shook his head. "It seemed like a lot of work when I already knew where you were. Now, there's no more time to run away. *Andiamo, mi amico.* They are waiting for you." Granacci stood and offered his hand.

Michelangelo crossed his arms and hunkered down, burrowing into his spot like a stubborn gopher. "Let them wait. Or better yet, unveil it without me."

"Come on, Michel, you can't stay up here forever."

"I can, too." Granacci could bring him food. He could live a perfectly comfortable life up here, overlooking his city, surrounded by stone. He could carve this guard tower into something miraculous. Unless, of course, David was a failure, in which case he would never carve anything again. Ever.

"This is your moment. You made the David. He is yours."

"I know he's mine. You think I don't know that? I think about it every day. I can't deny that statue." He buried his head in his hands. "It's miserable." When he'd finished the *Pietà*, he had broken into the Vatican to carve his name into the stone so no one could ever forget he carved it. Now, he wanted to run away from David and pretend he had never known him. What if his father cursed Michelangelo for embarrassing the family? What if the crowd booed? Or worse, what if David was met with silence? What if Florentines shrugged and went back about their business as though they had seen nothing? "I can't go. David can handle this on his own."

"Well, of course David can handle it," Granacci said with a laugh. "David is a piece of rock. David doesn't have feelings." He walked toward the stairs, but before descending, he turned back. "You should know there's a crowd of Florentines gathered in the

piazza right now, and they are scared, just like you. Only they aren't afraid of how an audience will receive their work. They are scared of the Medici. Of papal armies and French invaders. Do you know how it will look if the sculptor of the mighty David is too afraid to show up to his own unveiling? Do you think that will inspire anyone to stand up and fight their own Goliaths? Our countrymen don't need a statue. They need someone to show them that they can face the unknown and survive. So don't get up and go for you, Michelangelo Buonarroti. Or for me. Or your family. And certainly don't go down there to protect the feelings of an inanimate mound of rock. But go. For the people of Florence. Go."

Leonardo

The front door swung open. "Maestro Leonardo. Welcome, come in, come in," Francesco del Giocondo said, waving him and Salaì into the house.

"I've brought your painting." Leonardo held up the linen-wrapped panel, but didn't hand it over just yet. When Giocondo closed the door behind them, Leonardo's left eye twitched. He had brought the painting inside. It would never leave this house again. "Is the lady at home?"

"Yes, but she is up with the children." Giocondo adjusted the high collar of his red and gold brocade velvet jacket. It had long tails and large gold buttons. He looked dressed to entertain a king. "She does not tend to my business transactions."

Leonardo nodded. He hadn't expected her to see her, but the answer was now definite.

"Would you like to see where I will hang her?"

"Very much."

"I'm glad you're here," Giocondo said as he led them down the hall, past the sitting area where the couple usually greeted guests, by the formal dining room, and even beyond the music salon. "Several friends saw the portrait at your viewing. They said I would not be disappointed. But I didn't want to see it with the others. I wanted to wait and see it privately." They kept walking until they reached the back of the home. Giocondo opened a

small door. "My personal office," he announced. "This is where the picture will go."

Leonardo took in the small, dark, musty chamber. There was one small window to the left, rolls of fabric stacked in corners, and a massive, ugly, dark wooden desk piled with buttons and thread and lace. The strong scent of smoke from the fireplace did not obscure the stale air.

Giocondo moved a stack of books and a few sewing utensils from the mantel, and then extended his arms. "Here, give it to me."

Leonardo gripped the portrait tighter. The bulky stone fireplace was crackling with fresh logs. If a single ember popped out and landed on that old, frayed rug, this cluttered room would quickly catch fire, and all of the contents would be turned to ash. "Do you receive visitors in this room, signore?" Leonardo had never been invited into this room before.

"A family member or two, a close associate every now and again, but, no, no, not really. It's my private office. I keep it for my own musings."

"So no one else will see the portrait?"

"I like to keep my wife to myself. Now, let me have her," he insisted, beckoning with his fingers. When Leonardo did not move, he repeated, "Maestro Leonardo? The painting."

Leonardo nodded, but kept the portrait under his arm.

"Master," Salaì whispered.

It is impossible to keep her. Impossible. She belongs to him. "Of course." Leonardo extended the portrait to its owner.

Giocondo took the package. Grabbing a knife off the mantel, he sliced through the linen wrapping as though cutting butcher paper from a hunk of meat.

"There she is," Giocondo said, lifting the painting.

Leonardo turned away and looked out the tiny window so he wouldn't have to see the portrait inside that dingy room. He had already said his goodbyes.

"Interesting, interesting . . . but quite strange. I've never seen anything like it," Giocondo said, as though searching for a compliment. "Where are the rolls of silk and my music box and her father's family crest? Or those beautiful opal buttons on her dress—those were from Venice. And not even the picture of me. And where is that landscape behind her? I don't recognize it. But my friends were right. She does look rather like herself. Very alive. It's as if she is sitting before me, here and now, and she will always sit with me in this room . . ."

There was a scratch of wood against stone as Giocondo shoved the portrait onto the mantel. "Be careful," Salaì urged. "A painting is a delicate thing."

Lisa belonged to her husband, not to him. She was a wife and a mother and she cherished those things about herself.

"There. That is the right place for her. As though she were made for this very spot. Maestro, look. Doesn't she look perfect?"

"Yes," he responded without turning around.

"Now, I've heard rumors that you hide little puzzles in your paintings. Is that true?"

Leonardo looked down at the Arno glimmering in the sunlight. It was back in its old riverbed, flowing the way nature intended.

"If it is true, you must tell me what kind of riddle is in mine. You simply must. I won't tell anyone else, of course, but it will be fun for me to know the secret. I heard there was some sort of addition or other number problem hidden in your—*St. Jerome* was it? And something about the patterns of the stars in that rocky Madonna picture. And was it a musical score in the Signora de' Benci portrait? Or no, it was a poem in the picture and the musical score was in . . ." Giocondo kept rambling.

Leonardo stared out the window and thought of all the secrets, big and small, he had dropped into his paintings over the years. Most viewers wouldn't discover the mysteries, of course, and he would never admit to them, but now all the previous ones seemed

trivial in comparison to one hidden in Lisa's portrait. This mystery was more profound than any other, even though it had nothing to do with science or math or the stars. A viewer could not use knowledge of history or literature or mechanics to translate it. No matter how hard someone searched for this secret, they would never find it with their eyes or their brains. They could only feel it with their hearts.

This time, the secret was love.

Only people who had deeply felt love would be able to detect the secret hidden in Lisa's face. If they hadn't felt it, she would seem as lifeless and dull as a tin plate. They wouldn't understand what drew others to her. They would dismiss the painting as small and unimpressive. However, those who had felt true love would be transfixed. Her image would inexplicably haunt them forever. They would never be able to articulate what drew them in. The moment someone tried to explain why they were attracted to the painting, words would evade them, and the feeling would dissipate, fast as a wisp of smoke from a votive candle. As with love itself, when a person pulled back to study it, the very thing they were trying to understand was destroyed. Because love doesn't thrive under scrutiny from a distance, but flourishes from closeness and unquestioning faith. It blooms in the deep parts of the heart, in the silence where no thought is allowed. The only way to be truly in love is to be fully in it, just as the only way to feel the secret of the *Mona Lisa* was to give the heart absolutely to it.

Laughter drifted up from the streets and in through the window. "What is going on out there?" Giocondo asked. "There have been so many people out today. I'd like to think they are all out celebrating my new portrait, but even I know that is a foolish hope." He came up behind Leonardo and looked over his shoulder at the people below. "This usually only happens on festival days."

Leonardo didn't feel like explaining, so he gave Salaì a look.

"It's the unveiling of the new David at the palazzo, signore," Salaì said.

"Oh, yes, of course. I can't believe I forgot about that." Giocondo waved Leonardo out of the way, so he could get a better look out the window. "I would have expected you to be at the ceremony, maestro. In one of those seats reserved for dignitaries."

"I don't like crowds."

"Don't like crowds!" The merchant laughed. "Come, we'll go together. Nothing like an outing to celebrate a new addition to my tidy little office."

As they prepared to leave, Leonardo was careful to face away from the fireplace so that he wouldn't have to see the picture. He didn't want to remember it hanging over a mantel in this dark, cramped office. He wanted to remember it displayed in his own spacious studio, surrounded by his things and bathed in sunlight.

But when he turned, he found himself looking at Lisa, anyway. Not at the picture, but the lady herself.

She stood in the doorway and stared up at her portrait hanging over the mantel. Her eyes glistened. A flush rose up her chest and neck. Leonardo hoped she would smile. She did not.

"Isn't it perfect?" Giocondo asked, as he crossed the room and wrapped his arm around her waist. "Now, I don't have to share you with anyone," he said and kissed her on the cheek.

Leonardo wanted to tell her about the parade of people who had streamed through his studio to study her, discuss her, see her. But he knew he couldn't speak so intimately in front of her husband, and besides, he now realized the smallness of his gift. One night of admiration was no consolation for a lifetime of being trapped in this room.

"We are about to go see the unveiling of that young man's new David. It's exciting. The whole city is out in the streets. You should look." Giocondo pointed her toward the window, but she didn't take her eyes off the painting. Her brow furrowed.

Did she remember giving him that half-smile as she left his studio? Did she know how she appeared in that moment? When she looked at herself, did she see what he saw? Or something different?

"We had better go before we miss the entire thing." Giocondo checked his appearance in a small mirror hanging on the wall and donned a red silk hat. "Come, Lisa," he ordered, extending his hand.

"I beg you to go without me, sir. I have a headache."

"Oh," Giocondo said, sounding disappointed. "Well, you will miss out. I hope you feel better. Come, Maestro."

Was it really time to go? So soon? He looked at Lisa, hoping for one last glance, one last smile, one last blush, but she just stared blankly at her portrait as if he were not in the room.

"Maestro Leonardo, *per favore*," Giocondo insisted, waiting in the doorway.

His legs felt heavy as he followed the silk merchant out of the room. As Leonardo walked down the narrow hallway, he glanced over his shoulder back into the office where Lisa still stood. For the first time, he saw his painting hanging over the mantel. From there, it looked like nothing more than a domestic portrait, small and insignificant, hung in a tiny, private room.

As Giocondo led Leonardo further and further away from her, Leonardo reminded himself that Lisa was a wife and a mother, and she cherished those things about herself. It might not be fair, but this was where the lady belonged. She could not come with him. It was impossible.

Michelangelo

Michelangelo sprinted across the Ponte alle Grazie, the longest bridge in all of Florence. His lungs burned, but he refused to stop running. He did not want to be late.

After Granacci had left the guard tower, Michelangelo realized how badly he wanted to witness the unveiling. He had permanently damaged his hands and eyesight, worked so hard he almost died in the hospital, angered his father, and made his brother so distraught he burned down the family's house, all to bring David to life. He had poured his blood into that marble and filled David's lungs with his own breath. Michelangelo had put so much of himself into the sculpture that it was as though he were the one about to stand nude in front of Florence.

As he crossed to the north side of the Arno, he noticed he was dripping with sweat and his clothes stunk. He thought about stopping by the river to clean up, but if he paused, he might miss the ceremony. Besides, he thought sheepishly, it wouldn't be the first public event he had attended looking a little unkempt.

He turned down a normally crowded street that was strangely empty that afternoon. He didn't have time to wonder where all the people had gone, because he soon reached the end of the road and turned into an alleyway. Up ahead, he spotted the high arches of the Loggia dei Lanzi, the gateway into the Piazza della Signoria. His David stood a few steps to the right of the loggia.

He was almost there. As he approached, he saw a crowd gathered outside the square. His stomach lurched. The event was probably over, and they were heading home. "*Permesso*," he muttered as he approached the edge of the group. He hoped he wasn't too late.

As he waded through the people, Michelangelo realized this was no small gathering, but a thick mob. Everyone was pushing into the piazza. He stood on his toes to see over heads, but saw only more people. The city must have erected a barricade to search people before they entered the square. They must be worried about vandalism. "*Permesso*," he said a little louder. He moved one way, then another, but couldn't move forward a step. "*Scusa!*"

"Eh, *coglione*, back off," a husky farmer growled.

"I need to get into the piazza."

"We're all trying to get in, but there's not enough room, *capito*?"

"That's impossible. The piazza can hold the entire population of Florence."

"Yeah, well, it's full, so you better get comfortable." The farmer widened his stance to block Michelangelo's path forward.

"*Dieci*," the crowd roared in unison.

Why was the crowd yelling "ten"?

"*Nove*," the crowd called.

The mob was counting down. "Counting down?" Michelangelo yelled. "Are they counting down to the unveiling already?"

"Of course," the farmer said, clearly annoyed.

"*Otto*."

"Oh, no. Wait." Michelangelo's ears burned. "We have to stop them." He was still around the corner from David. He had no hope of seeing the unveiling from there. "That's my statue. I'm the sculptor. I need to be up there."

"*Sette*."

The farmer smirked at Michelangelo's rough appearance. "Yeah, you're the artist, like I'm the pope's footman."

"*Sei*."

If he scaled city hall, he could grab onto a flag and swing onto stage. Or maybe he could clamber across people's shoulders all the way to the front. He could start by asking the farmer to lift him onto the back of that bald-headed priest, jump over to that curly-haired man, then onto the shoulders of that young woman with the pretty profile.

"*Cinque.*"

Wait. That wasn't just any young woman. Her hands were dyed red. The color of her silk, the color of his brother's love. That was Maria, the silk weaver's daughter, Buonarroto's beloved. She was closer to stage. If he could get her attention, she might be able to help him. "Maria! Maria!"

"*Quattro.*"

Several women looked back at him. Half of the women in this crowd were probably named Maria, and he didn't know her family name. Maybe she was called Maria di Giovanni or Luigi or Francesco, after her father. The family made silk. Her last name could be Dyer or Weaver. He had no idea.

"*Tre.*"

"Maria Buonarroti," Michelangelo bellowed. It was as close as he could get.

She turned around. Then she saw him.

"Michelangelo?" Panic rose in her green eyes. "You should be up there," she said, pointing in the direction of the stage.

"*Due.*"

Michelangelo dropped his head. His shoulders sagged. He was standing only a few feet away, but he was still going to miss it.

"Aiiiiiiii!" Maria's high-pitched scream echoed through the piazza like a church bell pealing on a holiday morning. Michelangelo hadn't known a human could make such a noise.

The crowd stopped chanting and looked around for the source of the scream.

"The artist has arrived," she called. Maria fought her way back to Michelangelo, grabbed his hand, and dragged him through the

crowd. "Sometimes it's nice to have a set of pipes," she whispered, and Michelangelo was transported back to the day of the pope's death, when Maria's voice had carried a funeral dirge across the entire Piazza del Duomo. No wonder his brother was in love with this woman.

As people called to one another that the artist had arrived, the crowd parted like the Red Sea under Moses's command. Over the heads of the spectators, Michelangelo saw that David's wooden shed had been taken down, and the statue was now covered by nothing but a black curtain. As soon as that curtain dropped, David would stand revealed.

At the platform, Granacci and Giuliano da Sangallo grabbed Michelangelo under his arms and hauled him up. "Cut that one close, didn't you, *mi amico*," Granacci said with a grin.

Michelangelo faced the piazza. "*Santa merda*."

An ocean of Florentines flooded the piazza and spilled out into the surrounding streets. Monks, blacksmiths, nobility, housewives, prostitutes, gentlemen, beggars, all crammed in together. Young children sat on fathers' shoulders, older ones climbed on top of statues in the loggia, and families hung from balconies. That was why the streets had been so empty, he realized. They were all here, the entire city, waiting for him.

Michelangelo's fears flooded back. His vision blurred. Those old familiar black dots filled his head again. But why did it feel like hands were squeezing his shoulders?

"Breathe, *figlio mio*, just breathe, you don't want to miss this."

Michelangelo took two deep breaths. As the black cleared, he turned to see his father rubbing his shoulders with concern. "You came," Michelangelo whispered.

"Everyone else was coming, we decided we should be here, too," Lodovico said gruffly.

Beyond his father stood Michelangelo's entire family. Buonarroto gripped Maria's hand. His grandmother, aunt, uncle. Even his older brother, Lionardo, whom Michelangelo hadn't

seen since he'd joined the Dominican order, and his youngest brother, Gismondo, who was supposed to be off fighting in the war against Pisa. Michelangelo wrapped both long-lost brothers into a hug. Then he spotted Giovansimone, standing off to one side. Michelangelo released his other siblings and advanced on him.

They stood nose to nose, brother to brother.

He hadn't seen Giovansimone since before the house fire. He mentally catalogued a list of curses he would like to hurl at him.

"I'm sorry," Giovansimone said. "For everything." His pleading eyes glistened with tears. "I won't do it again."

"Of course you'll do it again," replied Michelangelo. "And I'll forgive you again."

They embraced.

"Ladies and gentlemen," Piero Soderini called. Men bellowed Soderini's words to the people behind them until the words carried to the back of the piazza. "The artist."

As Soderini gestured to him, Michelangelo felt a rush of pride. Wind rustled David's black curtain, and he said a quick prayer of thanks that he had made it in time.

"Would you like to say a few words before we continue?" Soderini said.

Michelangelo shook his head. He couldn't even utter the word, "no."

Soderini murmured in his ear, "These things always go better when there's a good speech to rile the people up. Say something inspiring."

As he looked out over the sea of people, he shoved his hands into the pockets of his tunic, but there was not even a pile of marble dust to help calm his nerves.

"Go on, boy. They're waiting," Lodovico whispered.

Michelangelo wished David were already uncovered, not still shrouded under that thick black curtain. If David were awake, they could march into battle together. But Michelangelo was

alone, and God hadn't filled his head with fancy words and grand speeches.

He was a sculptor, not a performer.

Just as David had been a shepherd, not a warrior.

Yet, David had still marched into battle. But at least David had had a pebble, Michelangelo thought glumly.

A chill tickled his spine.

Just like David, every one of God's children had a pebble of their own, even if they didn't know it. A silk weaver might have nimble fingers that could weave fabric faster than his competitors. A farmer might have fertile land, a strong plow horse, or a love of working the earth. One man might have a hen that continued to lay eggs even though she was old and tired, or a sturdy wagon passed down generation to generation. Michelangelo's brother Buonarroto had the love of a woman, and his father had the love of his sons. Maria had her voice. Machiavelli had a sharp mind, Soderini a politician's smile, and Leonardo da Vinci, Michelangelo admitted grudgingly, seemed to have a whole pocketful of pebbles.

Michelangelo had a pebble too. His pebble wasn't inspiring audiences with great speeches or funny jokes or explosions of colored smoke, magic tricks, and music. His pebble was carving marble. If Soderini wanted him to say something inspiring, there was only one way for him to do that.

He grabbed the rope attached to David's curtain and pulled. "Behold, my pebble."

Leonardo

D o you know why I'm so interested in seeing that young fellow's *David*?" Giocondo asked as he led Leonardo down the hallway, farther and farther away from Lisa. "It's not because it's some symbol of Florentine freedom or a great Christian icon or whatever nonsense people say. It's not even that the sculptor is so committed that he nearly worked himself to death, although I do admit that's part of it. It's because everyone kept telling him it was impossible, but he went ahead and did it anyway."

Leonardo stopped walking.

"Maestro Leonardo? Is everything all right?"

Leonardo's breathing slowed. Sound fell far away. The bland walls vibrated with color.

"Maestro?"

Whirling on his heel, Leonardo marched back toward Giocondo's office, his long green satin coattails flapping behind him like a sail.

"Maestro Leonardo? Where are you going?"

At the sound of her husband's cry, Lisa turned to see Leonardo barreling down the hallway. Her mouth opened with a gasp.

"My wife needs her rest," Giocondo called.

But Leonardo kept advancing.

Lisa clumsily shook her head. Her cheeks flushed. Did she want him to kiss her? Did she want to fight him off? Did she want him to carry her away or leave her forever? By the looks of her face, she wanted all of that at the same time.

"Signore," Giocondo cried.

Striding into the office, Leonardo yearned to pull Lisa into his arms. She belonged to him. He and Lisa, together. It was possible.

But Leonardo didn't stop and take her into his arms. He moved past her, stepped up to the mantel, and took his painting off its perch.

"What are you doing?" Giocondo asked, arriving in the office. He, too, brushed past Lisa and went right for the portrait.

Leonardo tucked the picture under his arm. "It is not finished."

"Seems finished to me," Giocondo said.

"I know when a work of mine is done and when it is not. And this one is not." He glanced at Lisa. She was no longer staring away, but looking directly at him. "I must take it with me."

"You can't take it. I'm the patron. It's my painting," Giocondo declared.

"Until I deem it finished, it is mine."

Lisa nodded, so fast and so small it was almost imperceptible, but he caught it.

"Well . . . well . . . when are you going to be done with it?" Giocondo asked.

"I will know I am done when I am done." He stepped toward the door.

"I have paid good money for that painting, sir. All in advance." A servant grabbed Leonardo's elbow. "If you do not leave the picture with me, I will have no choice but to call the authorities."

"Salaì, my moneybag."

Salaì came over and faced away from the others. "Sir, we have spent all of the money he paid us."

"I don't care which money we use, Salaì, just give me one hundred florins."

"There is none."

"What?"

"We spent . . ." Salaì leaned in closer to whisper in Leonardo's ear. "I spent it all." He cringed. "Until the city pays us, I mean, pays you for your fresco, we don't have enough to reimburse him. I think you had best leave the picture."

Leonardo sighed. It was his own fault.

Giocondo extended his hand. "I believe you have something that belongs to me."

"Yes, I do," Leonardo said. He couldn't look at Salaì. Or at Lisa. He looked down at his left hand. "I believe this," he said, slipping his ring off his finger, "will more than cover my debts." Leonardo dropped the shimmering bird into Giocondo's hands.

"No," Salaì whispered.

The silk merchant started to protest, but then he saw the gold, rubies, and emeralds winking back at him. "Is this real?"

"It was given to me by the King of France, Louis the Twelfth. He was much amused by my aspirations for human flight. I assure you, it is very real."

"You thought you could fly?" Giocondo asked.

"Preposterous, I know." He caught Lisa's eye. "But I regaled His Majesty with stories about my flying experiments, so he gave me that as a gift. To encourage me to never give up." Now, there was only one dream he wanted to retain when he walked out of that house. "You could hire a hundred artists to make a hundred new paintings for what that ring will bring you."

"I don't doubt it," Giocondo said.

"So, I am free to go? With the portrait?"

"Yes, yes . . ." Giocondo muttered, still transfixed by the jewels.

Leonardo held Lisa's gaze for one final moment. She was

trying to hide her smile, but she could not conceal her joy. He turned and walked toward the door.

"But you're going to finish the picture, right?" Giocondo called after him. "And when you're done, you will bring it back and let me pay for it again?"

"Of course," Leonardo said, the portrait secure in his arms, "I am a man of my word. I always finish what I say I will."

Michelangelo

S unlight reflected off white marble skin. Muscles taut, ribs rippling, knee flexed like a spring, eyes fixed on an approaching enemy, *David* stood alive and exposed, facing his audience with courage.

The reaction to the unveiling was so immediate and so enormous, it overwhelmed Michelangelo's senses. One roar of approval started near the back of the piazza, another swelled in from the west, more erupted in the front, until the separate waves crashed over each other and together and rushed back out across the crowd in surges of cheers. In the front, a thin woman wearing a shawl collapsed to her knees and sang a prayer to God. A young boy, sitting atop shoulders, whistled with approval.

Michelangelo had spent so many years living with *David* that he couldn't judge the marble anymore, but by watching these people behold the statue for the first time, he could see *David* through their eyes. Through the enraptured look of Father Bichiellini, the Santo Spirito priest who had allowed Michelangelo to dissect corpses in his mortuary, Michelangelo saw *David* as a figure of faith. Through the soldier waving a Florentine flag, he saw a symbol of courage. Through the eyes of a young maiden, gazing dreamily up at the marble, *David* was apparently something to be desired. Through Buonarroto, talking to Maria and her family,

David morphed into a clarion call for love. And in Michelangelo's father's eyes, *David* became a thing of pride.

David no longer belonged to Michelangelo. He belonged to every person in that square, every Florentine, every pilgrim who would ever travel to the city to visit him. Everyone who stood before *David* would see him differently, speak to him in their own language, and share their own fears and hopes. And, just as people are changed with every human interaction, each time *David* saw and spoke to someone new, he would change, too. Not his physical makeup or the grains of his marble, but in his soul. Visitors would leave something with *David*, as he would leave something with them.

Michelangelo took his leather satchel off his shoulder and handed it to his father. Lodovico looked inside, and his eyes widened with what appeared to be terror, but Michelangelo knew was joy. Inside was a mound of gold florins. That bag had been heavy; Michelangelo was relieved to finally hand it over.

He turned to congratulate Gonfaloniere Soderini on a successful event, but the city leader had vanished. Instead, Michelangelo faced a black-haired beauty wearing a long gown of black velvet and a bejeweled crucifix clasped around her neck. She could not be over twenty years old, but she still glowered at him with eyes that knew their own power.

He instinctively squared his shoulders and bowed.

"Felice della Rovere," the lady said. She didn't have a provincial accent that marked the speech of so many illiterate Italians. This was an educated woman. "Emissary from the Vatican."

Michelangelo looked up. Felice della Rovere was the rumored illegitimate daughter of the new pope, Julius II.

"The Holy Father has seen your *Pietà* in St. Peter's. He feared you were only capable of creating one such miracle, so he sent me here to discern how talented a sculptor you truly are." Her head tilted to one side. "Be prepared to serve your church very soon." She curtseyed and then sauntered off before Michelangelo could offer a response.

He watched as two armed guards helped Felice into a horse-drawn carriage and drove away. His Holiness the Pope, the Vicar of Christ, the bearer of St. Peter's legacy, wanted to hire *him*, Michelangelo Buonarroti, a simple stonecutter from Florence. He let out a half-cry, half laugh, and sank down at *David*'s feet. He had won.

He scanned each face in the crowd. Every man, woman, and child, every city official and member of every guild, every artist, merchant, and farmer was packed into that piazza.

Every Florentine, except one.

Leonardo da Vinci seemed to be the only one who had skipped the unveiling, and yet he was the one person Michelangelo wished had been there. Not because he wanted to boast that he had succeeded where Leonardo had predicted failure, but because Leonardo was still, in his estimation, the greatest artist of all time. He was the one person whose favor Michelangelo still craved. And once again, the Master had refused to give it.

A clang echoed across the square.

Michelangelo startled. What was that? He looked around for the source of the noise.

Another clang, then another. It sounded like a low metal rumbling or a very large, very distressed animal. Was it the vandals returning to attack *David*? Or the Medici themselves firing cannon balls over the walls? What was it?

"*Guarda*," a man called and pointed up to the Palazzo della Signoria's bell tower. There, standing in an opening of the tower, was Gonfaloniere Piero Soderini.

He was ringing *La Vacca*.

For the first time in years, the city's bells were tolling. Not for some official ceremony or festival or even for the execution of a traitor. Everyone in that square understood what that ringing meant.

It was a battle cry.

"*Viva Firenze!*" Soderini called. The people repeated the line, the words rushing to the back of the piazza with the speed of a

gale-force wind. A chant started low, in the belly of the crowd. "*Viva Firenze. Viva Firenze.*" It grew until every Florentine was chanting in unison. "*Viva Firenze. Viva Firenze.*" Florentine flags unfurled. Children raised their arms in victory. The chanting and chimes reverberated through the city, and Michelangelo had no doubt the sound would echo across the countryside, reaching the ears of the Pisans, the French, the Papal Armies, the Holy Roman Emperor, and especially the Medici. They would all shudder with fear at the sounds of those bells and the roar of a citizen's army.

"It seems I was wrong." Machiavelli stood on the platform next to Michelangelo, observing the crowd. "Florence looks ready to defend herself after all." He offered a short bow, then strode toward the palazzo. Michelangelo watched him go, figuring that was about as close to a compliment as he would ever receive from the inscrutable diplomat.

Granacci pushed through the crowd and kissed his friend on both cheeks. "Have you thought about carving your name onto the *David*, like you did with the *Pietà*?" he asked, gazing up at the looming giant. "You could do that with all of your sculptures."

"No thanks, *mi amico*," Michelangelo yelled over the din of the chanting crowd. "I think I'll let this one speak for itself."

Leonardo

W hen *La Vacca* tolled, Leonardo was sitting on the railing of the Ponte Vecchio, gazing dreamily into the Arno River below. As the people chanted, *"Vive Firenze,"* Leonardo turned to Lisa's portrait, propped up next to him as though keeping him company, and said, "It seems they like the statue."

The celebration in the square lasted for well over an hour, but eventually Leonardo watched as happy Florentines straggled back home. Most who passed over the bridge ignored the strange old man sitting on the railing, dangling his feet over the Arno like a carefree child. Leonardo smiled and nodded at a few of the passersby, but he spoke to no one, and he never once pulled out his sketchbook to record their excited faces. He could do that another day. Today, he wanted to sit and think of nothing.

Once the revelers returned home, he was alone again. The old bridge, usually bustling with butchers, grocers, and shoppers during the week, was locked up and empty on Sundays. Sitting on that bridge with nowhere to go and nothing to do, he felt something bubble up from the bottom of his gut. It wasn't a thought. It wasn't a physical ailment. It was a feeling. He probably lived with the emotion all the time, but he rarely allowed himself to be conscious of it.

It was a powerful urge to paint.

Leonardo was no longer under contract to finish the altarpiece of the Virgin and St. Anne for the friars at Santissima Annunziata,

yet he felt a desire to return to the composition. And he had a burst of inspiration for the city's fresco of the Battle of Anghiari. And then Leonardo conjured a strange image of Christ giving a benediction while holding a mysterious clear crystal ball. The image, whatever it was, gave him a sense of peace and comfort. He wouldn't dwell on it now, but he might paint that picture next. Above all, he felt a tickle to add a brushstroke or two, every so often, to his Lisa.

"Signore," a young man called from the far bank of the river.

The voice startled Leonardo out of his reverie. He looked up and saw a well-dressed gentleman running toward him from across the bridge. Leonardo put Lisa's portrait under his arm. He didn't feel like showing her off right then.

"Signore! You're the first person I've seen since entering town," the young man said, coming to a stop. "I started to think Florence had been attacked, everyone taken prisoner."

"No, just a sleepy Sunday." He couldn't help but notice how beautiful the young gentleman was. He was probably around twenty years old. He had small graceful features and large round eyes. His hair was long and well groomed, and he wore the clothes of a wealthy courtier.

The young man pointed to the painting under Leonardo's arm. "Are you a painter?"

"I suppose carrying a picture around gives me away."

"Well, I'm a painter, too." The young man smiled broadly. "From Urbino. I was on my way to Rome to study the ancients, but when I was just outside of town I heard that the most miraculous piece of art ever created was unveiled here today in your Piazza della Signoria. Is it true?" he asked with wide, excited eyes.

"Ah, you seek the *David*."

"Yes, of course." The young man beamed. "I hear it must be studied in order to understand the future of art."

"If that's the case, I suppose I ought to go see it, too." Leonardo stood and brushed off his tunic. "*Andiamo*, I'll take you to it."

As they walked, the young man kept up a steady stream of chatter. His father had been a painter for the Duke of Urbino,

so he'd grown up at court. He'd apprenticed as a painter in the Urbino branch of Perugino's studio, and the local guild had considered him a fully trained painter for three whole years. He had even been hired to paint a couple of altarpieces on his own. And of course, he'd studied all the masters. Masaccio, Botticelli, Mantegna, even the great Leonardo da Vinci. All from copies, of course, but he had every one of their paintings memorized.

Leonardo nodded along. The lad might have Leonardo's paintings memorized, but he didn't seem to recognize the painter's face. To him, the Master from Vinci was a piece of history. The youth probably thought he was already dead.

The pair turned a corner and entered the now empty piazza. Across the square stood the statue of David at the entrance to the palazzo. Even from this distance, the giant commanded the scene. The setting sun peeked through the surrounding buildings and glinted off the white marble with a heavenly luminance.

"*Che bello*," Leonardo's young companion said in awe, then sprinted toward the statue.

Leonardo approached at a slower pace, taking measured steps so that he might observe the sculpture from every distance. When he'd first seen the Duccio Stone, he hadn't been able to imagine the possibility of a figure emerging from that weathered, beaten, botched lump of rock. Michelangelo had not only been able to imagine it, he had somehow lured a classically beautiful giant from those battered remains. Even from afar, the statue looked like a colossus that might have been plucked from ancient Rome. And that curve of *David*'s posture, dipping in at his left hip, was a revelation. That pose must have been a result of the day when Michelangelo had lost his temper and beaten the stone in a fury. But where Leonardo had seen disaster, Michelangelo had seen potential, molding a gentle swooping stance to fit the gash.

As Leonardo walked closer, he saw that *David* wasn't simply an aesthetically pleasing classical beauty, but a real man suffering from real conflict. Sling resting beneath his jaw, a stone in his

right hand, eyes staring off at an enemy in the distance, this *David* had not already won the battle against Goliath; he was heading off for the fight. This *David* was not a trite, fierce warrior filled with pure, courageous confidence. This *David* was in turmoil. His left side was wound tight as a sling with anxiety and tension, arm and leg bent, neck twisted, ribs contracted, while his right side was relaxed, ready to face his destiny. Some of his muscles were taut, others loose; his ribs rippled, yet breathed; some fingers clenched while others fell slack. Even his toes were simultaneously limp, yet gripping the ground in fear.

And that face. Leonardo drew in a breath as he stepped to the front of the statue. The face was a sublime mix of hope, fear, angst, dread, passion, determination, pride, and courage. Leonardo recognized that expression immediately. The features were different. *David*'s nose was longer and straighter. His cheeks were fuller and softer. The lips and nose were much more handsome. But that marble forehead rippled with the same anxious furrows he had seen at least a dozen times, and the lines under *David*'s eyes captured a familiar weariness and trepidation. Leonardo knew that look well.

He saw it every time he encountered Michelangelo.

When Leonardo first met the scraggly, smelly, temperamental sculptor in his studio, he never would have imagined that such an uncouth youth could create such a beautiful piece of art. Leonardo might have more experience, more knowledge, and more intelligence, but Michelangelo had something that Leonardo did not have, and might never develop. He instinctively knew how to give his whole mind, soul, and heart, without holding back. This statue thumped with life, not because of some legendary piece of marble or because of the sculptor's skill with a hammer and chisel, but because of Michelangelo's own intensity. In comparison, Leonardo was an apprentice in the field of passion, only beginning to know enough to understand that he still had much more to learn.

Leonardo turned to his companion, who was staring up with wonder at the *David*. "What's your name, *mio ragazzo*?"

"Raphael Sanzio, signore," the young artist said. "And you?"

Leonardo gave a dismissive wave. "No one of consequence. So, Raphael, what do you think of our little statue?"

"It's so amazing, I don't have the words, signore."

"Well, in that case, I highly suggest a young artist such as yourself sit down to sketch it." Leonardo reached into his pocket and pulled out a sheet of paper and some chalk.

"Thank you, signore, but I never travel without it," Raphael said, pulling out his own sketchpad. He settled down at the foot of the sculpture and flipped through his sketchbook to find an empty page. Leonardo was surprised to see such beautiful, graceful drawings from the hand of such a young man. Yes, the sketches were a little clumsy; the young painter needed more experience and practice, but his figures had a lightness and grace that transfixed Leonardo. The young artist flipped past a copy of Leonardo's own *Madonna of the Rocks*. Raphael had drawn such a serene rendition that Leonardo shook his head. Even inexperienced, no-name youths in the street were starting to surpass him.

Then he noticed a figure standing on the edge of the piazza, watching him. The man was short, muscular, with a scraggly beard and black hair. Even from a distance, Leonardo could feel the intensity of his gaze.

Leonardo stood up straight and faced the sculptor. Gesturing to *David*, he gave a deep, sweeping bow usually reserved for courts and kings. As he looked up, he placed his hand over his heart.

With Michelangelo still watching, he made a show of opening his sketchpad and gripping his piece of chalk. Then he settled on the stairs in front of the statue, turned his attention to *David*, and began to draw. After all, the only way to keep learning was to sketch the masters.

Coda

David remained in the Piazza della Signoria (now more commonly called the Palazzo Vecchio) until 1873, when he was moved indoors to the Galleria dell'Accademia to protect him from the elements. In 1991, a deranged man attacked *David* with a hammer and broke off the second toe of his left foot. Museum patrons visiting the *David* tackled the assailant and restrained him until authorities arrived.

Today, *David* is considered the world's most famous sculpture, with over three million visitors traveling every year to the Accademia to visit him.

In 1516, Leonardo da Vinci moved to France to serve as the painter to King Francis I. On May 2, 1519, he died in the king's arms. At the time of his death, Leonardo still kept one of his paintings in his private chambers: the portrait of Mona Lisa del Giocondo. To his dying day, he claimed the portrait was unfinished. The painting hung in King Francis I's palace at Fontainebleau until King Louis XIV was rumored to have taken it to Versailles in the 1680s. After the French Revolution, the painting was relocated to the Louvre, a former royal palace transformed into a public museum. Several times since its installation, the portrait has been moved for safety, and it may have spent a few years hanging on Napoleon's bedroom wall in the Tuileries Palace. In 1911, an Italian immigrant

stole the *Mona Lisa* from the Louvre and held her hostage for two years. She was recovered, unharmed.

Today, the *Mona Lisa* is the most popular attraction at the Louvre. It is estimated that every year over six million people travel to the museum to see her.

stole the *Mona Lisa* from the Louvre and held her hostage for two years. She was recovered unharmed.

Today, the *Mona Lisa* is the most popular attraction at the Louvre. It is estimated that somewhere around 8 million people travel to the museum to see her.

Author's Note

I first asked the question that inspired this novel twenty years ago, when I was in college and learned that Leonardo and Michelangelo both lived in Florence from 1501 to 1505. The historical record tells us the two openly disliked each other. Contemporaries reported contentious run-ins on the streets. As far as their rivalry goes, art historians focus on the dueling frescoes commissioned when they were each hired to paint an opposing wall inside Florence's city hall. As addressed in this novel, Leonardo was hired to paint the Battle of Anghiari in 1503. Michelangelo was brought on after he completed the *David* to paint the Battle of Cascina. For a few months, until Michelangelo left for Rome in the spring of 1505, the two worked alongside each other in the same room, but neither completed his fresco. For centuries, art historians have lamented that this great battle came to nothing.

But, I wondered, did it really come to nothing? During the years just prior to the fresco commission, Michelangelo carved the *David*, while Leonardo painted the *Mona Lisa*. Surely it wasn't a coincidence that the two most iconic works of art in all of western civilization were created in the same town, at the same moment. Is it possible to believe that these two brilliant, competitive artists did not try to best each other? Seemingly invincible opponents drive us all to greater heights than we could reach on our own. Isn't it only logical that the young Michelangelo pushed

the aging Leonardo to paint the *Mona Lisa*, just as Leonardo drove Michelangelo to carve the *David*? This novel is my attempt to answer that question.

Leonardo really did sketch the *David*. When I first saw that sketch (now held by the Royal Collection in England), I pictured Leonardo sitting at the foot of the *David* while the young Michelangelo looked on. And with that one drawing, this book was born.

Oil and Marble is based on twenty years of research and grounded in real history, but it is unapologetically a work of fiction. I have taken artistic license to tell the story of these two characters who have lived in my imagination for over two decades.

Leonardo was illegitimate and disinherited by his father, but the details of their relationship are unclear; I believe it was one of the most painful parts of the artist's life. There is evidence that he was considered for the Duccio Stone, but the scene of the two competing for the commission is imagined—based on a Florentine tradition of hosting such events. During Leonardo's service as Cesare Borgia's military engineer, he mostly stayed out of war zones, but there is evidence he saw battle. I do not know whether he built his multi-barreled armored cannon, but I like to believe he had a chance to bring some of his inventions to life. He and Machiavelli were at Borgia's camp at the same time; I wish I had been able to eavesdrop on their conversations. Leonardo's notebooks are filled with designs for flying machines, sketches of birds, and even a reference to a trial flight, but the attempt must have failed; he surely would have recorded it if he had succeeded. Florence hired him to divert the Arno River, and the project collapsed during a storm, killing eighty. However, I moved the diversion site closer to the city and the date of the flood by a few months to fit the story. The bird ring is made up. Why didn't Leonardo give *Mona Lisa* to its patron, her husband? And why did the artist keep the picture with him until he died? We will never know.

According to Giorgio Vasari, the famous biographer of Renaissance artists, Michelangelo carved his name into the *Pietà*

after it was mistakenly attributed to Gobbo (some historians now claim that story as a myth; any fiction writer would be foolish to leave it out). Michelangelo did have money saved after the *Pietà*, but I have him robbed on the road home for story purposes. His arrest upon entering Florence is fiction, although he was detained once when entering Bologna and a friend had to bail him out; I used that story as inspiration. Michelangelo's father really was unsupportive of his chosen profession. His brother Giovansimone was always troublesome. I once read an anecdote that Giovansimone set fire to the Buonarroti family home in Settignano (yes, the Buonarroti family held property, even if it did not bring a large income. Their home in Florence was rented); that story inspired the fire in this book. The Duccio Stone was as botched as described, and Michelangelo really did build a privacy shed. The shed from history was brick; I imagined it as wood, and I let my imagination win on that detail. We do not know how the two artists met or if they ever argued over a dissected corpse; I like to think they did. The move of the *David* to the Palazzo della Signoria, including the attack on the statue one night, is historically accurate. The date of *David*'s official unveiling is correct, but I have no idea what that moment looked like. Was it as momentous as I made it out to be? I would hope so. And, of course, no one can ever know the internal process of creation. I don't believe any work of art comes fast or easy, and I tried to explore the artists' struggles as they created these masterpieces.

As is usual for writers of this time period, I translated all dates into our modern calendar to avoid confusion for readers. In Renaissance Florence, a new year did not begin until the Feast of the Annunciation on March 25.

For a complete description of the real history behind the novel, an explanation of when and why I used artistic liberties, and a bibliography, please visit the "History Behind the Novel" section of my website at www.OilandMarble.com.